ROMANESQUE ART
IN EUROPE

ROMANESQUE ART IN EUROPE

EDITED BY
GUSTAV KÜNSTLER

WITH 254 BLACK AND WHITE PLATES
23 MAPS AND PLANS

NEW YORK GRAPHIC SOCIETY LTD.
GREENWICH CONNECTICUT

SBN 8212-0359-2
Library of Congress Catalogue Card No. 69-18001
© 1968 in Austria by Anton Schroll & Co., Vienna
Illustrations printed in France by Braun et Cie, Mulhouse
Text printed in Holland by Koninklijke Drukkerij G. J. Thieme n.v., Nijmegen
Bound in Holland by Van Rijmenam n.v., The Hague

CONTENTS

PUBLISHER'S FOREWORD

This book is a selection from six volumes published between 1955 and 1968 by Schroll Verlag of Vienna: *Gallia romanica*, with text by Joseph Gantner and Marcel Pobé and photographs by Jean Roubier; *Hispania romanica*, with text by Marcel Durliat and photographs by Jean Dieuzaide; *Italia romanica*, with text and photographs by Heinrich Decker; *Germania romanica*, with text and photographs by Harald Busch; *Britannia romanica*, with text by Robert T. Stoll and photographs by Jean Roubier; and finally, to complete the series, *Scandinavia romanica*, with text by Armin Tuulse. The volumes on France, Italy and the British Isles were also published in English by Thames and Hudson, under the titles *Romanesque Art in France*, *Romanesque Art in Italy*, and *Architecture and Sculpture in Early Britain*. This large-scale survey of Romanesque art was planned by Gustav Künstler who, in his editorial capacity, was able to collaborate closely with the authors and photographers of most of the volumes and so to shape the project as a whole according to his own conception.

For the present composite edition new introductory sections have been prepared; the notes on the plates are based on those of the original publications.

ROMANESQUE ART
IN EUROPE

ROMANESQUE ART was the first pan-European style since the fall of the Roman Empire, and it began as a deliberate revival of Roman, imperial art. When Charlemagne was crowned Emperor of the West in 800, he set out to be a second Constantine, and fostered a new development of painting, scholarship and architecture based on Roman or Early Christian models. Later, when Henry IV in 1080 rebuilt Speyer Cathedral, it was with the same consciousness of a Western Christian Empire and the same deliberate use of Roman motifs.

Christendom was divided: the Eastern Church, based on Constantinople, had grown apart from the Western, Roman, Church: the formal break was made by the Patriarch of Constantinople in 865, and confirmed in 1054. Where Romanesque buildings do appear in remote corners of the Byzantine empire, as in eastern and southern Italy, this was usually as a result of military conquest. The case of Bari is typical: the land-hungry Normans had by the end of the eleventh century taken possession of all the south Italian domains of the Byzantine Emperor, but there were still occasional risings against them. Bari, the chief port of Apulia, suffered extensive destruction when it was recaptured by the Normans in 1165. It is not known how badly the Byzantine cathedral of San Sabino was damaged in the fighting: normally in wars between Christians churches were spared. We do know, however, that this cathedral which had stood for less than a century was torn down, and a larger and more imposing Norman church erected in its place. This may have been in part an offering of atonement for the blood shed in the battle; there can be no doubt that it impressed the Norman conquest firmly and finally in the minds of the people.

Bordered on the east by the Orthodox Church, to the south Romanesque Europe extended as far as the Arab territories. The power and culture of Islam had spread along the Asian and African coasts of the Mediterranean, touched on Sicily and southern Italy, and struck deep roots in Spain. Its influence is marked in the architecture and art of Christian Spain, south-western France and Sicily.

In 732 the advance of the Arabs had been checked in France; in 955 the Magyars, who penetrated as far as northern Italy and Burgundy, were finally repulsed by the German king Otto the Great, and withdrew to Hungary. Raids by pagan Vikings gradually ceased in the north, and the invaders, converted to Christianity, established themselves politically and culturally in the conquered territories. Relatively free at last from external threats, Christian Europe was able to turn outward itself; and by the end of the eleventh century two great aggressive crusades were

7

under way: the *Reconquista* of Spain, and the struggle to free the Holy Land from the infidel. At first the Crusades were a confused movement, made up of crowds of people drawn from all classes of society in France and neighbouring countries, but they soon developed into organized armies. However precisely the knights, the priests, and their followers may have imagined the dangers they were going to meet, they must have known that the long journey into strange and hostile lands might cost them their lives. Nevertheless they were drawn irresistibly by the promise of excitement and a passionate longing to see the Holy Sepulchre in Jerusalem and visit the scenes of Christ's Passion. At home the same aggressive instincts led to the perfection of ever bigger and more subtle fortresses, and the same fervour moved men to build ever larger and more splendid houses of God.

Churches were also founded for particular motives: we have seen that the Normans may have rebuilt Bari Cathedral in atonement for blood shed in battle; it is certain that this was the reason for William the Conqueror's foundation of Battle Abbey, on the site of his decisive victory over Harold in 1066. Before he left Normandy, William and his wife Matilda had founded two abbeys at Caen, Saint-Etienne and La Trinité, to expiate their fault in marrying in spite of a papal interdict. Thus, as when the Emperor Henry IV was reduced to going barefoot through the snow to obtain pardon from Pope Gregory VII, even the most powerful figures of Romanesque times lived in fear and respect of God and the Church, and expressed this respect in symbolic acts. Just as Charlemagne had been crowned at Rome on Christmas Day 800, so William chose Christmas Day of 1066 to be crowned King of England in the royal abbey of Westminster – establishing at the same time his religious and political legitimacy.

THE YEAR 1000

For several centuries before the year 1000 many Christians had felt a growing sense of dread at the approach of what they expected to be the end of the world. This idea was based on prophecies in the Book of Revelation, whose literal interpretation had already been condemned in the fifth century by St. Augustine, who wrote in the *City of God* (Book 20, chapter 7) that the Evangelist 'used the thousand years as an equivalent for the whole duration of the world, employing the number of perfection to mark the fullness of time'. Nevertheless in certain areas repeated natural disasters and destructive wars seemed to confirm that final chaos was near, and fear of the Last Judgment increased. When William the Pious, Duke of Aquitaine, founded the abbey of Cluny in Burgundy in 910, he no doubt regarded this as a final virtuous act. The monastic rule at Cluny was a reform of existing Benedictine practices; its effect, the spiritual intensification of monastic life, can hardly be overestimated. The Cluniac Rule demanded a total devotion to God: no time was lost in manual tasks – departing in this from the Benedictine rule, 'work and pray' – and the monks, drawn almost exclusively from the aristocracy, spent their life in liturgical offices. This heightening of the spiritual life spread with extraordinary speed, helped largely by Cluny's many daughter-houses, and increasing numbers of the clergy were swept up in the spirit of reform. The intensity of the movement could almost certainly have been achieved only in the face of imminent

Judgment: human weakness and sin had to be sloughed off, earthly ambitions had to be rejected. That at least was the spirit of the first century of the Cluniac reform.

It would of course be wrong to suppose that as the year 1000 approached Western Europe froze in a state of passive expectation. Nevertheless in many regions it was only after that date that large and ambitious buildings began to rise in any numbers, a sign in itself of renewed vigour and confidence. This was the time when the contemporary chronicler Raul Glaber noted to his joy that Europe was becoming covered with 'the white robe of the Church'.

A few large churches were built or started in the last decades of the tenth century: for this there are various reasons. The church of Gernrode in the Harz mountains was founded in 959 by the great margrave Gero, who had subdued the Slavs and introduced Christianity as far as the Oder. His son had just been killed in battle, and in the following year he established a convent, where his daughter-in-law would be provided for as abbess. When he himself died in 965 he was buried at the entrance to the chancel. These then were his aims: a church erected in memory of his son and doubtless also intended from the first to be his own resting-place; a convent where the young widow should spend the rest of her life mourning her husband and praying for his soul and that of his father.

Some of the churches of the tenth century seem to have been erected out of a sense of release from actual persecution: thus about 950 a group of Benedictine monks safely established at last at Tournus in Burgundy, after suffering at the hands of Norsemen and Huns, began to build a new church for the relics of St. Philibert. In England the repeated Danish invasions seem only to have strengthened the will to survive. In the mid-tenth century monastic reform was accompanied by a new impetus in the arts, under the influence of St. Dunstan, Archbishop of Canterbury. Many parish churches were begun, the monastic churches of Ely and Peterborough were consecrated in 970 and 972, and the great cathedrals of Canterbury and Winchester were rebuilt (only to be replaced in turn by Norman churches after the Conquest).

As soon as the dreaded year had passed, there was a sudden surge of building over large areas of Western Europe. The three great Kaiserdome ('imperial cathedrals') of the Rhine are all contemporary: at Mainz rebuilding began in 1009, the plan of Worms as it is today dates from the first quarter of the eleventh century, and the crypt of Speyer was consecrated in 1039. Bamberg Cathedral was begun in 1004, St. Michael at Hildesheim *(pl. 141)* in 1010, and the extensions to Trier Cathedral in 1035 *(pl. 193)*. In 1048 the church of St. Peter at Utrecht and the western transept of Mittelzell Church on Reichenau *(pl. 183)* were consecrated; they were followed by the crypt and westwork of Essen Minster (1039–56, *pl. 201*) and the rebuilt St. Maria im Kapitol at Cologne (1065, *pl. 197*). In Salzburg, where church life had older roots, the crypt of the Benedictine convent of Nonnberg was consecrated in 1043.

Outside the German Empire the story was the same. In France, the abbey church of Saint-Rémi at Reims was begun in 1005, and the crypt of Saint-Bénigne at Dijon *(pl. 7)* is as early as 1001. Work began again at Saint-Philibert in Tournus, the church built by fugitive Benedictines mentioned earlier, after a fire in 1007 or 1008 *(pl. 2–3)*. The rebuilding of the abbey church of Saint-Savin-sur-Gartempe *(pl. 48)* began about 1021. The choir of Notre-Dame-de-la-Couture

in Le Mans was completed in 1031, and the abbey church of Jumièges in Normandy *(pl. 69)* was begun about 1040. These are only a few of the many buildings that rose between the Atlantic and the Mediterranean in the architectural renaissance of the eleventh century.

Spain lay on the frontiers of Christendom: only Asturias, in the extreme north, managed to survive as a Christian province throughout the Arab occupation, though the Christian religion was never banned in the rest of the peninsula. But as the Arabs were pushed further south during the *Reconquista* new churches were needed; in Catalonia the ambitious rebuilding of Ripoll started about 1020, and the church in the fortress at Cardona *(pl. 75)* was consecrated in 1040.

Finally in Italy, which already had a wealth of Early Christian and Early Byzantine churches, new buildings were started and old churches rebuilt from the early eleventh century onwards. The cathedral on the island of Torcello in the Venetian lagoon was begun in 1008, San Miniato al Monte in Florence *(pl. 110)* was restored in 1018; in the ancient city of Aquileia on the Isonzo delta the rebuilding of the cathedral in its present form began between 1021 and 1031. Later in the century the year 1063 is remarkable for the simultaneous commencement of three famous churches: Sant'Abbondio in Como *(pl. 98–9)*, San Marco in Venice and the Cathedral of Pisa *(pl. 108)*. The first has affinities with buildings in nearby German lands; San Marco is the epitome of a domed Byzantine church; the plan of the cathedral at Pisa, which like Venice had a thriving trade with the Levant, suggests Syrian influence.

In the early Middle Ages there was a constant exchange, not only of goods but also of forms and ideas, along the great trade routes. Equally important were the pilgrimage routes, on which anybody – including artists, masons, and enlightened patrons – might travel. The most venerated of goals was of course Jerusalem; it was also the hardest to reach. In the west Rome had always been the most important goal; after it, much later, came Santiago de Compostela in north-west Spain. The fact that Rome was the seat of the Pope was of importance primarily to the clergy, who had to travel to Rome periodically to report to him, though some penitents did undertake the pilgrimage to receive papal absolution for the greatest sins. Most pilgrims were drawn to Rome by the graves of the Apostles Peter and Paul, especially the tomb of St. Peter in the basilica founded by Constantine the Great. Already by the end of the eighth century King Offa of Mercia, overlord of the other Anglo-Saxon kings, obtained from Charlemagne safe conduct through the Frankish empire for all English pilgrims bound for Rome.

At Santiago de Compostela there was in the ninth century only a modest building over the shrine of St. James the Great; in spite of poor roads and the danger of capture by the Moors, the flow of pilgrims increased steadily. Perhaps this was as a result of the legendary vision of Charlemagne (first recorded, with an interpretation by Pope Callixtus II, about 1120): the Emperor, it was said, had seen a starry road leading from Friesia, through Germany, Italy, France and Navarre to Galicia, ending at the tomb of the Apostle James; the Pope interpreted this to mean the route that the pilgrims should take. And indeed at the end of the eleventh century a greatly improved road was built, at the same time as the cathedral of Santiago *(pl. 96)* went up. Naturally some kind of provision had to be made along this great road for the pilgrims' needs. At one of the main crossings on the Loire *(pl. 19)* there is still to be seen, beside the great monastic church, a complex

of buildings offering shelter and rest for several hundred weary pilgrims. The name of the town still commemorates its former purpose: La Charité-sur-Loire.

The roads to Compostela, Rome and Jerusalem made possible lively cultural and artistic exchanges between widely differing areas; this, combined with the new vigour and optimism which welled up when the year 1000 had passed uneventfully, fostered an art that is powerful and rich, and extremely varied. It was a time of experimentation which led, in the next two and a half centuries, to a wealth of large-scale and individual structures which included castles and private houses as well as ecclesiastical buildings – though the latter are of course the most splendid and the most important. Along with this vast increase in building activity came a revival of sculpture in stone, sometimes at first imitating ivories and metalwork, and learning depth and liveliness from classical reliefs.

Unfortunately little secular architecture survives from the period before 1200, but what there is suggests considerable progress, particularly where castles are concerned, towards a greater sophistication of plan and richness of decoration; in England, for instance, the square keep *(pl. 206)* made way for experiments with round and polygonal keeps. At the very end of the period, especially in the cities of Italy and southern France, palaces were built for the civic community or for noble families, and at Santiago de Compostela portions remain of the large palace of the bishop, finished about 1140.

THE NATURE OF ROMANESQUE ART

Throughout Western Europe a style begun to evolve dimly in the seventh century which was fundamentally shaped by the idea of ancient Roman and Early Christian architecture and art. About the year 1000 a new impetus led to the construction of buildings larger than any had been for centuries in the West, and as late as the thirteenth century a pure Romanesque style was flourishing in Germany and southern Italy. One may classify the works of the period chronologically: thus the art of the beginning of the eleventh century is often termed Pre-Romanesque, and that of the second half of the century Early Romanesque; the twelfth century is the time of High Romanesque and the thirteenth of Late Romanesque. In this book we have felt it useful to include buildings earlier than the year 1000 – such as Aachen – because of their importance in the creation of the Romanesque style. Other works, such as the Scandinavian wooden churches, have been included because although they belong stylistically to a completely different convention, they complete the immensely varied picture of Western European art in the early Middle Ages.

After the fall of the Roman Empire, the many ruins which survived – except in the extreme north of Europe, beyond the imperial frontier – were an obvious source of inspiration; Christianity, with its spiritual roots in Rome, gave these ruins new meaning. Here local builders could see structures on a monumental scale, with round arches, walls composed of a finely-faced core of rubble and concrete, and masonry vaults. They were also impressed by classical decoration – marble facing, columns of stone with ornate capitals, painting to imitate marble, and the whole repertory of classical ornament from pediments to bead-and-reel mouldings. Travellers went to

Italy, where they could see the great Early Christian churches of Rome, Milan and Ravenna, and from these the basilican plan was derived. Of a completely different form, but equally inspired by the past, is Charlemagne's chapel at Aachen *(pl. 129)*, consecrated in 805; it is directly based on the sixth-century church of San Vitale at Ravenna, just as Charlemagne's large and complex palaces at Ingelheim and Aachen must have reflected surviving Roman secular buildings. The power of such a pedigree led to the reproduction of the Aachen elevation over two hundred years later in the westwork of Essen *(pl. 201)*.

In plan Romanesque churches of longitudinal type ranged from the simple aisleless structures of south-eastern France to such monumental creations as the third abbey church of Cluny, finished early in the twelfth century with a nave, double aisles, two transepts, an ambulatory with radiating chapels, and a western porch (plan, p. 25).

The great majority of churches were based on the Early Christian basilica. They have a broad, high central nave with windows in the wall above the lower, narrow side-aisles, which are divided from the nave by a row of columns or piers; the nave at first terminated at the east in an apse. Already in the Carolingian period the predominant form for Benedictine abbey churches was a basilica with a transept, and a chancel extending beyond the transept to the east. Thus an extra compartment of space was added between the crossing and the apse, to accommodate the monks during services. On this basic theme a seemingly endless number of variations were played: the proportions might be altered; a rectangular east end substituted for the apse (a Cistercian feature which became standard in England); an extra gallery storey introduced between the arcade and windowed wall above, or substituted for the clerestory. In some areas, notably around Périgueux in France, churches were domed and reached a considerable size without aisles. Along the Rhine, beginning with Charlemagne's Centula (consecrated in 799), a number of churches were built with a multi-storeyed projection at the west end, the 'westwork', which provided a lobby or porch at ground level and above it one or several chapels (see, e.g., *pl. 131*). This arrangement is also found at Tournus in Burgundy.

Plans were sometimes affected by the presence of a shrine, with the consequent flood of pilgrims into the church: thus along the road to Compostela a church type evolved with continuous aisles right round the transept arms and ambulatory, and sometimes double aisles in the nave. At the east end the shrine of the saint usually lay in a crypt under the choir. Crypts were built in two basic forms: they might be horseshoe-shaped, allowing a single file of pilgrims to pass the shrine but not to congregate there. The earliest examples of 'passage-crypts' occur in Italy, about 590. At Santiago de Compostela steps lead down from the ambulatory into a passage under the chancel, and halfway along the passage a narrow opening in the wall allows the faithful to see the Apostle's tomb, which lies pointing toward the east. The other form of crypt consists of an open room, its vault supported on a number of pillars, which may more or less exactly follow the shape of the choir above. This was the form chosen for the crypt of the church of San Nicola at Bari, when in the eleventh century the relics of St. Nicholas of Myra were captured in Asia Minor and brought to Italy. This event stirred Western Christendom, and the merchants of the city, the bishop and the Norman duke combined to build a new church *(pl. 121)* to house them. The spacious crypt

containing the altar-tomb was consecrated in 1089, a mere two years after the arrival of the saint's bones, by the Pope himself.

The location of a relic-chapel under the church was to a certain extent a practical arrangement: no space was taken up inside the church, and the relics and their attendant treasure could be more securely guarded. But beyond this surely lay the idea of making a holy grotto-tomb for the bones of the saint. The rows of pillars in the half-light create the effect of a mysterious forest: the eye is led in a diagonal or lateral direction where it inevitably falls on yet other rows and intersections. This must be the experience which gave its name to the 'Crypt of a Hundred Pillars' *(pl. 179)* at Gurk in Carinthia, of 1170.

The presence of a crypt three-quarters buried under ground raised the floor level of the chancel: the high altar, reached by one or several flights of steps, dominated the interior, an arrangement most striking in Italian churches such as Pavia *(pl. 103)* and Piacenza *(pl. 126)*. The original stimulus for this form may have come from Rome, where at San Lorenzo – and probably in the old basilica of St. Peter – the *presbyterium* containing the altar is raised a few steps above the nave; in the middle of these steps there is a broad flight leading down to the tomb of the saint, the *confessio,* below ground level. At Bari, on the other hand, the crypt is completely below ground, and at Trani it forms the ground floor of a two-storeyed church.

While passage-crypts remained relatively rare, larger crypts became popular throughout Europe for a variety of purposes. There are, for instance, crypts at Leyre in Spain (consecrated in 1057), Lund in Sweden (*c.* 1080), Canterbury in England (*c.* 1120), and Brunswick in Germany (consecrated in 1195). At Speyer a crypt was built to house the bones of kings, while at Saint-Benoît-sur-Loire St. Benedict, founder of the order, is buried.

The wish to accommodate an increasing number of side-altars, where masses could be celebrated simultaneously by monks or for pilgrims, dictated more complex plans. At St. Gall in the ninth century there were altars ranged along the sides of the church. Chapels could also be fitted in on the eastern face of the transept, where they were sometimes provided with individual apses: four such subsidiary apses, as in the cathedral of Aquileia, are the mark of a large building; six, as at Ripoll, are exceptional and indicate the major importance of this Benedictine abbey in Catalonia. The third and largest church at Cluny, with two eastern transepts, had no less than fifteen apsidal chapels, each provided with an altar. In France a system of chapels radiating off the ambulatory was developed.

Along with the rectangular, basilican churches, there exist a considerably smaller number of round churches. Although these are widely scattered throughout Western Europe, they have obvious similarities: they are generally two-storeyed buildings, with the cylindrical inner space divided by pillars from an outer, annular ambulatory. Examples of this type are the isolated eleventh century church of San Tomaso in Lémine in the Bergamo Alps, now a centre of pilgrimage *(pl. 102)*; the church of St. Michael in Fulda *(pl. 159)*, also built in the eleventh century; the ruined church of Saint-Sépulcre at Charroux in Aquitaine, which dates from before 1100, and the church of the Holy Sepulchre in Cambridge *(pl. 242)*, which dates from the early twelfth century. The form persists, if slightly more complex internally, in the thirteenth-century church of Vera

Cruz at Segovia. Even the smaller round churches, whose form is basically a single circular unit, seem to be inter-related; for example the so-called Chapelle des Templiers at Laon in northern France *(pl. 61)*, dating from the mid-twelfth century, and, of approximately the same date, the oldest Austrian *Karner,* or charnel chapel, in the cemetery of the village of Petronell on the Danube *(pl. 177)*. Little is known about these buildings; sometimes they are connected with the order of the Knights Templar. What is certain is that their form derives ultimately – at however great a remove – from the grand design of the early round church, consecrated in 336, built over the Holy Sepulchre in Jerusalem.

The Romanesque development with the greatest implications for the future was the creation of high stone vaults. Here at last was a permanent, fireproof, and acoustically preferable way to roof over large buildings, which furthermore gave a new aesthetic unity to the interior. From the very beginnings of Christian architecture under the Emperor Constantine, after the Edict of Milan in 313, the standard basilican church had an apse vaulted with a semi-dome, though its nave and aisles were roofed with wood. From the early eighth century onwards it was not unheard-of for small structures to be given stone vaults, either square groins or longitudinal tunnel vaults. In larger churches aisles might be vaulted while the nave continued to have a wooden roof – an arrangement especially favoured in the north. Where there was a crypt it obviously required a stone vault, to support the weight of the chancel often crowded with clergy and celebrants: here the groin vaults, low or stilted, appear not so much a roof over an enclosed space as the hollowing-out in stone of a tomb.

Experiments with high vaults followed, and during the eleventh century the Benedictine church at Tournus in Burgundy was given a series of vaults that look like a builder's trial-ground. Here over the main nave there are transverse tunnel-vaults, buttressed by groin-vaulted aisles *(pl. 2)*; the ante-church has groin vaults in nave and aisles, and the chapel above it *(pl. 3)* has a longitudinal tunnel vault supported by quadrant vaults in the aisles.

The two basic forms of vault throughout the Romanesque period were the groin vault and the tunnel vault. Both had existed in Roman times, and appeared on a gigantic scale in Roman buildings, but the tradition had died and the techniques had to be re-developed by later builders. In tunnel vaults, consisting of a single curve of stones mortared together, the weight presses directly downward and the walls on which the sides of the vault rest must be of great strength. Long tunnel vaults, which were commonly used to roof naves, were often supported at intervals by transverse arches; as well as being structurally efficient, these arches also allowed the vault to be built in stages, so that centering did not have to be erected in the entire length of the nave simultaneously. While transverse arches are the rule in south-western France and at Santiago, they were dispensed with in other regions: at Saint-Savin-sur-Gartempe in Poitou there are none, and the massive vaults of Auvergne churches are uninterrupted from the west wall to the crossing. In the case of Auvergne it has been suggested that the thick forests of the region provided enough timber for complete centering throughout the nave. There can be no doubt that where transverse arches are used they provide a stately rhythm leading the eye to the crossing and the dim chancel beyond.

Groin vaults can be seen as two intersecting tunnel vaults; the weight is thus carried down in

14

the corners, making it possible to vault open areas such as crypts. They are the ancestors of rib vaults, but as long as they remained round and not pointed in section they presented the masons with problems. Groin vaults can only be used easily over square spaces: where the space is oblong, the solution is either to stilt the narrower arch – that is, to build it up on straight sides until it reaches the height of the wider arch – or to depress the wider arch so that it is no longer a semi-circle. Neither was really satisfactory: stilted arches in combination with normal semicircular arches look awkward and create awkward spaces, and depressed arches involve a structural risk. Thus the masons, whenever possible, used square vaulting bays. In aisles, where the distance from pillar to wall could easily be made the same as the distance from pillar to pillar, it was a simple matter. In high vaults, however, this would have meant making the distance between the piers of the arcade which ultimately supports the vaults the same as the width of the nave – resulting in extremely wide arches on relatively squat supports. And so a system developed in which the major vault carrying piers are separated by an intermediate pier, usually more slender, often a column between massive compound piers. This results in a rhythmic alternation of supports along the nave, which determines the spatial effect.

The tunnel vault, regionally modified, was especially favoured in France; the groin vaults at Vézelay in Burgundy have been explained by its relative nearness to the Rhineland, where they were the rule. In Italy, much of the German-speaking area, and the French Duchy of Normandy, instead of vaults flat wooden roofs were used, sometimes elaborately painted; painted ceilings of the eleventh century survive at Zillis in Switzerland *(pl. 282)* and at Peterborough in England, and the ceiling of St. Michael at Hildesheim is of this type, though of a somewhat later date *(pl. 142)*. In Normandy the first stone vault was used in the choir of La Trinité at Caen; it was probably in place when Queen Matilda, the church's foundress, was buried there in 1083.

Wooden ceilings were standard in the Norman dominion of England (see, e.g., *pl. 208*), which makes it all the more remarkable that it is probably in England that the first rib vaults were built: though the present nave vault of Durham Cathedral *(pl. 231)* is early – about 1130 – it seems certain that its choir was already vaulted with ribs between about 1093 and 1104.

The forward movement of the vaulted nave towards the chancel ended triumphantly in the tower over the crossing. This was open from below *(pl. 208)* and gathered all the movement together, leading the gaze of the beholder upwards and then allowing it to fall again on the rays of light from the lofty windows. Only then could one comprehend the chancel which again receded into a half-light. Perhaps the grandest and at the same time most subtle treatment of the crossing is the *cimborio* found in the ancient kingdom of León. Here in the cathedrals of Zamora *(pl. 94)* and Salamanca light, fantastic, dreamlike forms, domes divided by ribs into sixteen shallow segments, rest above the crossing, true temples of the Grail, the place of spiritual assembly before the chancel.

The pleasure which we take today in the essential nature of materials, their structure and their surfaces, and the delight which comes from seeing the bold and technically ever more skilful handling of masonry and sculpture, has, historically, no place in Romanesque art: then the basic materials used were accorded little or no aesthetic merit. At the most, arches (at Vézelay) or walls might be built of different coloured stones, laid in geometrical patterns such as stripes, which,

for example in the great Romanesque churches in and near Pisa *(pl. 108)* and Lucca *(pl. 105)*, brightens the buildings but detracts a great deal from the monumental effect that might be expected from their dimensions.

More commonly good or bad masonry of walls and vaults, clumsy carving or almost unbelievably crisp and subtle sculptures at Vézelay *(pl. 15)*, all was covered with limewash and bright paint. Few interiors survive intact, but at Saint-Savin-sur-Gartempe *(pl. 48–50)*, in western France, we come as close as we ever will to experiencing a Romanesque church as its builders and congregation knew it. The walls and giant pillars are painted in different colours to imitate marble – the marble of the columns and wall-panelling in the Early Christian churches of Rome and Ravenna. The porch is painted with scenes from the Book of Revelation; inside, on the nave vault, monumental frescoes illustrate the Old Testament, beginning with the Creation. The crypt, in which the colours are particularly bright and fresh, is decorated with a series of episodes from the lives and martyrdoms of St. Savinus and St. Cyprian.

Another form of decoration was mosaic. While Moorish craftsmen worked on Christian buildings in Spain, Byzantine workmen were imported by the Norman kings of Sicily to execute the great mosaic decorations at Cefalù *(pl. 117)*, Palermo and Monreale. Here the semi-dome of the apse bears a mosaic of the Pantocrator, Christ as ruler of the world; in his left hand he holds a book open at the words 'I am the light of the world', while his right hand is raised in blessing. At Monreale the intended scheme was completed, and the walls of the nave are covered with mosaics, of saints and biblical scenes from the Creation to the Harrowing of Hell.

Sculpture in stone, like large-scale vaulting, was an art which had to be re-invented, and like vaulting it was inspired by Rome. Until shortly after the year 1000, the greatest achievements of plastic art were on a small scale. There had indeed been a promising flowering of stone sculpture in Anglo-Saxon England, but it had led nowhere. In the Romanesque story the earliest occurrence of sculpture in combination with architecture, which was to have such a splendid future, seems to be a lintel on the church at Saint-Génis-des-Fontaines, in the Pyrenees, of 1020. The form is rigid and the relief shallow.

The main sources of inspiration for monumental sculpture were Early Christian and Carolingian ivories and metalwork, the reliefs on classical sarcophagi, and manuscript illuminations. The five panels in the choir of Saint-Sernin in Toulouse, showing Christ *(pl. 31)* flanked by angels, must have been modelled on ivories: the compositions are compact and the surfaces highly polished, and the pattern on the mandorla surrounding Christ suggests the jewelled ornament used on book-covers and portable altars. But there was nothing weak or over-refined in the convention, and the figure of Christ has a monumentality which is fully suited to the larger scale. Of a slightly later date (the Saint-Sernin panels probably date from before 1100), the sculpture on Modena Cathedral shows a different tradition: biblical stories are carved on panels in compositions derived from late Roman reliefs. Later still, in the second half of the twelfth century, the font of San Frediano at Lucca *(pl. 106)* is surrounded by curved panels representing the life of Moses in a completely classical style, from the type of vegetation to the treatment of the draperies; only the horses of Pharaoh's army introduce a new note.

In France, from Saint-Sernin onwards, the development was towards greater movement: figures were elongated and stood in complex poses (especially at Moissac and Souillac, and at Autun), and draperies began to swirl until at Vézelay *(pl. 15)* the robes of Christ and the apostles move in a staccato flutter. Finally, the figure moved out of the plane of the wall: St. Peter on the jamb at Moissac, of about 1120 *(pl. 35)*, is the first step towards sculpture in the round, a move taken a decisive stage further in the tall, cylindrical, *statues-colonne* at Chartres, which stand almost detached from the shafts of the portals *(pl. 52, 53)*.

In the great tympana of the south-west the Last Judgment and the Second Coming were the favoured subjects: in treatment they range from the overwhelming grandeur and stateliness of Moissac, with great subtlety and depth in the poses and expressions of the twenty-four Elders of the Apocalypse, to the compartmentalized jumble of demons and blessed souls at Conques *(pl. 39)*. At Autun in Burgundy the subject is again the Last Judgment, with smoothly elongated angels and spiky demons struggling for possession of tiny child-like souls *(pl. 12)*. At Vézelay *(pl. 15)* the theme is more elaborate – Pentecost and the mission of the apostles – but the sculptor has managed to keep the crowded scene under control and with the figure of Christ, whose head is always in shadow, he has given us a visionary creation as intense as that at Moissac.

When carving capitals the sculptors were not necessarily confined to a rigid iconographic programme, though here too no doubt some subjects were prescribed by the clergy. Capitals survive from the choir of Cluny in Burgundy which may be as early as the Saint-Sernin reliefs, but which already – perhaps because of the small scale – are carved in depth with great vitality. They represent the four Rivers of Paradise and the tones of Gregorian chant *(pl. 4, 5)*, subjects which must have been dictated by the intellectual community of Cluny. The influence of Cluny is strong in the crisp and lively carving of the capitals at Vézelay and also at Autun. The latter is one of the few cases where, after eight hundred years, we know the name of the sculptor: right below the feet of Christ on the great tympanum appears the bold inscription *Gislebertus hoc fecit* – Gislebertus made this.

The narrative capitals so often found in churches and cloisters in France are relatively rare elsewhere. Sculptors in Germany and England on the whole preferred geometrical decoration or plant forms, though the crypt of Canterbury Cathedral has capitals enriched with vigorous animals – mythological beasts or real animals engaged in fantastic activities – which seem to have been inspired by manuscript illumination *(pl. 203, 204)*. In Italy antique forms were preferred, and where Roman or Early Christian work was not available for re-use sculptors often copied, more or less successfully, Corinthian and Composite capitals. The cloisters of Monreale *(pl. 119)* provide an exception, perhaps at the stipulation of the Norman King William II. Here the capitals are carved with scenes from gospel stories and legends, and with fantastic, grotesque, even monstrous figures, many of a significance which is lost or only partly comprehensible to us today.

For the exteriors of their churches, Romanesque masons developed a form which was completely unclassical, the tower. In Italy and Spain single bell towers might be attached to the church or built separately beside it. In Normandy, in England, and under the influence of the third church at Cluny, the west front might be given two towers rising high above the aisles and above

17

the apex of the roof, massive structures with an effect entirely different from that of the small pepperpots placed at the corners of façades in western France. At Exeter in England, untypically, substantial towers rise over the arms of the transepts. The greatest efforts in High Romanesque architecture were devoted to the crossing tower, and from England and the Rhineland across France to Spain, there is an astonishing variety of responses to this architectural challenge. Normally square, they are sometimes polygonal, and of widely varying heights and proportions. Like other towers they are pierced with arched openings, to lighten the structure and release the sound of the bells.

It is in the Rhineland that towered churches reached their greatest glory: steep-roofed towers and turrets, polygonal, square, or round, stand over the crossing and flank the apse, the westwork, and the transept arms, until the entire church rises like a ship bristling with masts above the surrounding town. In this medieval man turned away from classical repose and began the vertical aspiration which was to culminate, within the thirteenth century, in the short-lived spire of Beauvais and the nine intended spires of Chartres.

FRANCE

DURING THE ROMANESQUE PERIOD in France a dazzling variety of forms evolved. Perhaps surprisingly, the Ile-de-France which was to be the birthplace of the Gothic style was least important: the real power and artistic vigour lay elsewhere, and it is in terms of regional styles that French Romanesque must be examined.

In Burgundy, which was administered for a time by the Holy Roman Emperor, there is no one architectural norm throughout the area: the buildings are individual and often experimental, of great interest and high quality. At Tournus *(pl. 1–3)*, as we have already seen in the Introduction, an astonishing number of different types of vault were tried out, and the building itself, with its extremely tall arcade of columns and its masonry composed of thin, regular stones, is unique. Saint-Etienne at Nevers, consecrated in 1097, has a standard three-storey elevation *(pl. 17)*, but on the high walls pierced by both gallery and clerestory the builders rested a tunnel vault – a dangerous feat, which was never attempted in Languedoc or Auvergne where tunnel vaults are the rule. Unfortunately the masterpiece of Burgundian Romanesque, the great third abbey church of Cluny, was destroyed except for one transept during the French Revolution. From what survives we know, however, that the elevation was again of three storeys and supported a pointed tunnel vault (the arcade was pointed as well, a Cluniac speciality), but the masons did not risk an open gallery. Instead they devised a triforium of three arches per bay, of which two are solid: the arrangement can be seen clearly at Autun *(pl. 8)*. There, in addition, the major as well as minor attached shafts are given the form of fluted pilasters. Vézelay, on the other hand, has a completely different internal system derived, it has been suggested, from the Rhineland: heavy groin vaults rest on a two-storeyed elevation of arcade and clerestory.

The influence of Cluny was strong throughout Burgundy and beyond. We can guess at the effect of the great fresco in the apse of Cluny III from the contemporary wallpainting of Christ in Majesty at Berzé-la-Ville *(pl. 6)*. A series of capitals have survived from the choir of Cluny *(pl. 4, 5)* which show a remarkably lively treatment of the human figure, particularly in the nudes which represent the Rivers of Paradise, entwined with foliage and flowing water. The carving is crisp and clear, and it must have been sculptors trained at Cluny who went on to Perrecy-les-Forges *(pl. 20)* and created the brilliant series of capitals in the nave at Vézelay, culminating in the majestic tympanum of the narthex *(pl. 15, 16)*. A slightly different style is evident at Saulieu *(pl. 13)* and in the contemporary work of Gislebertus at Autun: the carving is rounded and flow-

ing rather than sharp, and the eyes of animals and figures are hollowed out to receive lead or paste inlay – giving a lively, bright-eyed expression. Altogether the variety of mood is astonishing: the fall of Simon Magus (whose magical flight failed in response to a prayer by St. Peter) is shown with frightening realism *(pl. 9)*, the victim's face distended in a scream of terror. On a fragment of a lintel *(pl. 10)* Eve, reaching for the apple, seems to glide like the serpent; while on another capital *(pl. 11)* the Flight into Egypt, with an exhausted Joseph leading a sprightly donkey, is placed on a row of wheel-like rosettes which set the group in motion.

In Burgundy a number of polygonal crossing-towers survive (e.g. at Paray-le-Monial, *pl. 18*, and La Charité-sur-Loire, *pl. 19)*; but of the two-tower west façades planned on the model of Cluny III at La Charité and at Vézelay, only one tower was ever built on each church. At Vézelay there is in addition a tower unusually placed to the south-west of the crossing *(pl. 14)*.

While the major churches of Burgundy date from the earlier twelfth century, the flowering of the style in Provence was later. The churches are smaller, generally without aisles, and covered with tunnel vaults and roofs of low pitch. Romanesque art in Provence is imbued with a provincial Late Roman quality; Arles had been the capital of Roman Gaul in the fifth century, and innumerable ruins survived in the region. Masonry is on the whole fine, and marble was often used. In some buildings the proximity of contemporary Italy is felt – as in the small church at Thines *(pl. 22)* with its arcaded and banded apse in polychrome masonry. In others the sculpture shows awareness of classical models but no skill in reproducing them (e.g. the lower church at Cruas, *pl. 23)*. The major churches of Saint-Gilles-du-Gard and Saint-Trophime at Arles display a complete artistic confidence and a natural feeling for Roman forms and monumentality. The porch of Saint-Gilles *(pl. 27)* is like the lower stage of a Roman triumphal arch; there are fluted pilasters, slender columns with Corinthian capitals, and the outermost moulding of each arch is formed (in a highly unorthodox way) by bending round a classical cornice. The sculptures themselves at Arles *(pl. 28)* have a Roman solidity and dignity.

South-western France is one of the richest areas for Romanesque sculpture in all of Europe. Beginning with the ivory-like reliefs around the choir of Saint-Sernin in Toulouse *(pl. 31)*, of the end of the eleventh century, works range from the brilliant figure-sculpture at Moissac *(pl. 35, 36)* to the eccentric all-over relief carving on the tribune at Serrabone in the Pyrenees *(pl. 32)*. The influence of Moissac, finished probably about 1115–20, radiated throughout the Cluniac houses in the region, and is clearest at Beaulieu *(pl. 37)* and Souillac, where the figure of the prophet Isaiah is a broader and more energetic version of a prophet at Moissac *(pl. 36, 38)*. The style is characterized by sharp, linear carving; folds in drapery are represented by repeated pairs of parallel lines, and end in zigzag hems. Figures are elongated and may be shown in complicated poses with crossed legs. Moorish influence is suggested by the scalloped door-jambs at Moissac *(pl. 35)* as well as by the use and treatment of certain abstract designs and plant motifs, for instance on the cloister capitals at Moissac. At Conques *(pl. 39)* the style is slightly different: figures are stockier and drapery is less sharply linear, and the eyes – as at Autun – originally had inlaid centres. The favourite subjects for tympana were related to the end of things; they were the Apocalyptic vision and the Last Judgment, themes which were not taken up in northern France until later.

21

Architecturally south-western France is dominated by the great churches of the pilgrimage roads to Compostela (p. 100): like Santiago, they have a nave and aisles (double at Saint-Sernin in Toulouse), transepts usually with an aisle around each arm, and an ambulatory with radiating chapels. The elevation is of two storeys only, arcade and gallery, so the interiors tend to be dark; the nave has a tunnel vault with transverse arches, separated from the gallery by a stringcourse (see *pl. 30*). Outside, the churches have crossing towers, of which the most splendid is on the church of Saint-Sernin at Toulouse, built entirely of brick *(pl. 29)*.

In Auvergne churches the internal elevation is the same – arcade and gallery – but the tunnel vault springs directly above the gallery and has no transverse arches. The most distinctive architectural feature of the region is the treatment of the crossing: outside, the tower rests on a sort of oblong lantern with sloping roofs, formed by raising the roof level of the innermost bays of the transept on each side. Thus the crossing is lit across a wide area, and complicated internal spaces are created; the nave ends at the east with a massive diaphragm arch pierced by an arcaded opening, and the chancel is lower *(pl. 42)*. Radiating off the ambulatory there are often four chapels, not three or five as in other regions; Issoire *(pl. 43)* is relatively unusual in having a square axial chapel inserted between them.

The local building material is granite, and there is consequently little sculpture; patterns in stone were favoured. In the crossing and above the arcade at Clermont-Ferrand *(pl. 42)*, for instance, there are patches of grey volcanic tufa above the arches; this may however have been done for practical rather than aesthetic reasons, since porous tufa would put less strain on an arch than solid granite. The entrance to Saint-Michel-d'Aiguilhe at Le Puy *(pl. 40)* shows what could be done with patterning, here combined with sculpture; the lobed Islamic arch is not altogether unexpected since Le Puy lay on one of the pilgrimage routes to Spain.

Poitiers and Angoulême introduce a different type of façade *(pl. 44, 51)* in which sculpture is no longer confined to porches or window-surrounds, but spreads across the wall in a relatively inorganic way: thus above the right-hand arch at Poitiers scenes of the Visitation and Nativity are uncomfortably squeezed in below a heavy corbel-table. The voussoirs of the arches at Poitiers show a typical feature of mid-western French Romanesque, which is paralleled in England: each stone carries a separate carved motif radiating from the centre of the door, creating a repetition of small patterns; where figures occur they are therefore tiny, since they could not be enlarged vertically (as for example at Bourges, *pl. 56*, and Chartres, *pl. 54*).

Internally, Poitevin churches typically have no gallery or clerestory, and instead have tall piers or, at Saint-Savin, columns dividing the aisles from the tunnel-vaulted nave. Fragments of painted decoration survive in several churches of the region, but Saint-Savin is unique in France in having, as we saw in the introduction, a completely preserved ensemble *(pl. 48–50)*.

The region of Angoulême is linked to that of Périgueux, to the south-west, by the use of domes. Angoulême Cathedral has no aisles, and its nave is covered by three large domes which rest directly on the walls. Saint-Front at Périgueux *(pl. 60)* has a more complicated system: the church is basically a Greek cross, covered with five domes, and these domes rest on enormous square piers with arched openings cut through their base. From Périgord and Poitou southward,

church exteriors may be decorated with small pepperpot turrets ending in scaly or pinecone textured 'roofs'.

A small group of diverse but highly important buildings grew up in the Loire valley: the largest of these was Saint-Martin at Tours, of which only mutilated fragments remain. Saint-Benoît-sur-Loire, however, has survived almost intact. Begun probably *c.* 1070, it is the mother-church of the Benedictine order in France. Like Saint-Martin, it originally had two towers in axis, one over the crossing and one on a massive west porch of Carolingian type. A tradition of fine masonry also survived in the area from the time when it was the Carolingian province of Neustria. The choir of Saint-Benoît *(pl. 57)* has a three-storey elevation but with a blind triforium instead of a gallery, and an unusually large expanse of wall between this triforium and the arcade below. Again, as at Cluny and Saint-Etienne in Nevers, the builders took the risk of resting a tun-nel vault on a wall weakened by windows. There are no wall-shafts and the triforium runs on in an even, unbroken series of identical arches, so that the effect of horizontality is marked. The ground floor of the west porch contains lively narrative capitals *(pl. 58)*.

With the Portail Royal of Chartres Cathedral *(pl. 52–54)*, of about 1150, we reach the cul-mination of Romanesque sculpture and the threshold of Gothic. Adopting elements from various regional styles, the Chartres master fused them into a unified composition. Certain features in particular had far-reaching effects: the long jamb figures, standing against columns, mark a deci-sive step beyond the St. Peter at Moissac *(pl. 35)* and the figures on trumeau and jambs at Vézelay *(pl. 15)* towards the monumental jamb figures which are so essential a feature of Gothic portals. The central tympanum, with Christ in Majesty surrounded by symbols of the Evangelists, was in-spired by the tympanum of Cluny III (as the pointed arches of the three portals were no doubt also inspired by Cluny); but from the figure of Christ, with his delicately modelled face and new hu-manity of expression, the line runs direct to the 'Beau Dieu' of Amiens, three generations later. The sculptor also introduced, in the voussoirs of the arches, small figures engaged in various ac-tivities; those on the right portal in particular, representing the Liberal Arts, sit freely in the space provided and seem no longer confined in the blocks of stone which make up the arch – a distinc-tion easily seen when they are compared with similar figures at Bourges *(pl. 56)*, where the portal was itself inspired by Chartres.

North-west of Chartres, in Normandy, there is relatively little figure sculpture; but the great churches, whose features soon appeared in England, are remarkably early and fully as impressive as those of other regions. Designed with a nave, aisles, transept and chancel, they rise to a consi-derable height with a three-storey elevation of arcade, gallery and clerestory. The nave was nor-mally covered with a flat wooden roof. This typical elevation can be seen at Mont-Saint-Michel *(pl. 68)*, begun as early as 1022. At La Trinité in Caen (begun *c.* 1064) instead of a gallery there is a blind triforium consisting of small arches running uniformly through each bay; this arrangement was continued in the transept *(pl. 70)*. Jumièges abbey church has a double-bay system, with al-ternating supports in the arcade *(pl. 69)*. Like Saint-Etienne at Caen it has two west towers: this feature was adopted by Ile-de-France builders for the great synthesis of Romanesque inventions that produced the Gothic style.

At the heart of northern France, bounded to the west by Brittany which at the time had no art to speak of, lay the *Domaine Royal*, the Ile-de-France. During the earlier Romanesque period it did not produce any really notable, original works, but by the mid-twelfth century the monarchy was in a stronger position, and the artistic flowering of the region had begun. The university of Paris, excelling in philosophical and theological studies, attracted students and teachers from England, Italy, Holland, Flanders, even Scandinavia, and of course from all regions of France. Scholasticism, with such exponents as Abelard, was evolving and trying to reconcile the revealed truths of the faith with the truth apprehended by reason. Abelard was condemned by St. Bernard at the Council of Sens in 1140, but scholasticism triumphed and already a certain rationalization of the arts was beginning.

The first architectural work to reflect this new spirit was Saint-Denis, where rebuilding was initiated by the powerful abbot Suger, adviser to Louis VII and a great patron of the arts. Increasing numbers of pilgrims to the shrine of St. Denis made it necessary to enlarge the existing church: Suger began, about 1134, with a new narthex, then went on to the choir (dedicated in 1144) and transept. He himself recorded that he was helped in the rebuilding by men of all provinces, and the result was the first work in which the structural principles of Gothic are fully realized. Saint-Martin-des-Champs in Paris *(pl. 67)*, of the same date, is still Romanesque, but the work at Saint-Denis is rib-vaulted, and all structural arches are pointed. On the west front of the narthex Suger placed three monumental portals, which may have had as early as *c.* 1140 the *statues-colonne* for which Chartres is famous. Although this building marked the beginning of a new era, the Romanesque style was of course not yet exhausted; in parts of western Europe – notably Germany and Italy – it flourished for another century, and even in the Ile-de-France the innovations of Saint-Denis did not immediately prevail; but it was an effective starting-point, a visible model. As Gothic art and scholastic philosophy grew to pre-eminence, Paris became the unrivalled centre of intellectual life, and France the artistic centre of Europe.

4, 5 CLUNY (SAÔNE-ET-LOIRE), *capitals from the former abbey church of St. Peter and St. Paul*. The quality of the sculpture which adorned the choir of the third church of Cluny is shown by surviving capitals, carved probably between 1113 and 1118. These are now exhibited in the abbey granary. On the four sides of two of them the eight modes of Gregorian chant are represented by

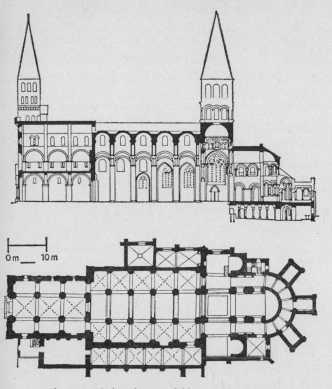

Elevation and plan of Saint-Philibert, Tournus

1–3 TOURNUS (SAÔNE-ET-LOIRE), SAINT-PHILIBERT. *Sculpture in the westwork; south aisle; St. Michael's Chapel.* Several architectural periods, from the late Carolingian to the Gothic, can be distinguished in the church, but in the main Saint-Philibert is a Romanesque building with portions dating from the 11th and early 12th centuries. Its plan consists of nave and aisles, crossing with a massive tower, transept, westwork with two towers, and a crypt which has what may be the first ambulatory with radiating chapels. Throughout, the church is stone-vaulted.

There are sculptures *(pl. 1)* in the embrasure of the great central arch – now blocked – which opened into the nave from St. Michael's Chapel in the westwork. They are probably fragments from the older, 10th-century building.

The groin-vaulted south aisle *(pl. 2)* is divided from the westwork by a wall. The beginning of a staircase can be seen, which formerly led up to St. Michael's Chapel; it, with its fellow in the north aisle, enabled pilgrims to go from the chapel along the aisles to venerate the relics of St. Philibert in the crypt. The nave arcade consists of extremely high cylindrical piers, with corresponding half-columns along the aisle walls.

The chapel of St. Michael is on the first floor of the westwork *(pl. 3)*. Its nave is tunnel-vaulted, while its aisles have quadrant, i.e. half-tunnel, vaults.

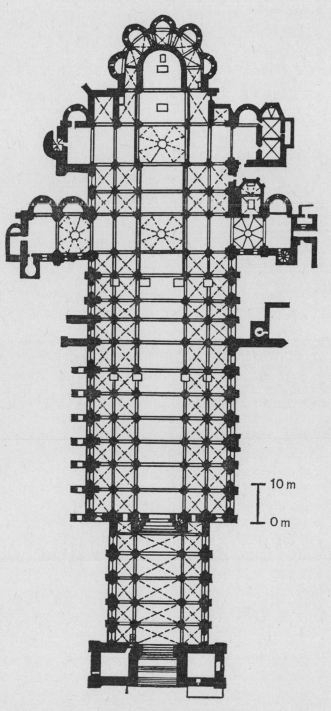

Plan of the former abbey church of Cluny

25

men and women playing musical instruments: the bearded lute-player *(pl. 5)* represents the third mode. On the four corners of another capital *(pl. 4)* the Rivers of Paradise are depicted as lively nude figures.

6 BERZÉ-LA-VILLE (SAÔNE-ET-LOIRE), CHAPEL. *Wallpainting in the apse.* In this chapel of the former Cluniac grange, and especially in its choir, are preserved the most beautiful examples of wallpainting inspired and encouraged by Cluny. The monumental figure of Christ in Majesty, nearly 13 feet high, was painted between 1103 and 1109.

7 DIJON (CÔTE-D'OR), SAINT-BÉNIGNE. *Capital.* This crudely-carved but vivid representation of a bearded man with his arms lifted in prayer appears on one of the capitals of William of Volpiano's influential crypt, and was carved shortly after 1000.

8-12 AUTUN CATHEDRAL (SAÔNE-ET-LOIRE). *North wall of the nave; capitals and former lintel.* Autun stands on the site of the important Roman city of Augusto-dunum. The cathedral was begun about 1120 and first consecrated in 1132; in spite of many later altera-tions, much of the original fabric and sculpture is still visible.

The elevation of the north wall of the nave *(pl. 8)* clearly reveals the influence of Cluny III in its use of pointed arches and in its blind triforium of three ar-ches per bay, separated by fluted pilasters. The major pilasters are a unique feature derived from the Roman gate of Augustodunum.

The sculpture at Autun is the work of Gislebertus, who signed his name on the great west tympanum. This tympanum, carved between 1130 and 1140, de-picts the Last Judgment and the weighing of souls *(pl. 12)*. One capital *(pl. 9)* shows the sorcerer Simon Magus screaming as he falls from the sky, watched by St. Peter, who has thus defeated the devil on the right. Another *(pl. 11)* represents the Flight into Egypt, and may have been modelled on embroideries. The famous 'Eve of Autun' *(pl. 10)* was formerly on the lintel of one of the side doors; this sculpture, mysterious in its composition, ranks among the highest achievements of Romanesque art in Burgundy.

13 SAULIEU (CÔTE-D'OR), SAINT-ANDOCHE. *Capital.* A number of magnificent capitals, carved between 1115 and 1120, are preserved in this church. That de-picting the suicide of Judas shows how vividly Bur-gundian Romanesque art can elaborate a scene which is only intimated in the Gospels.

14-16 VÉZELAY (YONNE), LA MADELEINE. *Exterior from the south-west; west door; capital.* Vézelay was a meeting-place for pilgrims at the beginning of one of the roads to Santiago. The basilica, exactly contempo-rary with Autun Cathedral, is virtually intact. Re-mains of the monastic buildings can be seen next to the south transept with its tower *(pl. 14)*.

A majestic portal leads from the pilgrims' ante-chapel into the nave of the church *(pl. 15)*. Its tympa-num represents the mission of the Apostles: Christ appears to the Disciples between his resurrection and ascension (the scene is surrounded by clouds), and they are given the gift of tongues. All round, the peoples of the world – sometimes in fantastic shapes – wait for the Gospel tidings. On the trumeau is a figure of St. John the Baptist displaying the Lamb of God. One of the capitals *(pl. 16)*, slightly later than the tympanum, shows Joseph accused by Potiphar's wife.

17 NEVERS (NIÈVRE), SAINT-ÉTIENNE. *Interior looking east.* This, the church of a former Cluniac priory, is one of the purest and best-preserved Romanesque mo-numents of France. It was begun in 1063 and conse-crated in 1097, and is unusual in combining a three storey elevation with a tunnel vault.

18 PARAY-LE-MONIAL (SAÔNE-ET-LOIRE), SACRÉ-CŒUR. *Exterior from the south-east.* This church, built in the first half of the 12th century, gives today on a rath-er smaller scale a good impression of the architecture of Cluny III: its crossing tower is polygonal, and the apse with its ambulatory and radiating chapels is clearly articulated.

19 LA CHARITÉ-SUR-LOIRE (NIÈVRE), SAINTE-CROIX. *General view across the Loire.* The church of Sainte-Croix stands beside the river-crossing on the pilgrimage route between Burgundy and Berry. Only one of the west towers was ever built, and of the nave only the bays next to the crossing survive. The eastern part, however, splendidly rebuilt after 1125, still gives an impressive idea of the church's former glory.

20 PERRECY-LES-FORGES (SAÔNE-ET-LOIRE), PRIORY CHURCH. *Capital.* The carving of this warrior angel, probably St. Michael, on the corner of a capital dates from *c.*1120 and reflects the influence of the sculptures of Cluny III.

21 CRUAS (ARDÈCHE), ABBEY CHURCH. *Crypt.* The abbey church of Cruas, on the right bank of the Rhône, dates from the 11th and 12th centuries. In the crypt – more accurately a lower church lying beneath the choir

and transept – we find the beginnings in this region of a new, creative sculpture which, although awkward in technique, is bold in conception.

22 THINES (ARDÈCHE). *Apse of the church.* This simple granite church consists solely of an unaisled nave and an apse. The apse has the arcading and banding characteristic of northern Italy, and is further decorated by the use of coloured stone.

23 SIMIANE (BASSES-ALPES), CASTLE CHAPEL. *Vault.* This former chapel is one of the most controversial monuments of Haute-Provence. The polygonal interior was intended to house a prince's tomb, while the exterior is round and fortified. Dating from the 12th century, it is notable in particular for the spiral structure of the twelve compartments of its vault.

24 LE THOR (VAUCLUSE), PARISH CHURCH. The massive church of Le Thor, completed in 1202, is a typical example of Provencal Late Romanesque architecture. It consists of a nave with a small west portal, a main south portal with a porch, and a small polygonal apse. The bay just before the apse is raised and covered with a dome on squinches which is ornamented on the inside with carvings and on the outside forms the base for an arcaded polygonal tower.

25 MONTMAJOUR (BOUCHES-DU-RHÔNE), CHAPELLE SAINT-PIERRE. This 10th-century chapel is partly cut out of the rocky hillside. It belonged to a hermitage which existed before the famous Benedictine abbey of Montmajour was built nearby.

26, 27 SAINT-GILLES-DU-GARD (GARD). *West portals.* Saint-Gilles-du-Gard, on the western side of the Rhône estuary, has the greatest and most important façade in the south of France, with three portals in Late Romanesque style. The original design, a copy of a Roman triumphal arch, was modified towards the end of the 12th century, but the total impression is nevertheless one of majestic strength. The sober statues of apostles and saints on the jambs and in niches framed by fluted pilasters recall classical sculpture in the forms of their drapery and in their monumentality.

28 ARLES (BOUCHES-DU-RHÔNE), SAINT-TROPHIME. *Cloister pier.* The cathedral church of Saint-Trophime is a masterpiece of the late Provençal Romanesque. The remarkable sculptures of the cloister, dating from the second half of the 12th century, include this relief of the stoning of St. Stephen; the style shows a highly personal adaptation of antique models.

29–31 TOULOUSE (HAUTE-GARONNE), SAINT-SERNIN. *Exterior from the north-west; interior looking east; marble relief in the ambulatory.* The former collegiate church of Saint-Sernin is a representative example of a pilgrimage church, of a type which grew up along the roads to Santiago: it has a nave with aisles (double), transept with continuous aisles, and ambulatory with radiating chapels. Begun in 1060 and consecrated in 1096, it was finished in the 12th century; the upper stages of the tower were added in the 13th century. Inside, the elevation is of two storeys – an arcade with compound piers and a gallery with twin openings. The tunnel vault is carried on transverse arches which rest on demi-shafts running the full height of the wall.

Around the ambulatory there are five marble reliefs, of Christ in Majesty *(pl. 31)* flanked by four angels. They are obviously not in their original position, and seem to date from the end of the 11th century.

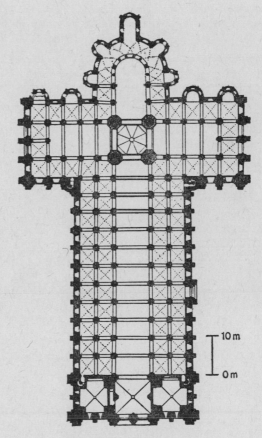

Plan of Saint-Sernin, Toulouse

32 SERRABONE (PYRÉNÉES-ORIENTALES), FORMER AUGUSTINIAN CHURCH. *Tribune.* The Mediterranean and Pyrenean province of Roussillon, lying between Languedoc and Catalonia, was influenced by both. The 12th-century 'Tribune' at Serrabone was probably originally a porch; the marble carving above the

fabulous creatures on the capitals is as monumental in its overall effect as it is original in its varied details.

33 SAINT-MARTIN-DU-CANIGOU (PYRÉNÉES-ORIEN-TALES), MONASTERY. Despite elaborate restoration, even rebuilding, Saint-Martin-du-Canigou remains an impressive example of a mountain monastery of Romanesque times. The church, with the simple Lombardic articulation of its tower, was begun in 1007 and consecrated in 1026. The drastically restored cloister retains, in its south gallery, original capitals with plant and animal motifs.

34 OLORON-SAINTE-MARIE (BASSES-PYRÉNÉES), SAINTE-MARIE. *Detail of the portal.* The marble portal of the church, well protected by a porch, is icono-graphically and artistically important. The tympanum includes the Descent from the Cross, above representa-tions of the persecuted and triumphant Church. In the archivolts the signs of the zodiac and labours of the months, interspersed with fabulous creatures, are sur-rounded by the twenty-four Elders of the Apocalypse. (In the picture caption, for Orlon-Sainte-Marie read Oloron-Sainte-Marie.)

35, 36 MOISSAC (TARN-ET-GARONNE), SAINT-PIERRE. *South portal: St. Peter, on the jamb; a prophet, on the tru-meau.* The whole of the 12th-century portal is a magni-ficent representation of the Apocalypse. The figure of St. Peter *(pl. 35),* particularly characteristic of Romanes-que art in his attitude and gestures, stands on a van-quished monster against the left jamb. The sculpture of Moissac set the course of the future development of Romanesque sculpture throughout Languedoc and far beyond it. The head of a prophet figure holding a scroll, which stands against the right side of the tru-meau, may serve as an example of this when compared with works at Beaulieu *(pl. 37)* and Souillac *(pl. 38).*

37 BEAULIEU-SUR-DORDOGNE (CORRÈZE), FORMER BENEDICTINE CHURCH. *Trumeau of the south portal.* The elongated figure of a prophet serving as an atlantid on the south portal trumeau (1130–40) is closely related to the Moissac figures; the merely superficial dissimilarity is due to the use of coarse-grained sandstone.

38 SOUILLAC (LOT), SAINTE-MARIE. *Isaiah.* This figure with extraordinary twisted limbs and drapery is also closely related to Moissac, and dates from about 1140. It was part of the original Romanesque portal of the former abbey church, which now has a 17th-century west end, and is set inside the west wall of the nave.

28

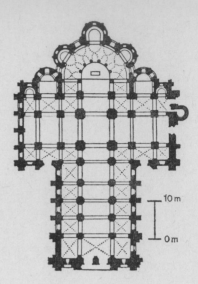

Plan of Sainte-Foy, Conques

39 CONQUES (AVEYRON), SAINTE-FOY. *Detail of the tympanum.* At Conques in the Rouergue, on the Le Puy – Moissac – Ostabat section of the road to Compo-stela, the spacious church of Sainte-Foy still stands sub-stantially as it was built between 1035 and 1200. The tympanum depicts the Last Judgment in a number of scenes with explanatory texts on the framing bands. The central figure is Christ as Judge; in our detail St. Peter and the Virgin can be seen on his right, and an angel weighing souls on his left. Below, the blessed (left) are separated from the damned, who are driven into the jaws of Hell. This work, which still shows traces of colour, retains some Languedocian features, but in style it is nearer to the Auvergne.

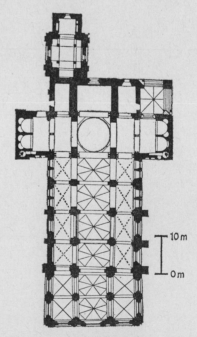

Plan of Saint-Michel-d'Aiguilhe, Le Puy

40 LE PUY (HAUTE-LOIRE), SAINT-MICHEL-D'AIGUILHE. *Portal.* This church stands on the Needle Rock, and is reached by 250 steps. Its portal, of the end of the 11th century, shows with unusual clarity the influence of Mozarabic art on Romanesque work along the pilgrimage roads. At the top, under arches, is Christ flanked by saints and angels. The two sirens on the lintel with their nets symbolize the dangers of concupiscence.

41 SAINT-NECTAIRE (PUY-DE-DÔME). *Interior looking west.* The interior of Saint-Nectaire, begun c. 1080, shows the solid and lofty architecture of Auvergne, with a twin-arched gallery opening above the nave arcade. In addition to the purely decorative, somewhat heavy capitals visible here, there are also a number of figurative capitals of the mid-12th century.

42 CLERMONT-FERRAND (PUY-DE-DÔME), NOTRE-DAME-DU-PORT. *Interior looking east.* Clermont, once the capital of the Celtic Arvergni, is still the heart of Auvergne. Notre-Dame-du-Port was begun in 1099, continued throughout the 12th century and completed at the beginning of the 13th century. The interior is high, of two storeys covered by an uninterrupted tunnel vault. The treatment of the crossing, divided from the nave by a pierced diaphragm arch, is characteristic; the chancel beyond is lower than the nave.

43 ISSOIRE (PUY-DE-DÔME), SAINT-PAUL. *Exterior from the east.* This former Benedictine church, of c. 1130-50, is the most complete example of the powerful Romanesque style of Auvergne. It shows the distinctive 'hipped' crossing, which includes the first bays of the transept, and the four apsed chapels which were sometimes augmented, as here, by a square-ended axial chapel. Above the chapel windows are reliefs of the signs of the zodiac; the walls are decorated with geometrical patterns in coloured stone and in relief.

44 POITIERS (VIENNE), NOTRE-DAME-LA-GRANDE. *West front.* This is the most richly decorated Romanesque façade in France, and dates from the mid-12th century. Individual scenes are recognizable above the three portals: Adam and Eve, kings and prophets of the Old Testament, the Annunciation, the Tree of Jesse, the Visitation, the Nativity, the bathing of the infant Jesus, and allegorical figures. Eight apostles are seated in the blind arcades above them, and another four stand below the upper arcades, flanked by two bishops, Hilary and Martin. In the gable Christ stands between the symbols of the four evangelists.

45 BRINAY (CHER), SAINT-AIGNAN. *Wallpainting of the Magi.* Scarcely any Romanesque wallpaintings survive in the south of France, but as soon as we approach the middle reaches of the Loire we find them. The church of Saint-Aignan has a cycle devoted to the childhood of Christ, painted shortly after the middle of the 12th century. The three Magi appear twice on horseback, first on their way to Bethlehem and again, reproduced here, on their return journey.

46 MARS-SUR-ALLIER (NIÈVRE), FORMER CLUNIAC CHURCH. *Capital.* The sculpture of this church is distinguished by the use of mask-like carvings, in conjunction with musical instruments or, as here, extremely simple abstract shapes.

47 MOZAC (PUY-DE-DÔME), SAINT-PIERRE. *Capital.* Mozac, near Riom, was attached to Cluny as early as 1095. This capital, showing the three Marys at the tomb, carrying ointment jars, dates from the first half of the 12th century. Formerly in the now-ruined ambulatory, it is reset almost at ground level in the nave.

48-50 SAINT-SAVIN-SUR-GARTEMPE (VIENNE). *Interior looking east; paintings on the vault and in the porch.* Built in the 11th century to serve a famous Benedictine abbey founded by Charlemagne, Saint-Savin is – especially because of its paintings – one of the most important of all the monuments of the western Romanesque style. Like others in the region, it is a hall-church with nave and aisles of equal height *(pl. 48)*, but its enormously high cylindrical pillars are unusual. The tunnel vault of the nave, without transverse arches, is covered with paintings of scenes from the Old Testament: *pl. 50* shows Noah's Ark floating on the floodwaters teeming with drowned men, while Noah's dove flies over the prow. The west porch is devoted, as was usual, to the Apocalypse. From this cycle we show a group of three angels *(pl. 49)* from the heavenly Jerusalem.

51 ANGOULÊME CATHEDRAL (CHARENTE). *Detail of west front.* The cathedral church of Saint-Pierre at Angoulême, the ancient Roman city in Aquitaine, is one of the finest domed churches of the Périgord type, though the entire church was much restored in the 19th century. The façade is treated as a great work of monumental sculpture. Our detail shows the central section above the west window: the subject is the ascension of Christ, surrounded by the symbols of the Evangelists. Angels look up from below and reach down from the clouds into which Christ's halo is just disappearing. The sculptures date from c. 1125-50.

52–54 CHARTRES CATHEDRAL (EURE-ET-LOIR). *Portail Royal.* Some art historians regard the world-famous Portail Royal, of the mid-12th century, as already Gothic. Yet its features are those frequently foreshadowed in the south-west and fully developed in the Romanesque style, fused here into an entity of unique grandeur and dignity. If we take a single figure as an example *(pl. 52)* we see that it is both Romanesque, hieratically sublime, and at the same time Gothic, beautifully human. The figures from the Old Testament on the columns of the intrados *(pl. 53)* give to the gospel events depicted above their royal foundation, and show at the same time the human ancestors of Christ. The right-hand tympanum is devoted to the Virgin.

The compositional centre of the whole ensemble is the figure of Christ on the central tympanum *(pl. 54)*: he appears as the ruler of the world, in a mandorla surrounded by the symbols of the four evangelists – God, in human form.

55 BOURGES (CHER). *Tympanum from Saint-Ursin.* The tympanum of the former church of Saint-Ursin is now built into the wall of No. 28, Avenue Henri-Ducrot. Here, ranged one above the other, are three bands showing the labours of the months, the hunting of wild boar and deer, and four scenes from the legend of Reynard the Fox. The work, of the late 11th century, is signed: *Giraldus fecit istas portas.*

56 BOURGES CATHEDRAL (CHER). *Detail of south door.* The Gothic cathedral of Bourges still retains its late Romanesque side-portals, of which the south one is better preserved. This detail of the canopies and capitals and beginning of the archivolts – carved in the middle of the 12th century – shows the influence of Chartres.

57, 58 SAINT-BENÔIT-SUR-LOIRE (LOIRET), ABBEY CHURCH. *Choir, looking east; capital in the portico.* In the Middle Ages this was one of the greatest Benedictine abbeys. It was founded with the name of Fleury in the mid-7th century, but soon afterwards the relics of St. Benedict were brought here from the ruined Montecassino, and under its new name of Saint-Benôit it became a great pilgrimage centre, with an outstanding monastic school. The spacious church with its nave and aisles is typical of a Benedictine abbey; the long choir *(pl. 57)* was needed to accommodate the many monks. It dates from the last third of the 11th century and has, instead of a gallery, a continuous blind arcade. The altar is raised above the crypt.

Much in the church was intended especially for pilgrims, particularly the many narrative capitals. One in

the portico *(pl. 58)* shows the human soul as an infant between an angel and a hairy demon; the figures are adapted to the form of a classical foliated capital.

59 MORIENVAL (OISE), NOTRE-DAME. *Capital.* Originally the church of a Benedictine nunnery, Notre-Dame has undergone drastic alterations since it was begun in the 11th century. Some of the early capitals inside testify to the impressively massive sculpture of the early Romanesque period.

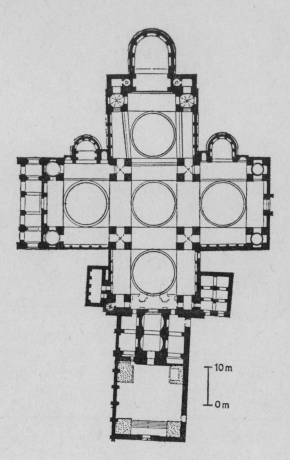

Plan of Saint-Front, Périgueux

60 PÉRIGUEUX (DORDOGNE), SAINT-FRONT. *Interior looking east.* Saint-Front is composed of two distinct parts: the older, so-called 'Latin' church with nave and aisles, of the 10th century, leads into the 'Byzantine' church, of 1120–50. This, in the form of a Greek cross, has domes over each arm and over the crossing, resting on enormous square piers cut through with arches. Like Angoulême Cathedral, the whole church was restored (in fact rebuilt) by Abadie in the 19th century.

61 LAON (AISNE), 'CHAPELLE DES TEMPLIERS'. Behind the Gothic cathedral at Laon stands this little

round church of the mid-12th century, with an added porch and apsed chancel.

62 NOUVION-LE-VINEUX (AISNE). *Belfry*. In this village, a little to the south of Laon, rises the most beautiful and best-preserved Romanesque tower of the area, as pleasing in its general effect – due to the happy proportions of the storeys – as it is fascinating in the details of its sculptured window-surrounds. It dates from the 12th century.

63–66 REIMS (MARNE), SAINT-RÉMI. *Capitals*. The great 12th century nave of this Romanesque abbey church in Champagne still survives. After being walled up for centuries, a number of slender capitals were discovered recently in the ruins of the former abbey. We show two purely ornamental capitals and two others on which are carved a shaggy, bearded creature and an owl perched among branches, behind which a similar bird with an almost human face appears in profile.

67 PARIS (SEINE), SAINT-MARTIN-DES-CHAMPS. *Exterior from the east*. There were several Romanesque buildings in Paris, nearly all of which were later rebuilt. The former Cluniac priory church of Saint-Martin-des-Champs survives, once, as its name implies, situated in fields outside the city walls. Today it is a museum of industry. The east end, of 1130–40, has a double ambulatory. A low tower rises to the south.

68 MONT-SAINT-MICHEL (MANCHE), ABBEY CHURCH. *Interior of the nave*. On a rock in the bay where Normandy and Brittany meet there has been a Christian settlement since the 8th century. Of the church which now crowns the rock, the nave and transept are Romanesque (1022–1135). The interior of the nave shows the typical three-storeyed Norman articulation of the walls, with a particularly beautiful triforium, and the clerestory above which has remained unchanged – a rarity, for unlike most other churches in Normandy Mont-Saint-Michel was never given a Gothic vault.

69 JUMIÈGES (SEINE-MARITIME), NOTRE-DAME. The towering ruins of the abbey church, situated in a bend of the Seine, testify to the former grandeur and splendour of one of the most important Romanesque buildings in Normandy. The view west from the crossing shows the nave, of 1052–67, and one of the twin west towers. Note the articulation of the nave wall, particularly the alternating supports and attached wall-shafts, and the extremely high clerestory.

70 CAEN (CALVADOS), LA TRINITÉ. *End wall of the transept*. William the Conqueror and his wife Matilda married despite their near relationship, and without papal dispensation. To atone for this they founded two abbeys in Caen – she La Trinité or Abbaye aux Dames (*c*.1062), he Saint-Etienne or Abbaye aux Hommes (*c*.1067). Of the former we show a detail of the articulation of the transept end, which continues the system of the nave in having a triforium of small blind arches; the vault was added in Gothic times.

71 LE MANS CATHEDRAL (SARTHE). *Interior of the nave*. The Gothic cathedral has retained its Romanesque nave and a south portal influenced by Chartres. The nave has alternating supports, a triforium instead of an open gallery, and twin windows in the clerestory. It was first consecrated in 1120; much of the aisle, and the outer round arches of the arcade, survive from this largely 11th-century building. A severe fire in 1134 led to an almost complete rebuilding designed to include stone vaults. The nave was given alternating supports and a new triforium and clerestory; the new work was completed by about 1154.

72 MURBACH (HAUT-RHIN), ABBEY CHURCH. *Exterior from the north-east*. Throughout the Middle Ages Murbach was a powerful abbey, which owed allegiance only to the Emperor and to the Pope. Of all its former splendour only the east end remains, of the second half of the 12th century, with a lofty twin-towered transept and equally high flat choir wall (due to Cistercian influence), decorated with Lombard motifs.

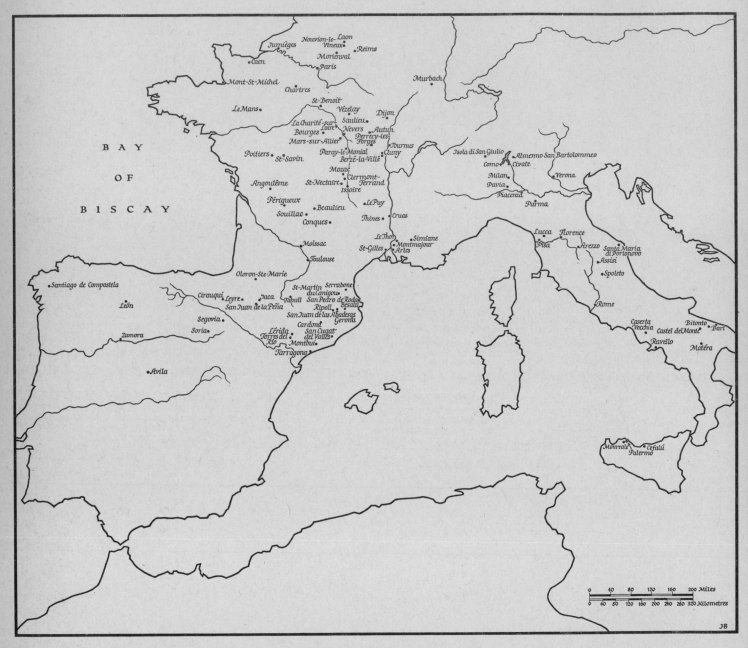

Sites of Romanesque monuments in France, Spain and Italy, illustrated in Plates 1–128

1

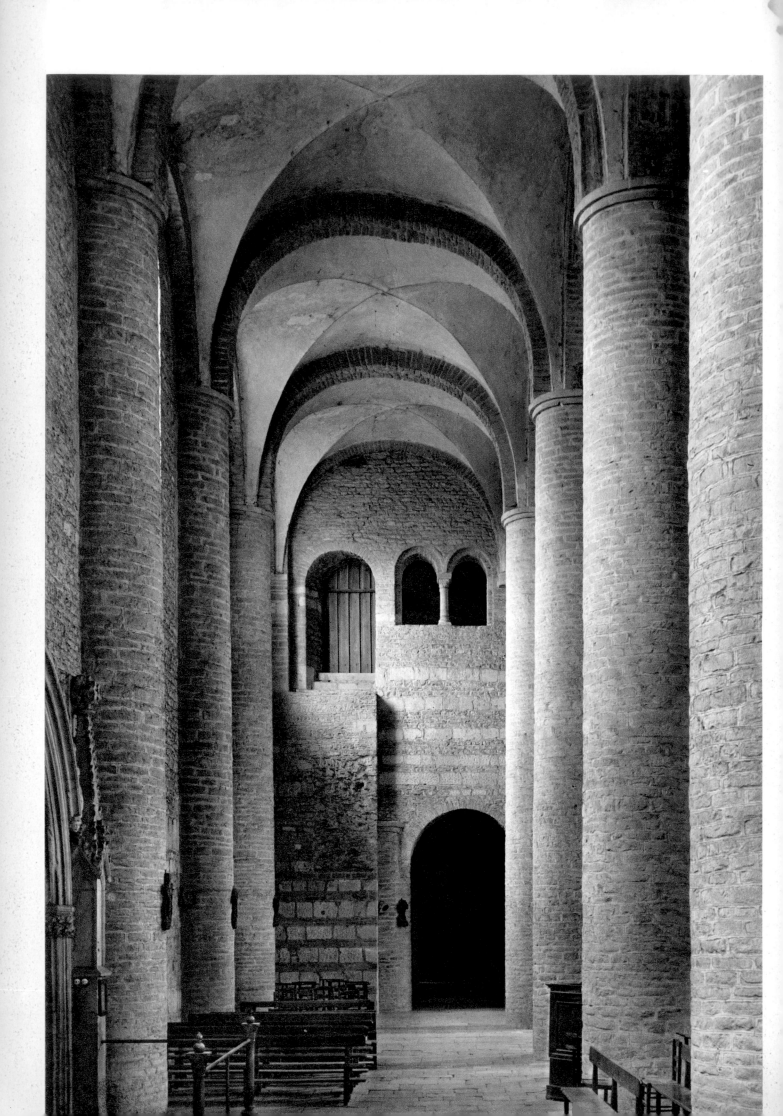

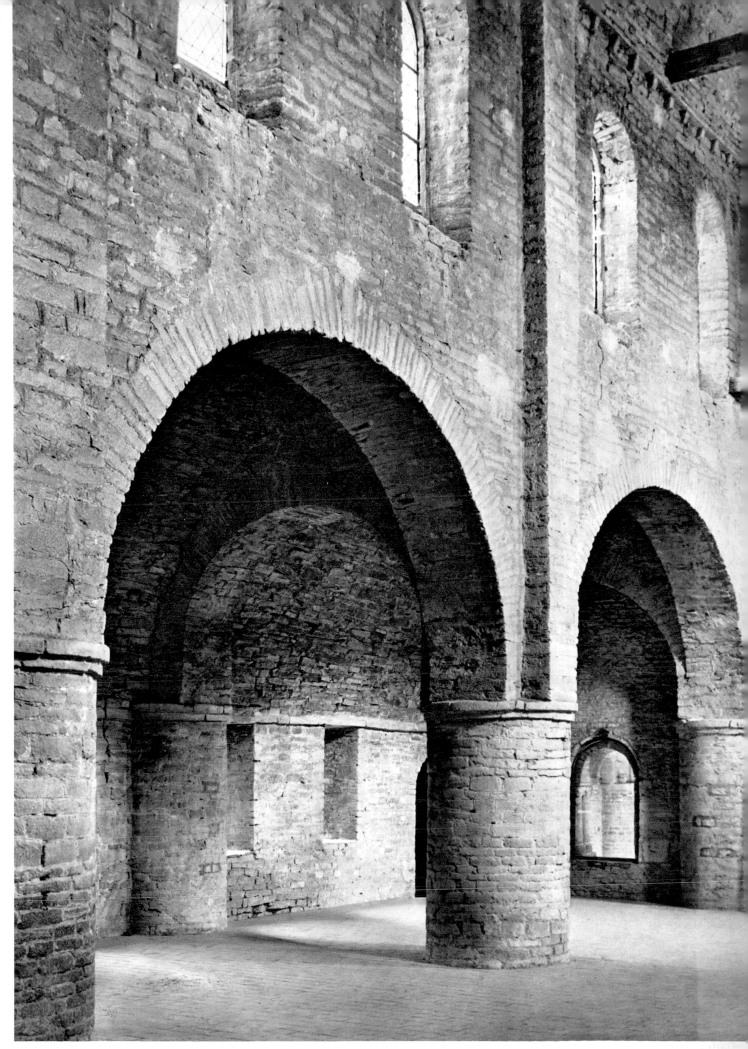

1–3 TOURNUS (Saône-et-Loire), Saint-Philibert

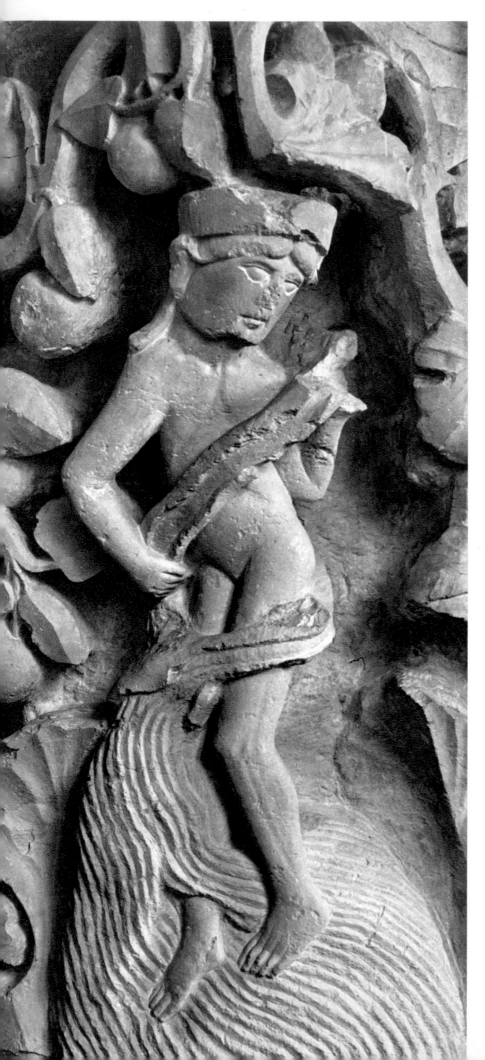

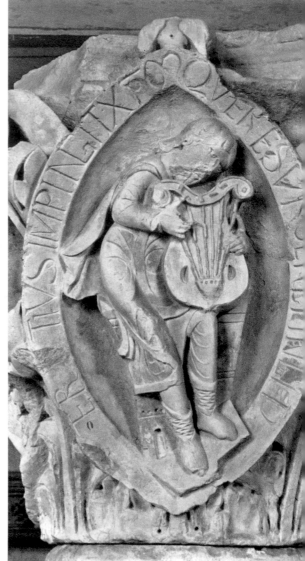

4. 5 CLUNY (Saône-et-Loire),
L'ancienne église abbatiale

6 BERZÉ-LA-VILLE (Saône-et-Loire),
La chapelle

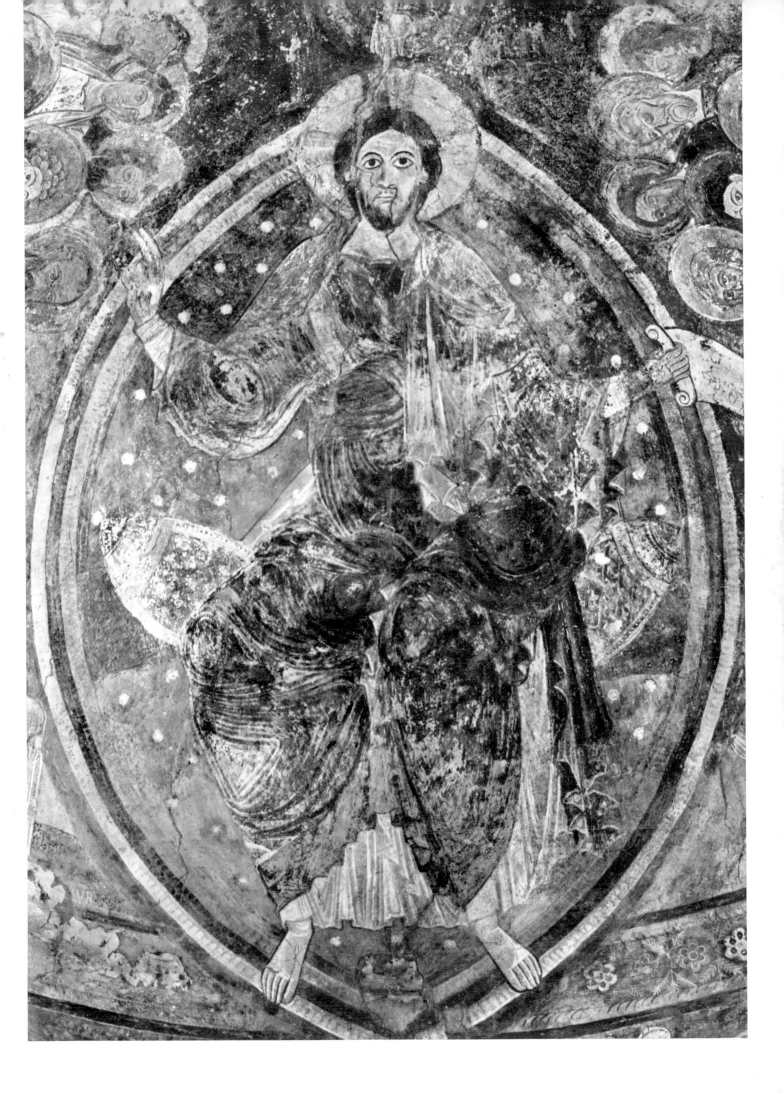

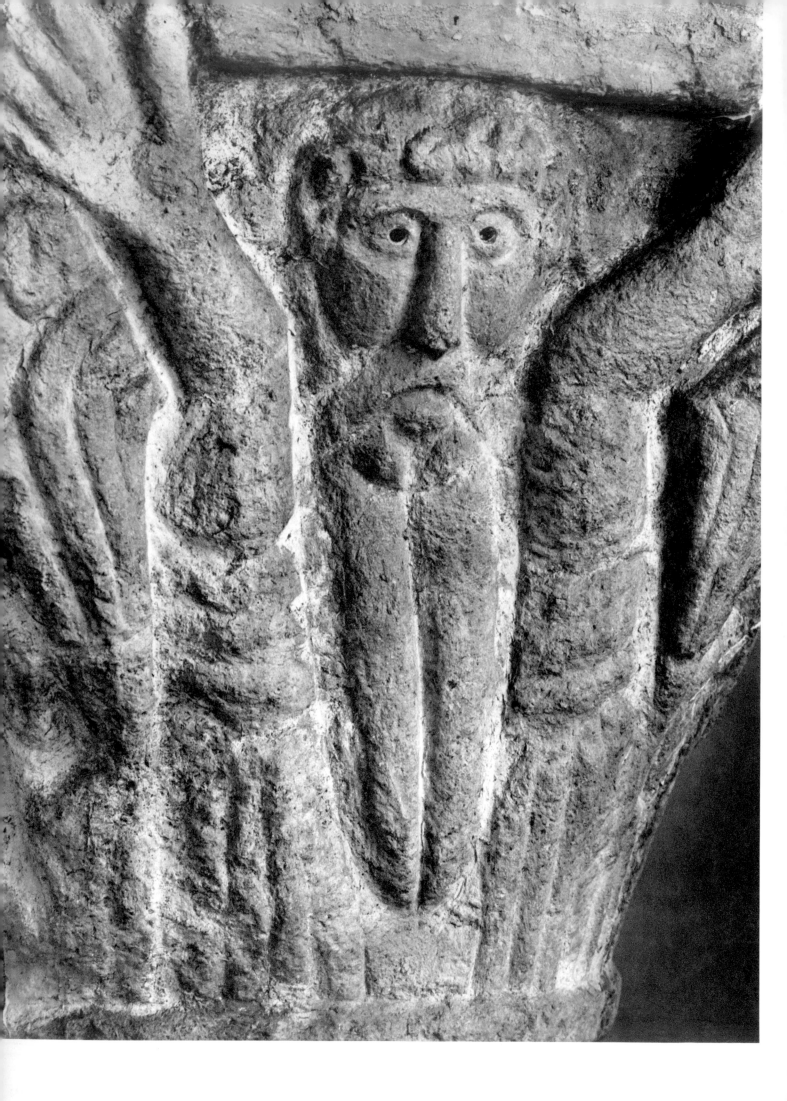

7 DIJON (Côte-d'Or), La cathédrale Saint-Bénigne

8 AUTUN (Saône-et-Loire), La cathédrale

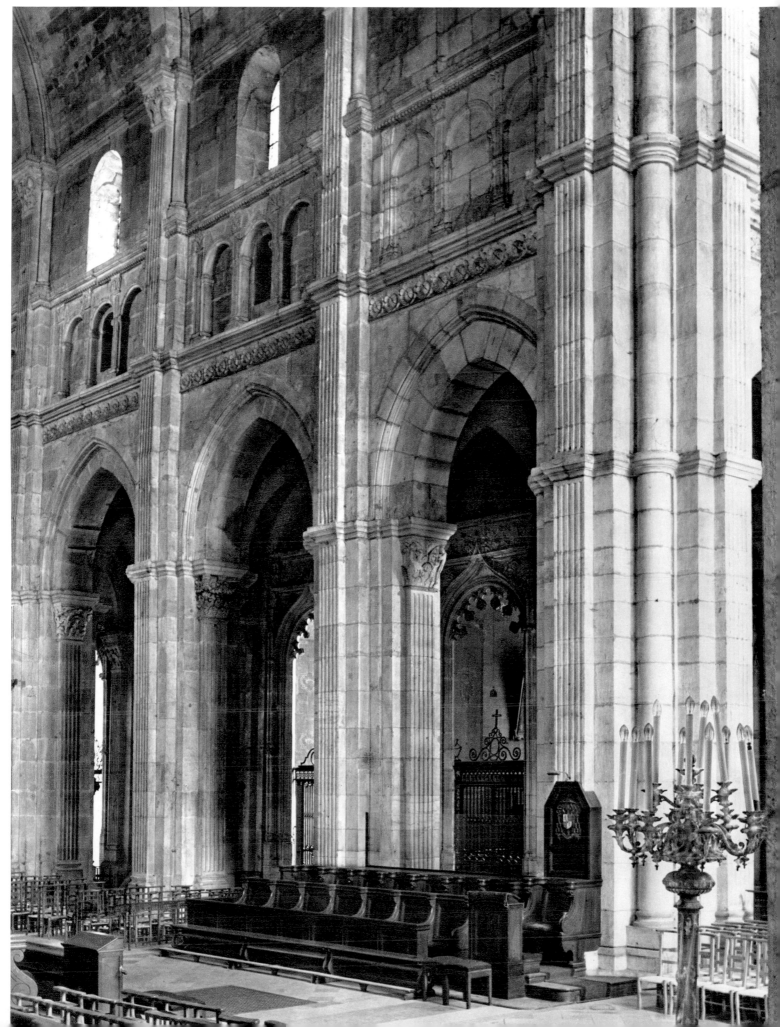

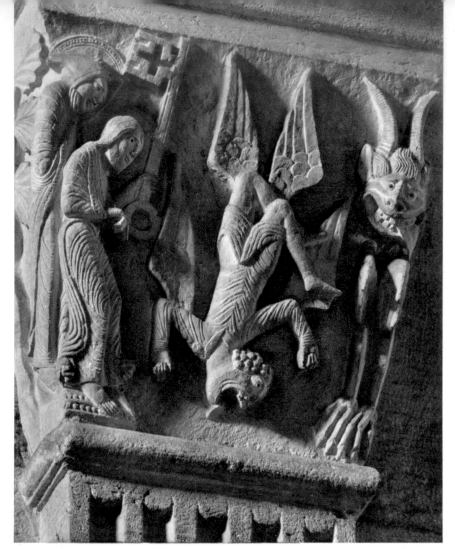

9, 10
AUTUN (Saône-et-Loire), La cathédrale

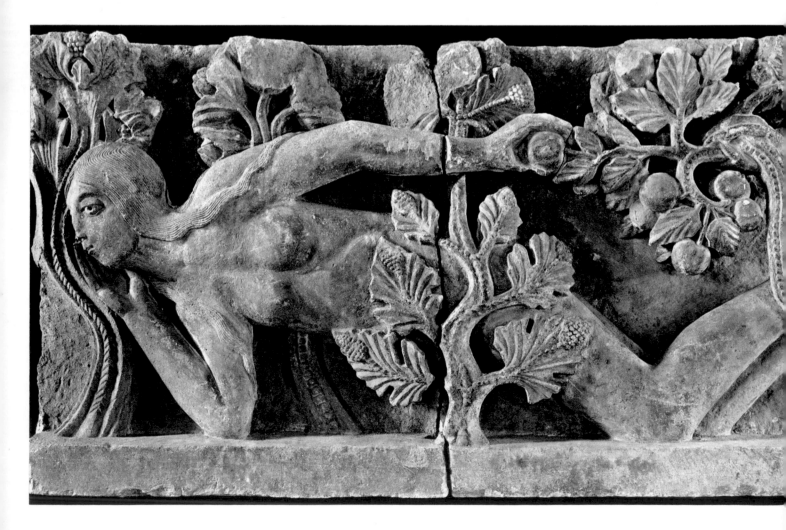

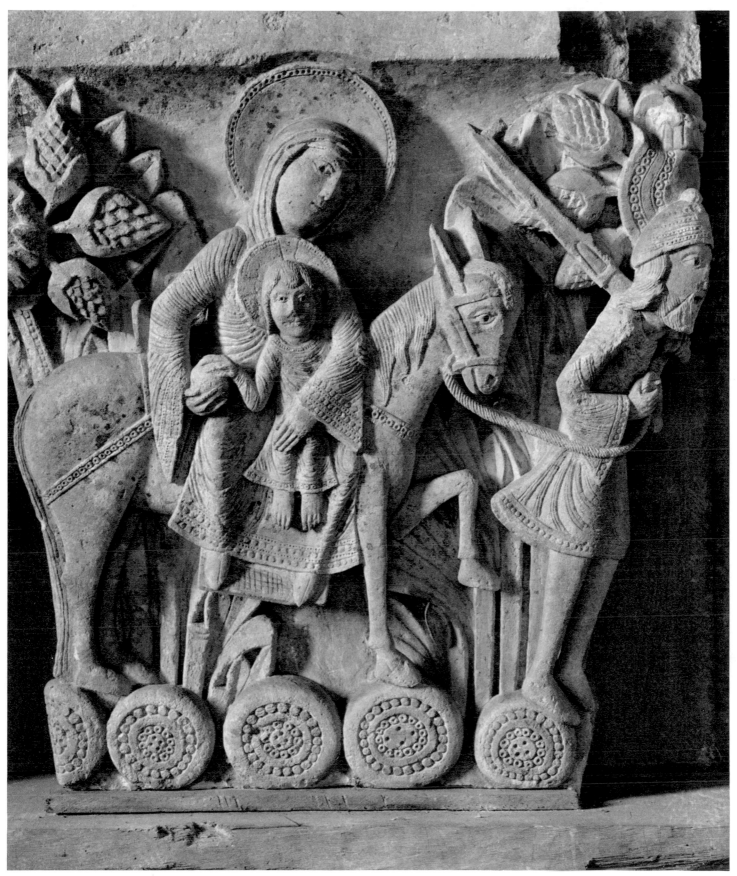

11 AUTUN (Saône-et-Loire), La cathédrale

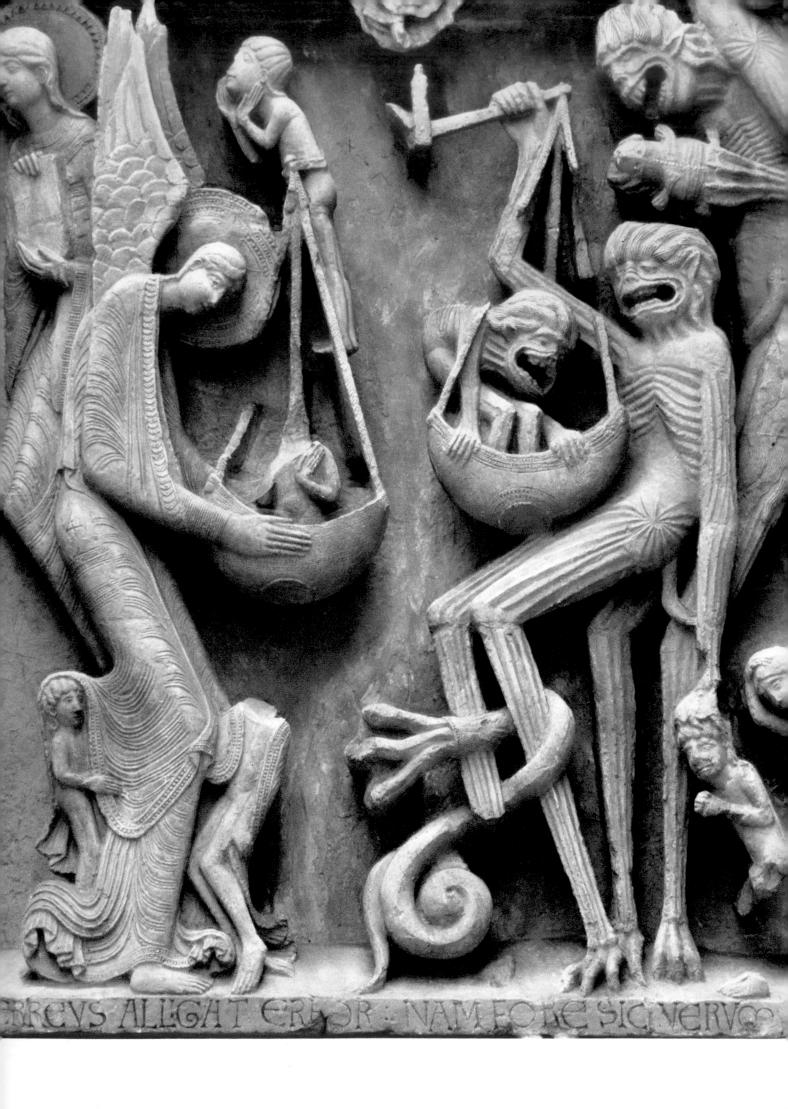

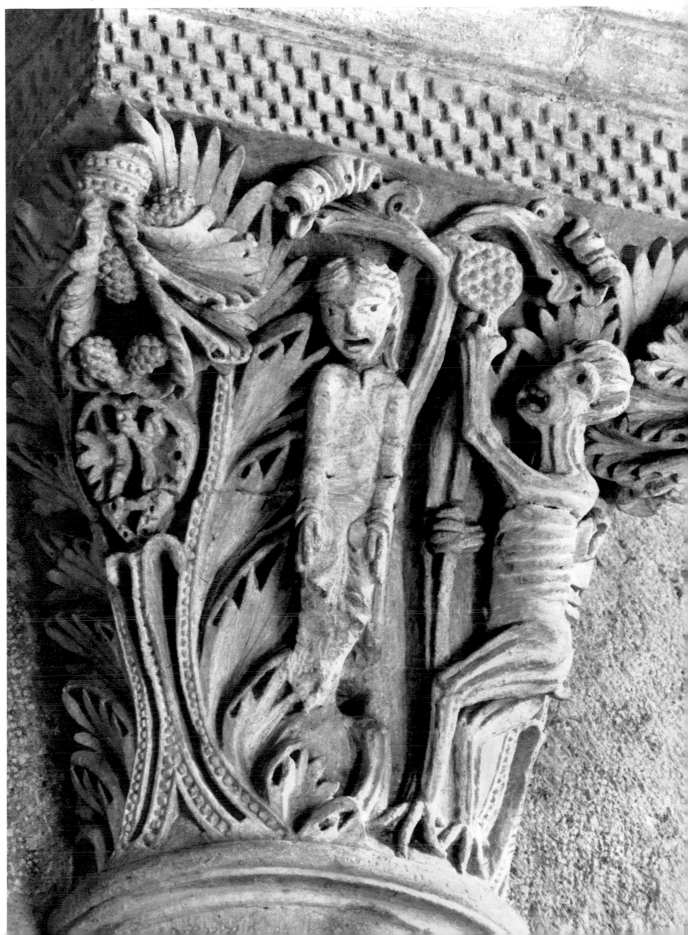

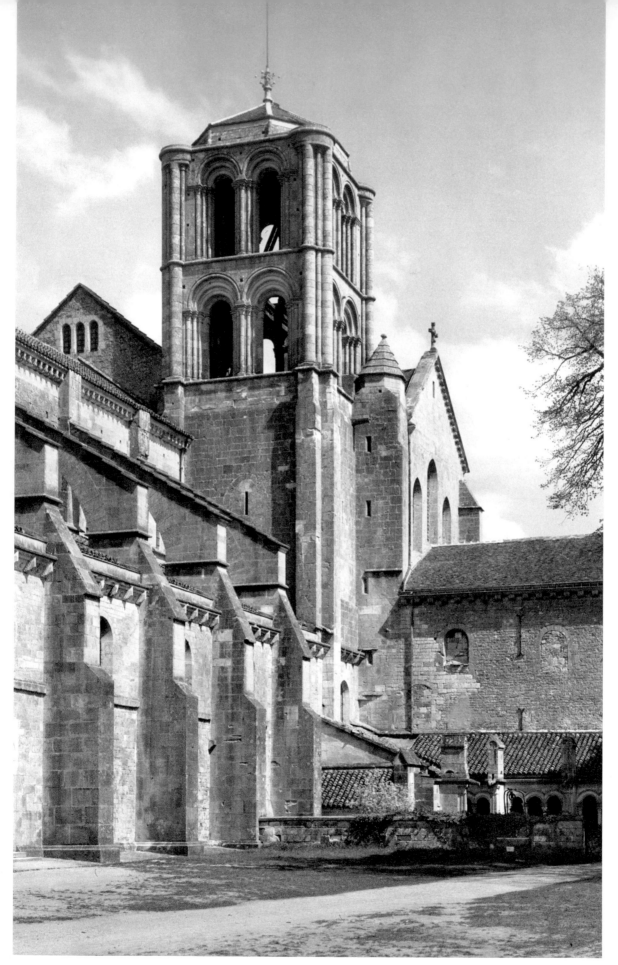

14, 15 VÉZELAY (Yonne), La basilique

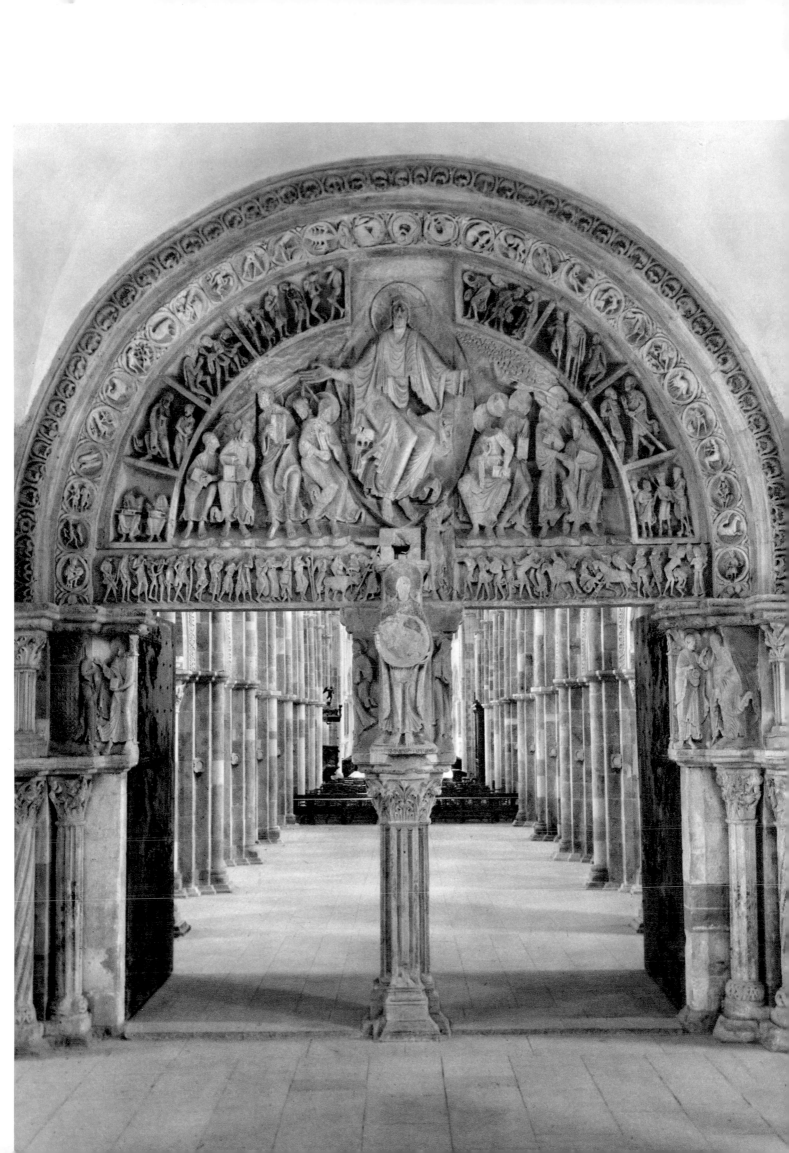

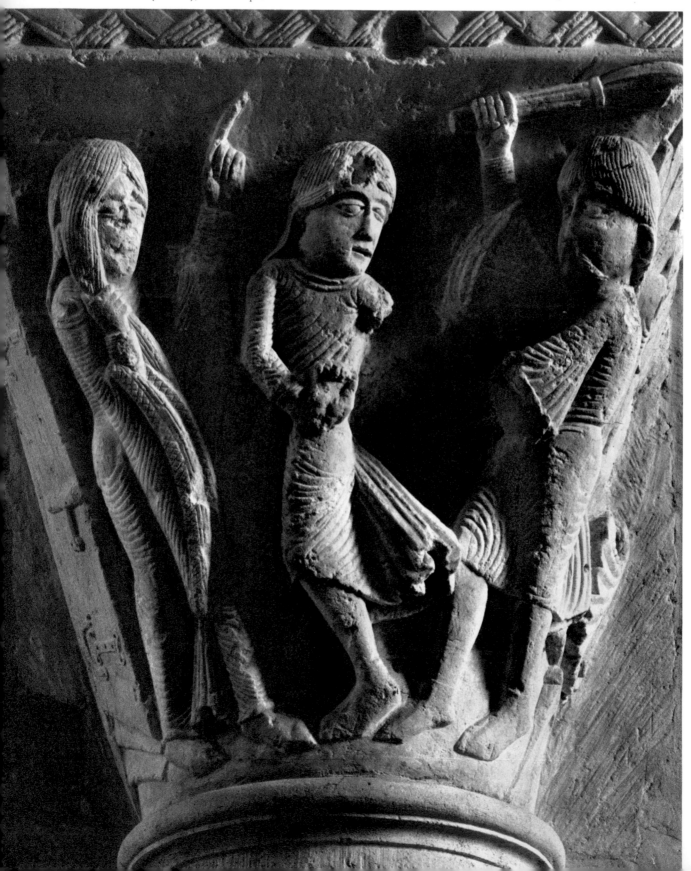

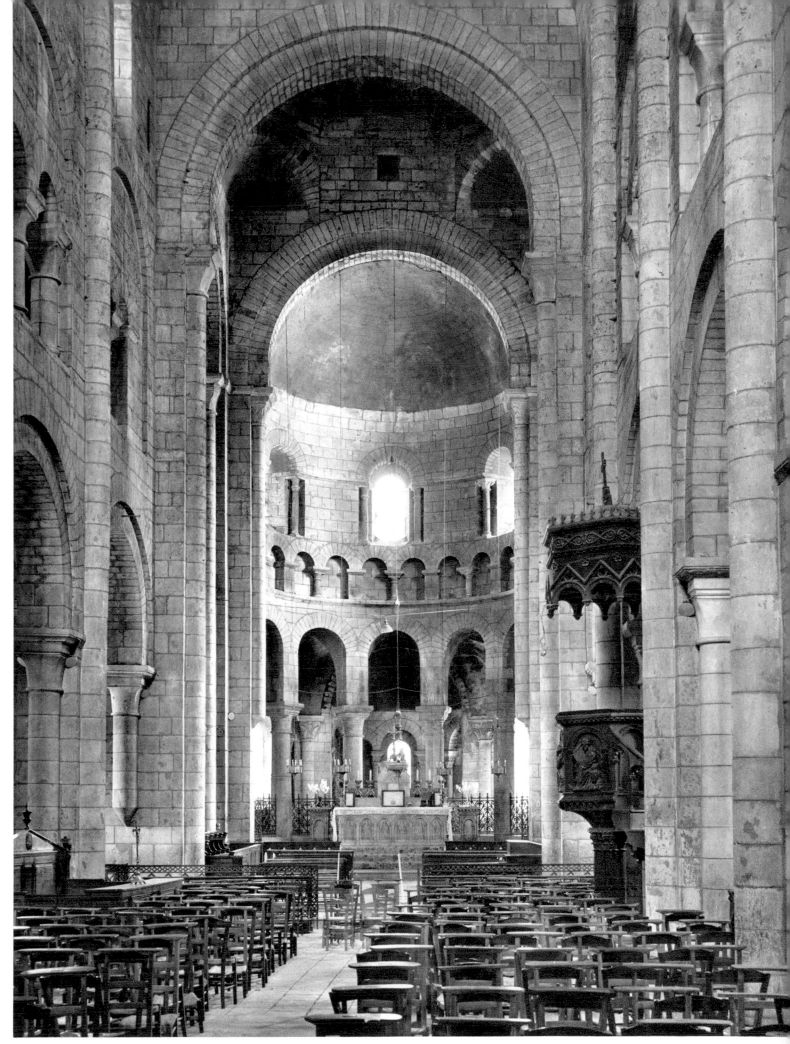

17 NEVERS (Nièvre), L'église Saint-Etienne

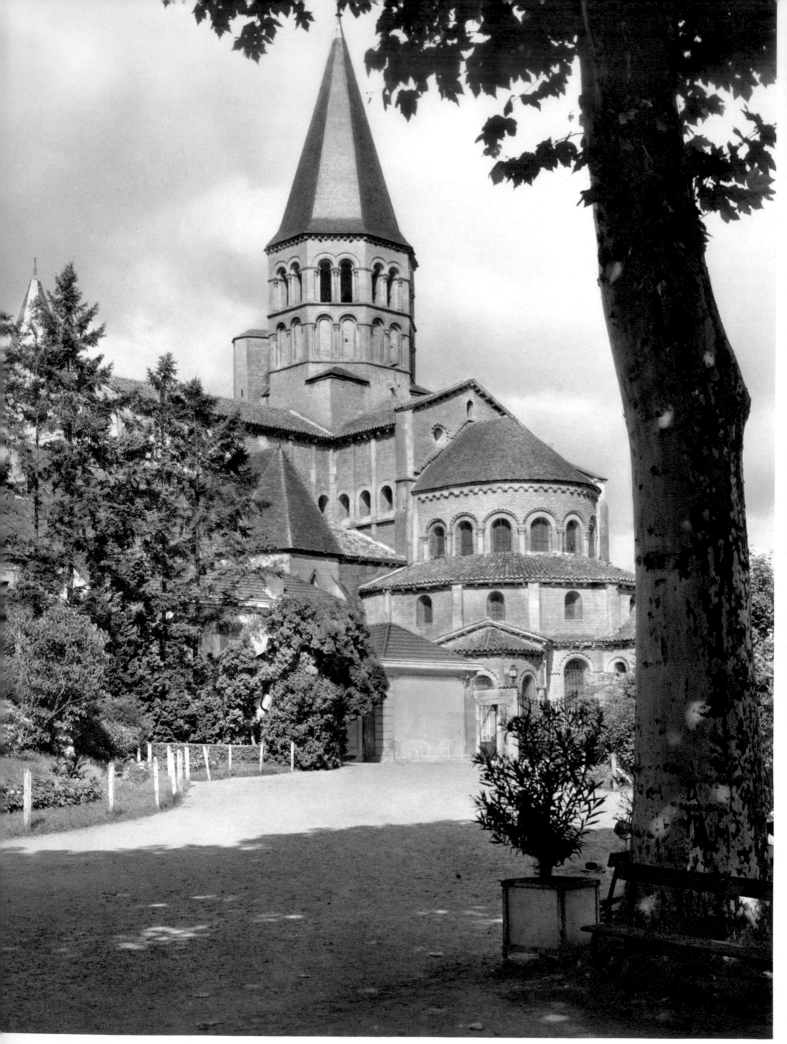

18 PARAY-LE-MONIAL (Saône-et-Loire), La basilique 19 LA CHARITÉ-SUR-LOIRE (Nièvre), L'église

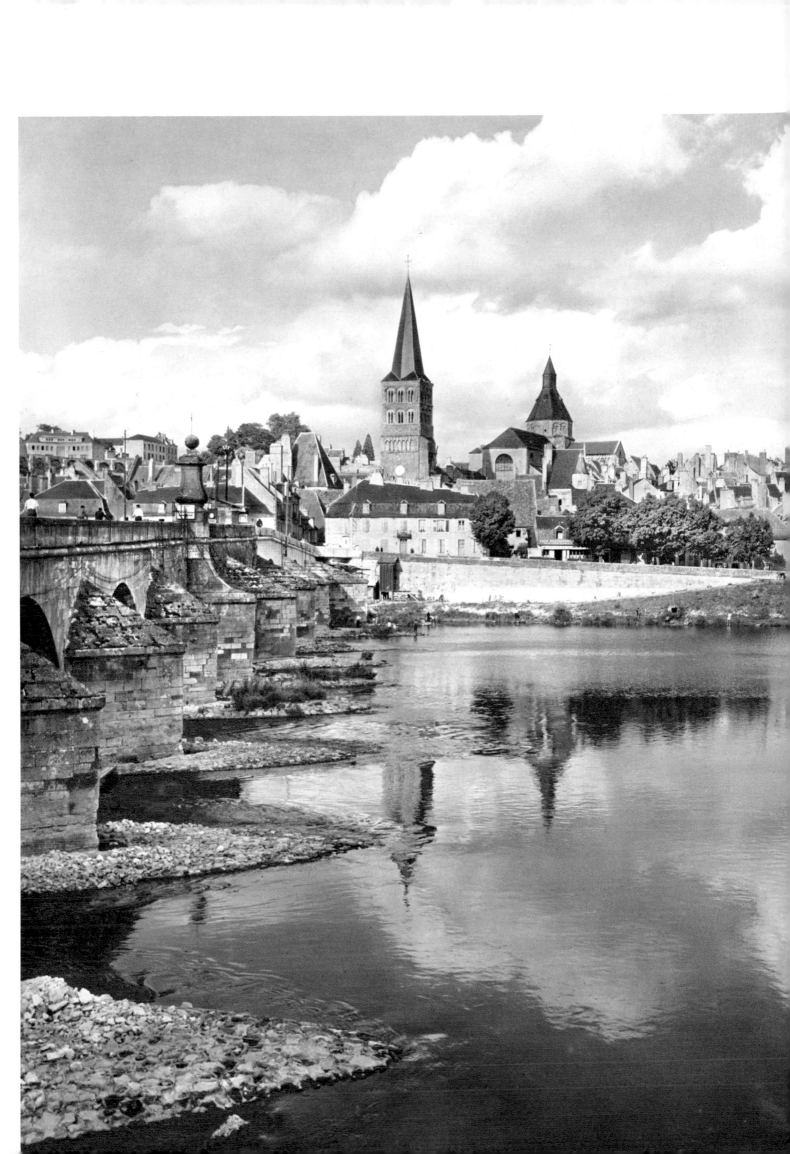

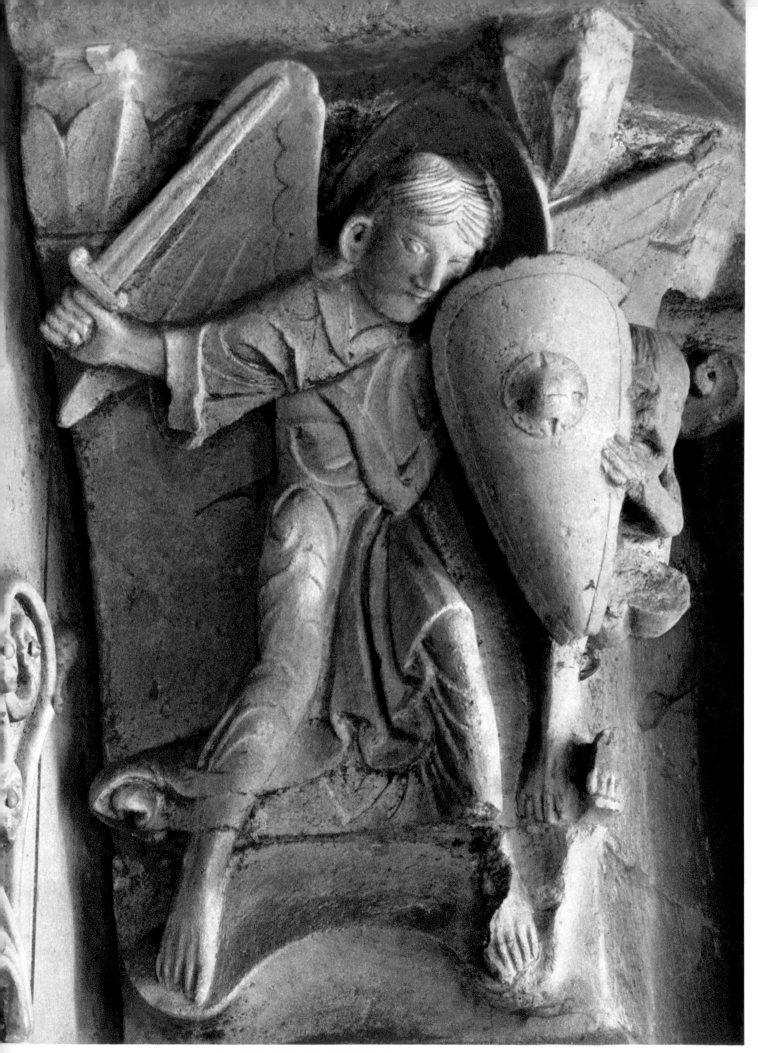

20 PERRECY-LES-FORGES (Saône-et-Loire), L'église

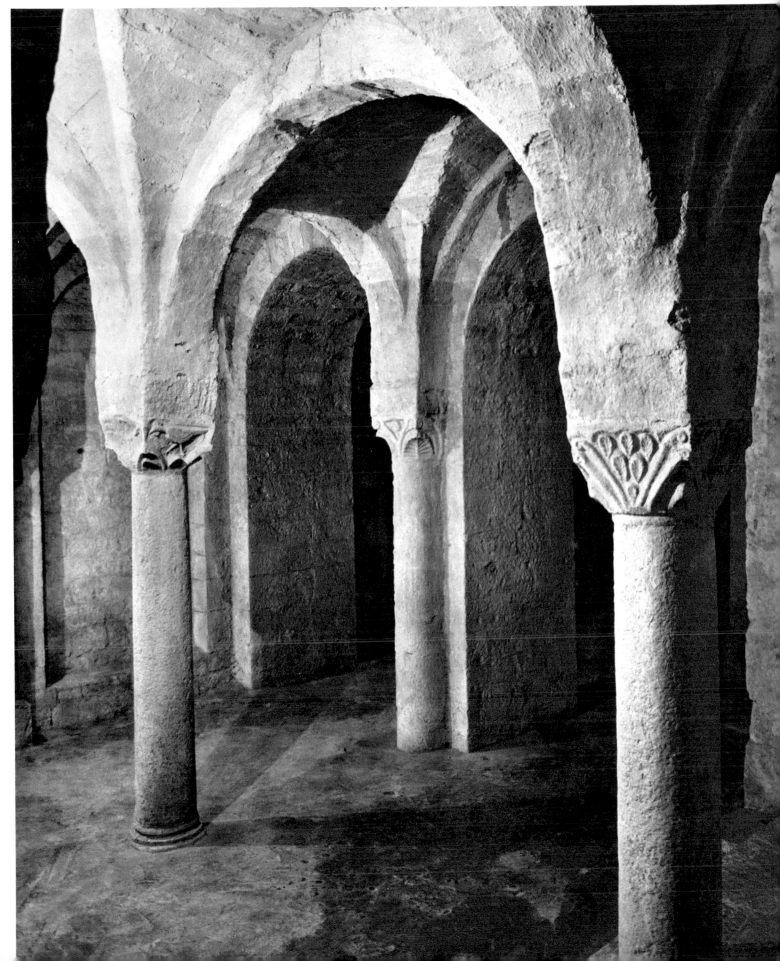

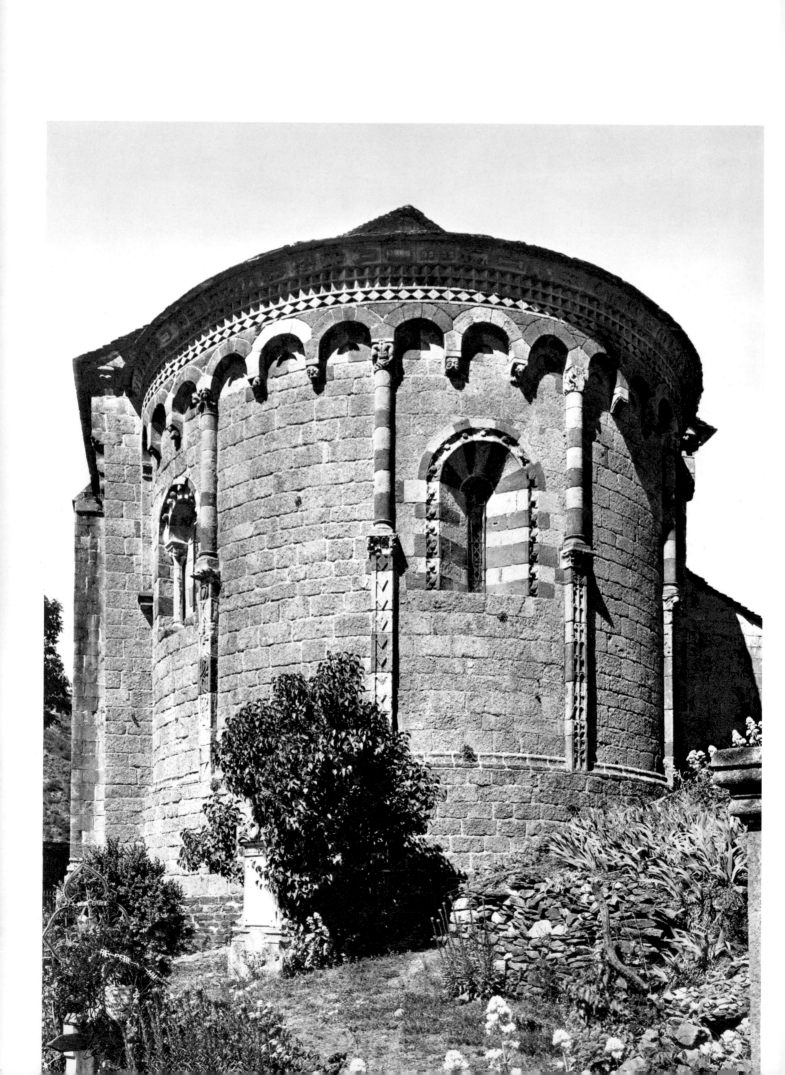

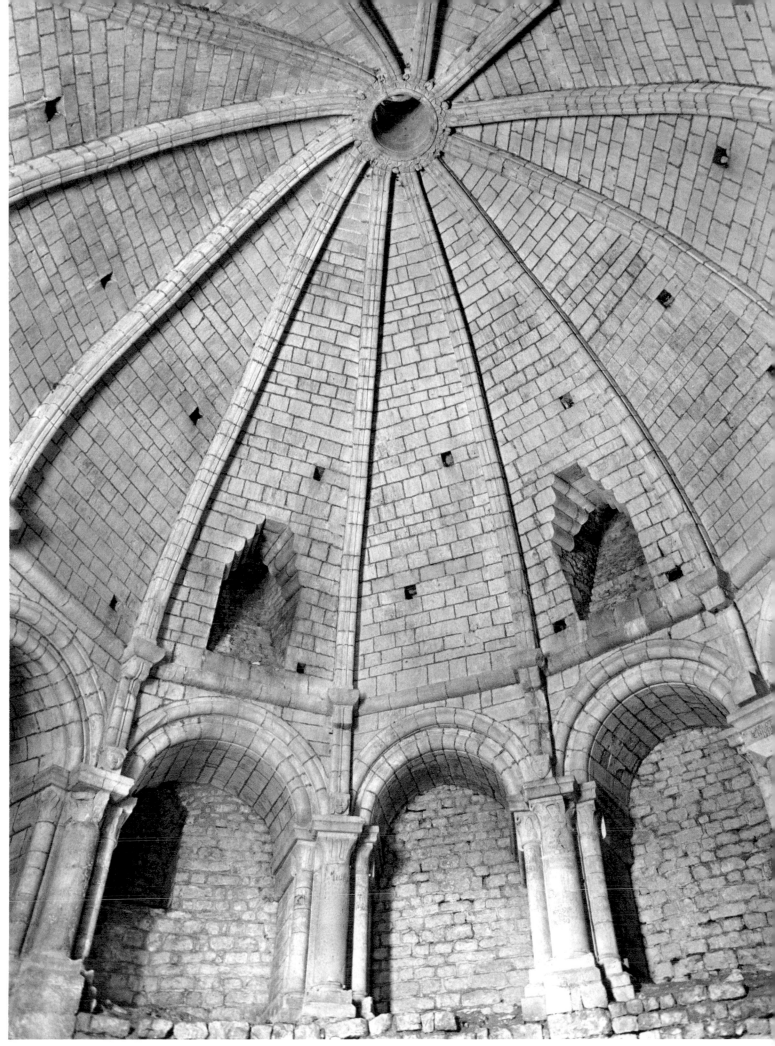

22 THINES (Ardèche), L'église
23 SIMIANE (Basses-Alpes), La rotonde

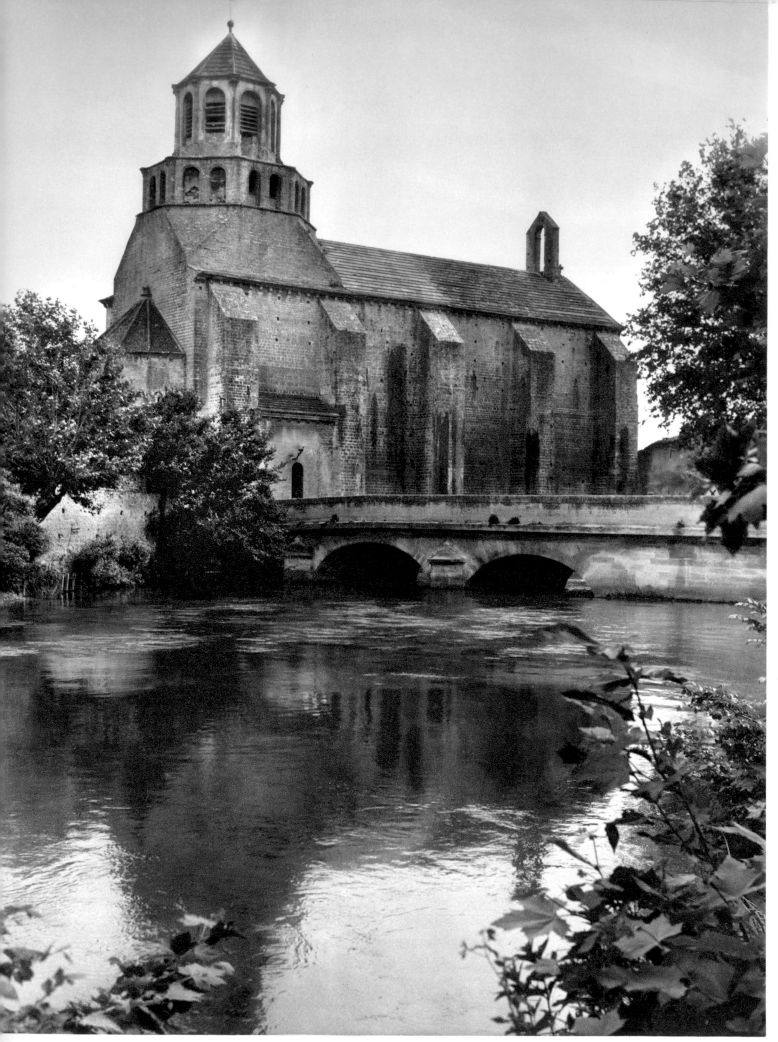

24 LE THOR (Vaucluse), L'église

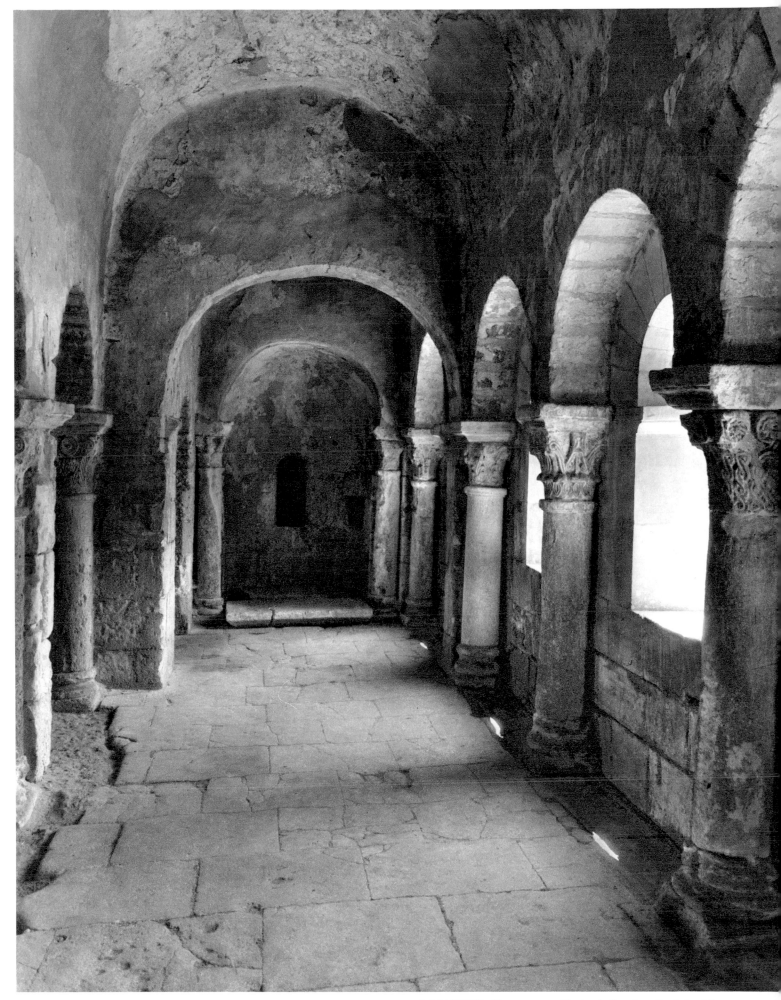

25 MONTMAJOUR (Bouches-du-Rhône), La chapelle Saint-Pierre

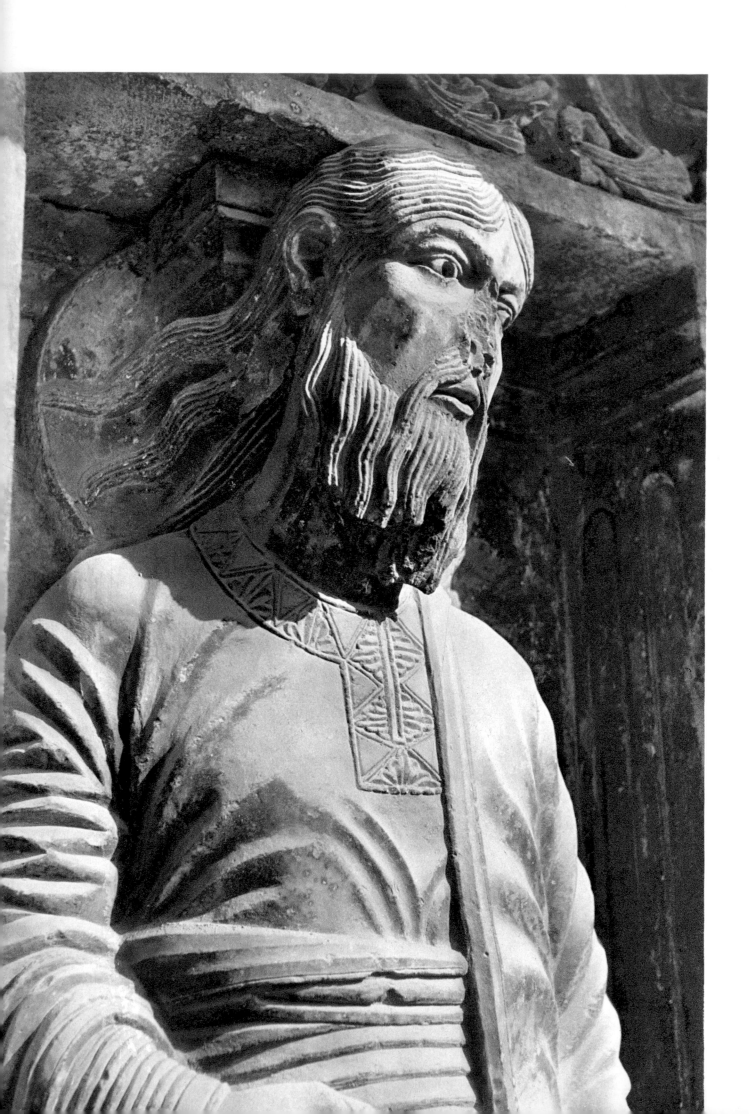

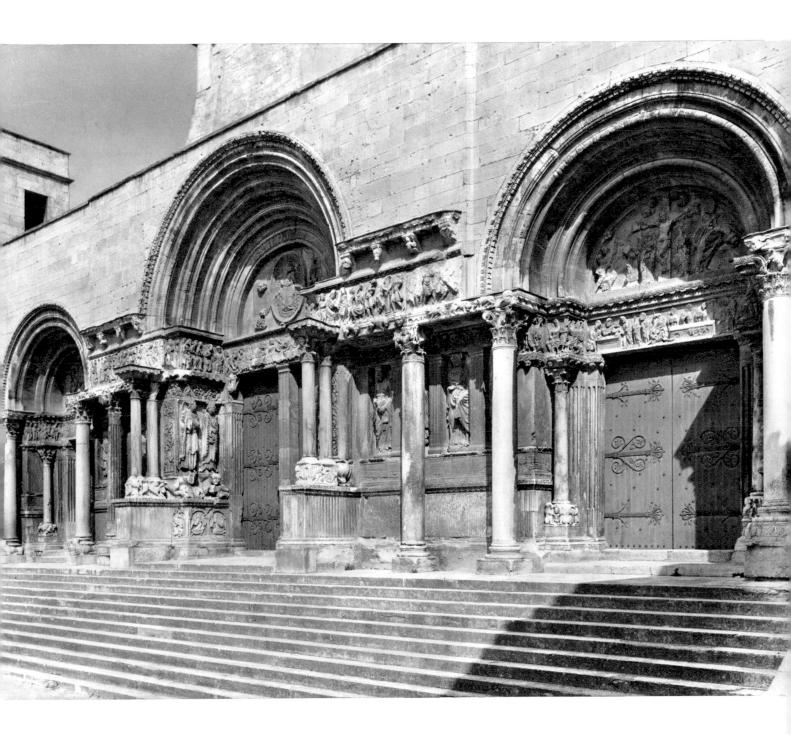

26 ST-GILLES-DU-GARD (Gard), L'église 27 ST-GILLES-DU-GARD (Gard), L'église

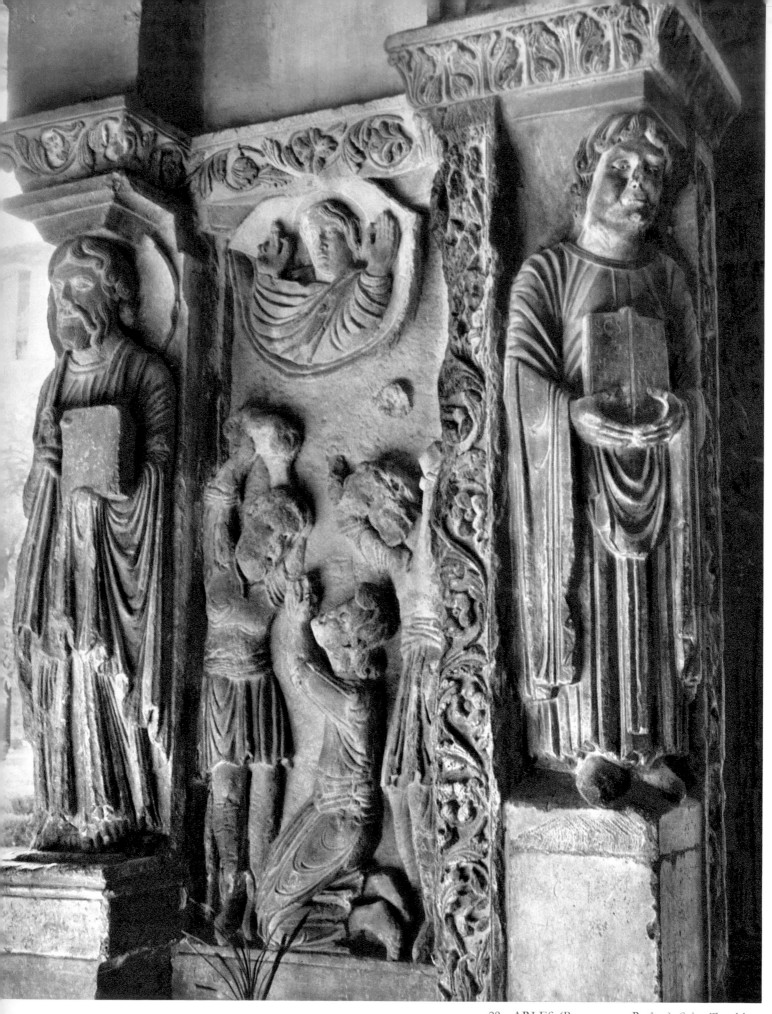

28 ARLES (Bouches-du-Rhône), Saint-Trophime

29 TOULOUSE (Haute-Garonne), Saint-Sernin

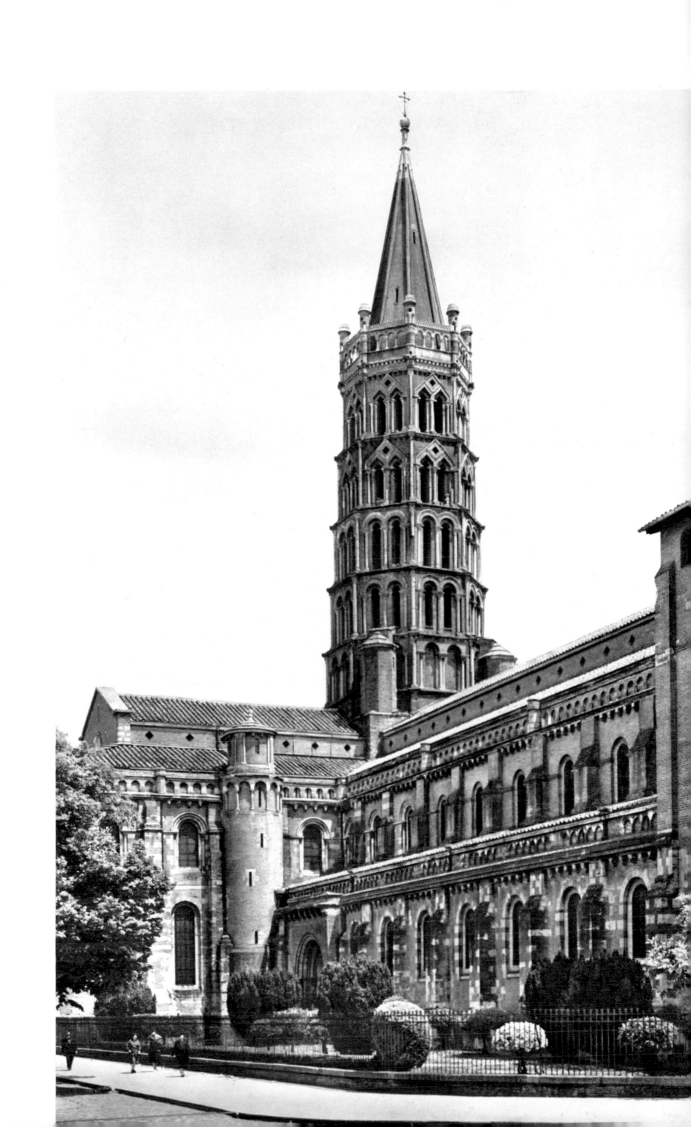

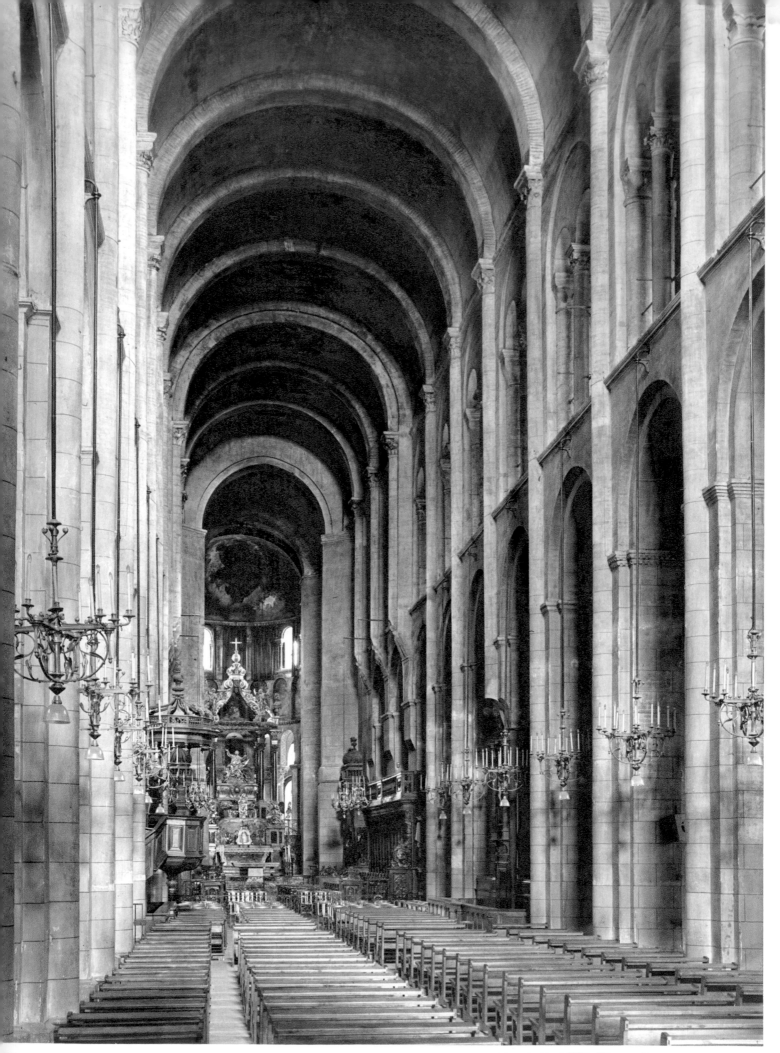

30, 31 TOULOUSE (Haute-Garonne), Saint-Sernin

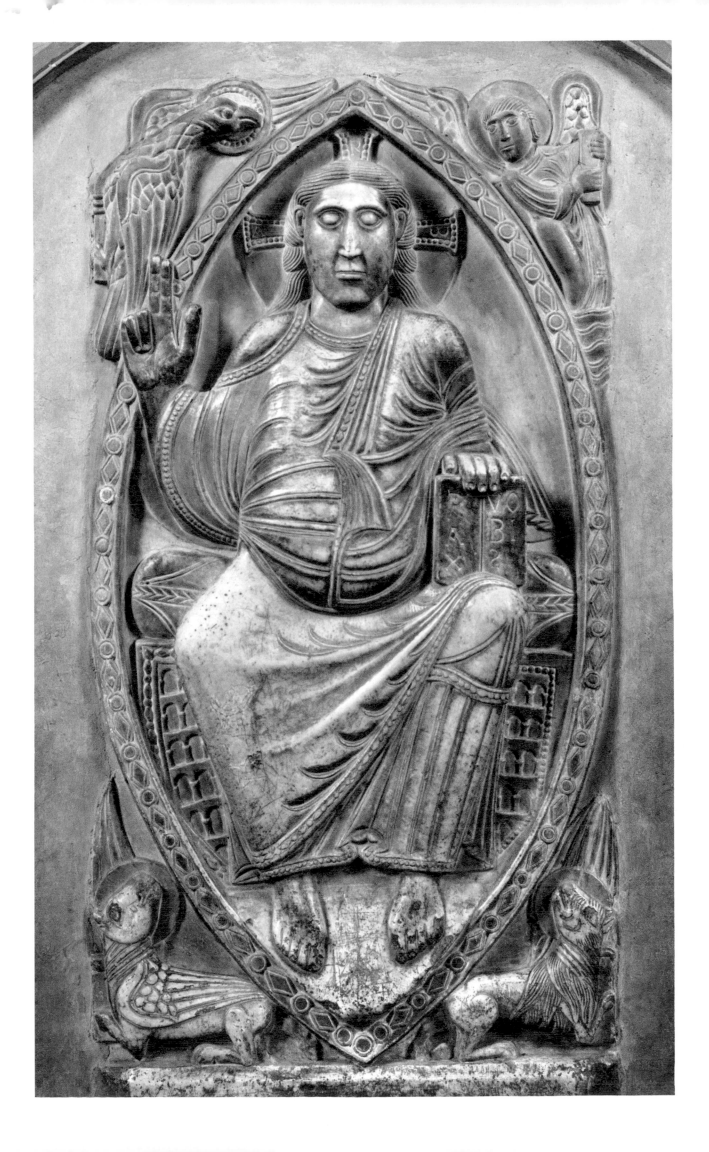

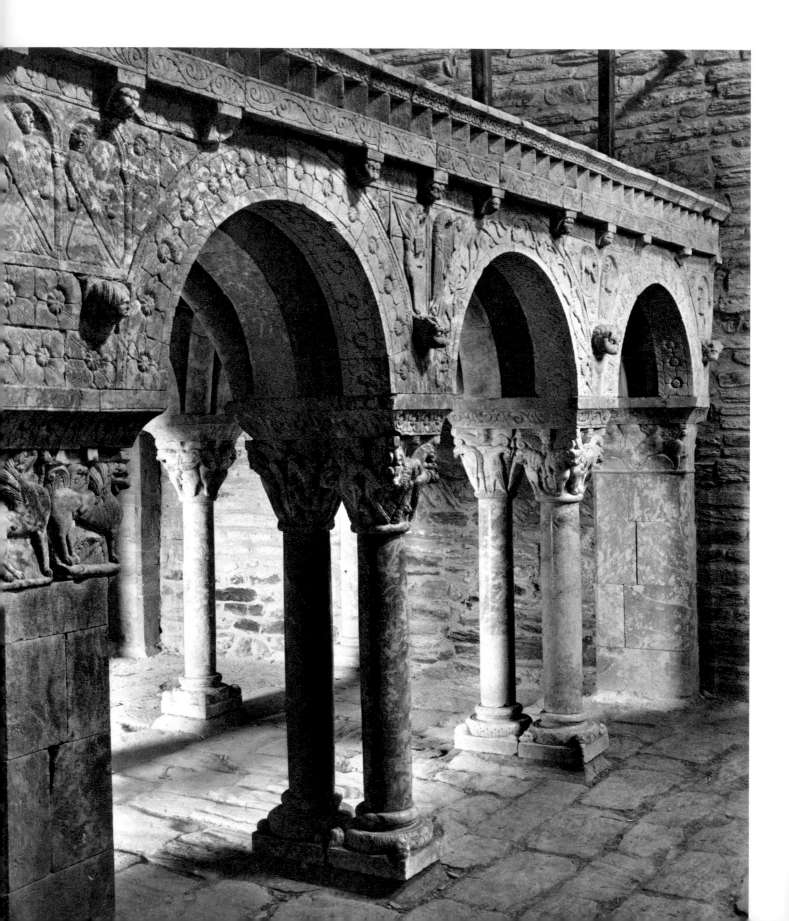

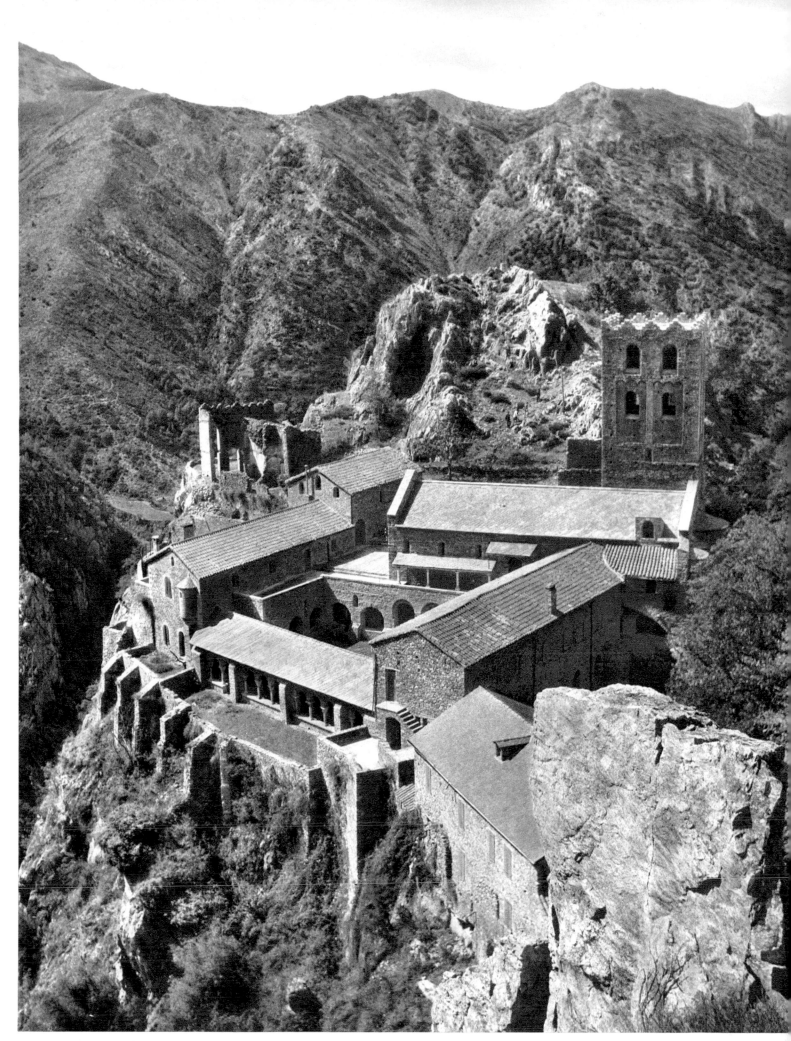

32 SERRABONE (Pyrénées-Orientales),
L'ancienne église augustine

33 ST-MARTIN-DU-CANIGOU (Pyrénées-Orientales),
Le monastère

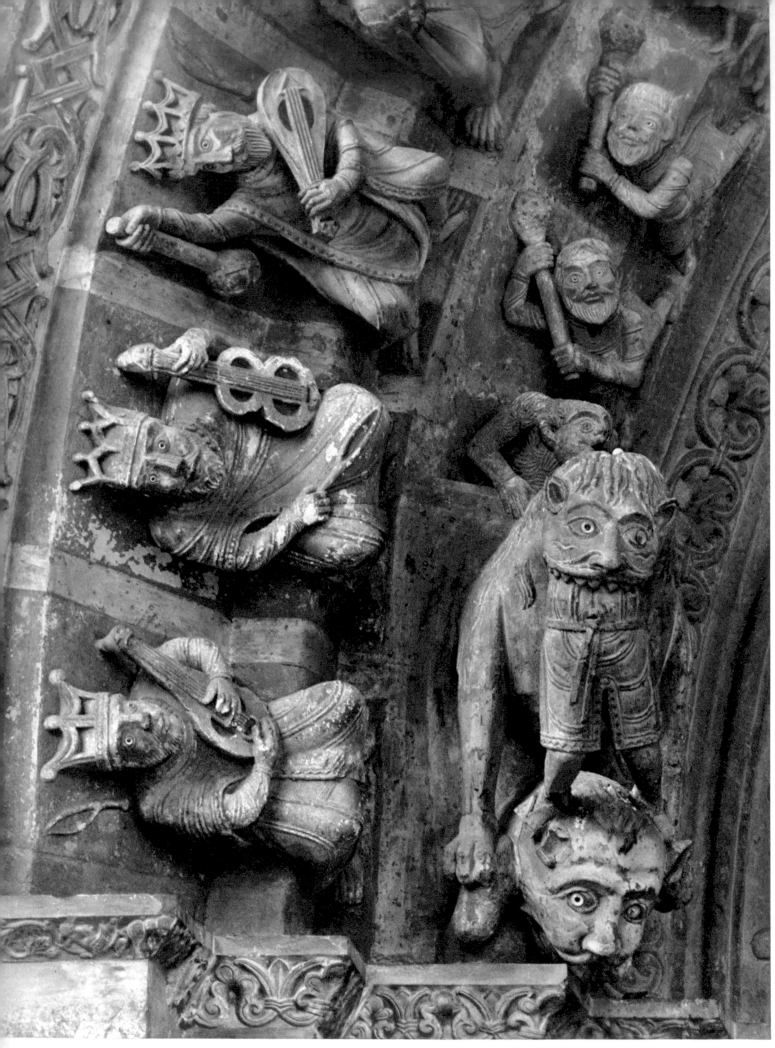

34 ORLON-SAINTE-MARIE (Basses-Pyrénées), L'église 35 MOISSAC (Tarn-et-Garonne), Saint-Pierre

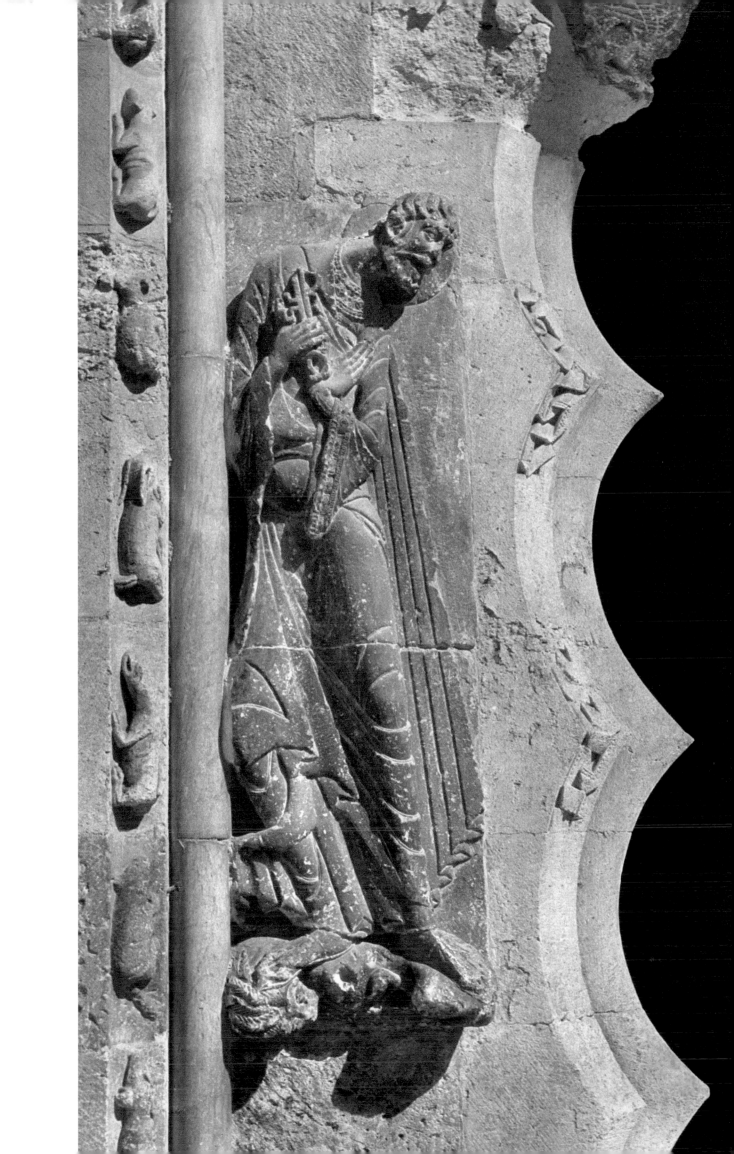

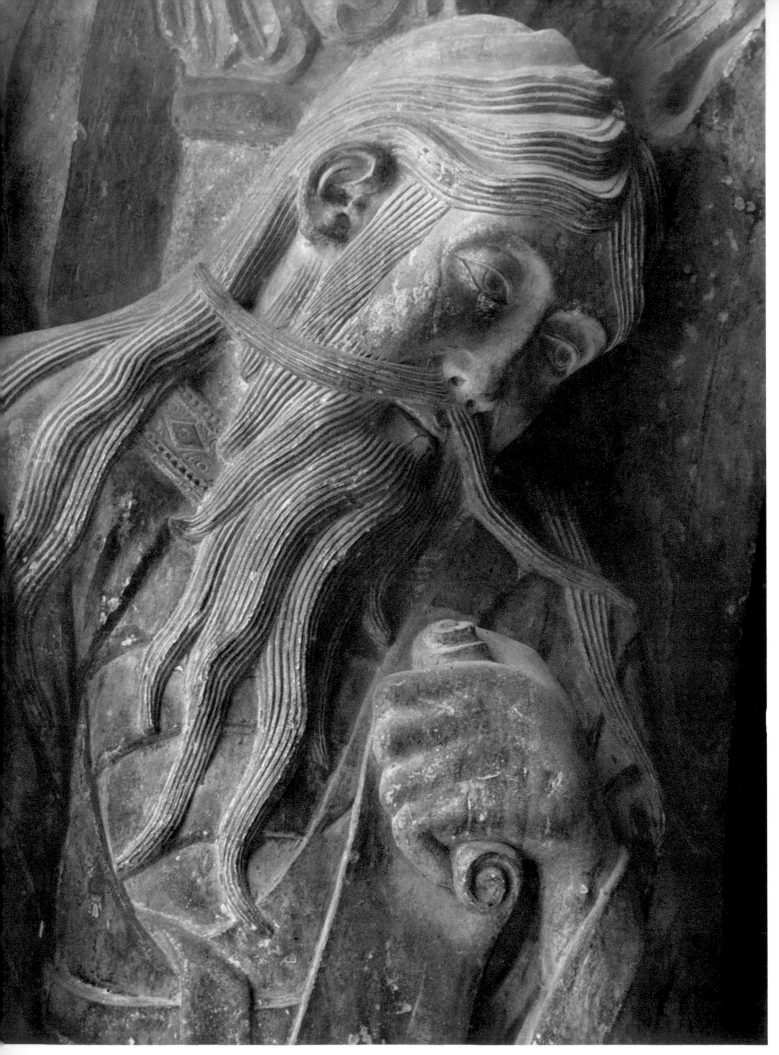

36 MOISSAC (Tarn-et-Garonne), Saint-Pierre

37 BEAULIEU-SUR-DORDOGNE (Corrèze), 38 SOUILLAC (Lot), L'église

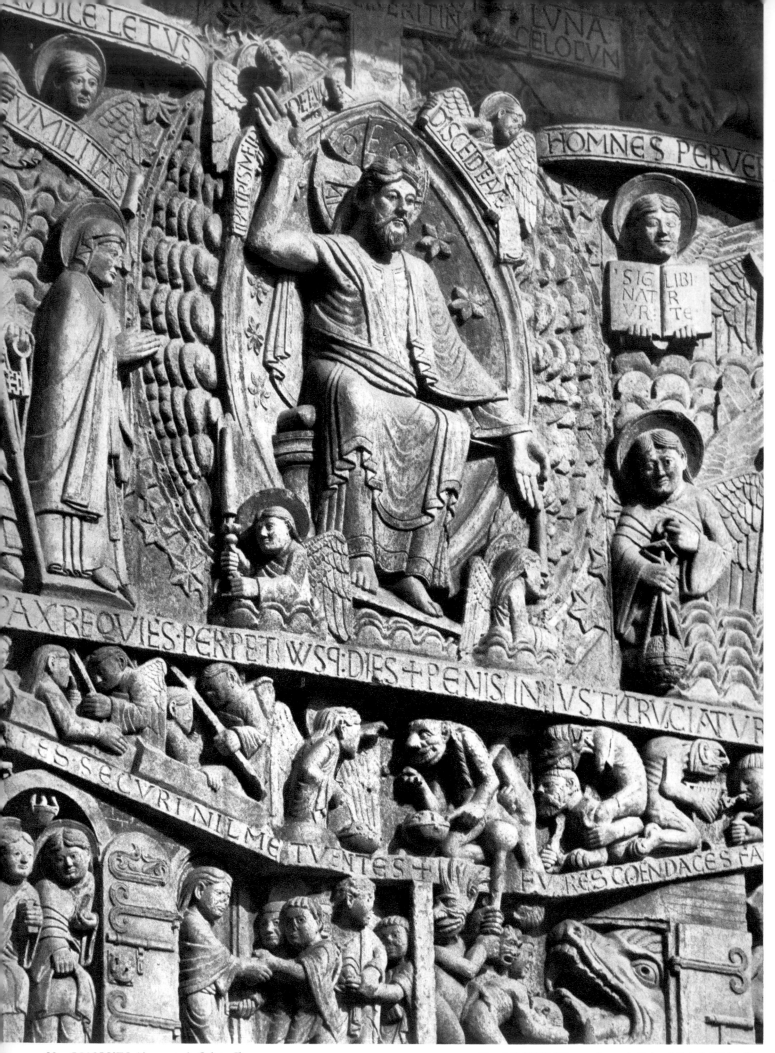

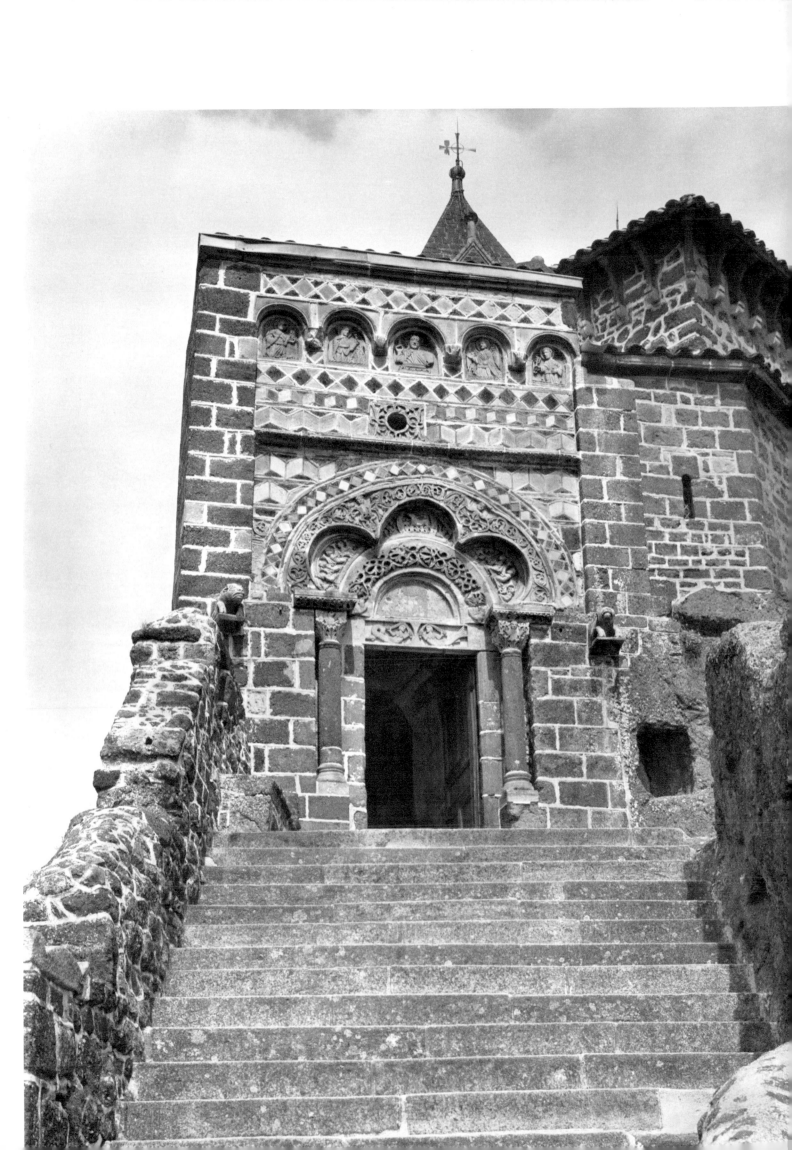

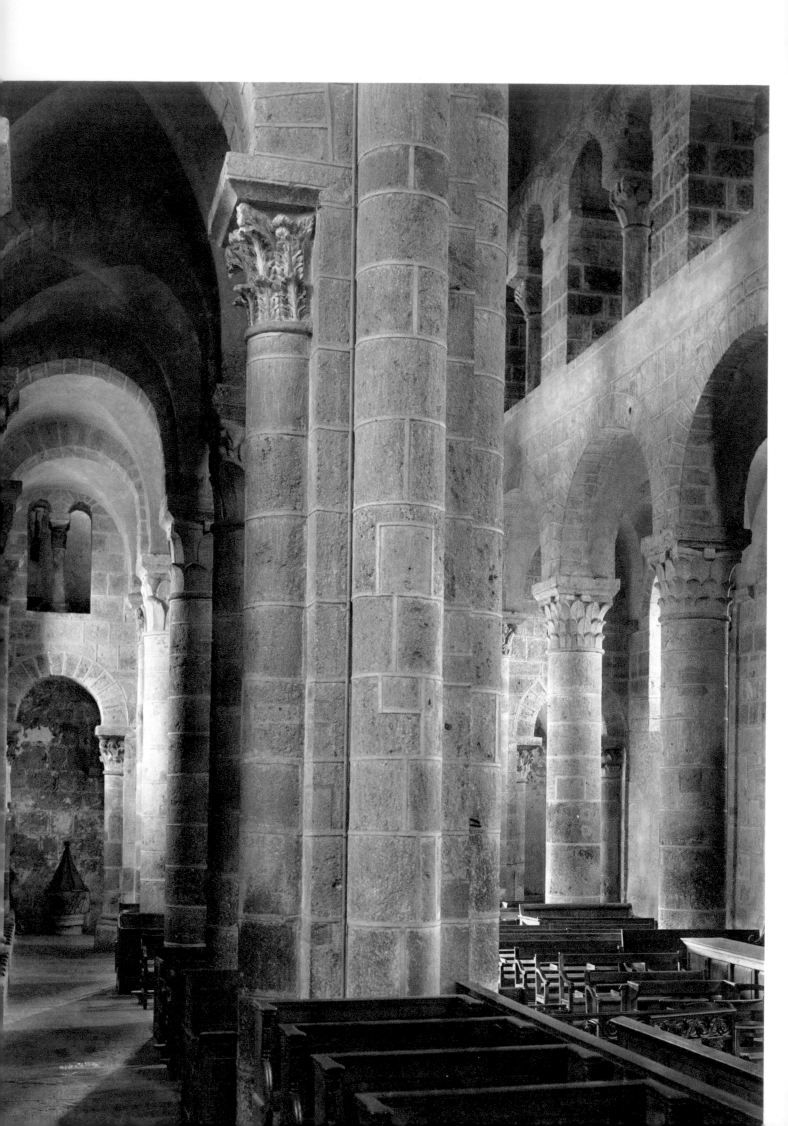

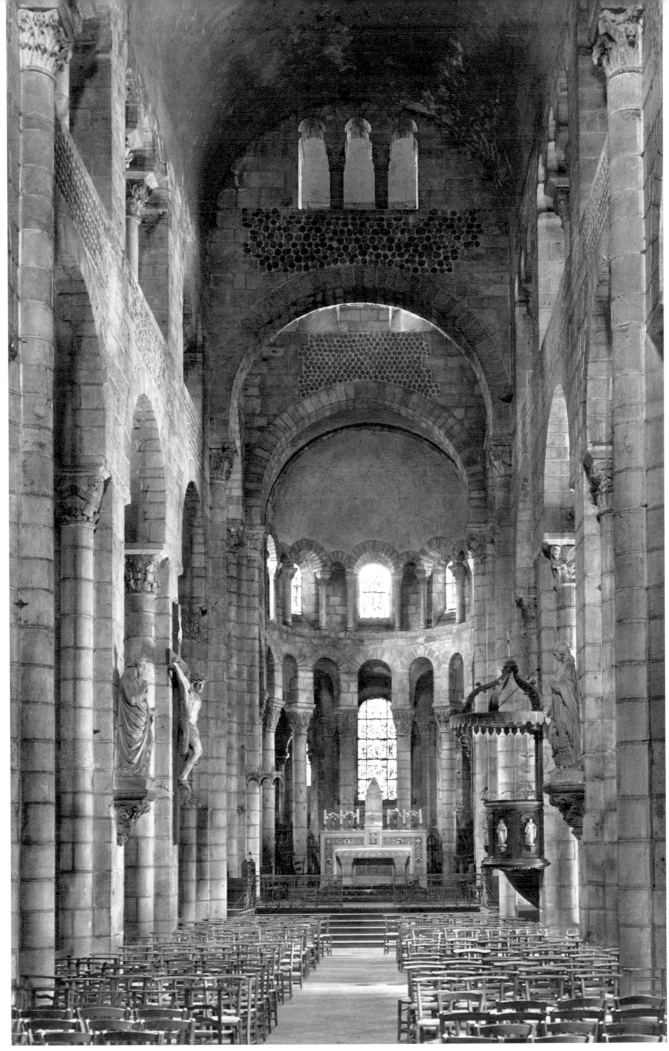

41 ST-NECTAIRE (Puy-de-Dôme), L'église 42 CLERMONT-FERRAND (Puy-de-Dôme), Notre-Dame-du-Port

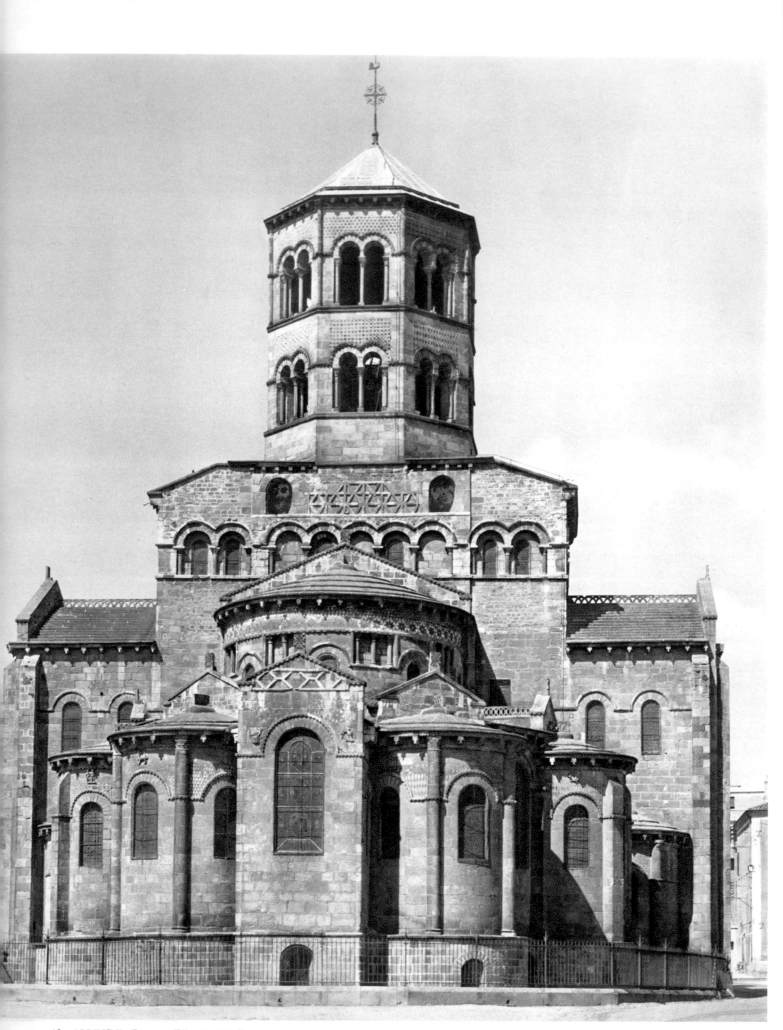

43 ISSOIRE (Puy-de-Dôme), L'église paroissiale

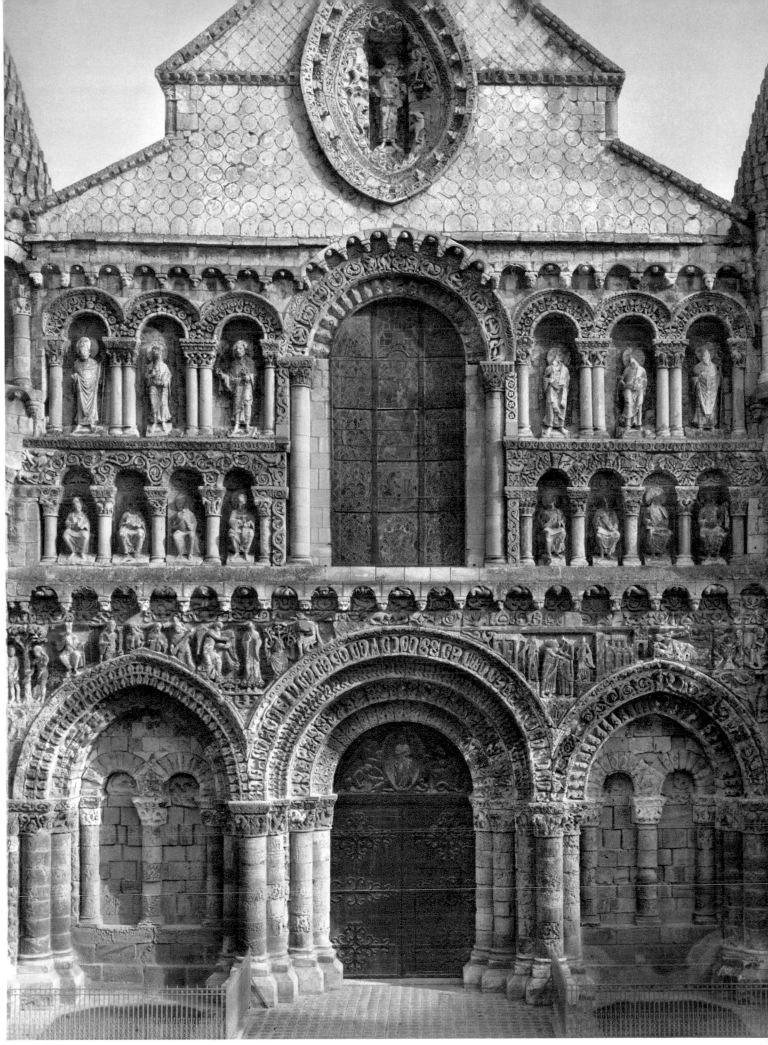

44 POITIERS (VIENNE), Notre-Dame-la-Grande

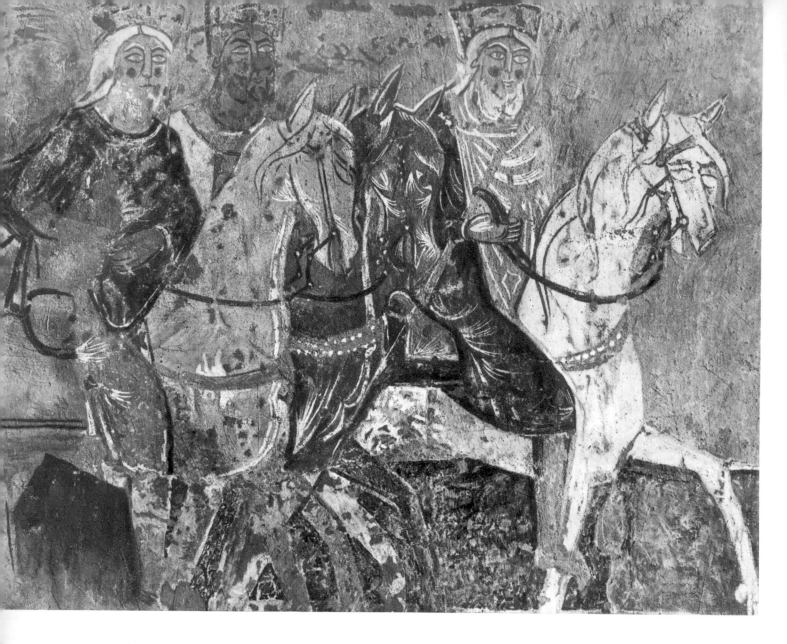

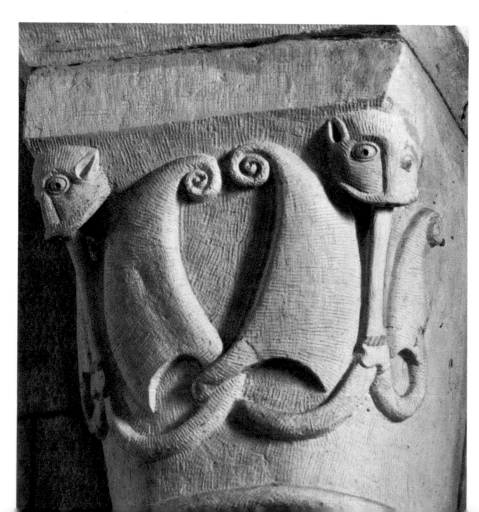

45 BRINAY (Cher), L'église

46 MARS-SUR-ALLIER (Nièvre),
Prieuré

47 MOZAC (Puy-de-Dôme),
L'ancienne église Saint-Pierre

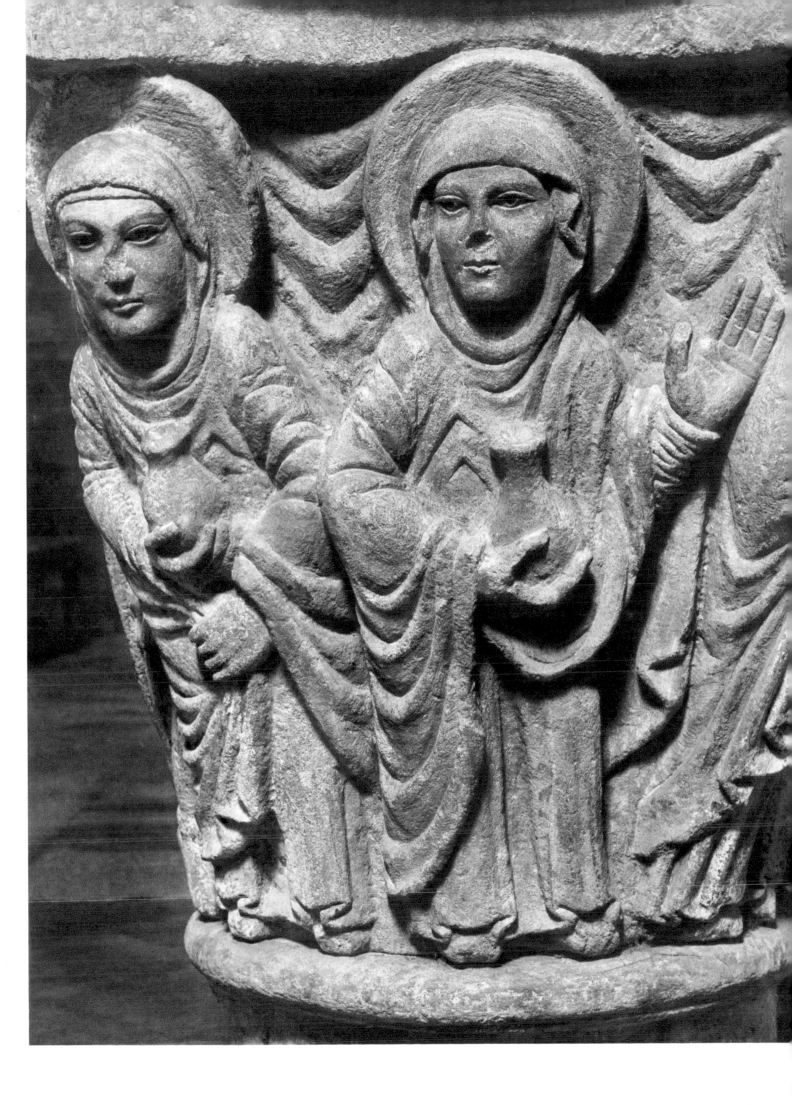

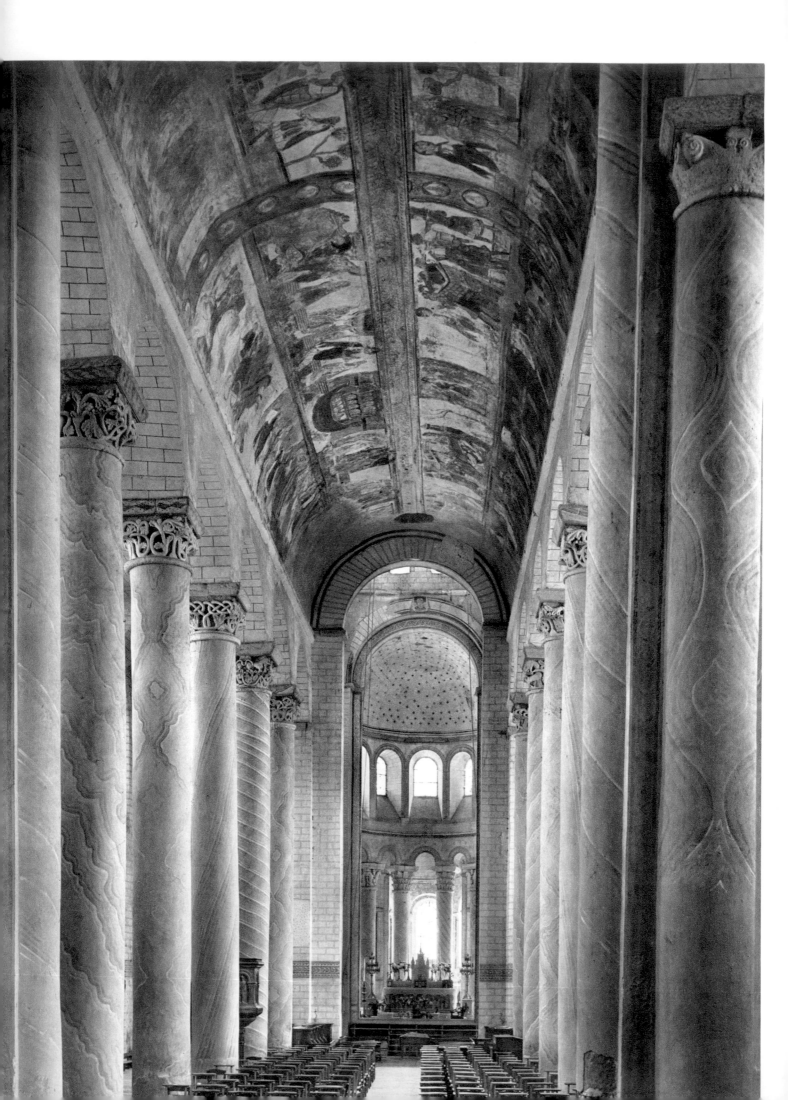

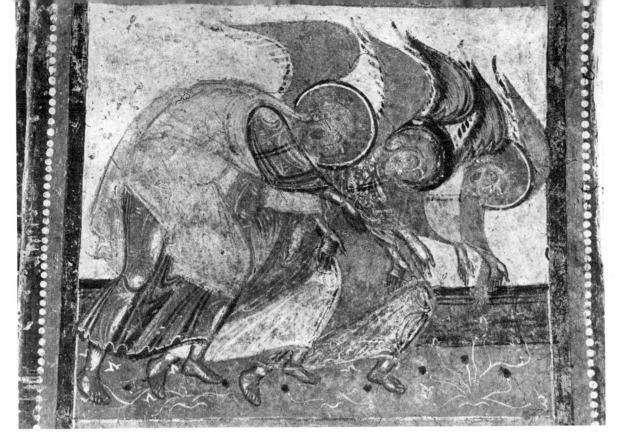

48–50 ST-SAVIN (Vienne), L'ancienne abbatiale

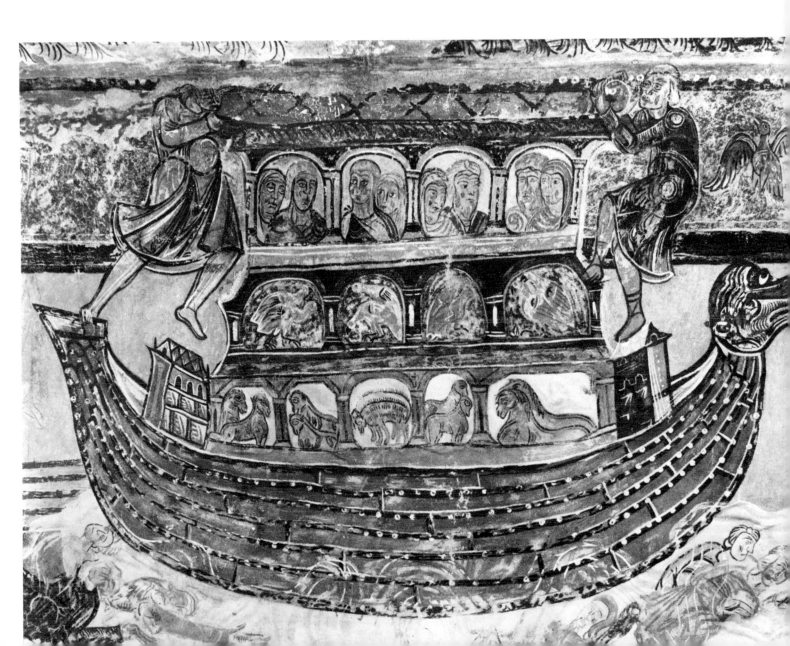

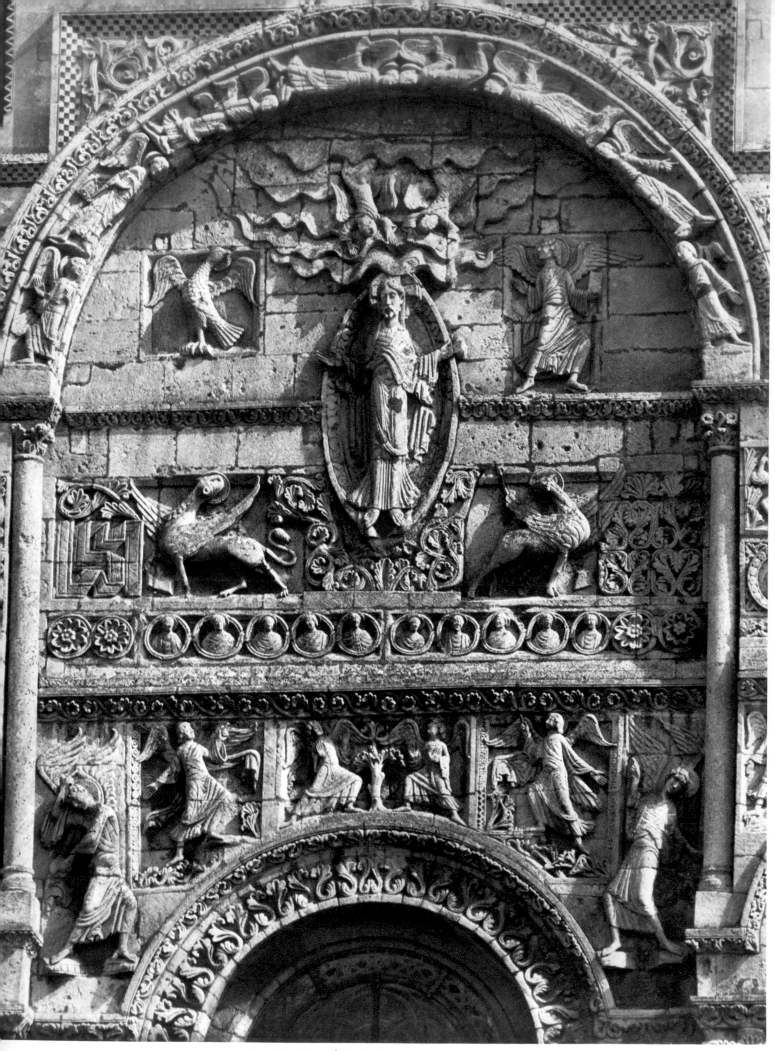

51 ANGOULÊME (Charente), La cathédrale

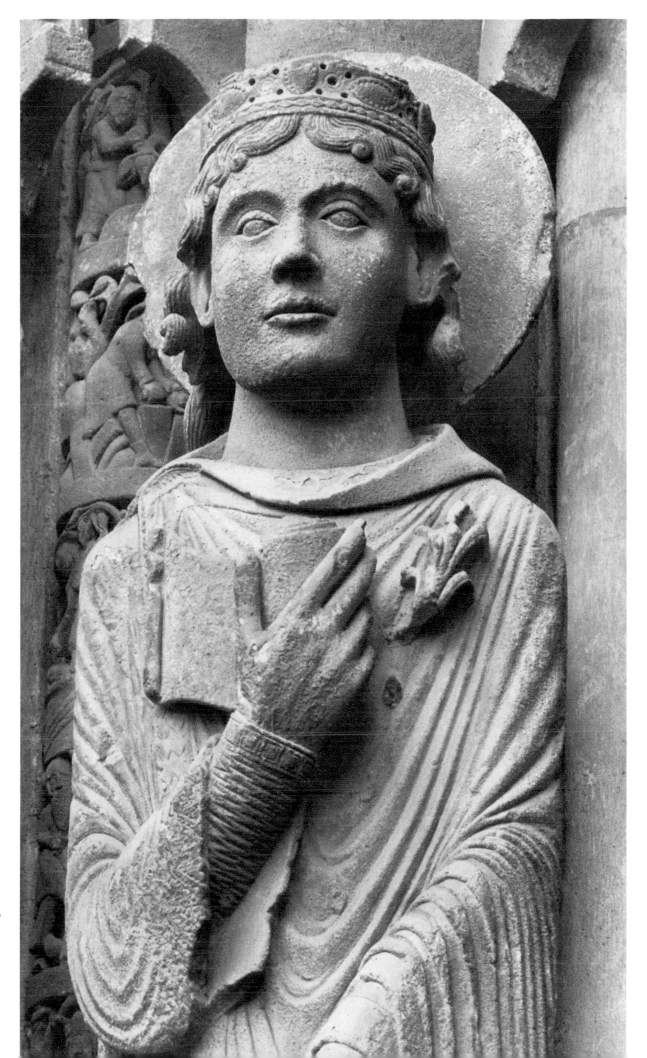

52 CHARTRES
(Eure-et-Loir),
La cathédrale

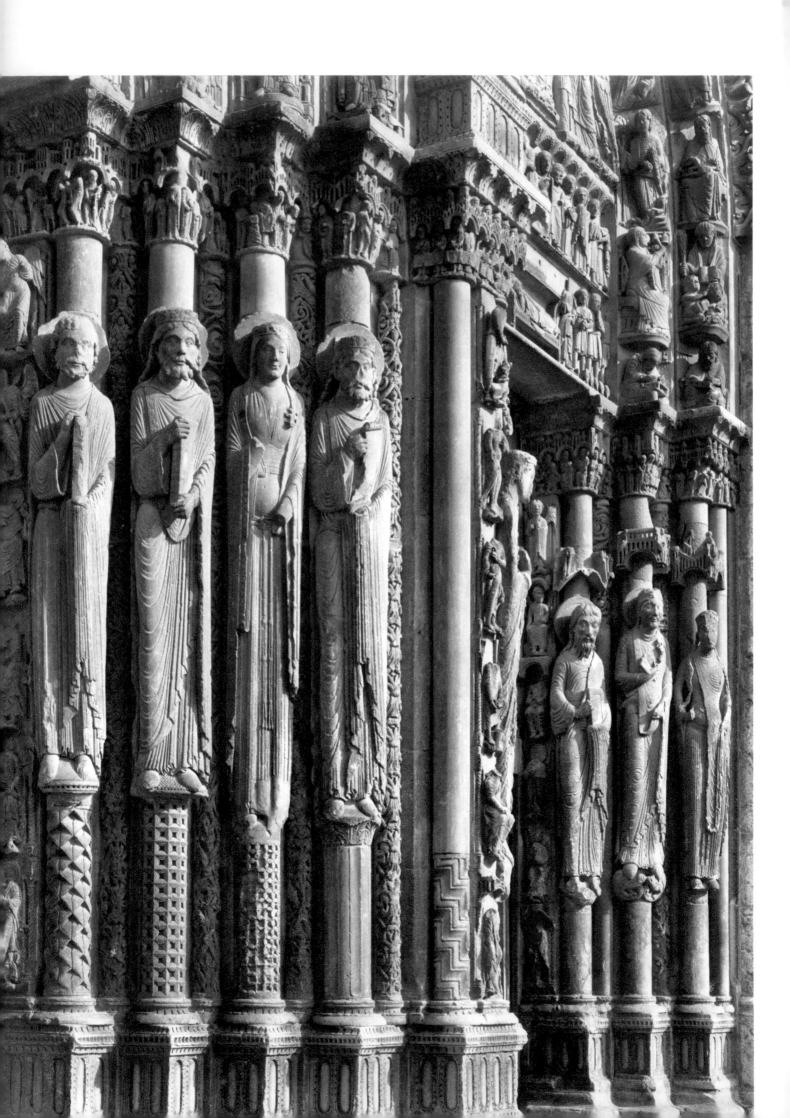

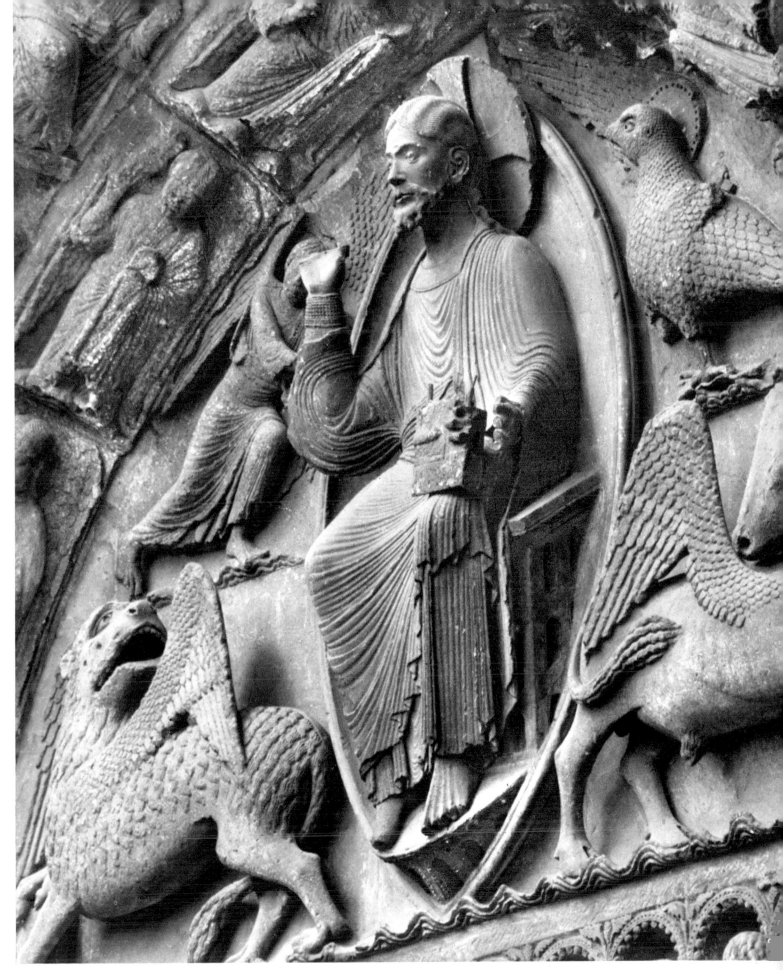

53, 54 CHARTRES (Eure-et-Loir), La cathédrale

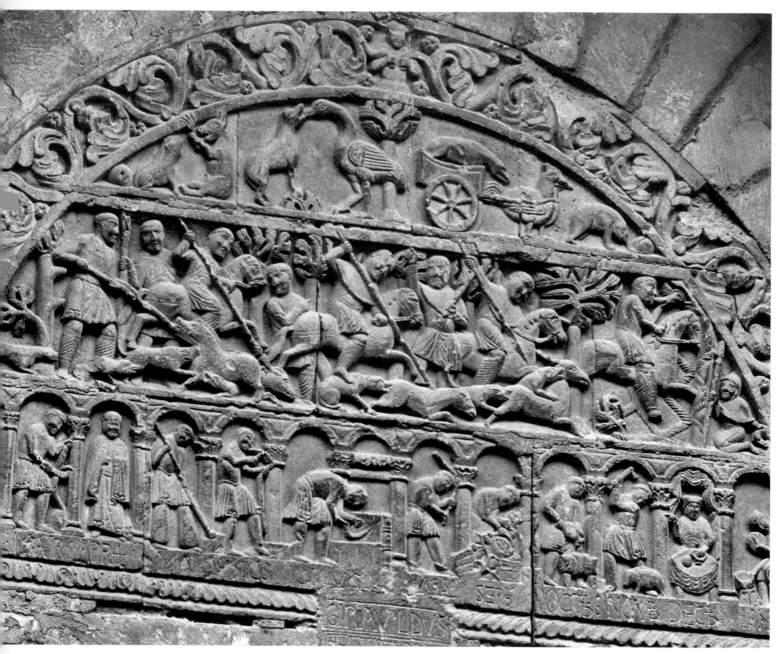

55 BOURGES (Cher), L'église Saint-Ursin

56 BOURGES (Cher), La cathédrale Saint-Etienne

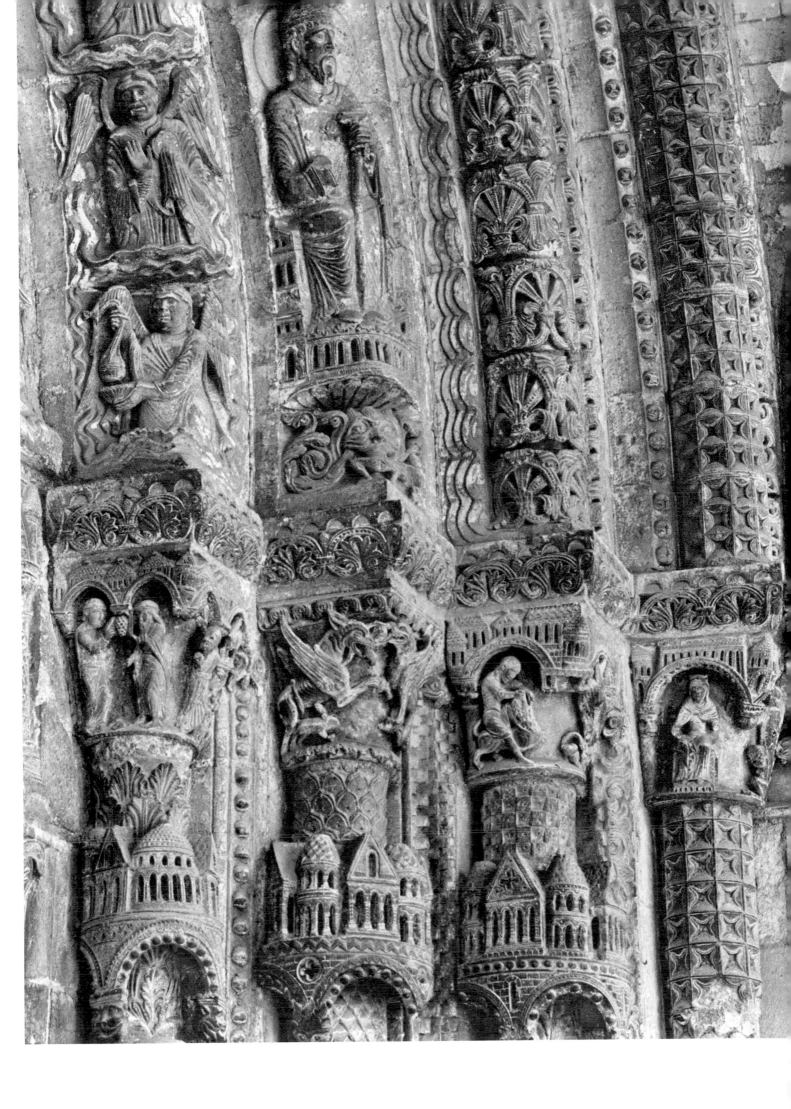

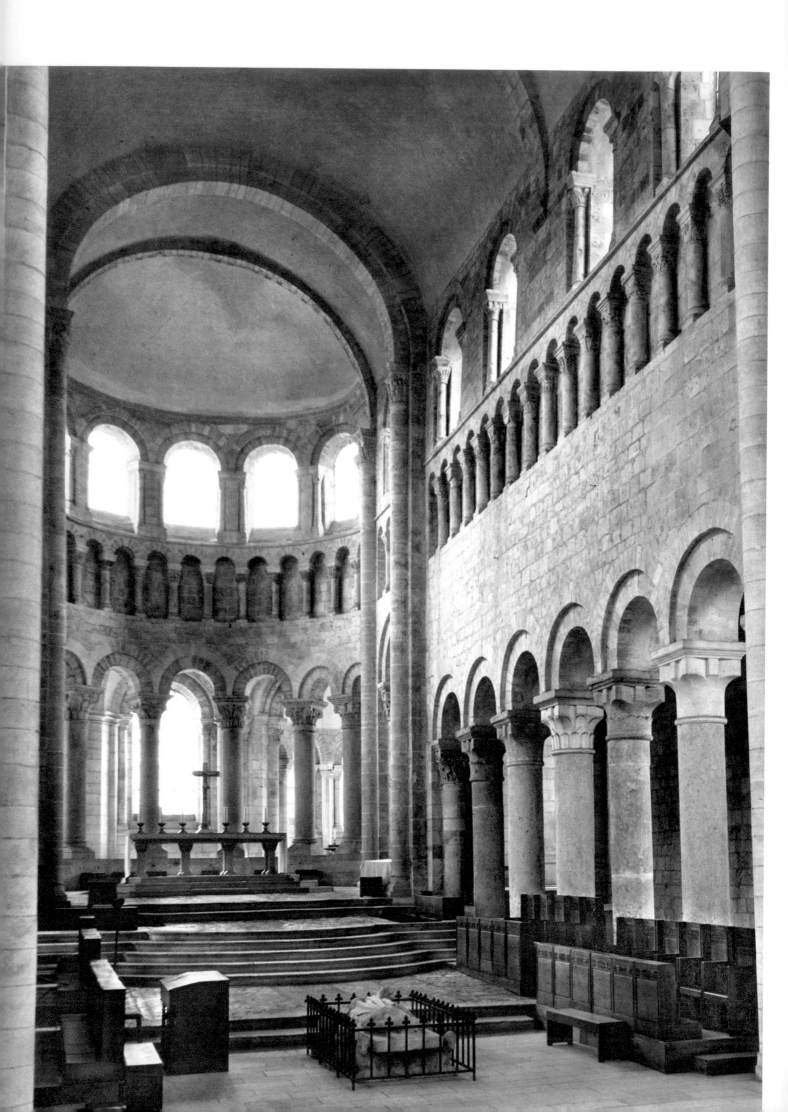

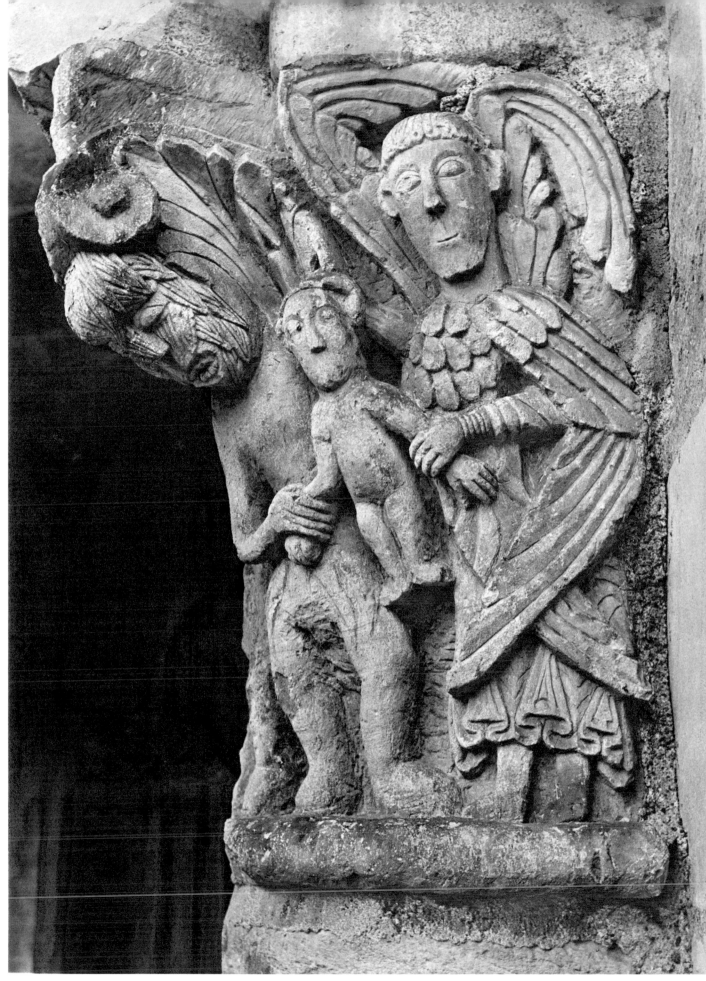

57, 58 ST-BENOIT-SUR-LOIRE (LOIRET), L'église abbatiale

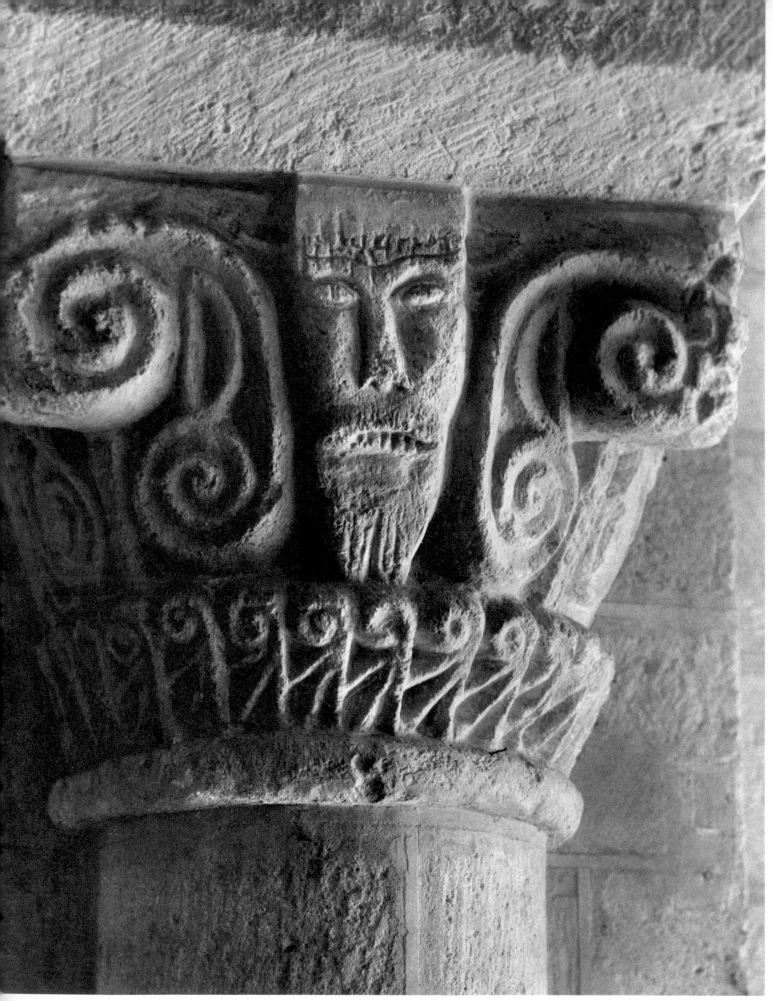

59 MORIENVAL (Oise), Notre-Dame

60 PÉRIGUEUX (Dordogne),
La cathédrale Saint-Front

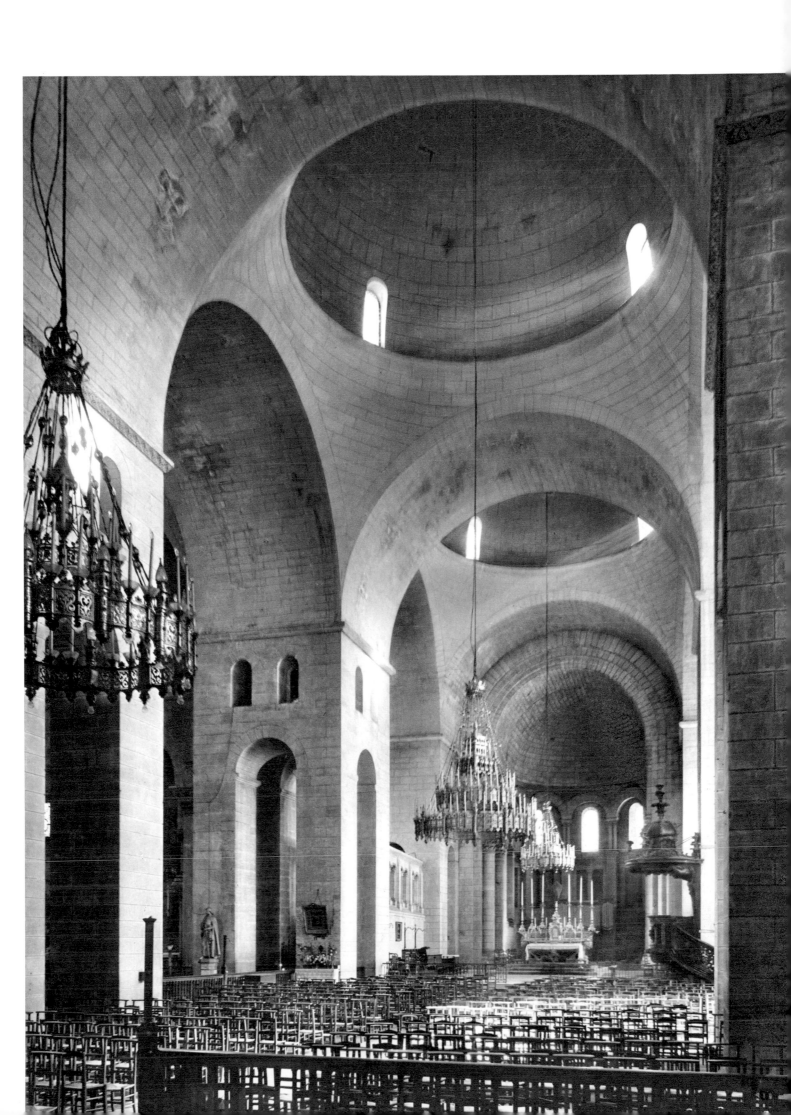

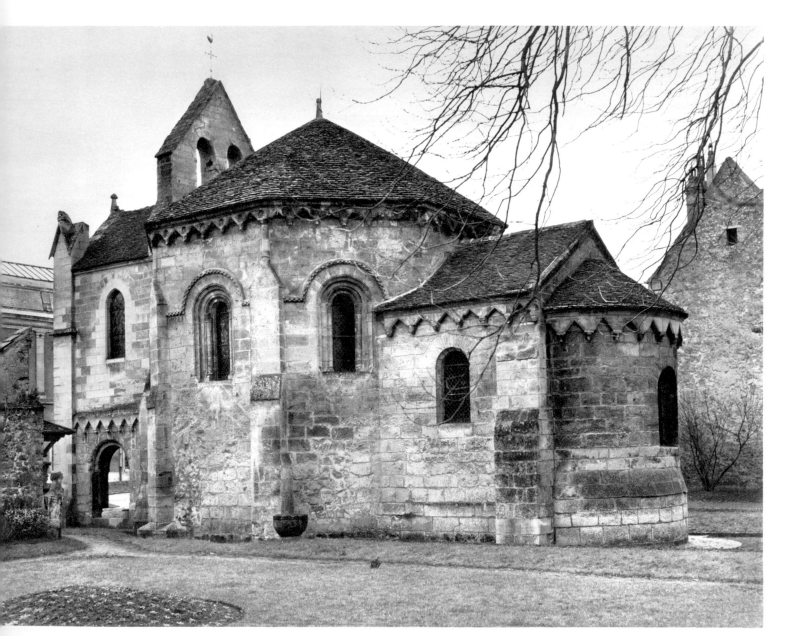

61 LAON (Aisne), La chapelle dite des Templiers

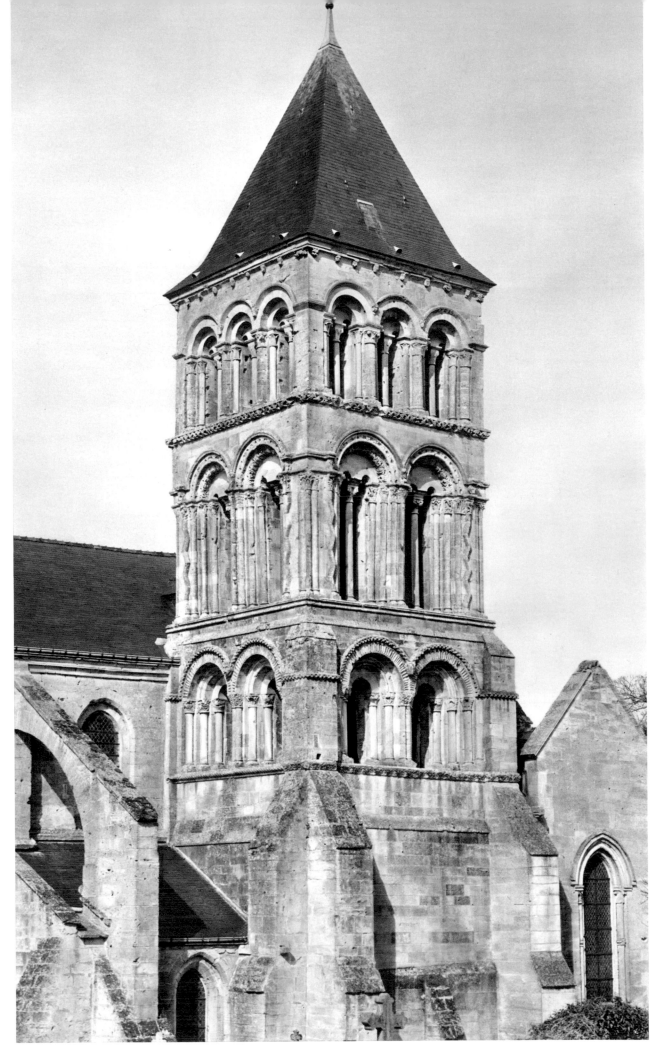

62 NOUVION-LE-VINEUX (Aisne), Le clocher

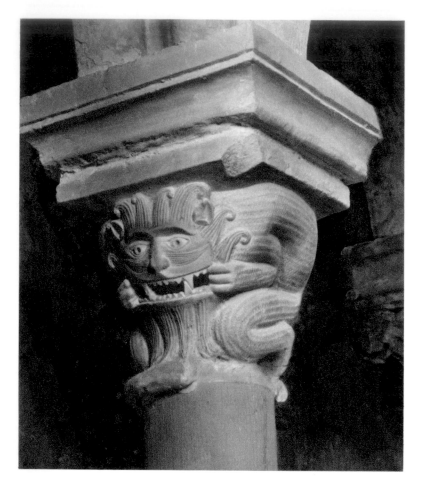

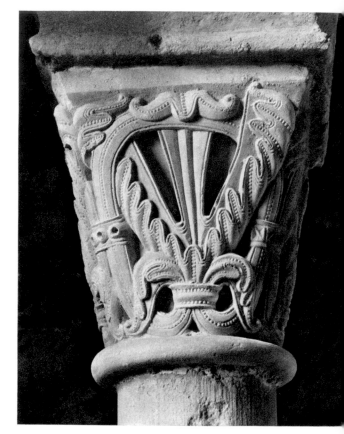

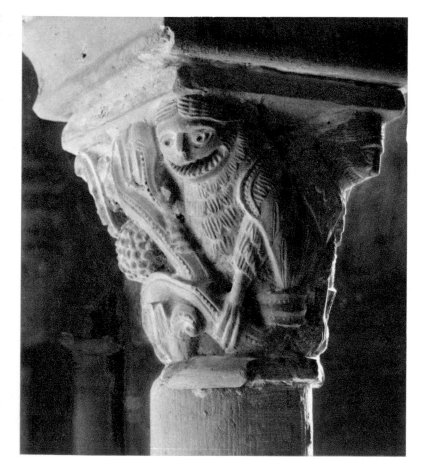

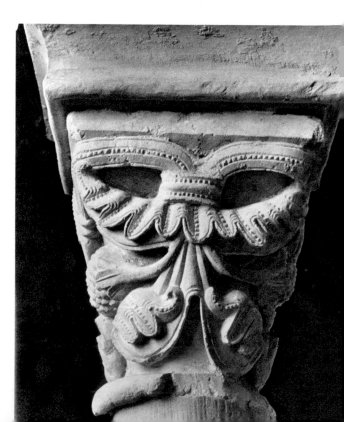

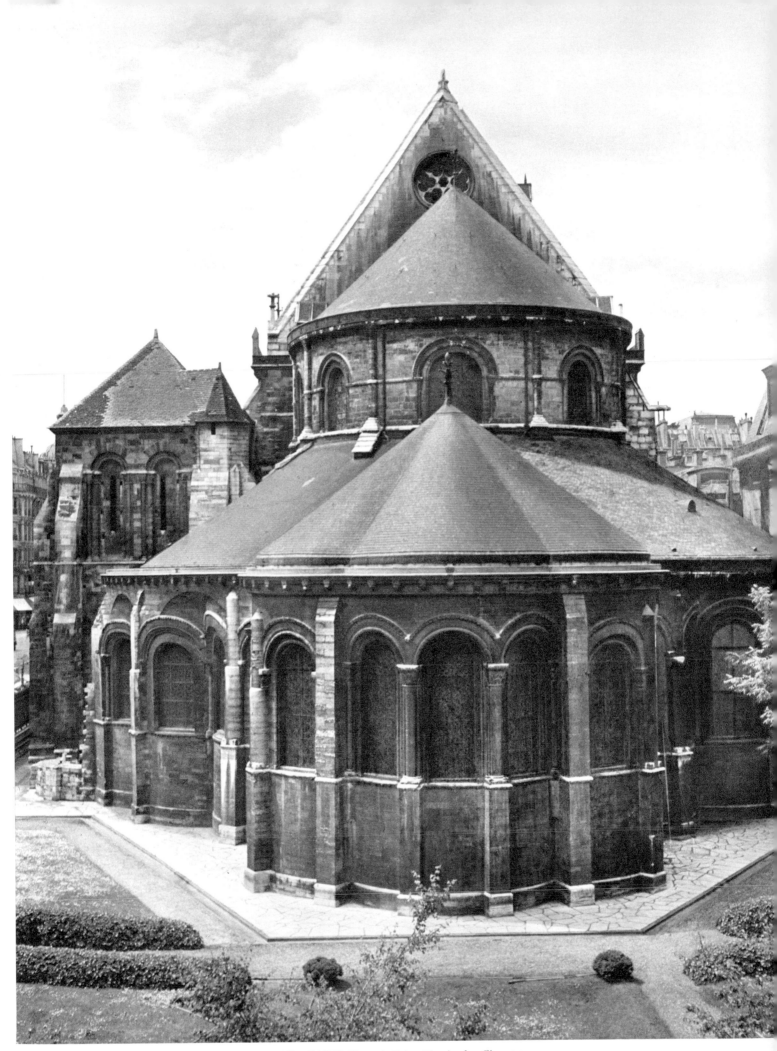

67 PARIS (SEINE), Saint-Martin-des-Champs

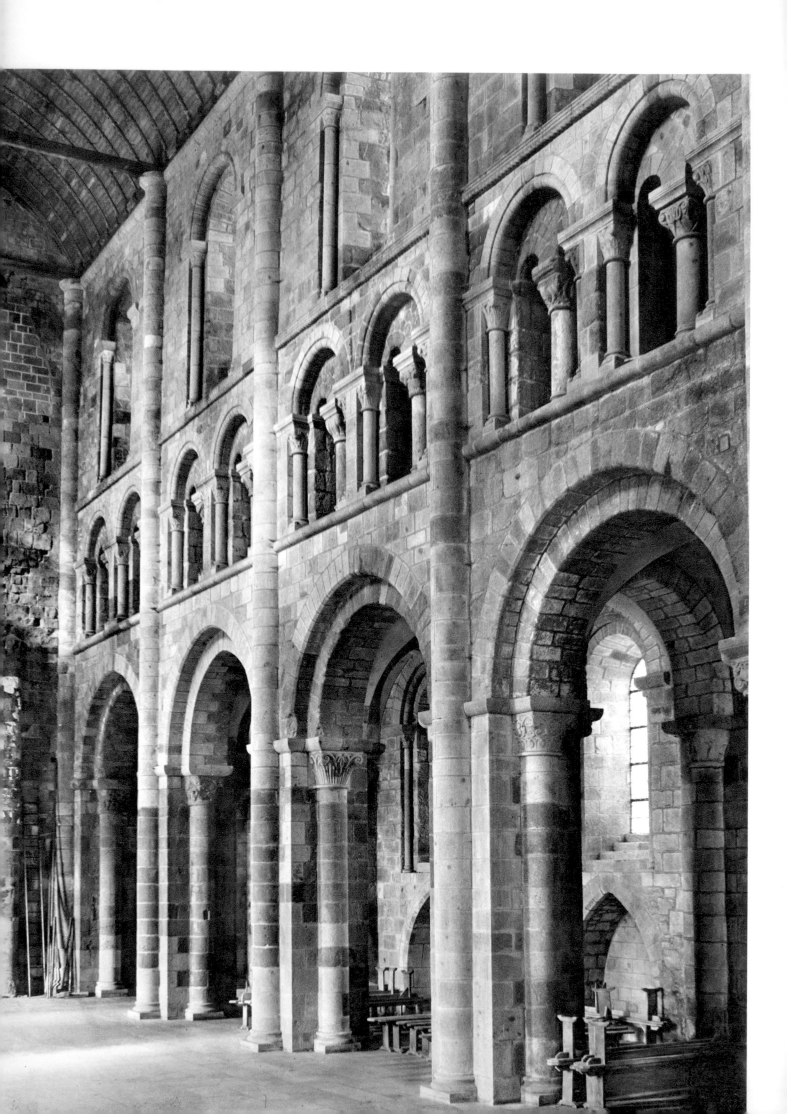

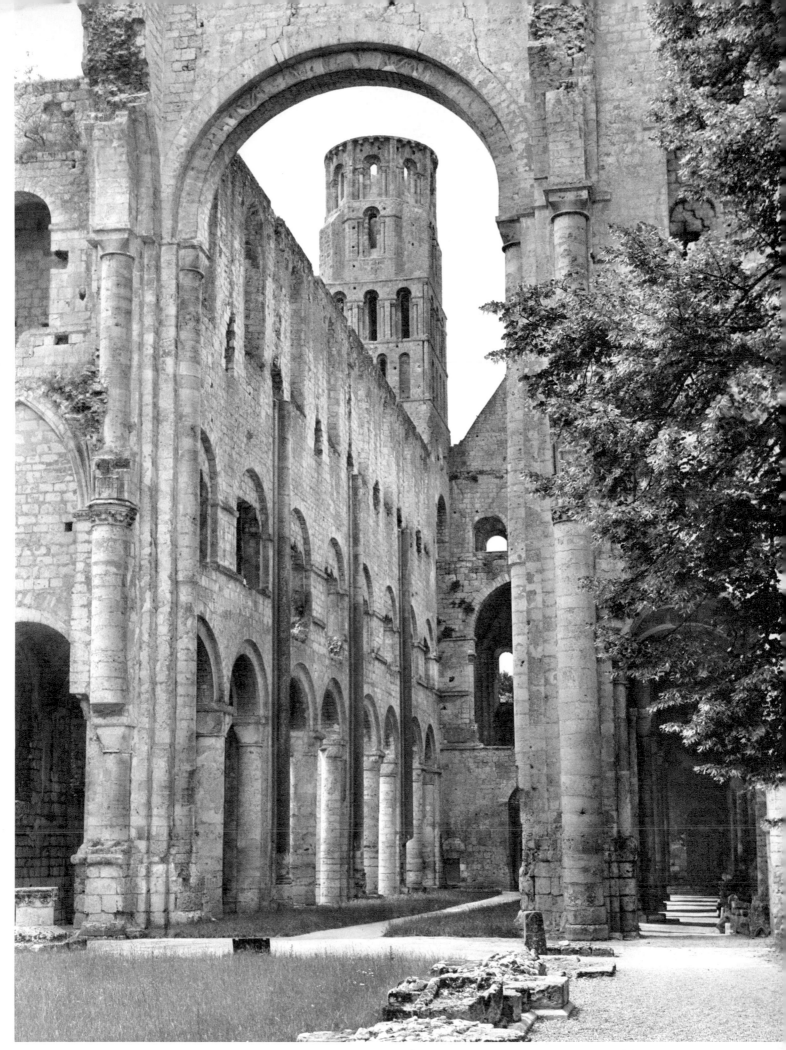

68 MONT ST-MICHEL (Manche), L'église 69 JUMIÈGES (Seine-Maritime), Les ruines de l'abbaye Notre-Dame

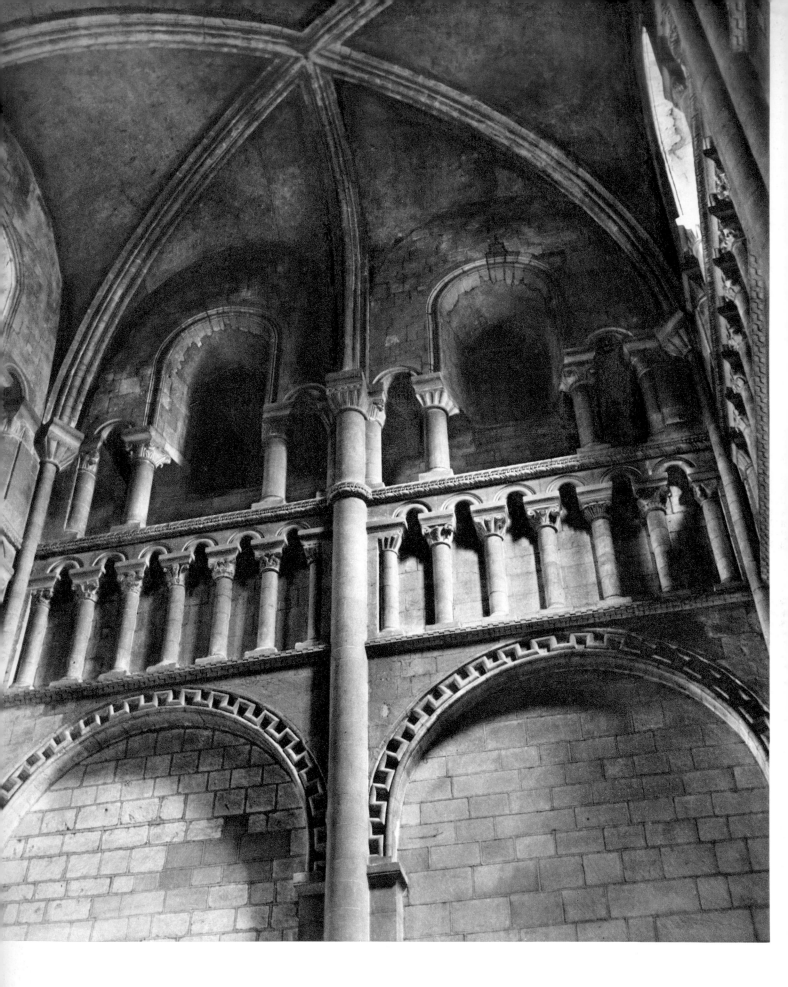

70 CAEN (Calvados), La Trinité 71 LE MANS (Sarthe), La cathédrale

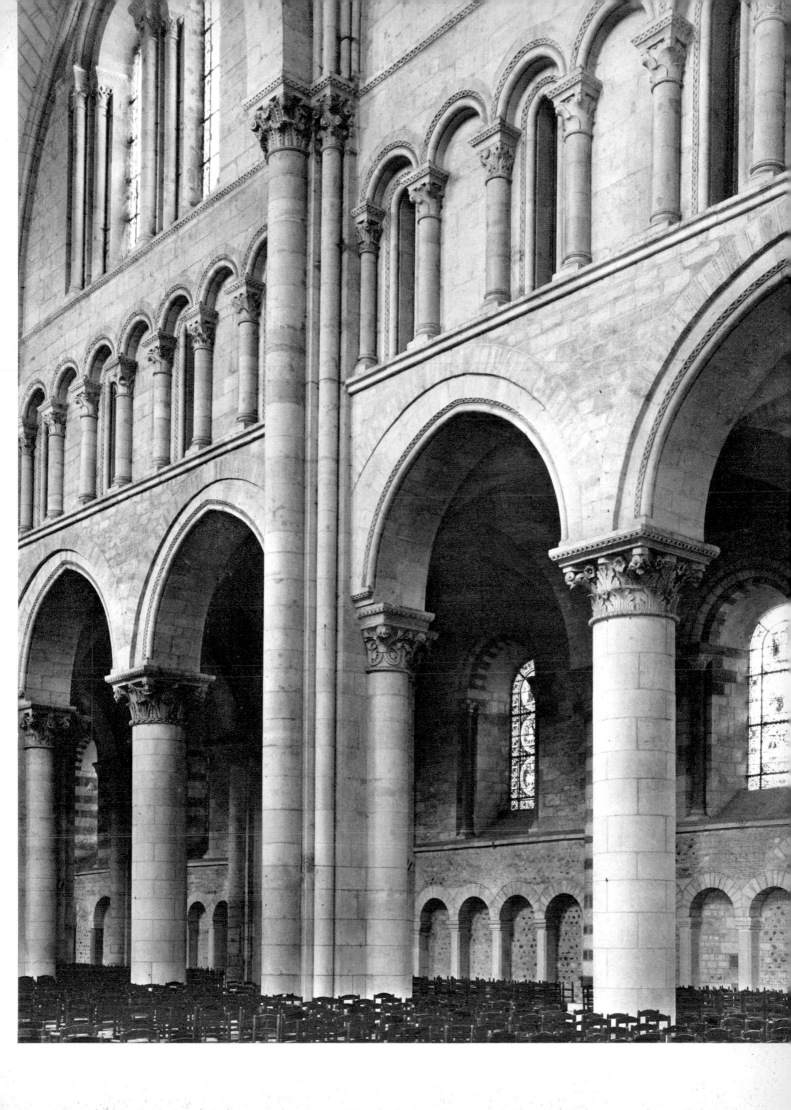

72 MURBACH (Haut-Rhin), L'église abbatiale

SPAIN

It is undeniable that Romanesque art is richest, most varied, and of the highest artistic quality in France. And yet there seems to be no end to the quantity and variety of Romanesque art in north-ern Spain; nowhere else is the impact of Islam on Christendom quite so apparent. The history of Spain from the eighth century onwards was one of almost continuous struggle against the Moors; at first the only Christian stronghold was Asturias, in the north-west corner, where Visi-gothic traditions were maintained; gradually the rest of northern Spain was reconquered. Navarre and Catalonia were included in the Carolingian Empire, and Catalonia continued to be connect-ed politically with France until the mid-eleventh century. The Kingdom of Asturias, with its capital at Oviedo, became the Kingdom of León in 924. Within the next century, Castile was annexed. In the north-eastern corner, the Kingdoms of Navarre and Aragon bordered on the Pyrenees; the County of Barcelona, or Catalonia, lay furthest east. Here the outstanding achieve-ments of early Romanesque art in Spain rose, under the influence of ideas from Italy. Santa Maria de Ripoll and San Pedro de Roda *(pl. 73)* were the first buildings in the Lombard style in Spain. By the end of the twelfth century, Catalonia was part of the Kingdom of Aragon; by then also over half the peninsula had been recovered for Christianity. Despite their military and political antagonism, the culture of the Christian kingdoms was profoundly permeated with that of Islam: Catalan monasteries were noted for their sympathy for Cordovan scholarship.

Thus during the early Middle Ages Spain was an amalgam of provinces with differing tra-ditions and concerns: Catalonia had relatively little in common with the Kingdoms of León and Castile. Within the art of certain small regions stylistic similarities can be distinguished: the district of Pamplona, for example, produced distinctive church porches, carved in very shallow relief re-miniscent of metalwork. Within Catalonia, striking differences are due to the change of ideas with the passage of time. There is a great difference between the interior of the collegiate church of San Vicente de Cardona *(pl. 75)*, a plain basilica in which completely unadorned pillars support a tunnel vault with transverse arches above the nave while the lofty, narrow side aisles are groin vault-ed, and the interior of Lérida Cathedral *(pl. 82)*, another basilica, but with rib vaults supported by thick compound piers with many attached shafts and carved capitals. The interval of time be-tween the construction of the two buildings was considerable: San Vicente, consecrated in 1040, is a distinctly progressive building for its time, and shows signs of strong influences from Aquitaine; the cathedral of Lérida on the other hand was begun in 1203 and the use of rib vaulting allowed

the creation of a spacious interior. But the fundamental difference between the two lies in the purely architectural conception of the former and – if the term may be used of a building – the plastic conception of the latter. The bundles of shafts at Lérida are basically the products of a sculptor's imagination and are set off by a quite deliberate restraint in the capitals, where that imagination would normally express itself most flamboyantly. It was on porches that the famous Late Romanesque Lérida school of sculpture chose to concentrate, producing such lavishly ornamented works as the portal of Lérida Cathedral itself *(pl. 84)*.

A further contrast is offered between the crypt of San Salvador at Leyre in Navarre *(pl. 87)*, which was probably consecrated in 1057, and the ground storey of the Panteón de los Reyes at San Isidoro in León, of almost the same date (1054–67, *pl. 93*). At Leyre thin, stubby shafts support wide capitals that are huge by comparison, and from which spring massive arches bearing the heavy tunnel vaults. The balance is too top-heavy for comfort, like a cave in the *Arabian Nights* – an impression reinforced by the masonry, large blocks of roughly-finished stone. In León, on the other hand, instead of a top-heavy balancing feat there is a balanced elevation, and though the room is low it gives no sense of weight and effort. This small chapel, built as the burial place for the kings of León, is the setting for a lavish display of sculpture and painting. The capitals, richly and extremely skilfully carved, show an awareness of Roman and Early Christian motifs and are the first examples of Romanesque sculpture in Spain – in fact the chapel as a whole, with its domical groin vaults, is more advanced than any French work of the same time. The wealth of ornament on the capitals was taken up, some hundred years later, by painted scenes from the life of Christ on the vaults, separated by luxuriant trails of foliage which echo the carved leaves above the capitals.

The masterpiece of the High Romanesque style in Spain is in Galicia: the cathedral of Santiago de Compostela *(pl. 95, 96)*. Standing at the end of the *Camino francés*, it is the classic 'pilgrimage church', in the same family as Conques and Saint-Sernin at Toulouse in south-western France. Like them, it is remarkable for its sculpture as well as for its architecture, sculpture which culminates in the Pórtico de la Gloria *(pl. 96)*. Whereas the other great doorway of Santiago, the Puerta de las Platerías, influenced sculptors as far away as Britain, the Pórtico de la Gloria is itself strongly reminiscent of France. Begun about twenty years after Chartres, it makes use of the new feature of figures attached to columns in the jambs, but here the figures are already more massive and their poses more varied.

The Romanesque period was a time of instability in Spain. On his deathbed in 1065, Ferdinand I of Castile divided the territories which he had inherited or acquired between his three sons and two daughters. The result was not only continuous changes of ownership, as the heirs argued over their possessions, but actual civil wars. In the parts of Spain under Muslim rule the inheritance of the Umayyads was broken up into small areas which warred against each other and within themselves. Again and again conflicts between Christian rulers and conflicts between Muslim rulers took a more savage form than did the wars where a common religion allied Christians against Muslims. There was in fact a considerable and fruitful exchange of ideas between the two groups, and the influence of this on Spanish Romanesque art is clear.

Romanesque art in Spain continually shows traces of Islamic influence, sometimes uncon-scious – as perhaps in the static balancing act of the Leyre crypt – and sometimes obvious. It is hard to imagine a more astonishing effect than that made by the pure Islamic vault with intersect-ing ribs in the shape of a star, which roofs over the Chapel of the Holy Sepulchre at Torres del Río in Navarre *(pl. 88)*. This chapel lay on one of the high roads of Christianity, the pilgrimage route to Santiago. The transformation of the Moorish style into the Romanesque can be seen in the porch of the church of San Román at Cirauqui *(pl. 89)*, also in Navarre and also on the *Camino francés*. The influence of Islamic metalwork on the shallow relief carving and the large number of patterns around the arch is evident; the monogram of Christ is placed at the apex of an arch com-posed of zigzags, evenly spaced indentations and lobed projections with linear ornament some-times closely resembling Arabic calligraphy, an extreme example of Spanish dualism. There is a final example in the cloisters of the monastery of San Juan de la Peña, partly cut out of the living rock in the mountains of Aragon. The entrance is through a small opening under a Moorish horseshoe-shaped arch *(pl. 85)*. And yet this very monastery was a place of refuge for Christians fleeing from Mohammedan oppression. It does not entirely explain the motivation for such works to say that they were executed by Muslims living within the Christian community, whose style is referred to by the term *Mudéjar*. It would be extremely interesting to know what was in the minds of the Christians who commissioned the work, who had a chapel dedicated to the Holy Sepul-chre vaulted in the style of an Islamic shrine. We cannot know, but they must have looked on the Infidel form as being in some way 'baptized'.

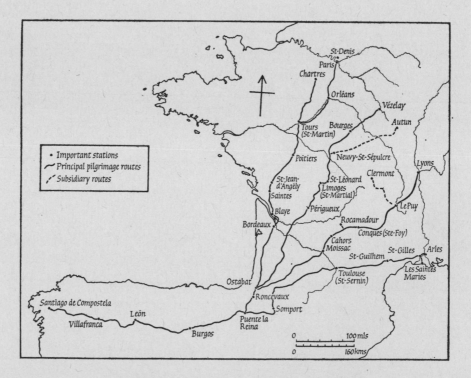

The pilgrimage roads from France to Santiago de Compostela

73 SAN PEDRO DE RODA (GERONA). The priory, first re-
corded in the 9th century, grew to importance under a
rich patron named Tassi. After he had obtained its in-
dependence from Louis IV of France in 945, he had
the monastery rebuilt at his own expense. The new
church was consecrated in 1022. If the ruins are indeed
those of the early 11th-century building, their impor-
tance is outstanding. The plan includes a nave and
aisles, projecting transept, and three round apses. Of
these, the central one is surrounded by an early form of
ambulatory, without radiating chapels but rising to a
gallery. There is a vaulted crypt below the apse and a
narthex-like structure at the west end. The ruins stand
in complete isolation, overlooking the Mediterranean.

74 MONTBUI (BARCELONA), SANTA MARIA. *South aisle
looking east.* Like San Pedro de Roda, this church shows
the effect of the impact of the Early Romanesque style
on the artistic traditions which prevailed before 1000.
The history of the building (made known by the ex-
cellent study of Mgr. E. Junyent), reflects the age dur-
ing which it was being built, the continual struggle to
reconquer and resettle which the Catalan people
waged against the power of Islam. After many vicis-
situdes the church, begun after 985, was completed in
1032. The oldest part of the building consists of most
of the nave and aisles, which are characterized by ir-
regular masonry, primitive capitals and bases, and
slightly stilted arches and vaults. The east end with its
three apses and the western end of the nave and aisles
date from the later part of the building period, towards
1032. Our illustration shows the awkward transition
which occurs between the earlier vaulting of the main
body of the church and the lower vaults of the apse.

75 CARDONA CASTLE (BARCELONA), SAN VICENTE.
Interior. This, the most perfect example of Early Ro-
manesque art in the south, was begun before 1029 and
consecrated in 1040. The great basilica, with nave and
aisles, and a non-projecting transept off which three
eastern apses open, shows considerable advances in
building techniques. The nave is roofed by a tunnel
vault resting on transverse arches, while in the side
aisles there are three groin vaults for every bay of the
nave. The crossing is covered by a dome on squinches.

76 TAHULL (LÉRIDA), SAN CLEMENTE AND SANTA
MARIA. Tahull lies in the mountains. Its two churches,
which contain the richest and most beautiful ensemble
of wallpaintings in all Catalonia, were consecrated
within a day of each other, on December 10 and 11

1123; they were already somewhat old-fashioned for
that date. While Santa Maria was drastically altered,
San Clemente (on the left) has retained its original
character. It has a nave and aisles, covered by an open
timber roof. The east end is more sophisticated, and
its three apses are decorated with arches and applied
shafts. The tall, well-proportioned belfry, which
stands to one side of the church, is a close copy of a
Lombard campanile.

77 BESALÚ (GERONA), SAN PEDRO. *Capitals in the am-
bulatory.* The 12th-century church of the former Bene-
dictine monastery of San Pedro has an ambulatory
with radiating apsidal niches; its annular vault rests
on four pairs of columns with richly decorated twin-
ned capitals. Corinthian capitals occur, of an advanced
kind, and there are also representations of such Gospel
stories as the Flight into Egypt, the dream and journey
of the Magi, their visit to Herod and the Massacre of
the Innocents.

78 GERONA CATHEDRAL. *Relief in the cloisters.* The
cloisters date for the most part from the second half of
the 12th century. The piers of the south walk are de-
corated with friezes illustrating the Book of Genesis,
from the creation of Eve to the story of Jacob. The
depiction of Jacob's struggle with the angel is of parti-
cular interest, since it combines two separate episodes of
Jacob's life (Genesis 28, 10–15 and 32, 23–33). At the
foot of the relief we see Jacob with his head on a stone
dreaming of the ladder up to heaven, and above we see
him wrestling with the angel. The sculptor has brought
together the two occasions on which God revealed
himself directly to Jacob.

79 RIPOLL (GERONA), SANTA MARIA. *Portal.* Ripoll is
one of the great historical centres of Catalonia, and also
the home of the most significant works of Catalan
Romanesque sculpture. Unfortunately the monastic
buildings themselves were almost entirely rebuilt be-
tween 1885 and 1893. The fire which had destroyed
the church and monastery in 1835 did not spare the
12th-century portal, and its present disintegrating con-
dition gives only a blurred impression of its former
magnificence. The doorway is framed on either side
and above by bands of carving. The whole composi-
tion is dominated by the figure of God surrounded by
the symbols of the four Evangelists, flanked by the an-
gelic choirs and the twenty-four Elders of the Apo-
calypse. Below this in three registers are scenes from
the Old Testament. On either side of the door itself

there are individual figures under arches: on the left King David with his musicians, on the right God the Father with Moses, Aaron, a bishop and a warrior. Animal figures carved along the plinth in medallions or in strong relief complete this splendid composition. The mouldings of the door itself are carved with scenes from the Old Testament and the lives of St. Peter and St. Paul and – on the innermost order – the labours of the months. In the jambs statues (now headless) represent St. Peter and St. Paul.

80 SAN CUGAT DEL VALLÉS (BARCELONA), ABBEY CHURCH. *Exterior from the south-west.* San Cugat del Vallés was a centre of religious life long before the foundation there of an important Benedictine monastery; excavations in the cloister garth in 1927 revealed a small Visigothic church. A programme of complete rebuilding of the abbey began at the start of the Romanesque era and was not completed until the Gothic period. The Romanesque origins of the church are evident in the tower, placed to one side, the transept, which does not project beyond the width of the aisles, and the three polygonal apses.

81 SAN JUAN DE LAS ABADESAS (GERONA). *Deposition group.* This group, called the *Santíssim Misteri,* is the object of widespread veneration. Although it was not consecrated until 1251 it is purely in the Romanesque tradition. It is the latest of a series of similar works, some of which have survived in their entirety while of others only fragments remain.

82, 84 LÉRIDA CATHEDRAL. *Interior of the nave; detail of the south door.* The distinctive effect of the interior is mainly due to the use of enormous piers surrounded by numerous attached shafts *(pl. 82).* The capitals of these shafts show the taste for classical forms which characterizes 13th-century Spanish Romanesque sculpture, and is reminiscent of Italy. The fame of the Lérida school of sculpture rests, however, on the cathedral portals. That of the 'Fillols' leads directly into the middle bay of the south aisle; it is the cathedral's most richly decorated doorway. The quintuple archivolts *(pl. 84)* are covered with geometrical patterns, dogtooth, intersecting semicircles, chevron, rings, and scrolls of foliage. The capitals below are carved with intertwining foliage in which men are caught, along with fantastic creatures such as griffins, mermaids and winged lions.

83 TARRAGONA CATHEDRAL. *East end from the cloister.* The grandeur and complexity of this cathedral reflect its dignity as the see of a metropolitan bishop.

Begun in the Late Romanesque, it was finished in the Early Gothic period. The geometrical severity of the earlier parts of the building is softened by later additions, such as the 13th-century lantern tower lighting the crossing, and the north transept apse, which is a beautiful example of mid-14th century work.

84 See above, plate 82.

85 SAN JUAN DE LA PEÑA (HUESCA). *Cloisters.* The dramatic position of this ancient monastery, in the shadow of an overhanging cliff, made it in the 9th and 10th centuries a refuge for Spanish Christians fleeing from Muslim oppression. Its reputation grew steadily; it was the burial-place of the kings of Navarre and of Aragon. In 1025 Sancho the Great, who united the larger part of the Christian lands of northern Spain under his rule, introduced the Cluniac reform to San Juan de la Peña. Finally a symbolic ceremony on March 22, 1071, celebrated the introduction of the Roman rite in Aragon, which was finally to drive out the Mozarabic liturgy. Although a first subterranean church (now the crypt) dates from the beginning of the 10th century, most of the monastery church was built in the 11th century and consecrated in 1094. The cloisters date from the end of the 12th century, and have been recently restored. They are entered by a doorway with a horseshoe arch which may be contemporary with the earlier Mozarabic buildings. The capitals are clearly the work of a local, peasant workshop, and are delightfully archaic. (In the picture caption, for San Juan de Peña read San Juan de la Peña.)

86 JACA CATHEDRAL (HUESCA). *Capital in the south porch.* Jaca Cathedral marked the introduction of monumental Romanesque art into the Pyrenean region of Aragon. Throughout its construction, from the end of the 11th century to the middle of the 12th, a notable school of sculptors was employed. We can trace the development of their work from the east end along the capitals of the nave to the west portal, and thence to the south portal. The capitals of the portals are particularly fine, the figures carved with supreme ease and grace. One of the most advanced stylistically is in the south porch and shows King David and his musicians.

87 LEYRE (NAVARRA), SAN SALVADOR. *Crypt.* With San Juan de la Peña, this was one of the most important centres of monastic life on the southern slopes of the Pyrenees. For a number of years it was customary to choose the Bishop of Pamplona from among the monks of Leyre; the kings of Navarre showed it special

favour by choosing it as their burial place and sometimes using it as a royal residence. The Cluniac reform was introduced towards the end of the reign of Sancho the Great. The community was at its zenith in the 11th century when the church was rebuilt; it was consecrated in 1057 and 1098. The earlier date seems to apply to the eastern part of the building, consisting of the choir and the spacious crypt, which are characterized by an austere and moving strength. In the crypt enormous capitals rest on fragmentary re-used columns and support massive stilted vaults. The sculpture on the capitals and on the corbel-table of the apse is extremely primitive, both in the choice of forms and decorative motifs, and in the execution.

88 TORRES DEL RÍO (NAVARRA), SANTO SEPULCRO. *Vault.* This unusual octagonal chapel is one of two erected on the pilgrimage road to Compostela, and is evidently connected with the Holy Sepulchre in Jerusalem. The most remarkable thing about it, in addition to its plan, is the obvious influence of Islamic art. This shows itself in the pattern of ribs supporting the dome and in the presence of numerous chip-carved corbels supporting the cornice outside. The church is crowned by an octagonal lantern reminiscent of Hispano-Moresque minarets.

89 CIRAUQUI (NAVARRA), SAN ROMÁN. *Portal.* The hill on which this village stands was a landmark for pilgrims on their way to Compostela. Art and ideas travelled by the same route, and it is to this that the church owes its monumental portal. There is no tympanum; instead the arch framing the door is given lobed projections and indentations which stand out clearly against the opening. In the archivolts plain rolls alternate with bands of geometrical ornament and foliage scrolls.

90 SORIA, SANTO DOMINGO. *Detail of west portal.* The city of Soria in Old Castile, near the Aragonese frontier, was a meeting-point of those currents of Christian and Islamic art which influenced the Romanesque in Castile. The complex structure of Santo Domingo is a result of three building campaigns, stretching from the 12th to the 16th century. The west front is a remarkable architectural composition, showing the influence of western France. In the archivolts episodes from the New Testament are mingled with scenes of the Last Judgment; the innermost order shows the twenty-four Elders of the Apocalypse, and frames a typically Spanish representation of the Trinity, with Christ on the lap of God the Father.

91 AVILA, SAN VICENTE. *The Virgin, on the south portal.* The large and handsome former Benedictine church of San Vicente stands just outside the city walls. It was probably begun about 1109, on the plan of San Isidoro in León and the cathedral of Salamanca. To this first campaign belong the three parallel apses, the transept and the beginning of the nave. Before this section of the nave was vaulted, a new architect took over and gave the building a strong Burgundian flavour, adding a narthex between two west towers. The south door has on its left jamb an Annunciation group of great beauty, of which we illustrate a detail.

92 SEGOVIA, SAN ESTEBÁN. *Portico and tower.* The many Romanesque churches of Segovia were built when the city was reoccupied by Christians after the capture of Toledo. Each is distinctive, but they have in common the feature of a prostyle portico. San Esteban has the finest Romanesque tower in all Segovia, apparently dating from the 13th century. On each face there are five tiers of arcades, each row different from the others in number of arches or in decoration. Next to it is a large portico with a continuous arcade on twin colonnettes.

93 LEÓN, SAN ISIDORO. *Interior of the Panteón de los Reyes.* The collegiate church of San Isidoro is the artistic heart of León, an important city in the Middle Ages, which was one of the main stages on the road to Compostela. The oldest part of the building is the royal chapel-mausoleum, of 1054-67, designed on the model of the tower of Saint-Benoît-sur-Loire. The capitals of the ground floor are of Corinthian type, or bear scenes from the Old and New Testaments; they are the work of accomplished and confident artists. The vaulted ceiling was painted probably under the reign of Ferdinand II (1157-88), and is well preserved: delightfully executed scenes from the life of Jesus stand out on a white ground.

94 ZAMORA CATHEDRAL. *Interior of the crossing dome.* The city of Zamora, on the very frontier of Christendom, began to flourish as the tide of Islam receded, particularly after the recapture of Toledo in 1085. The cathedral was begun in 1151. Its groundplan is that usual in the largest Spanish churches of the period: nave and aisles, and a slightly projecting transept. The central apse and the two smaller flanking apses were replaced by a large choir under the Catholic Kings. As building went on new stylistic elements were incorporated, such as the rib vaulting of the nave, and especially the magnificent *cimborio* over the crossing. This combines the forms of the oriental, Byzantine or Islamic dome,

with its numerous concave segments, and the French rib vault. Its sixteen domed-up severies are framed by sixteen ribs, which meet in the central keystone.

95, 96 SANTIAGO DE COMPOSTELA CATHEDRAL. *Pórtico de la Gloria; interior of the transept.* The famous Pórtico de la Gloria (1168–88) is the work of a sculptor of genius, whose name is known: Master Mateo. His nationality is unknown, but evidently he was well acquainted with most of the major work of his day in Burgundy and Aquitaine, as well as with Saint-Denis and Chartres. Yet he emerges as neither a pupil nor an imitator of France but as a creative artist of great originality, who produced the masterpiece of Spanish Romanesque art. The Pórtico de la Gloria, according to the excellent recent analysis by M. Georges Gaillard, has as its subject the Last Judgment and the Apocalypse. The colossal figure of Christ in the central tympanum is that of the Judge of the World, displaying the stigmata and surrounded by angels bearing the instruments of his Passion; but at the same time we see on either side of the Saviour the symbols of the Evangelists, and in the outermost order of the arch the twenty-four Elders of the Apocalypse stand with vessels and musical instruments in their hands. The scenes usually associated with the Last Judgment, the resurrection of the dead and the separation of the elect from the damned, do not appear on the tympanum; but on the archi-

volts of the right-hand doorway there are allusions to the Last Judgment. The great jamb statues that frame the three doors also combine two different iconographic traditions: here are the prophets, normally found on the earliest Gothic portals and on portals dedicated to the Virgin, side by side with the apostles, who usually appear in connection with the Last Judgment. St. James sits with his pilgrim's staff in front of the trumeau, in the spot often occupied by the patron saint in French churches, beneath a capital showing the Temptation of Christ, and above a column carved with the Tree of Jesse.

The cathedral is the successful culmination of a series of attempts, from Reims to Toulouse, to design a church which would accommodate vast crowds of pilgrims on high feast days, allowing them to move between the many sacred relics without hindrance. The apse is surrounded by an ambulatory, which continues in the form of groin-vaulted aisles right round the broad transept and along the nave. Five chapels radiate from it behind the chancel, and two more extend eastward from each arm of the transept. The high vaults of nave and transept are tunnel vaults, abutted by quadrant vaults over the gallery. As is usual in the pilgrimage churches, the elevation is of two storeys only, arcade and gallery with twin openings. The original design of the church appears particularly clearly in the transept, finished shortly after 1112.

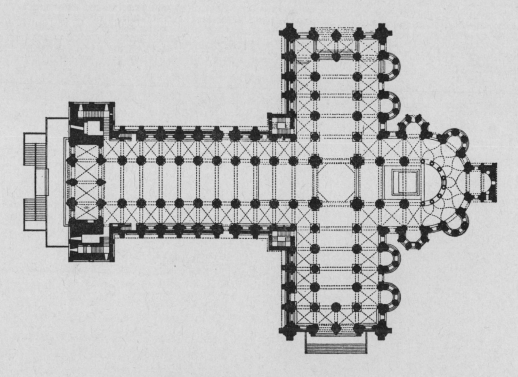

Plan of Santiago de Compostela Cathedral

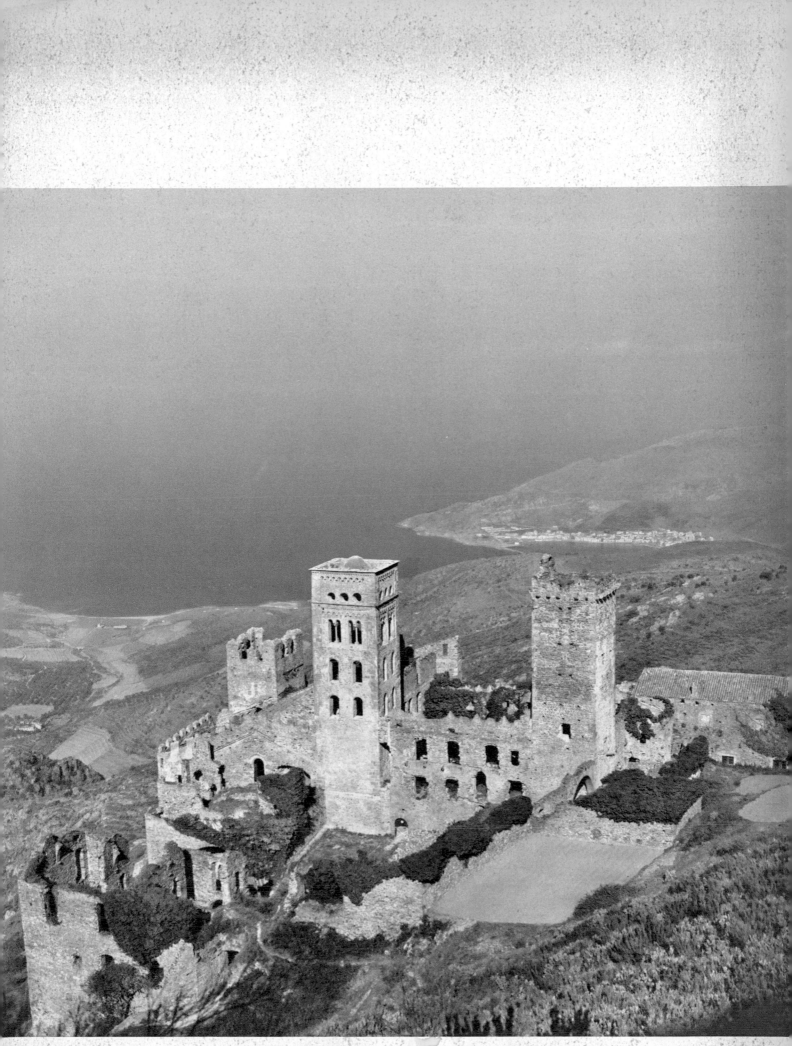

73 SAN PEDRO DE RODA (Gerona), Monasterio

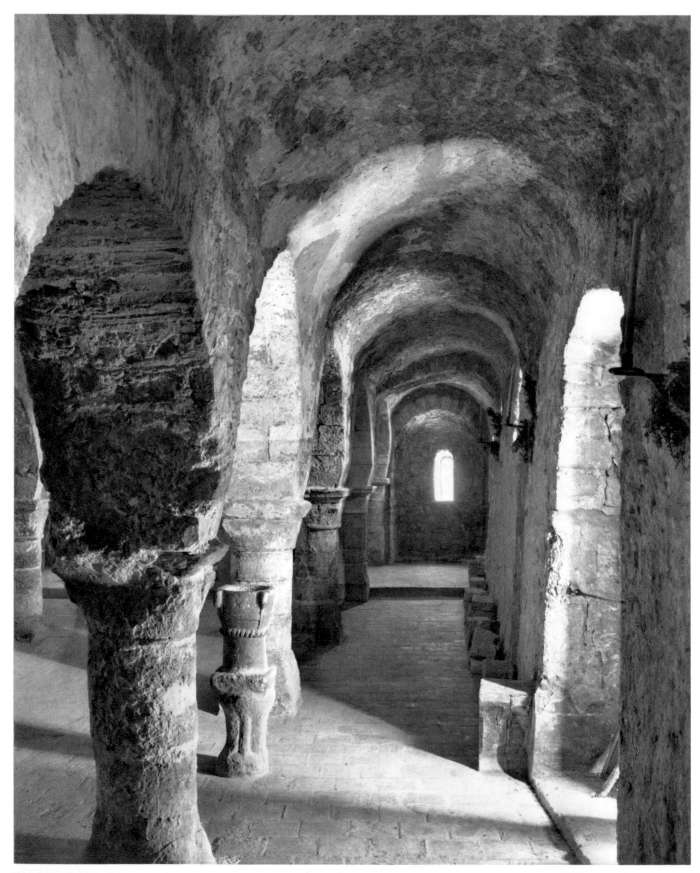

74 MONTBUI (Barcelona),
Iglesia de Santa Maria

75 CARDONA (Barcelona),
Colegiata de San Vicente en el castillo

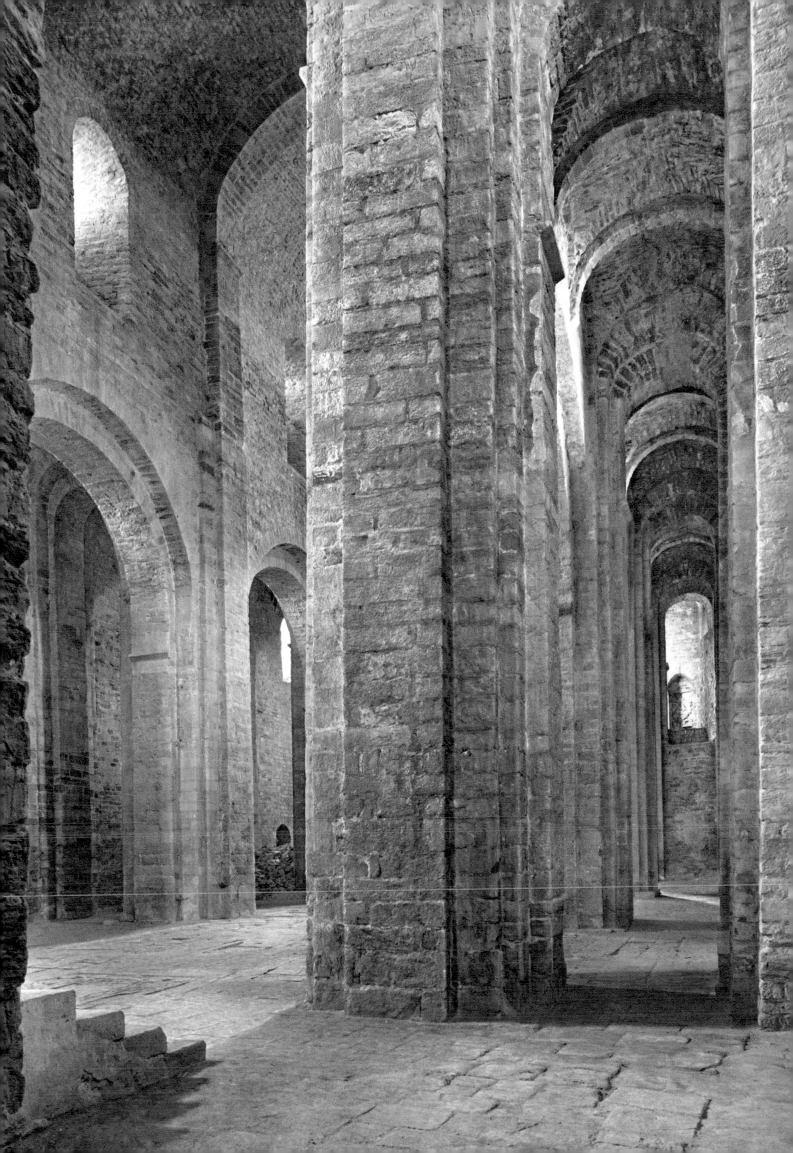

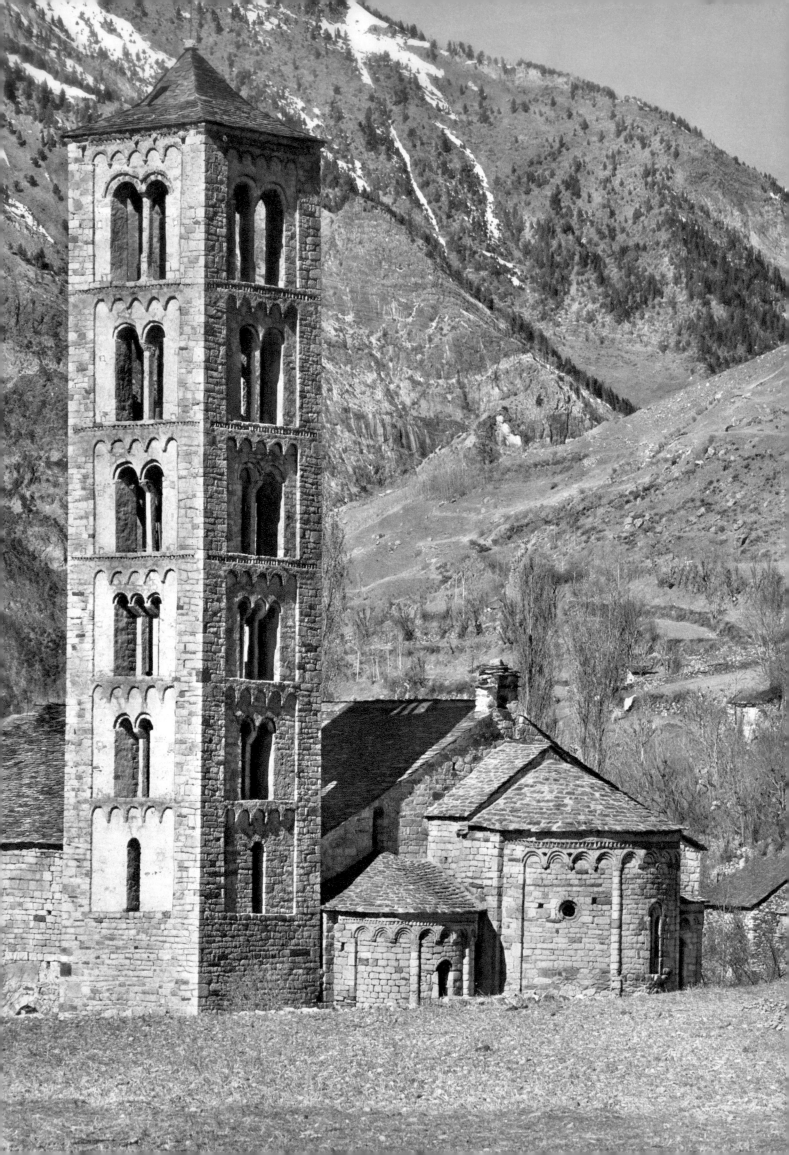

76 TAHULL (Lérida),
Iglesias de San Clemente
y Santa María

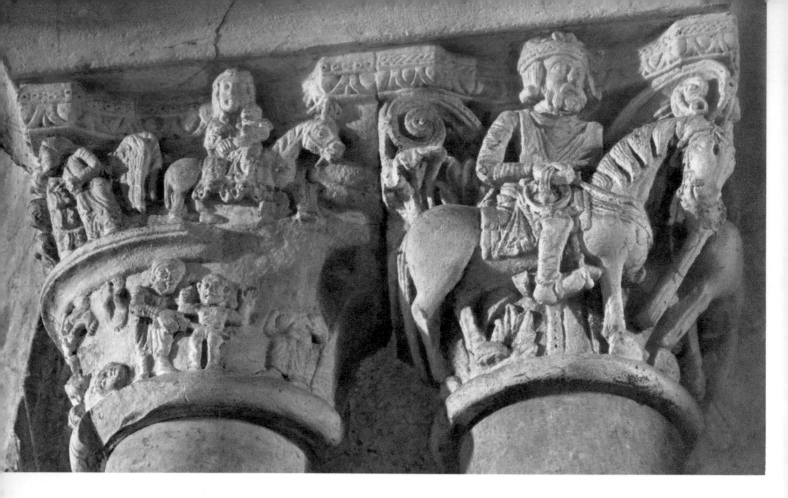

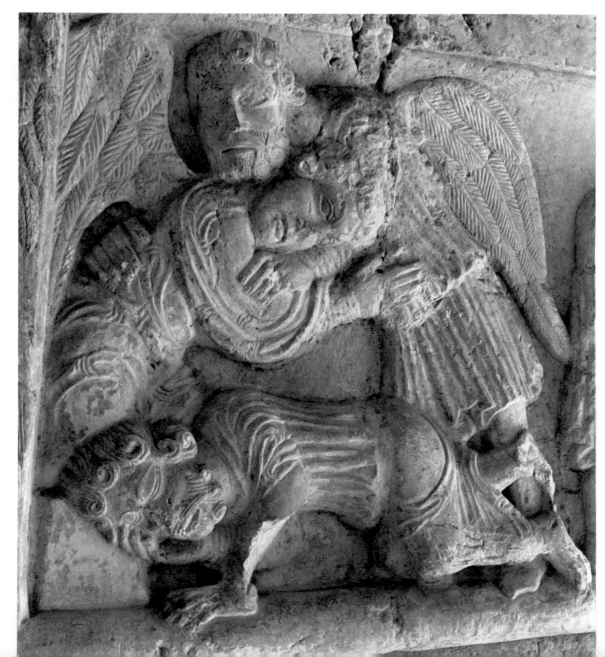

77 BESALÚ (Gerona),
Iglesia de San Pedro

78 GERONA, Catedral

79 RIPOLL (Gerona),
Monasterio de Santa María

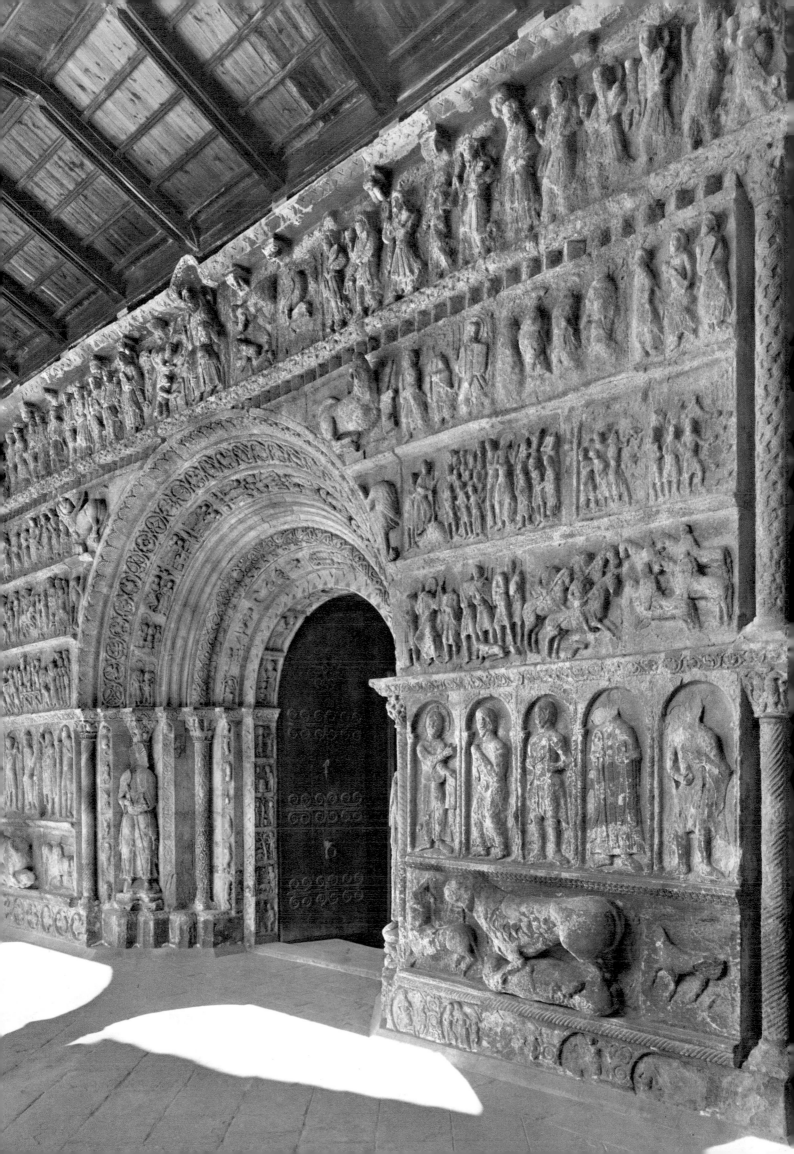

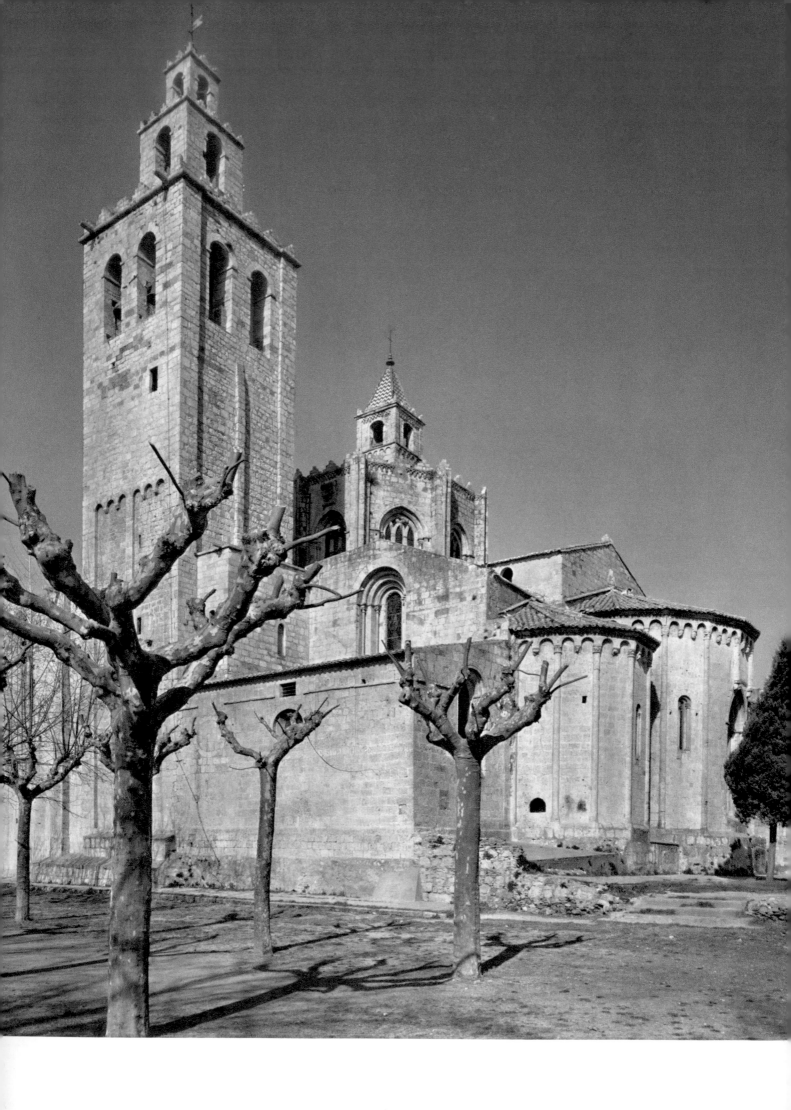

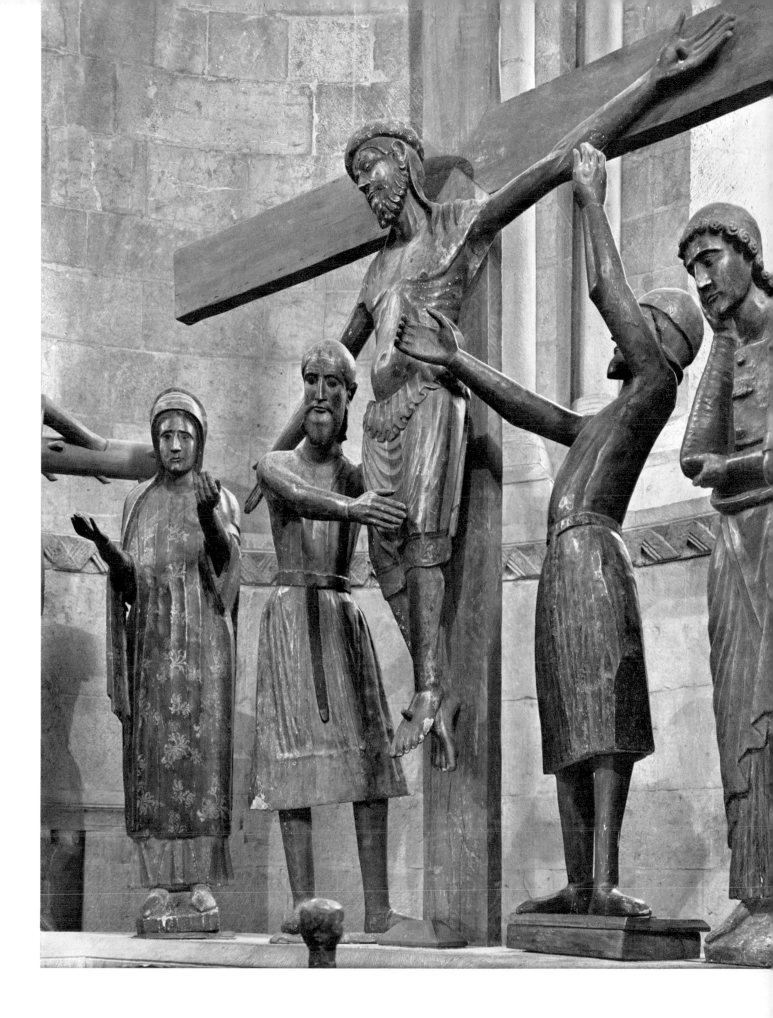

80 SAN CUGAT DEL VALLÉS (Barcelona), Monasterio 81 SAN JUAN DE LAS ABADESAS (Gerona), Monasterio

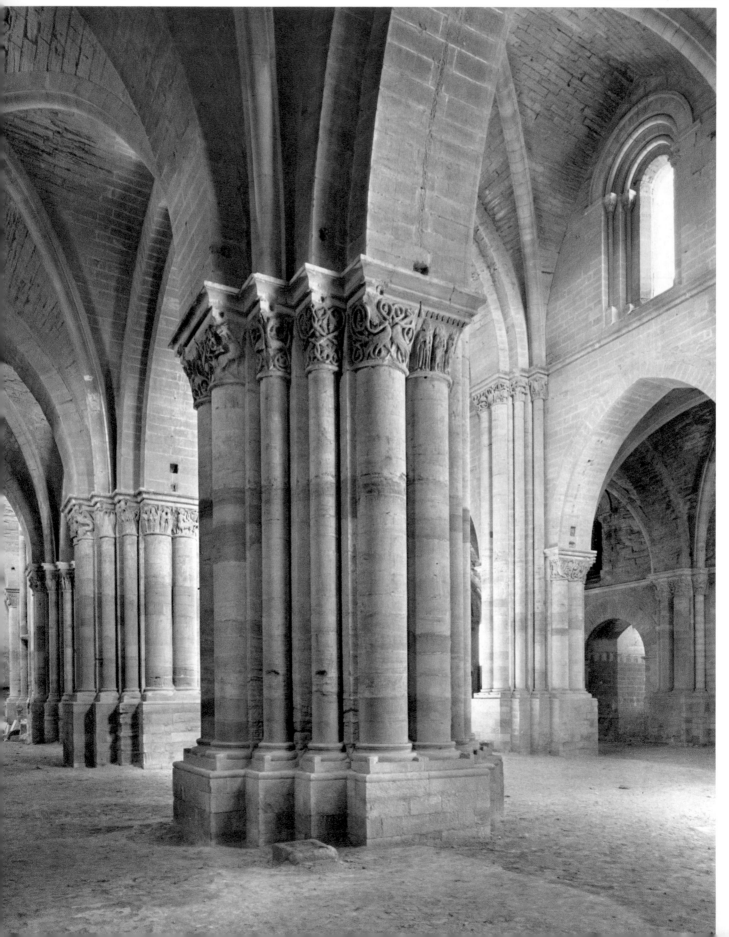

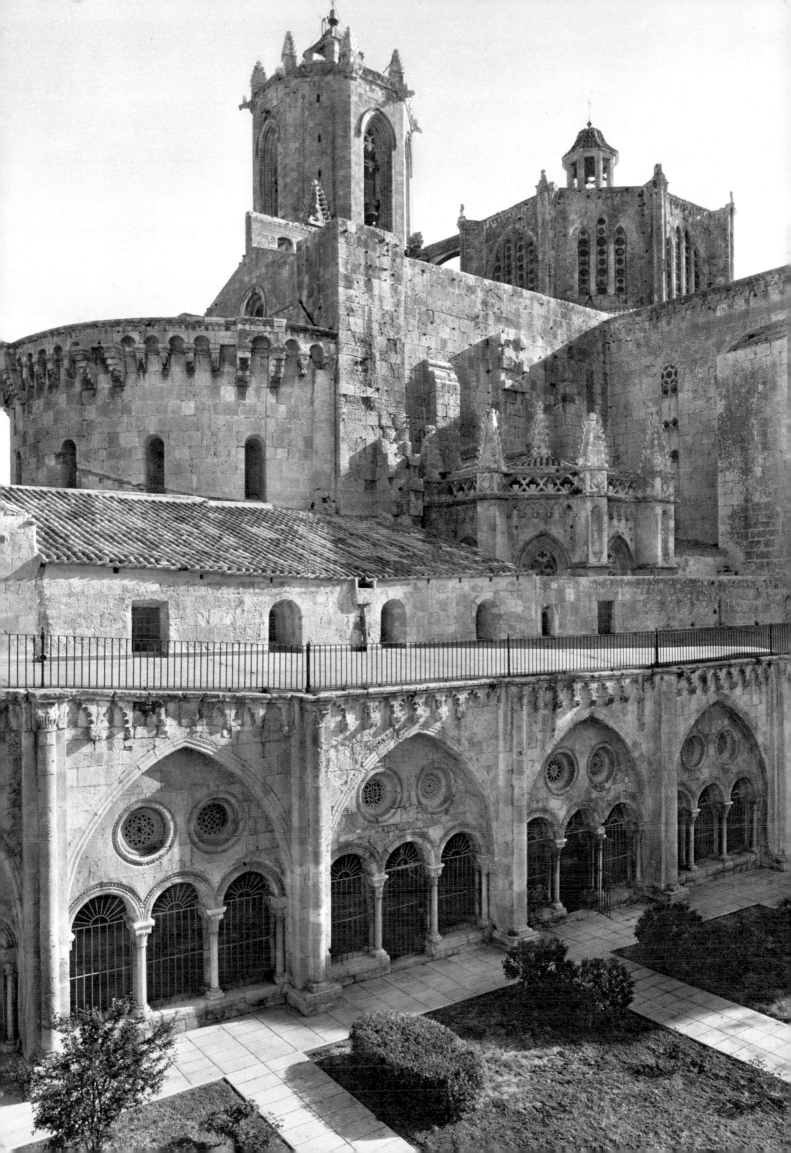

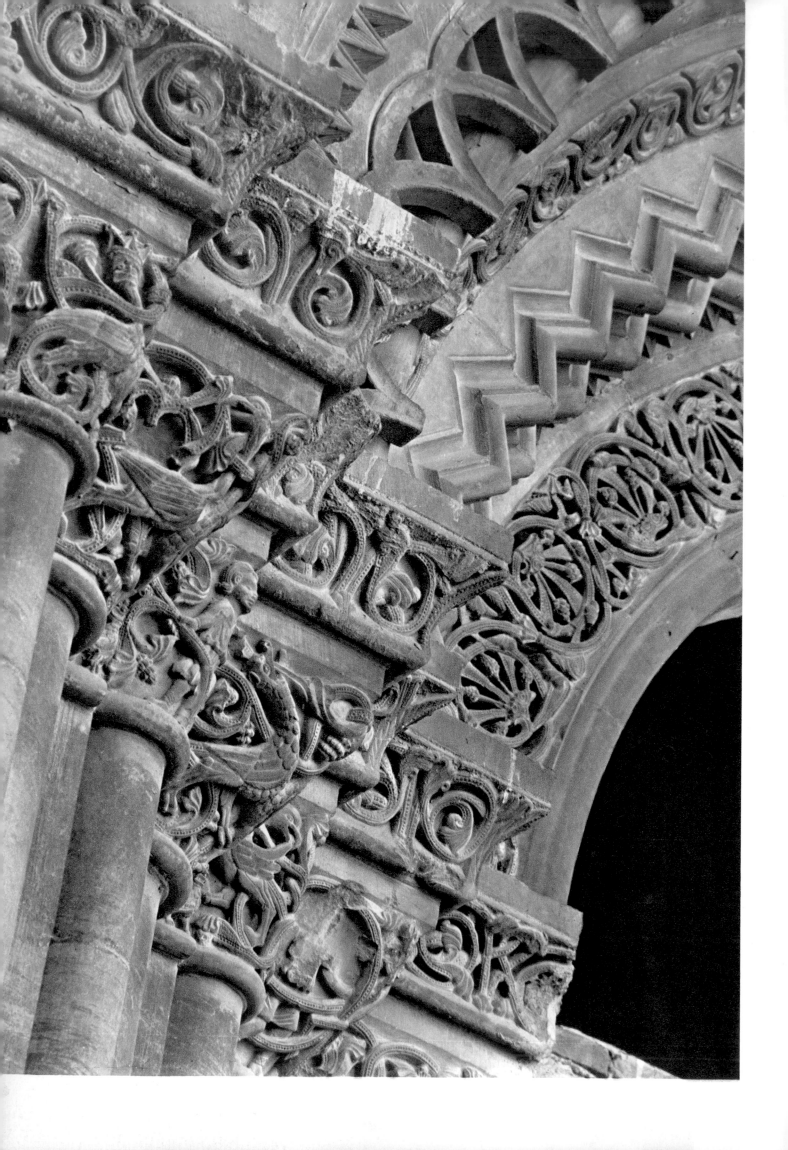

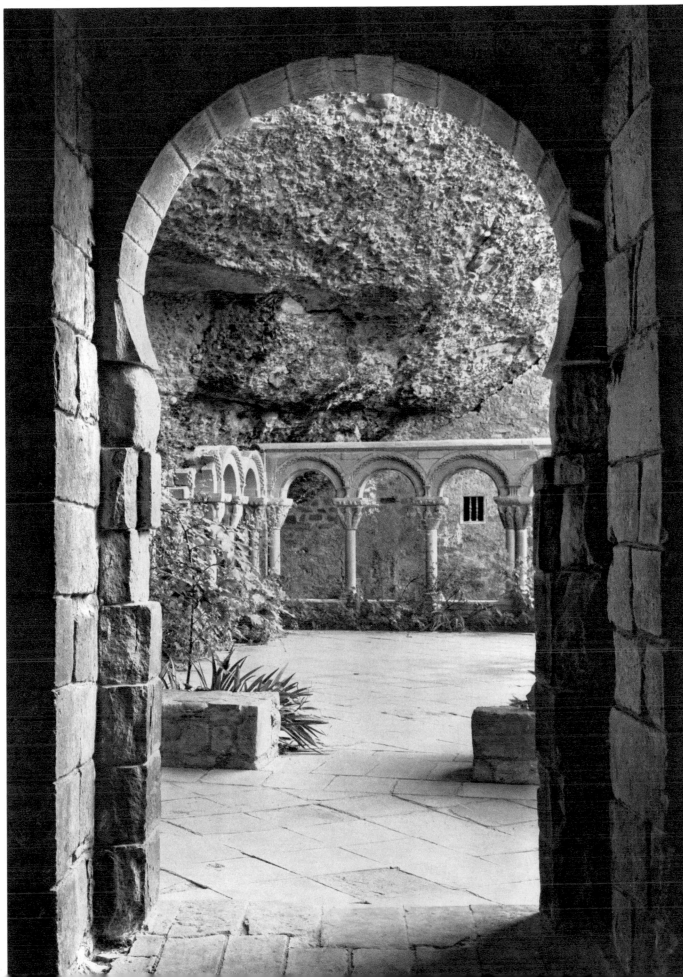

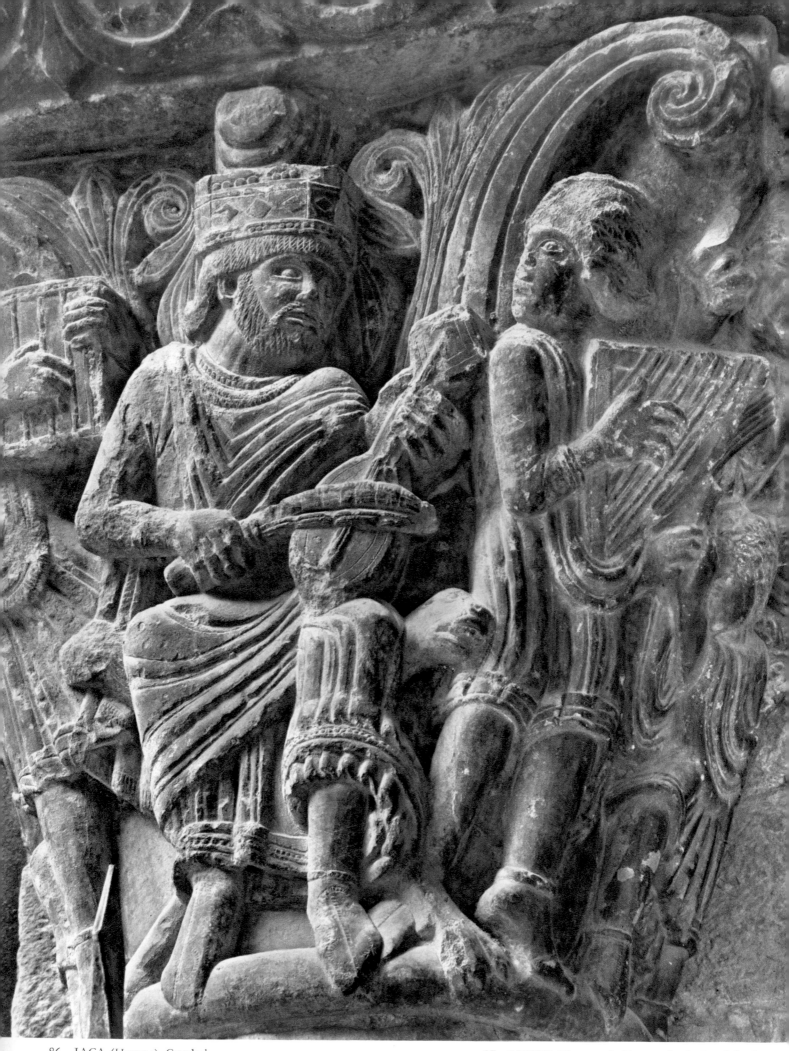

86 JACA (Huesca), Catedral 87 LEYRE (Navarra), Monasterio de San Salvador

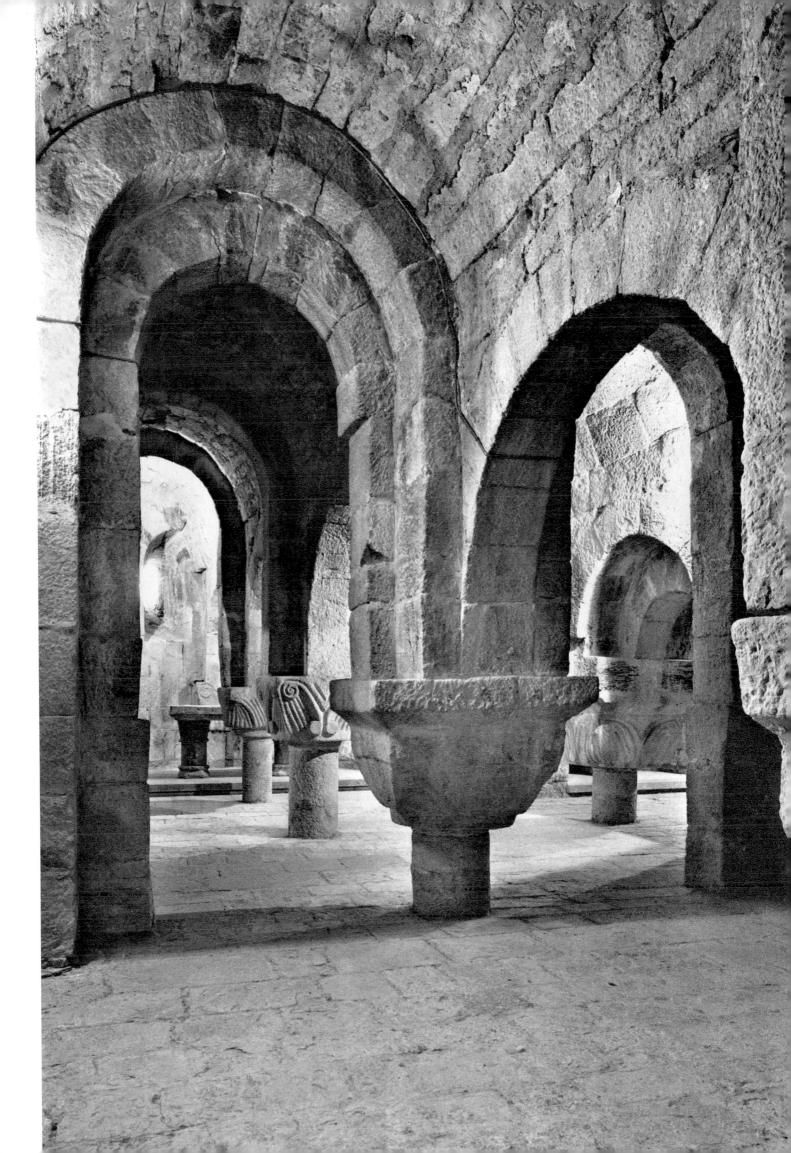

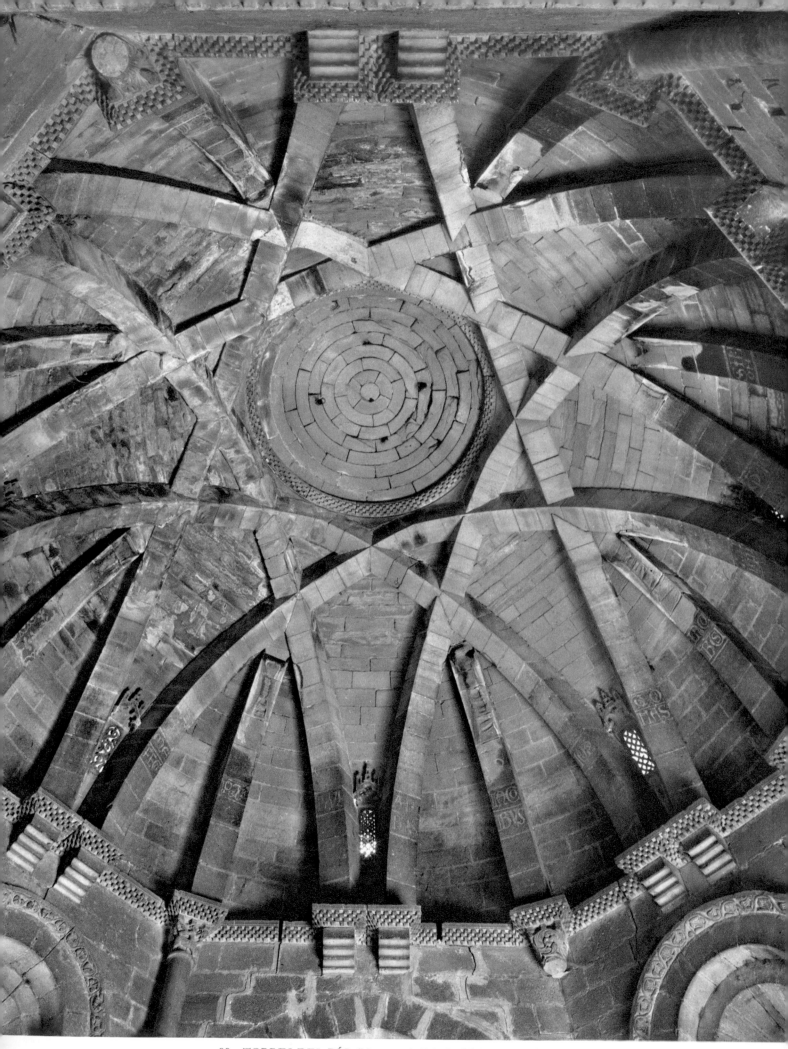

88 TORRES DEL RÍO (NAVARRA), Iglesia del Santo Sepulcro

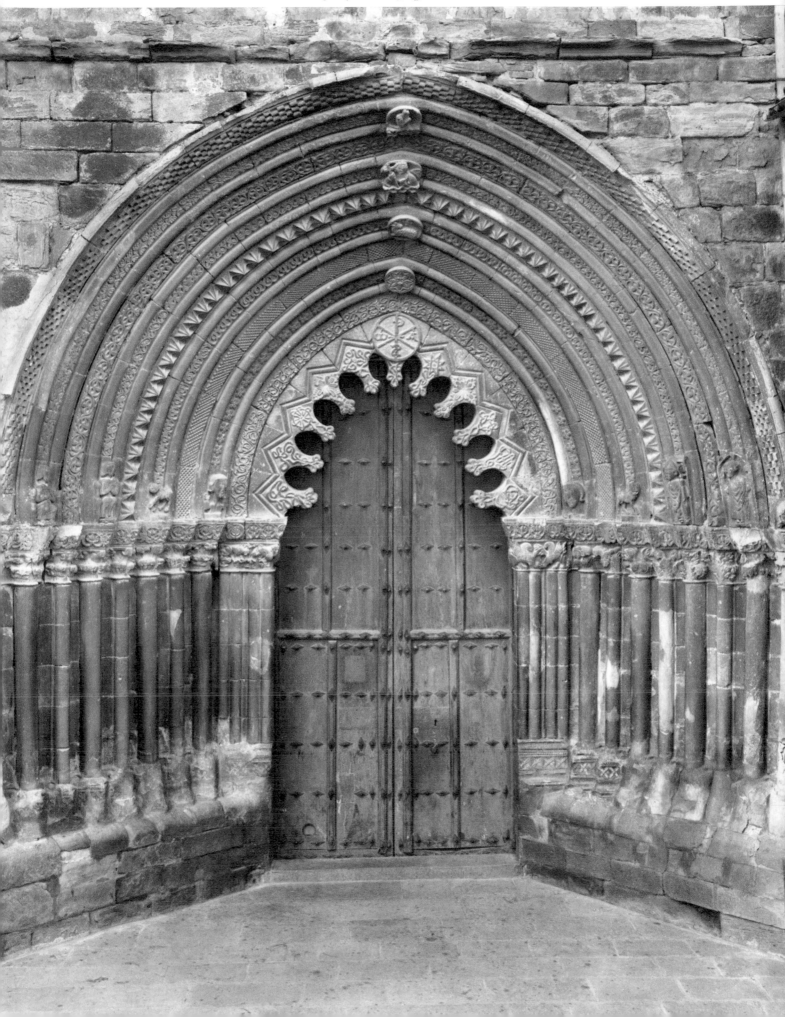

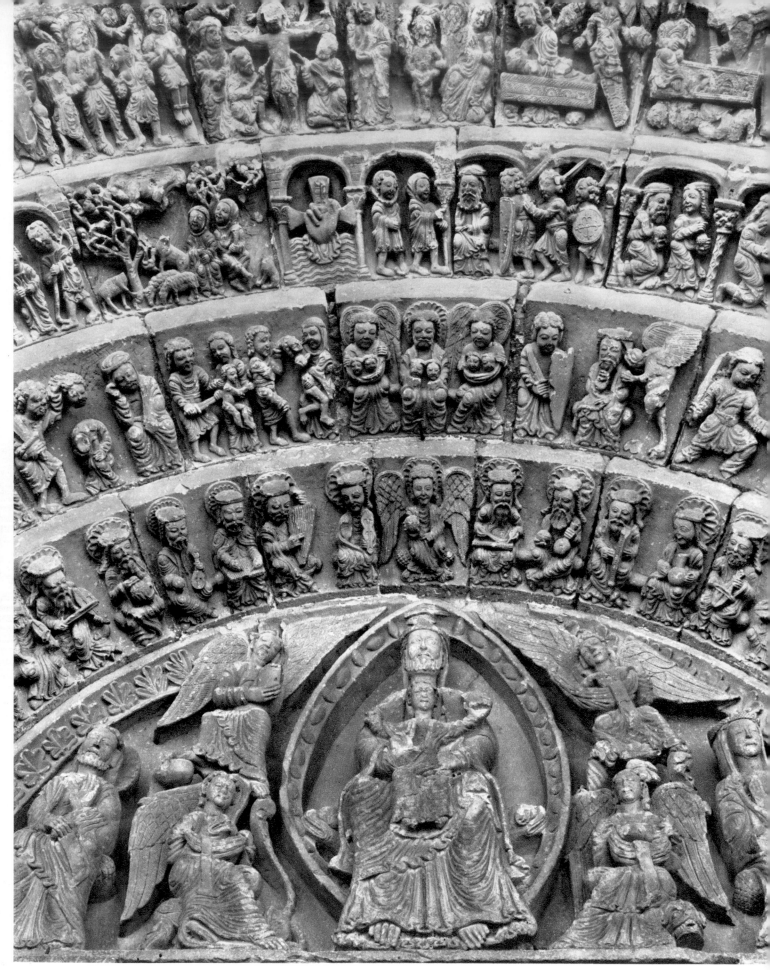

90 SORIA, Iglesia de Santo Domingo

91 AVILA, Basílica de San Vicente

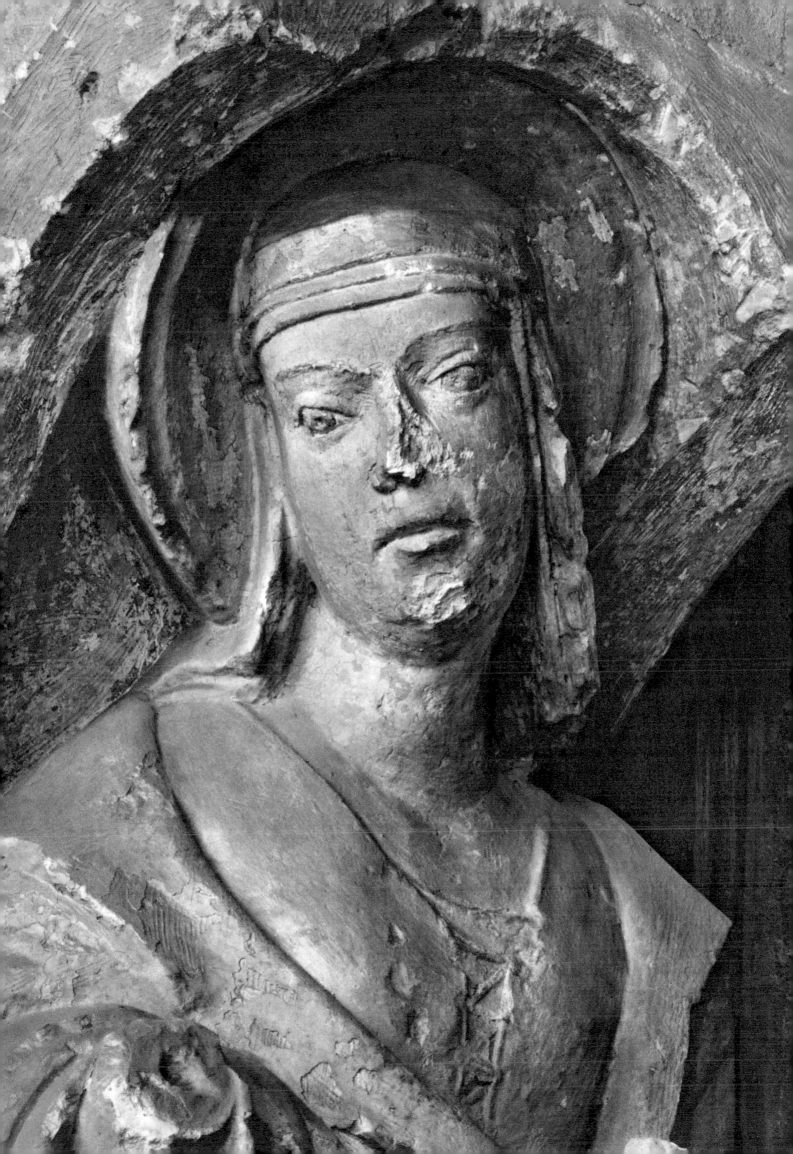

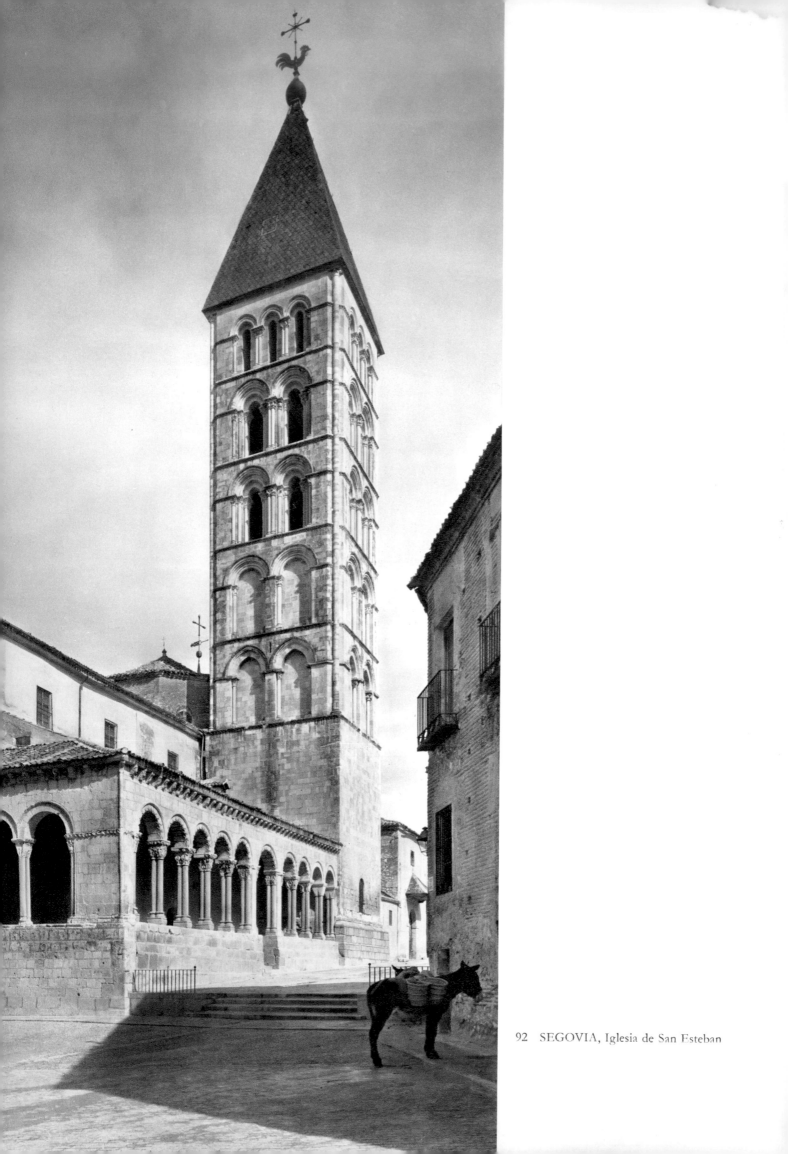

92 SEGOVIA, Iglesia de San Esteban

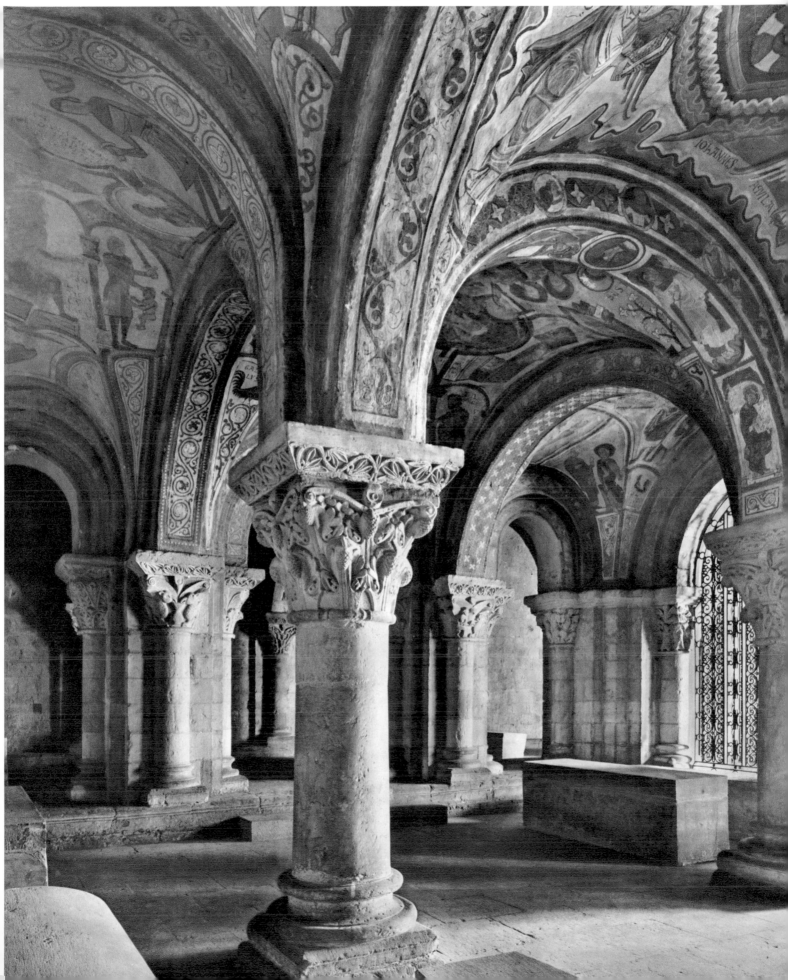

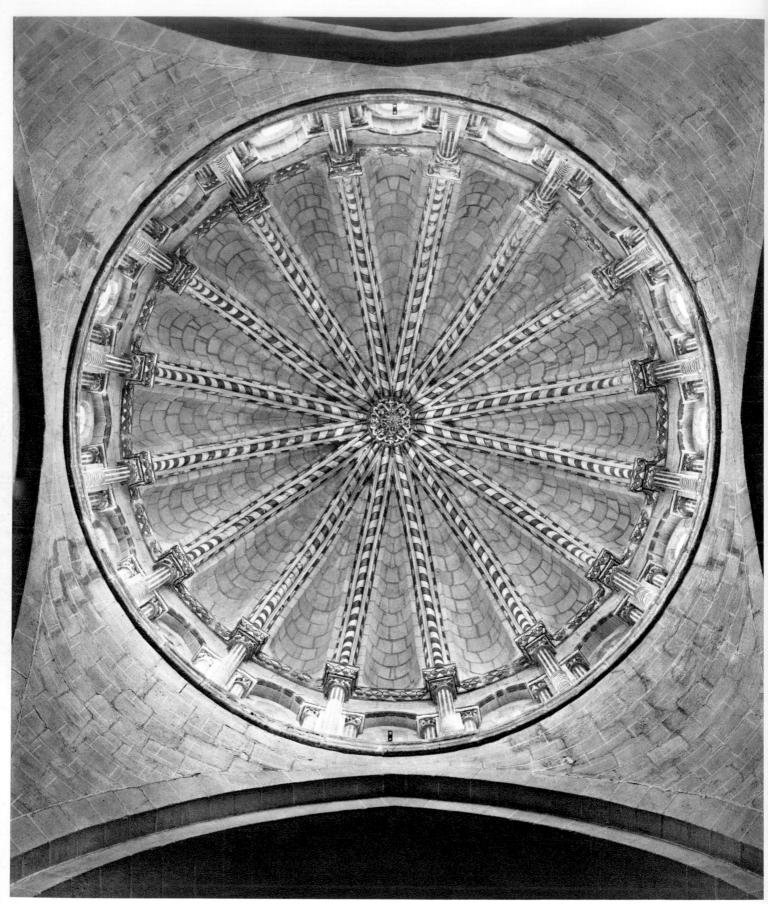

94 ZAMORA, Catedral

95, 96 SANTIAGO DE COMPOSTELA, Catedral

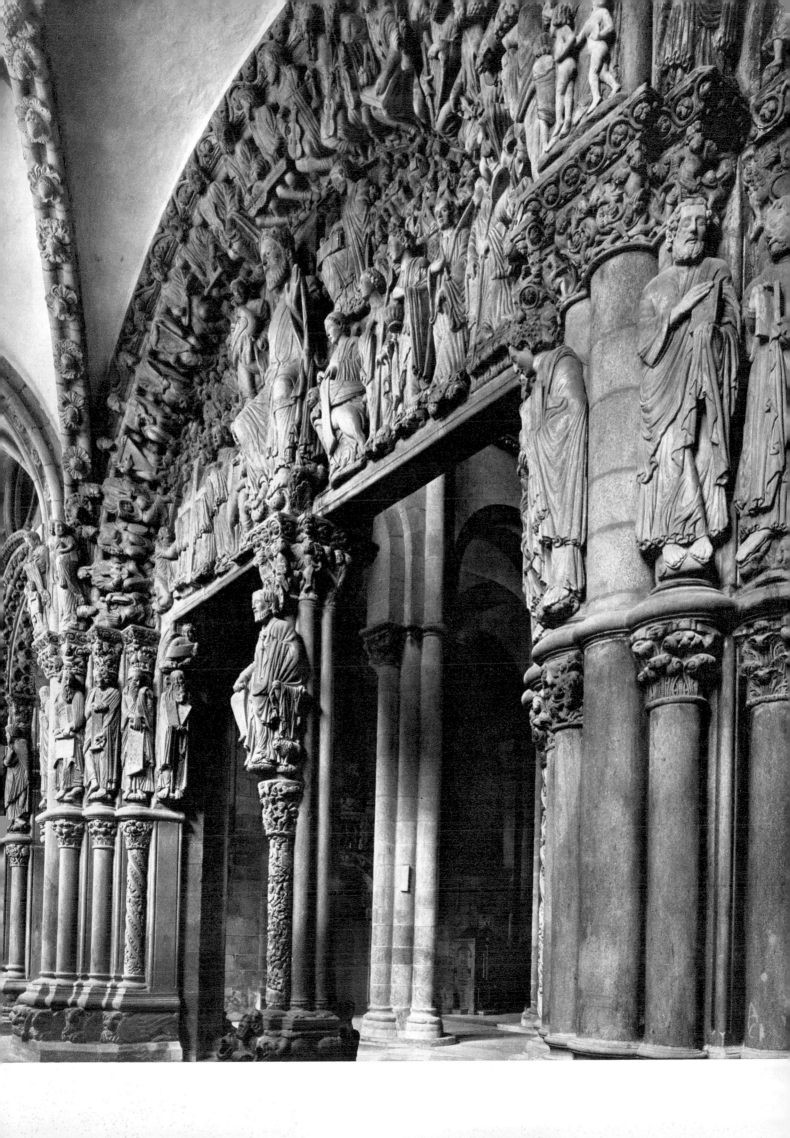

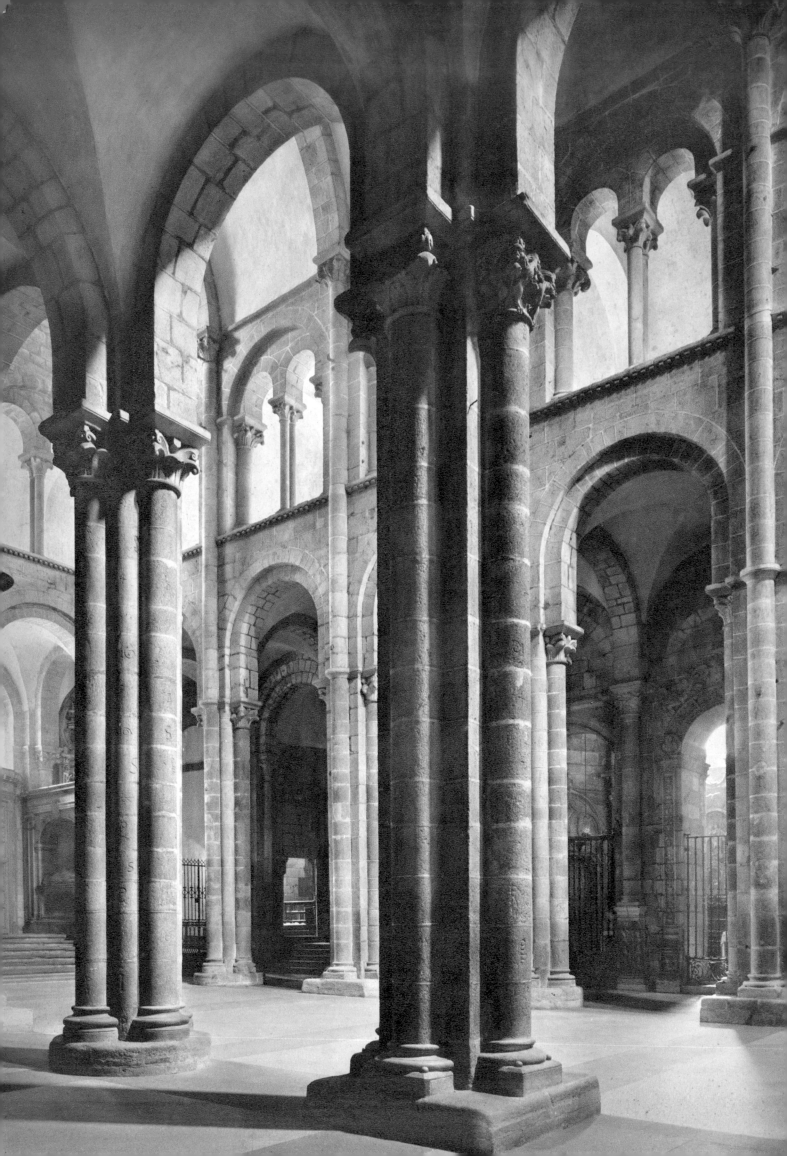

ITALY

THE SPIRITUAL FORCE which gripped the nascent West after the year 1000 is, superficially at least, less apparent in Italy than anywhere else. It has frequently been said that Rome, the centre of western Christendom, produced no art of its own during the Romanesque era, and this has been attributed to the appalling decline of the Papacy in the second half of the tenth century. This cannot, however, be the real reason, for the Papacy soon recovered its dignity. The first German pope of the Middle Ages, Gregory V (996–9), and his successor Sylvester II (999–1003), the first French pope, were men not only of integrity but also of forceful personality; the former showed skill and determination as a reformer, in spite of having to deal with an antipope, while the latter promoted the conversion of Eastern Europe and presented a crown to the first Christian king of Hungary, St. Stephen. Sylvester II was in addition one of the most brilliant and learned men of his day, closely in touch with advanced Muslim thought. The four German-born popes who succeeded each other in the middle of the eleventh century were also worthy of respect: Leo IX (1048–54) took strong action against corruption among the clergy. Gregory VII (1073–85) was the first Cluniac pope. His reforms applied particularly to lay investiture; he pronounced a ban on the appointment of laymen to ecclesiastical offices and thus on the occupation of bishoprics by secular rulers. The resulting controversy dragged on for years, causing most distress in the German Empire, and was only resolved when Henry IV went as a pilgrim to Canossa to beg the Pope's forgiveness.

Papal degeneracy and weakness were therefore certainly not the reason for Rome's failure to produce any architecture of great merit in the eleventh and twelfth centuries. There was no such failure in the other arts. The adornment of the existing churches with screens, chalices, pulpits, and mosaics, and the mosaic-decorated pillars in the cloister of San Paolo fuori le mura *(pl. 113)* bear witness to an exceptionally great delight in art, which had highly original results. Indeed the revival of antique types of paving and panelling in coloured marble, and brilliant mosaic work, was a speciality of Rome from the twelfth century onwards, and Italian workmen went as far as Westminster and Canterbury in England to carry out so-called 'Cosmati' work, named after a Roman family who excelled at it. But there was little or no ecclesiastical building at the time, apart from the addition of porticoes and campanili to existing churches. The reason must lie in the obvious but often overlooked fact that no new churches were built in Rome because none were needed, in spite of the greatly augmented flow of pilgrims. The churches built in the early cen-

130

turies of the Church still stood; some still stand today. It might be supposed that so new and powerful a feeling as that which found its expression in the Romanesque style would have torn down the old and replaced it by creations of its own. The preservation and continued use of the old church buildings in Rome can perhaps be interpreted as a unique example of traditionalism.

The inviolability which the memory of the apostles and martyrs lent to the churches of Rome, most of which were built over their tombs or on the site of their deaths, retained its strength over the centuries, and persisted during the new era of faith. Outside Rome, in the Exarchate of Ravenna for instance, ancient churches were again preserved where they were large enough to meet the needs of increased congregations.

In the north and south of Italy, however, from the second half of the eleventh century onwards, major ecclesiastical building was undertaken. It was stimulated in part by the example of the chief monastery of the Benedictine order at Montecassino – a building which influenced Cluny III as well, itself a seminal example in France. Thus Sant' Angelo in Formis, near Capua, was finished about 1073: its porch has the slightly pointed arches and groin vaults of Montecassino, and its interior survives with all its wallpaintings.

Both Pisa Cathedral and San Marco in Venice were begun in 1063: no doubt in the two greatest ports in Italy religious fervour was reinforced by a desire to show off the city's wealth and power. San Marco was intended partly to serve as a pantheon for the Doges; at Pisa building began after a Pisan victory over the Saracens. Pisa Cathedral, and especially its campanile, the famous Leaning Tower, is decorated with tiers of openwork arcading, a feature popular in the north, and visible on the nearby cathedral at Lucca *(pl. 105)* as well as on the parish church at Arezzo *(pl. 109)* where the whole façade, with its flat top, has a Roman air.

A third church, begun in the same year 1063, is Sant' Abbondio in Como. It is almost ostentatiously large for a Benedictine church, with double aisles and a forecourt. Its twin towers are a German feature, but the decoration of its apse is a classic example of 'Lombard banding': under the eaves runs a row of arches of which most end on corbels, but at intervals others are carried down by shafts running the full height of the wall. This motif spread into France and Spain (e.g. *pl. 22, 80*), but was especially popular in Germany. Inside Sant' Abbondio *(pl. 99)* the effect is austere, with tall slender columns, almost no carving, and flat wooden roofs over nave and aisles.

In northern Italy (excluding the strip along the Adriatic coastline from Aquileia to Venice and on to Ravenna which remained for a longer time under the influence of Byzantium) there were older churches, notably in Lombardy. Like the Goths, the invading Lombards spared them and indeed added to them. A number of important churches were built in the eleventh century, but a disastrous earthquake in 1117 destroyed many of the old buildings and affected some of the new ones. Of the cathedrals and large churches erected in the cities along the Via Emilia Modena was begun in 1099 and Piacenza in 1107; at Sant' Ambrogio in Milan rebuilding had begun about 1080 but the Canons' Tower and narthex *(pl. 97)* were not added until after 1117. Work began again at Parma after the earthquake. The two Romanesque churches of Bologna, San Pietro and the octagonal Santo Stefano, date from the mid-twelfth century.

A change which cannot be ignored had taken place since the early years of Romanesque art.

It was not only religious needs which urged the cities to rebuild and preserve their great churches: the rivalry between them, sometimes exploding into open war, inspired a desire to outshine their neighbours with the most magnificent churches they could afford. This motive is even more pronounced in southern Italy and Sicily, where the Norman kings built cathedrals and majestic abbeys out of a desire to rival the Byzantine Emperor. There is no one style to unify the many buildings that rose as a result *(pl. 114–121)*, reflecting the cosmopolitan population of Italian, Greek, Arab and Norman. The racial and religious tolerance of the rulers led to a combination of Italian and Byzantine, Oriental and northern elements in buildings of the twelfth century whose very diversity is intensely satisfying.

The rich schools of sculpture throughout Italy are more directly in the line of classical art than are the products of any other region except for Provence. Thus the font of San Frediano at Lucca *(pl. 106)*, as we have seen, has reliefs inspired by classical sarcophagi, and the eagle and lions on a pulpit at Ravello *(pl. 115)* are as Roman as the marble and mosaic decoration of the pulpit itself. Elsewhere a somewhat different style is represented by the relief on the pulpit at Isola di San Giulio, one of the earliest works of stone sculpture in Italy *(pl. 104)*, and the bronze panels of the great doors of Pisa Cathedral *(pl. 107)* where the compositions are derived from Byzantine ivories. All over the peninsula so many Roman remains survived that columns and capitals could be reused bodily, and the cathedral at Acerenza in south-central Italy, for example, is decorated with Roman funeral stelae. In architecture classical forms were often the natural form; at Castel del Monte *(pl. 122)*, the Apulian hunting lodge of Frederick II, a pointed Gothicizing arch with nook-shafts is placed between pilasters and under a steep pediment not inconceivable in provincial Roman architecture.

As we have seen, central Italy did not participate in the architectural revival; thus while one may speak of products of the Romanesque period in this region, it is only in northern and southern Italy that one may speak of the Romanesque style.

NOTES ON PLATES 97–128 (Map p. 32)

97 MILAN, SANT' AMBROGIO. *Narthex*. The narthex was built about 1140 to replace a Carolingian forecourt in front of the façade of the abbey church then recently completed. The disposition of the arcades and the classical echo in the rounded arches below, with their applied pilasters, forms a harmonious prelude to the silence and subdued light of the interior. The Torre dei Canonici ('Canons' Tower') on the left was begun shortly before 1128 by the architect of the church.

98, 99 COMO, SANT' ABBONDIO. *East end; interior*. This massive Benedictine abbey church stands on the 'Strada della Regina', named after the Lombard Queen Theodolinda, outside the walls of Old Como. It has double aisles like the cathedral of Pisa, begun at the same time,

and the somewhat later third church at Cluny, and although much smaller than either it is nevertheless a monumental building. It was begun in 1063 and completed shortly after its consecration in 1095. The splendid apse, decorated with typically Lombard arches and bands, is flanked by twin towers. Inside, the effect is of sombre majesty, due to the many tall slim pillars, mostly with plain cushion capitals. (In the caption, for Sant' Abondio read Sant' Abbondio.)

100 CIVATE (NEAR COMO), SAN PIETRO. *Wallpainting*. The original Lombardo-Carolingian church, an aisleless building with an eastern apse, was transformed in the 11th century by the addition of a western apse, making it a double-ender. The interior still preserves

frescoes – notably St. Michael's triumph over the devil, in the east end – of the 12th century. The pillars, capitals and arches of the eastern apse are decorated with outstanding stucco-work which, with some fragments at San Benedetto in Mals, constitutes the only parallel to the earlier stucco sculpture at Cividale del Friuli. The artists working at Civate were undoubtedly influenced by eastern models.

1, 102 ALMENNO SAN BARTOLOMMEO (BERGAMO), SAN TOMASO IN LÉMINE. *Vault; exterior.* This impressive pilgrimage church, probably the work of builders of the Como school, dates from the 11th century. It stands in isolation in the Bergamasque hill country, within sight of the forests of the southern Alps, and is most remarkable for its circular structure, of two storeys topped by a cupola and lantern. Inside, on the ground floor eight pillars separate an annular ambulatory from the well-lit central space under the dome. A gallery rests on the ambulatory, and opens into the church through an arcade of columns with very fine capitals.

Plan of
San Michele,
Pavia

10 m
0 m

103 PAVIA, SAN MICHELE. *Interior looking east.* The present building, which can hardly be dated before 1160, reflects the Germanic traditions of architectural and decorative work which remained especially strong in the ancient royal city of the Langobardi. Architectural sculpture of *c.*1180 appears in bands on the façade and on archivolts and capitals inside, and in it the fantastic nightmares of Germanic art of the early Middle Ages are revived. The interior, with vaults renewed in the Renaissance, is dominated by a dome on double squinches and by flights of steps leading up to the choir and down to the crypt.

104 ISOLA DI SAN GIULIO, LAGO D'ORTA (NOVARA), SAN GIULIO. *Detail of the pulpit.* The ancient basilica was rebuilt shortly before 1000 by the priest and architect William of Volpiano (962–1031). It still retains its early-11th-century pulpit carved of black marble from Ossola (Oira). The parapeted platform is supported on fine pillars, two of which are wreathed in decorative strips, with capitals of classical form. From the parapet three reading-desks project, ornamented in high relief. One of the reliefs shows a deer attacked by two beasts of prey. The style is similar to that of the stone carving on the pulpit of Sant' Ambrogio at Milan and the more old-fashioned reliefs of the bronze doors of San Zeno in Verona.

105 LUCCA, SAN MICHELE. The date 1143, found on the interior of the church, may be taken as that of its completion. The side walls with their arcades supported by almost free-standing columns, the lower section of the campanile and the design of the apses must no doubt be attributed to this building period. The chief glory of the church, however, its proudly rising façade of four superposed galleries crowned by the statue of St. Michael, belongs to the beginning of the 13th century. The galleries are decorated with coloured marble inlay of geometrical patterns and fantastic animals, of eastern inspiration; the corner piers are alternatingly composed of four interwoven colonnettes. The central door does not have the usual lunette: instead there is a carved lintel of 12th-century date.

106 LUCCA, SAN FREDIANO. *Font.* The decoration and design of San Frediano are older and more idiosyncratic than those of the other magnificent Romanesque churches of Lucca, San Michele and the Cathedral of San Martino. The building, with double aisles, was erected between 1112 and 1147, probably by Tuscan architects. The unique font dates from *c.* 1190. Its lower section is composed of ten reliefs showing the life of Moses, signed by a sculptor called Robertus. The fine plasticity and energetic attitudes of the figures obviously derive from the reliefs on Roman sarcophagi. The upper section, which was originally topped by a cross, was recovered from the Bargello Museum. Its representations of the Good Shepherd and the apostles are of cruder workmanship than the base.

107, 108 PISA, DUOMO SANTA MARIA. *Detail of bronze doors; exterior from the east.* The new cathedral was begun in 1063, a year after the city had conquered Palermo, till then held by the Saracens, and had thus established its position as a champion of Europe against Islam. The building was completed and its altar consecrated in 1121. It was planned on a grand scale by the Greek architect Busketos, as a massive basilica with double aisles, an aisled transept, and a flat roof with no dome.

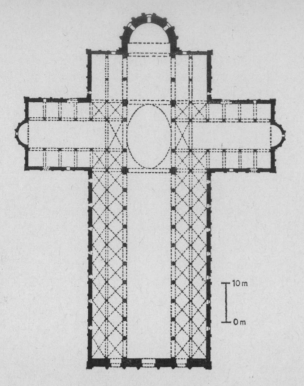

Plan of Pisa Cathedral

The crossing was vaulted by a dome on squinches by 1250. The nave was extended and a new west front provided between 1250 and 1270.

The famous campanile was begun in 1137, but due to subsidence building was halted until about 1350, when the belfry stage was added. Like the cathedral, it is decorated with tiers of arcading: this feature spread throughout Tuscany (cp. Lucca, *pl. 105*) and beyond.

The Romanesque ambition to rival antique art is evidenced in the bronze doors of the period. Formerly bronze doors, usually with incised decoration, had been supplied to Italy from the imperial foundries at Constantinople; during the 12th century native bell-founders and goldsmiths at Verona, Pisa, and elsewhere boldly began to produce bronze doors in relief. At Pisa the technique of applied relief was employed as well as casting, in accordance with German practice. The Porta San Ranieri tells the story, in twenty-four reliefs, of the life of the Virgin; the compositions are frequently inspired by Byzantine ivories. Yet each of the panels is instinct with original thought and feeling, and shows considerable confidence in the execution. The relief of the journey of the Magi to Bethlehem, for instance, shows the riders ascending a shallow arc representing the ground, while below it small figures enact the Fall and the expulsion from Paradise – from which the new-born Christ will redeem mankind. Despite the restricted space, the free, monumental style of this Tuscan artist is evident.

109 AREZZO, SANTA MARIA ASSUNTA E SAN DONATO. The façade of the parish church ('Pieve') of Arezzo, dating from *c.* 1210, differs from such arcaded façades as those of Pisa and Lucca in that it is articulated neither by gables – the shape of the church behind is ignored – nor by polychromy. It relies for its effect on the superposition of graded arcades, which give a surprisingly classical impression of majestic solemnity.

110 FLORENCE, SAN MINIATO AL MONTE. *Interior looking east.* The church of a Benedictine abbey founded in Carolingian times, San Miniato was rebuilt between 1140 and 1150, probably by an architect trained at Pisa and with knowledge of the Auvergne. The columns dividing nave and aisles are replaced in every third bay by compound piers carrying arches which support the wooden roof. The elaborately patterned stone floor is dated 1207, as is also the parapet of the raised choir, which supports the pulpit. The clear, precise proportions of the parapet and pulpit and of the inner space itself are characteristically Tuscan.

111 SPOLETO (PERUGIA), SANT' EUFEMIA. *Interior looking east.* The church must at one time have been attached to the ducal palace. Erected in the 10th century, it was vaulted at a considerably later date. Its height is unusual, and comparable to that of San Lorenzo at Verona; this may be partly explained as a late Carolingian architectural feature, but it is also due to the need, in this instance, of providing a spacious gallery for the court ladies. Like many churches in the Abruzzi, Sant' Eufemia has a *colonna santa,* visible at the far right, made from the architrave of a former building.

112 ASSISI (PERUGIA), DUOMO SAN RUFINO. Both St. Francis and the Emperor Frederick II were baptised in this cathedral. It represents mainly the reconstruction, begun in 1144 by Giovanni da Gubbio, of an earlier building. Additions to the portal were made between 1217 and 1228. The three splendid wheel-windows give the façade its distinctive appearance; that in the centre is surrounded by the symbols of the Evangelists and supported by three figures, possibly angels, that stand almost clear of the wall.

113 ROME, SAN PAOLO FUORI LE MURA. *Cloisters.* The best preserved in Rome, these cloisters were begun under Abbot Petrus of Capua (1193–1208) and finished in 1241. The designer was a certain Petrus, probably one of the Vassalletti family. The alternately inlaid and plain, twisted pairs of pillars, the coffered arches and mouldings in the antique style inaugurated a canon of architectural form in Rome. Figure sculpture, and

consequently individuality of style, became of less importance than mosaic and stone intarsia. Small carvings of animals, now mutilated, are to be found between the bases of the pillars.

114 CASERTA VECCHIA (NAPLES), CATHEDRAL OF SAN MICHELE. This massive cathedral is one of the finest examples of Norman building in the south. It was begun about 1120 by Bishop Rainulf and finished in 1153. The internal vaulting of the cupola is divided by ribs like those of the mihrab niche in the former mosque at Cordoba. Externally the cupola is encased in an octagonal drum, whose surfaces are enlivened by two rows of intersecting arcades. Within them light and dark stones, arranged as a mosaic, represent stylized animals including the lion, the badge of the Siculo-Norman royal house of Hauteville.

115 RAVELLO (SALERNO), DUOMO SAN PANTALEONE. *Pulpit.* The most striking feature of this episcopal church, founded in 1086 and rebuilt after being sacked by the Pisans in 1137, is the pulpit, resplendent with marble and mosaic. It was made in 1272 by an Apulian sculptor, Nicolo, son of Bartolommeo of Foggia, and represents the climax of the last phase of Apulian Romanesque sculpture. The walls of the pulpit are partly covered with patterns of gold mosaic and marble, probably the work of Sicilian artists, but its chief artistic attraction lies in its marble sculpture, which includes the head of a young women with imperial ornaments as well as the naturalistic lions and exuberant decorative foliage visible in our illustration.

116 PALERMO, SAN CATALDO. The three-aisled church begun in 1161 on the orders of the Lord High Admiral Maio of Bari was never finished internally, no doubt because of its founder's violent death. The building is of the same type as the three-domed Apulian churches but it is the work of a Sicilian architect: the spherical shapes of the three splendid domes are exposed outside in accordance with Sicilian practice, not given a pyramidal covering as in Apulia.

117 CEFALÙ (PALERMO), DUOMO SAN PIETRO. *Choir mosaics.* In 1131 King Roger II of Sicily ordered the building of this cathedral as a burial place for his family. The first sections to be built were the choir and the vaulted transept; after the founder's death construction seems to have ceased, until the nave was added about 1160 on a smaller scale. The west front with its two towers was completed about 1240. Only the mosaic decoration of the choir and apse, dated 1148, was carried out: it forms the most important record of the

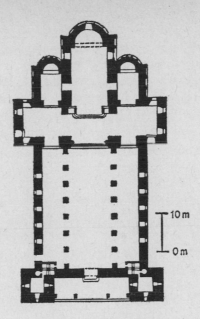

Plan of Cefalù Cathedral

activity of Byzantine mosaicists in Sicily. The mosaics show saints, apostles and angels, with a figure of the Virgin in prayer below the stern, half-length figure of Christ Pantocrator, ruler of the world, in the conch of the apse.

118, 119 MONREALE (PALERMO), DUOMO SANTA MARIA LA NUOVA. *East end; cloisters.* William II ordered the erection and decoration of the cathedral of Monreale in 1174 as a sepulchral church for his family. Teams of artists from a wide area were engaged for the work. By 1182 the building was far enough advanced to allow it to be used as the church of an archbishopric. The broad, well-lit nave, adorned with mosaics, leads into a tripartite choir on the Byzantine plan. The monumental dimensions of the cathedral can only be fully sensed in a view of the richly decorated group of apses *(pl. 118)*, covered with characteristic arcading and inlay-work (cp. *pl. 114).*

The architectural and decorative glories of Norman Sicily are represented most delightfully in the cloisters on the south side of the cathedral *(pl. 119),* erected quickly during the last decades before 1200 by men of several clearly distinguishable schools. They are best seen from the delicate fountain-house at their south-west corner; here one may look through and along the rows of twin colonnettes, or across the garden to the south tower of the cathedral. The shafts of most of the colonnettes are inlaid with strips of mosaic or carved in relief. Some of the capitals are carved with hunting scenes and tournaments, and one shows the King himself presenting a model of the cathedral to the Virgin — a title-deed in stone.

135

120 MATÉRA, SAN GIOVANNI BATTISTA. *Interior looking north-east.* This beautiful little building, completed in 1204, is in a perfect state of preservation. It represents the type of church erected by the Normans in Apulia on the plan of a Latin cross with a symmetrical double axis. In the dim light which penetrates the narrow, lofty nave from its high windows the carved capitals stand out vividly. The elevation and vaulting show Burgundian influence.

121 BARI, SAN NICOLA. *Interior looking east.* This massive church was begun in 1087 after the transfer to Bari of the relics of St. Nicholas, Bishop of Myra in Asia Minor. It is one of the four monumental palatine basilicas of Apulia. The interior is dominated by the broad, high crossing; its dome, on squinches, is now concealed by a wooden roof. Northern models were probably responsible for the *matronea*, the galleries with three arched openings above every bay of the nave. The walls were later reinforced at east and west by transverse arcades, to resist earthquake shocks; the eastern one takes the form of a triple-arched iconostasis. Seen through its arches is one of the finest and oldest high-altar canopies in Apulia, which dates from *c.* 1139.

122 CASTEL DEL MONTE (BARI). *Entrance.* The best preserved of the buildings of the Emperor Frederick II, Castel del Monte was erected as a hunting-lodge about 1220. It is an octagonal building with towers at the corners, laid out around a central courtyard; sited on a hill, it looks like a crystal growth. Its design was probably produced by a central imperial drawing-office which was responsible for the otherwise consistent plans of Frederick II's castles. The pedimented doorway demonstrates the conscious use of classical forms, whose grandeur and dignity were associated with imperial power.

123 BITONTO (BARI), CATHEDRAL OF SAN VALENTINO. *Relief on the pulpit.* The short time (1175–1200) taken to erect this building partly accounts for the fact that it is the most mature and perfect example of Apulian Romanesque architecture. It contains a high narrow pulpit, signed *Nicolaus sacerdos et protomagister* and dated 1229. A relief on the staircase wall has been supposed to represent the family of Frederick II, but it is more likely that the scene is of the three Magi before Herod. The background ornamentation shows Islamic influence.

124 SANTA MARIA DI PORTONOVO (ANCONA). *Interior looking east.* The church of a once rich Benedictine abbey, Santa Maria stands on a cliff within sight of the sea. It was completed in 1034. The elaborate scheme of the church, with single aisles in the nave and double aisles at the crossing, offers a variety of perspectives in the light descending from the cupola; the central space alone is brightly lit. The plan, invented by the Benedictines, is a variant form of the Byzantine cruciform, domed church.

125 PARMA, DUOMO SANTA MARIA ASSUNTA. *Detail of Deposition relief.* Parma Cathedral contains important works by Benedetto Antelami, born in the lake district of northern Italy, trained in Provence, and resident at Parma from 1196 onwards. To him we owe the bishop's throne, in the raised choir, and the former rood-screen; a relief from the latter shows the Deposition, in a style both severe and energetic. A detail of this scene shows the soldiers throwing dice for Christ's seamless robe, which is made the most important feature.

126 PIACENZA, DUOMO SANTA MARIA ASSUNTA. *Interior looking east.* The slow growth of the cathedral, from 1122 to 1233, led to numerous changes in the design. Nevertheless the interior seems all of a piece, though the vaulting of the nave (1205–15) already exhibits Gothic features and the dome, begun in 1215, was erected without reference to the transept. Massive, cylindrical pillars and soaring arches create a rhythmic approach to the choir.

127 MURANO (VENICE), SANTI MARIA E DONATO. *East end.* Here in the apse, of about 1140, bricks, terracotta and fragments of marble from older buildings are combined in a two-storeyed gallery, which stands out brilliantly against the dark background of the walls and forms a composition which overlaps the ends of the aisles and unifies the entire eastern face.

128 VERONA, SAN ZENO MAGGIORE. *West portal.* San Zeno was begun in 1125 and finished in 1178. It belonged to one of the most powerful Benedictine abbeys in Italy, which maintained regular communication with the German emperors. The structure of the main portal, altered around 1140, and the reliefs at the sides were executed, according to inscriptions, by two different artists. The reliefs illustrate the story of Genesis and the fate of the Emperor Theodoric, condemned by the Church as a heretic. The bronze doors of the church were probably given their present form about 1140: they were made from the remains of an 11th-century door with twenty-six relief panels of the life of Christ, which was destroyed in the earthquake of 1117. Eighteen panels illustrating the Old Testament were added when the doors were re-erected.

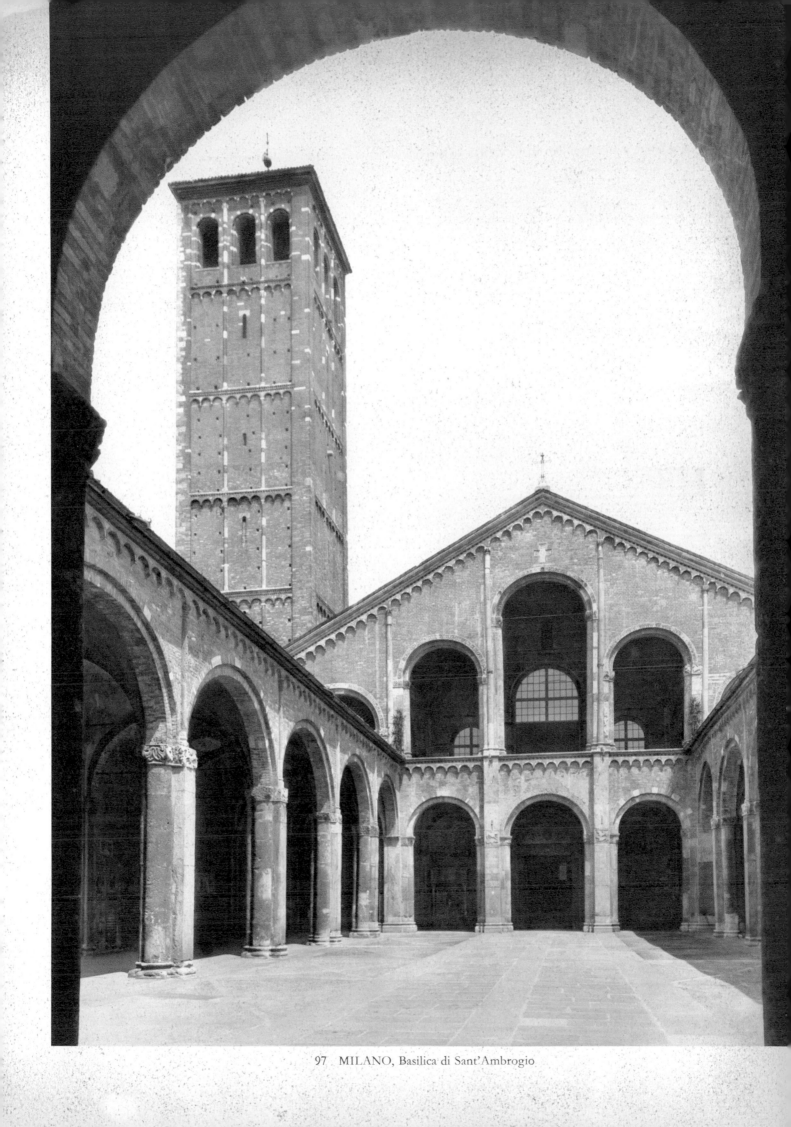

97 MILANO, Basilica di Sant'Ambrogio

98, 99 COMO,
Basilica di Sant'Abondio

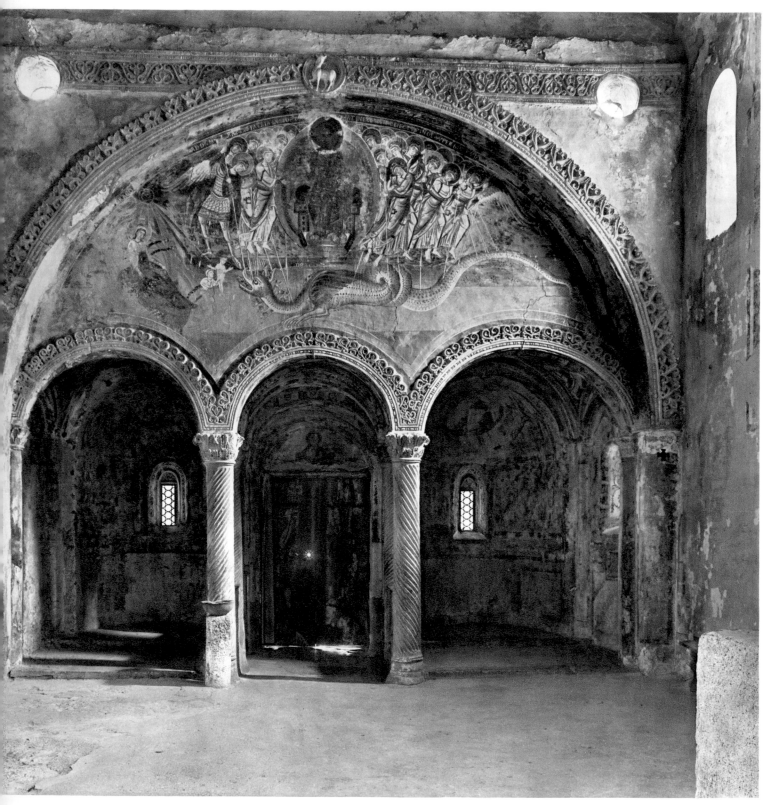

100 San Pietro — CIVATE (Como)

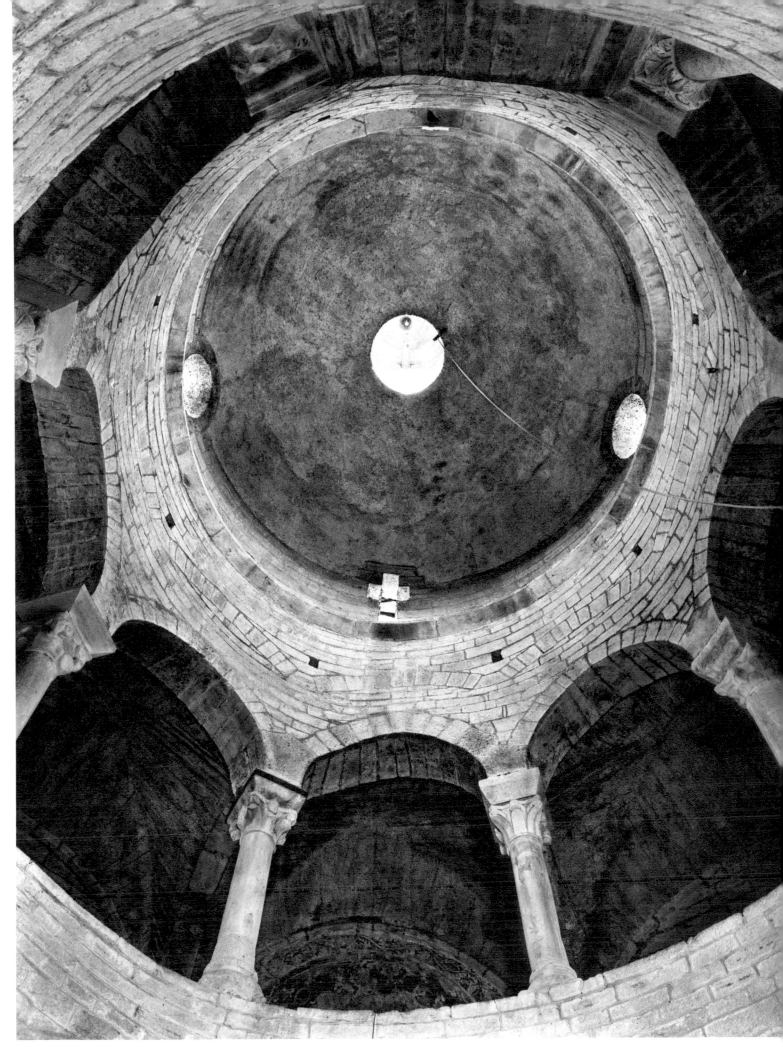

101 ALMENNO SAN BARTOLOMEO (Bergamo), San Tomaso in Lémine

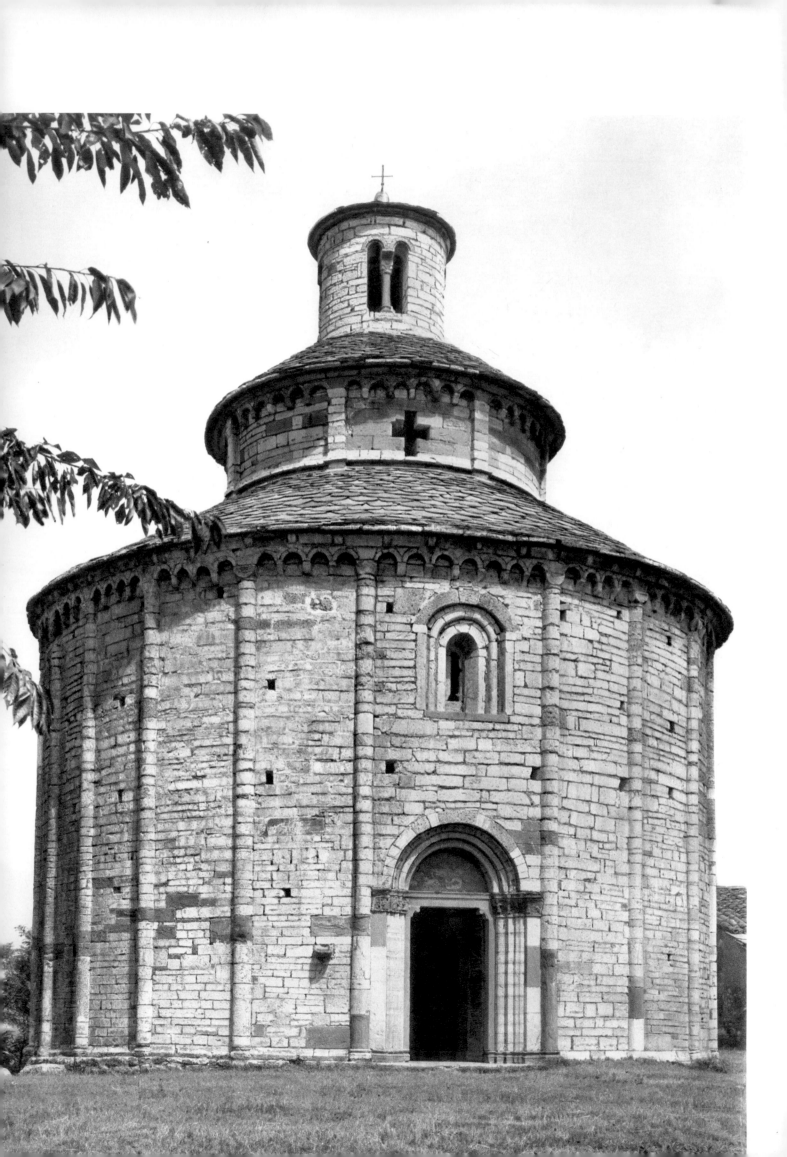

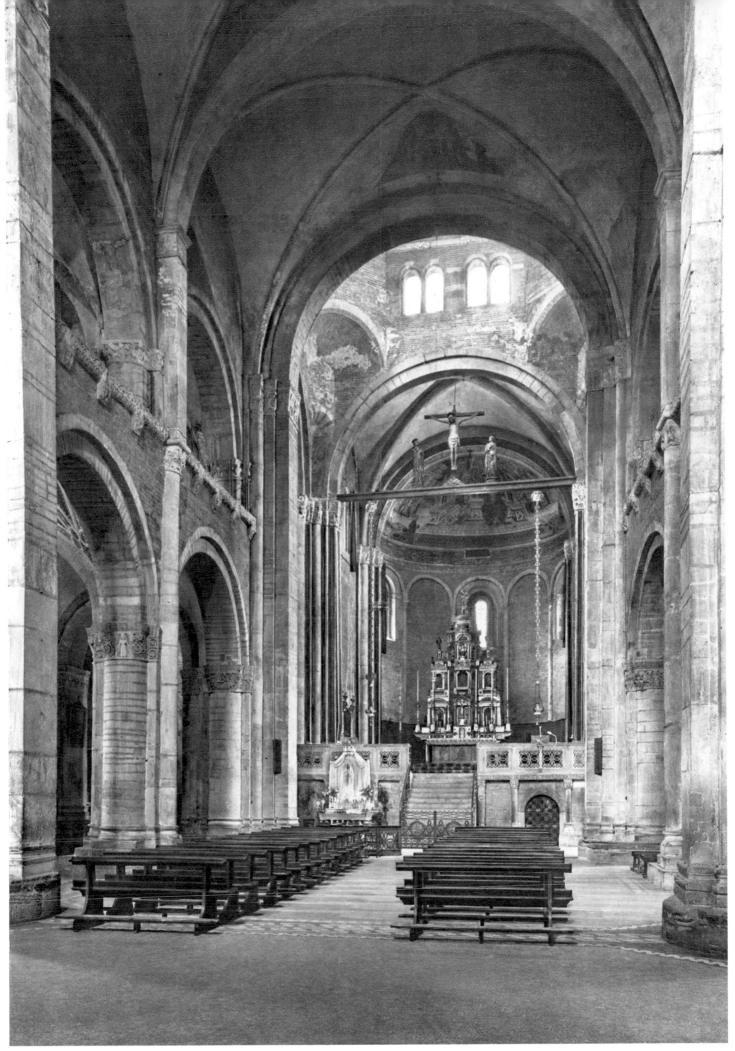

102 ALMENNO SAN BARTOLOMEO (Bergamo), San Tomaso in Lémine 103 PAVIA, Basilica di San Michele

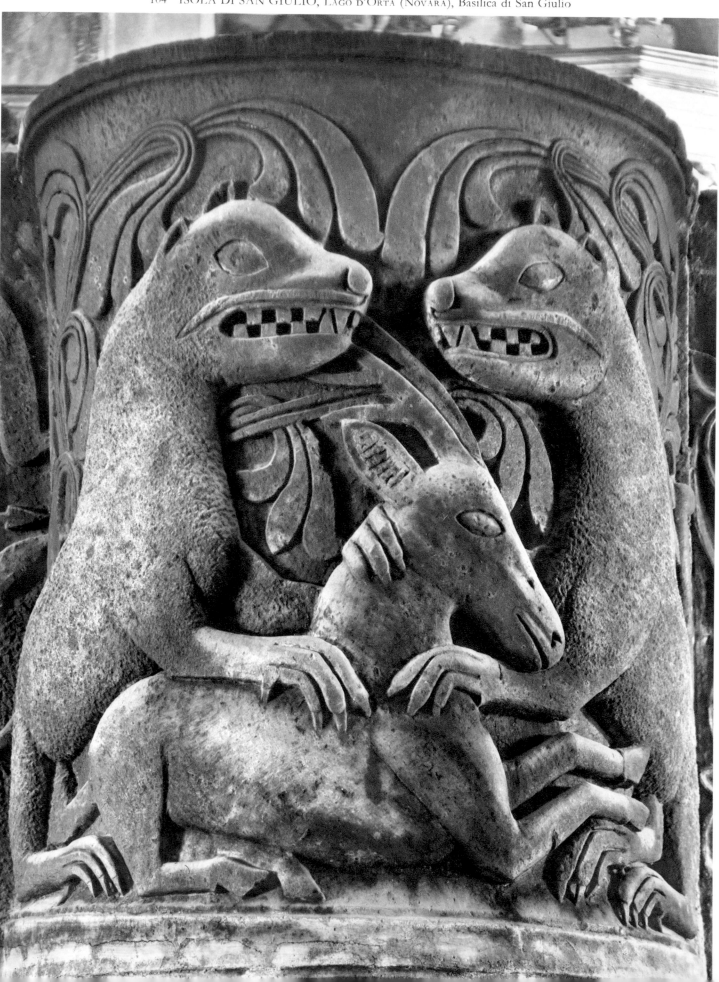

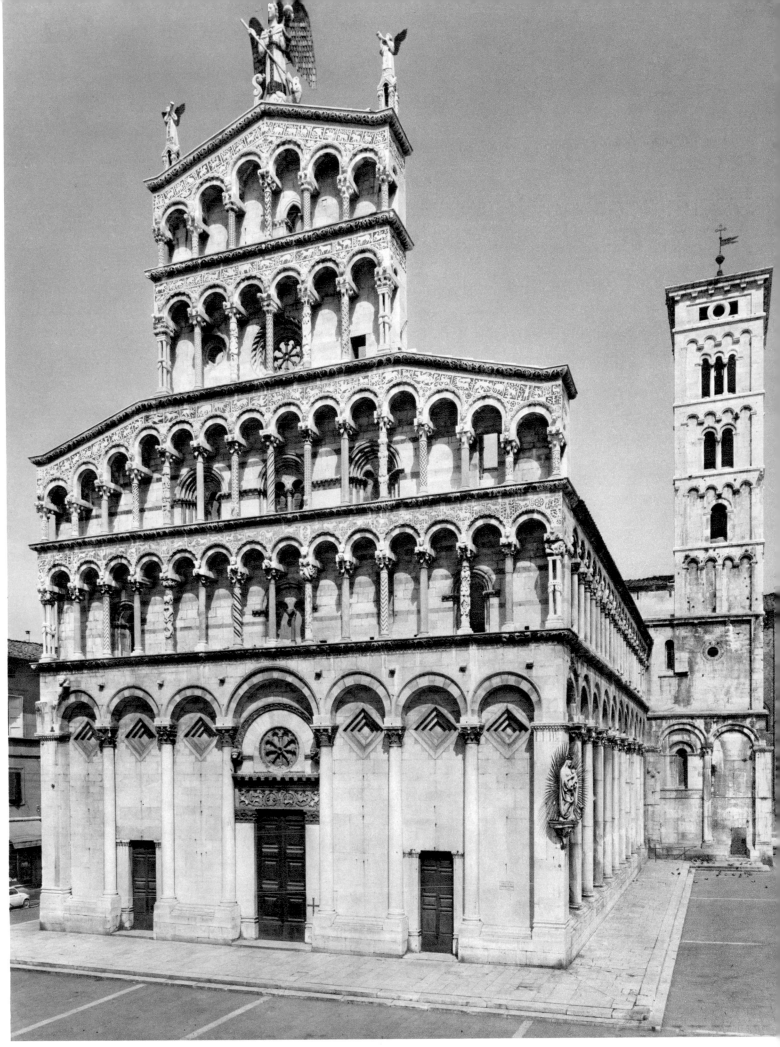

105 LUCCA, San Michele

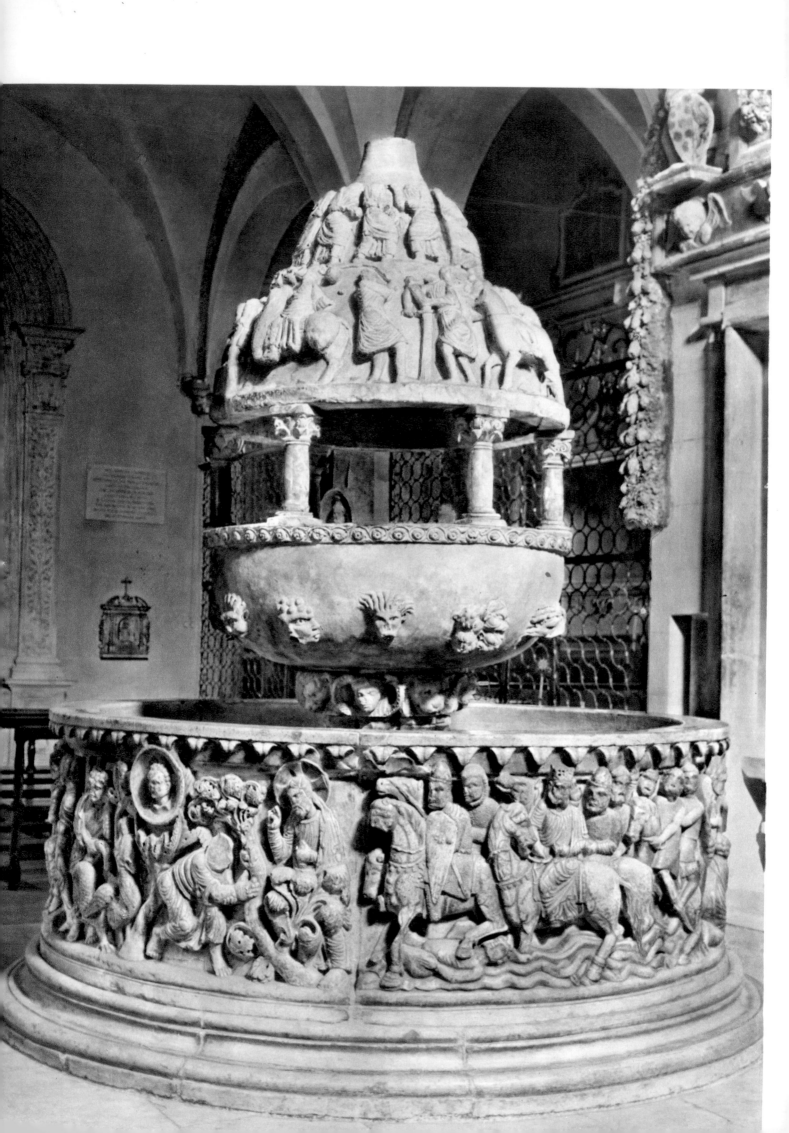

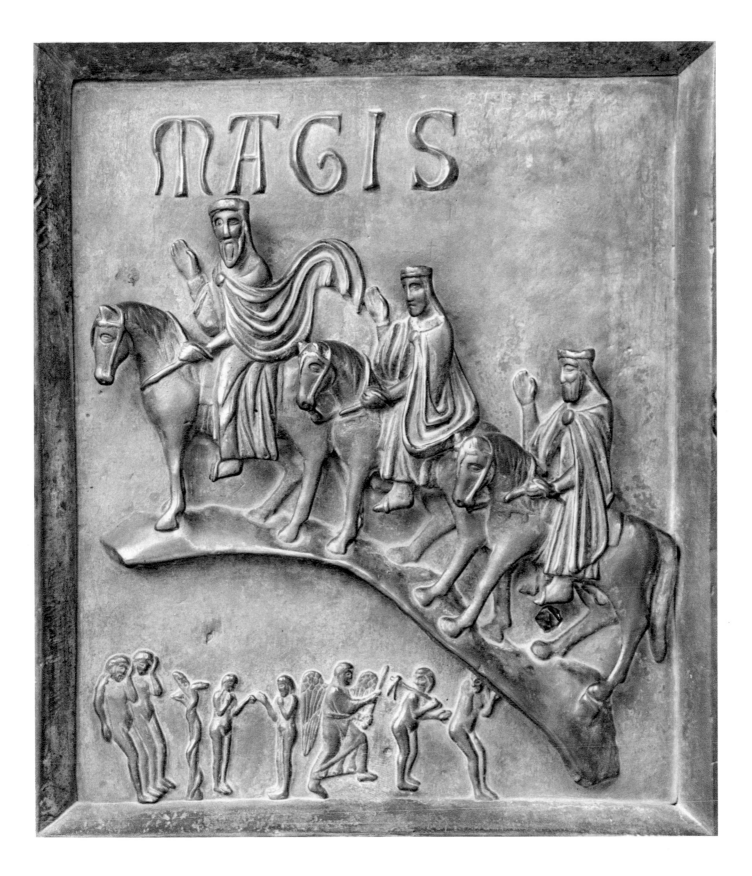

106 LUCCA, San Frediano 107 PISA, Duomo Santa Maria

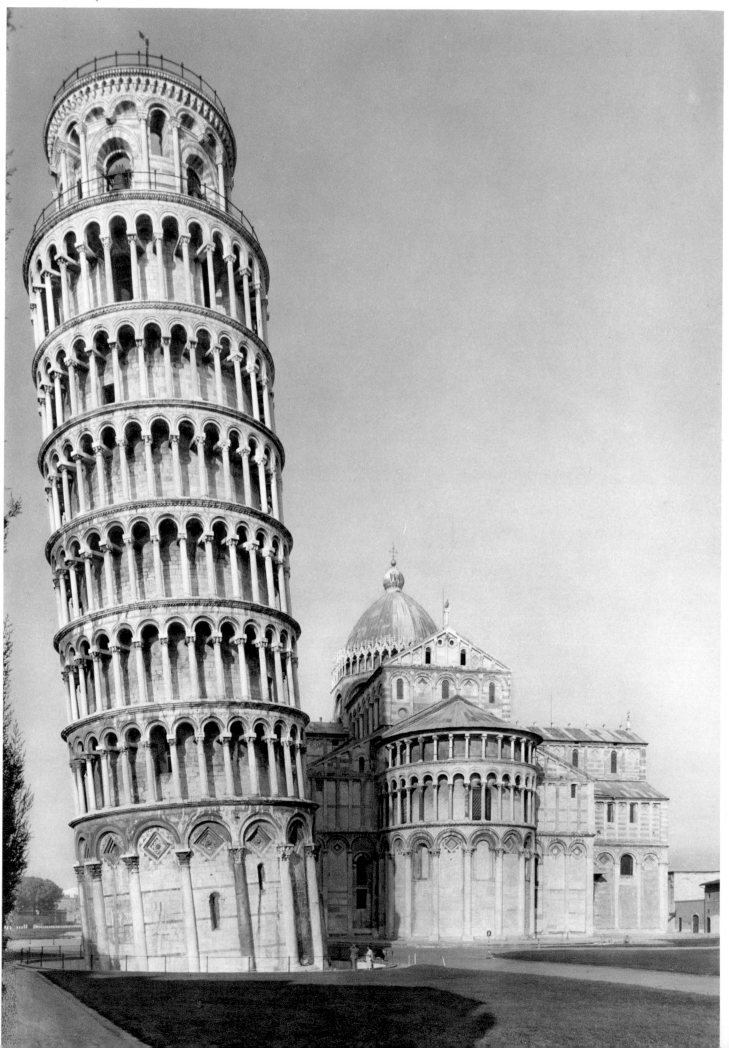

110 FIRENZE, San Miniato al Monte

111 SPOLETO (PERUGIA), Sant'Eufemia

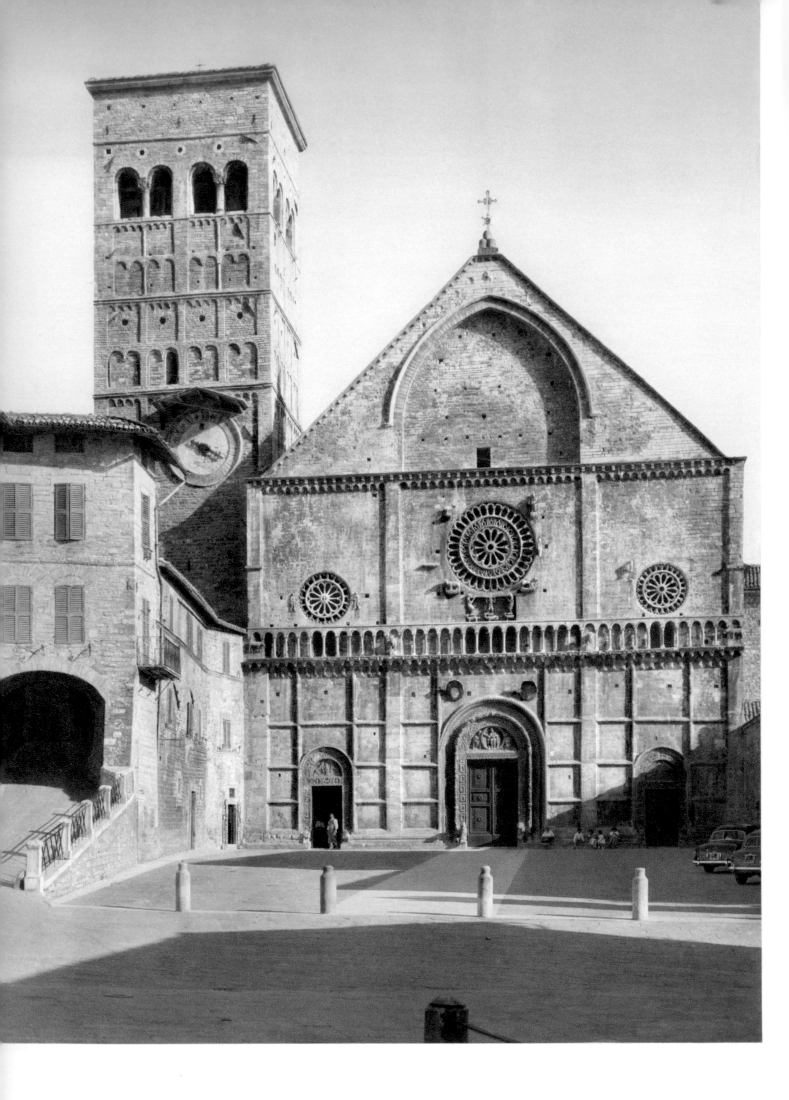

114 CASERTA VECCHIA (Napoli), Cattedrale San Michele

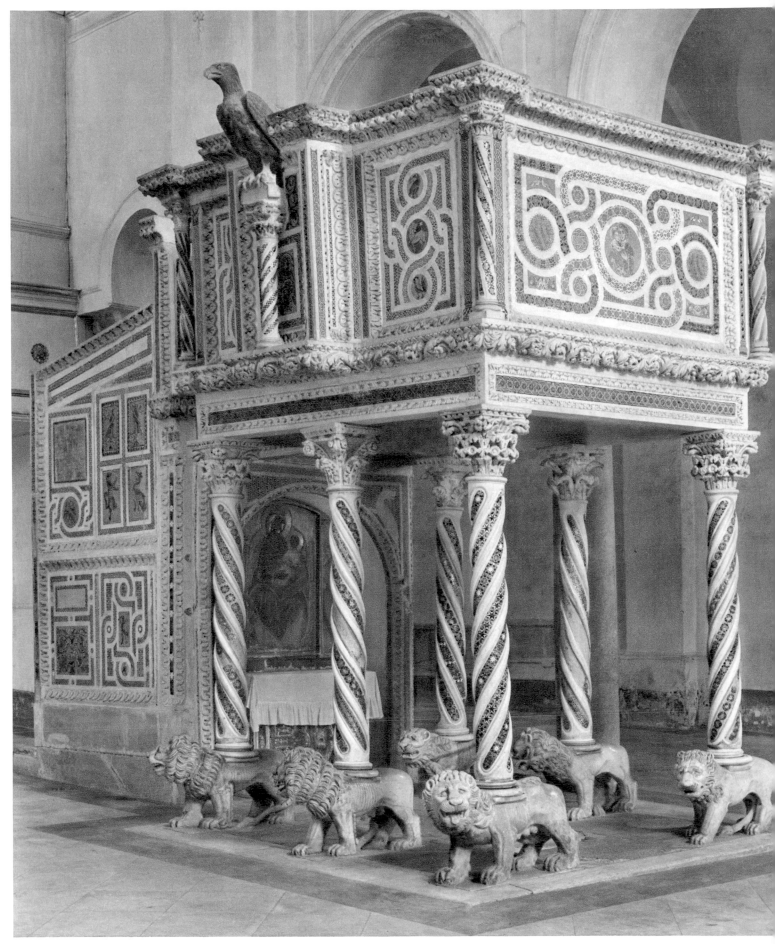

115 RAVELLO (Salerno), Duomo San Pantaleone

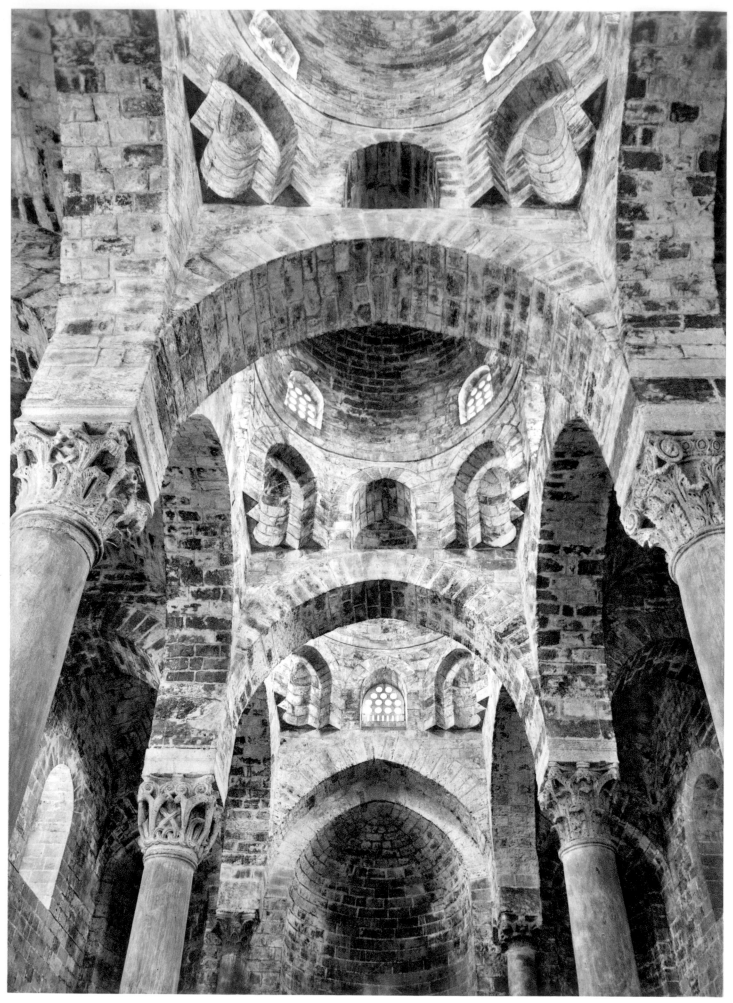

116 PALERMO, San Cataldo

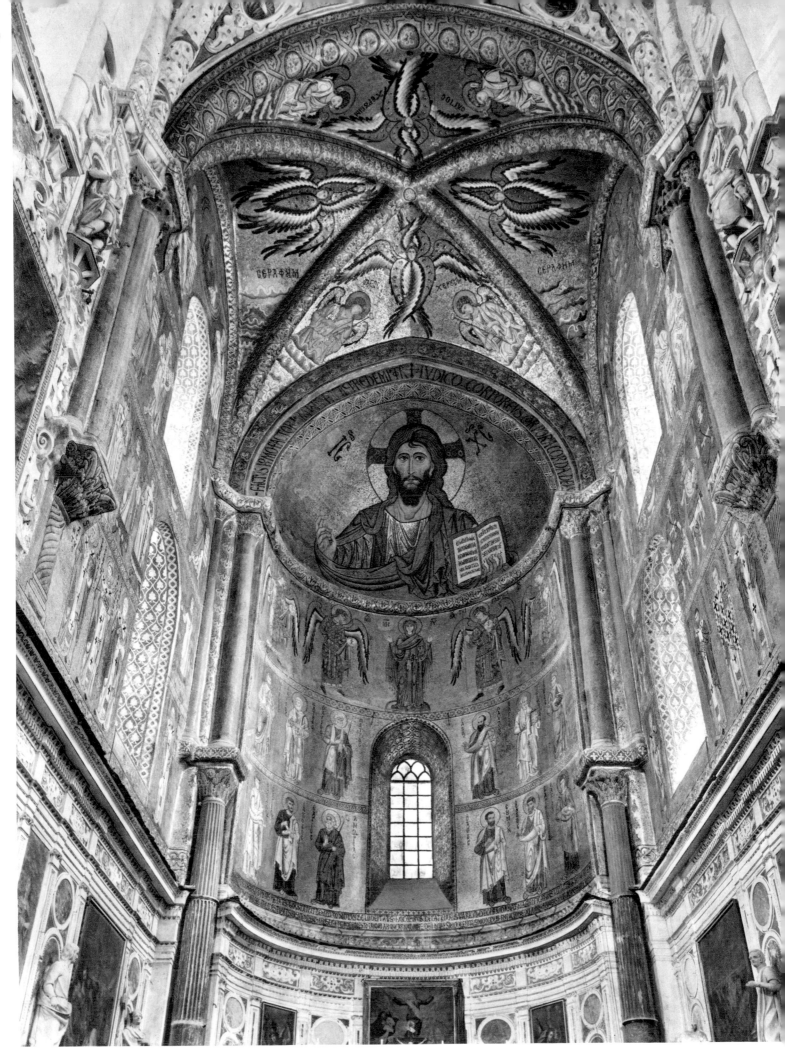

117 CEFALÙ (Palermo), Duomo San Pietro

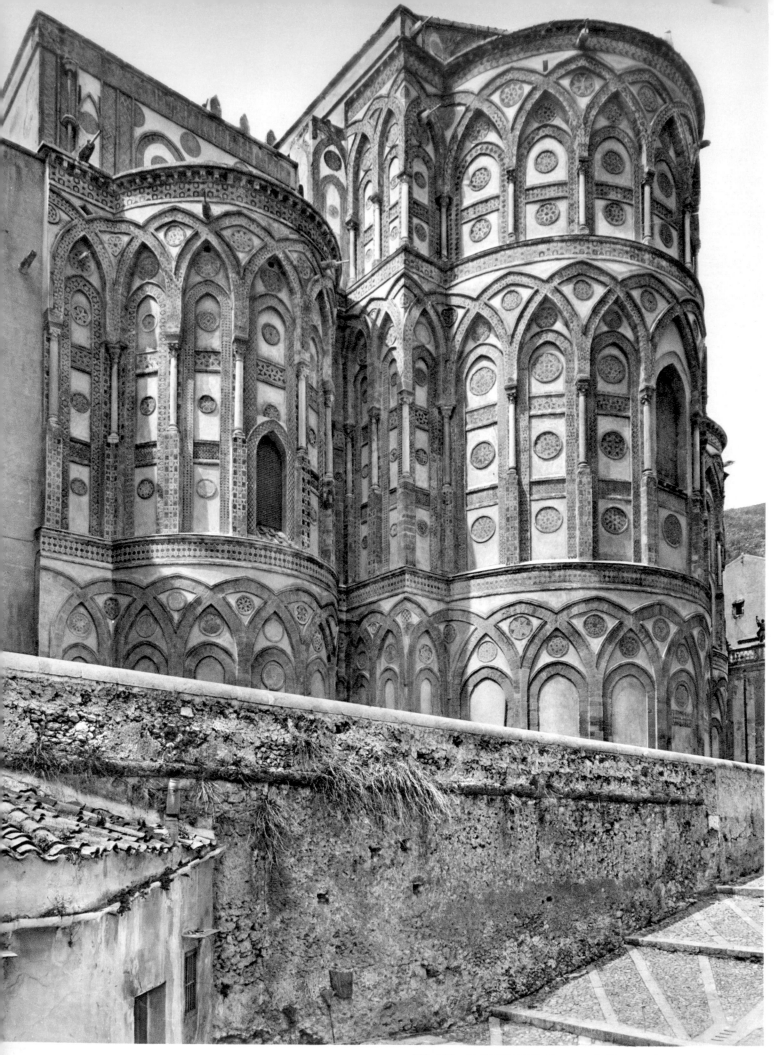

118, 119 MONREALE (Palermo), Duomo Santa Maria la Nuova

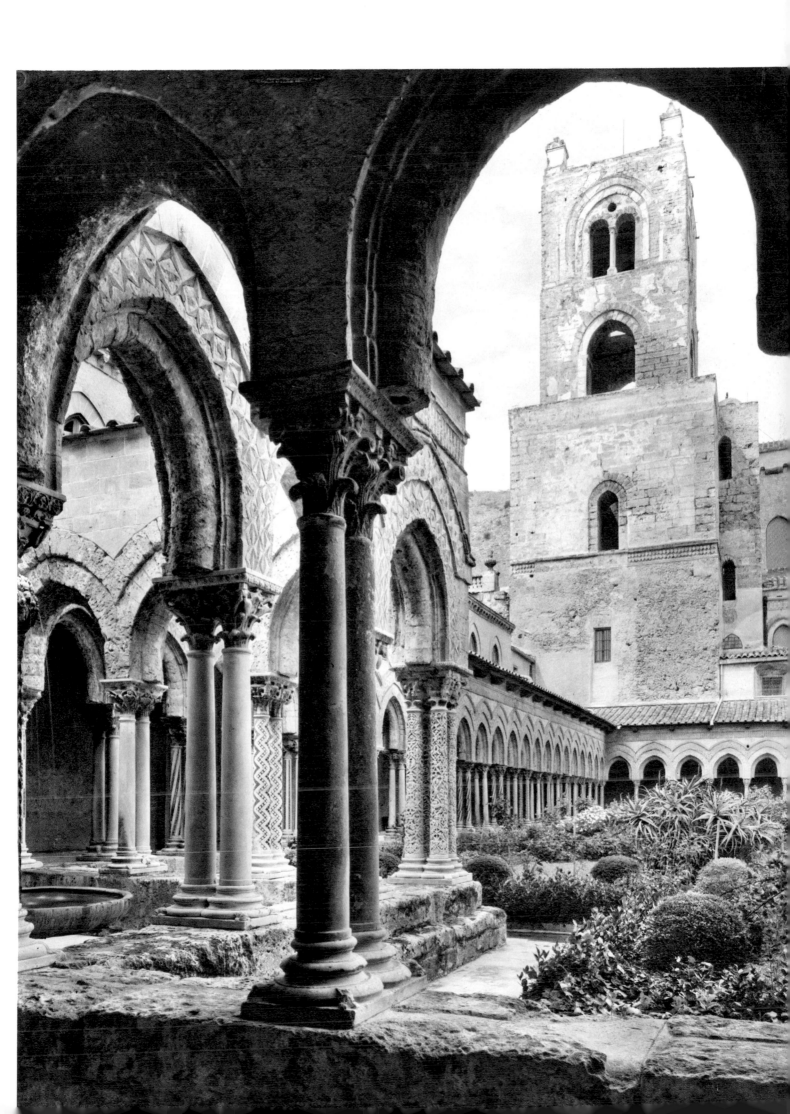

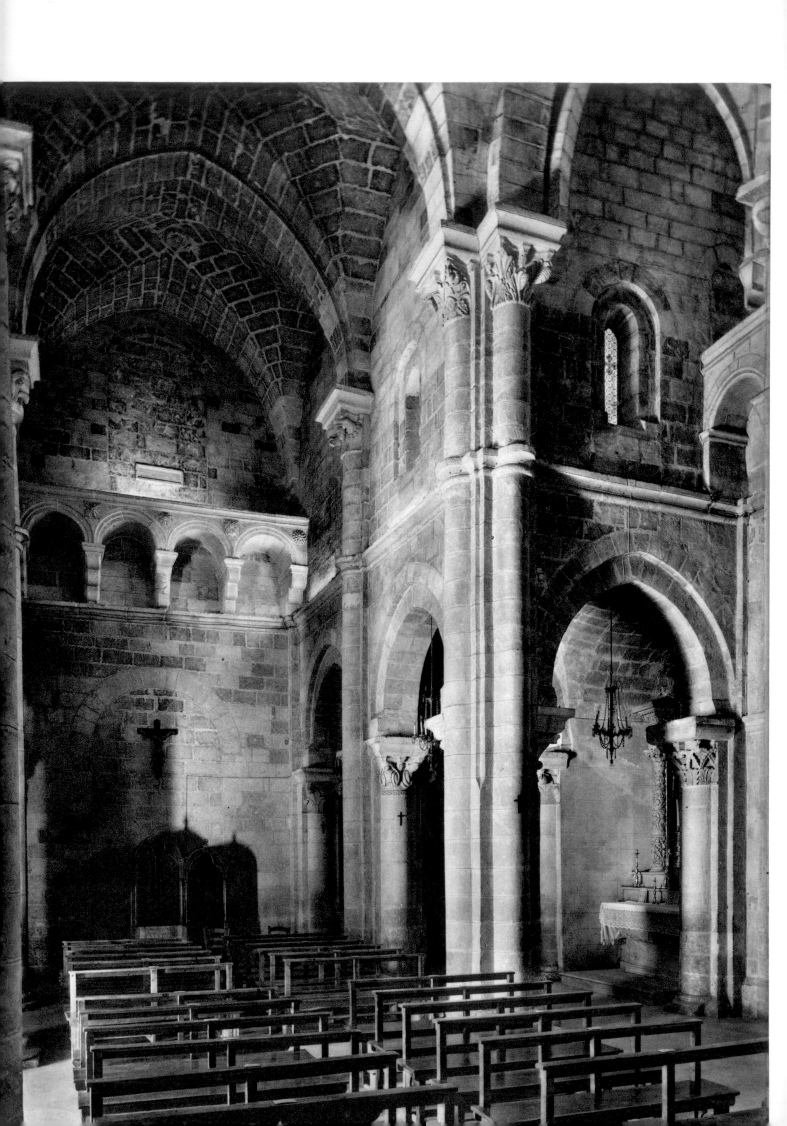

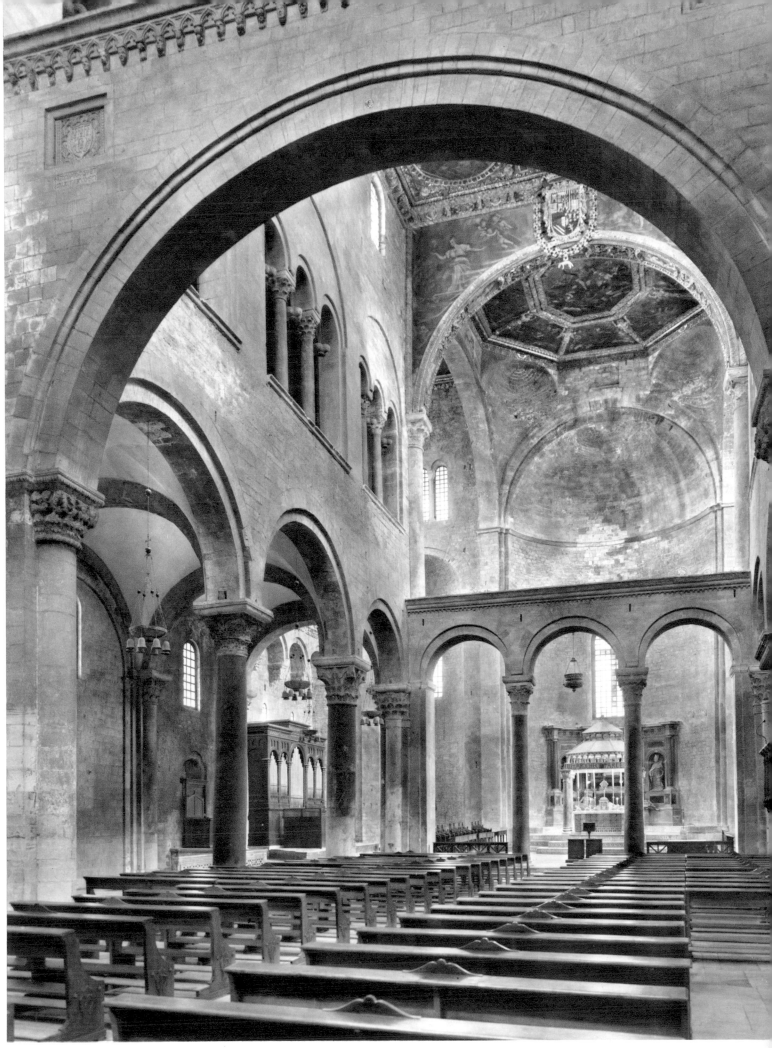

120 MATÉRA, San Giovanni Battista 121 BARI, Basilica di San Nicola

122 CASTEL DEL MONTE (Bari), Castello

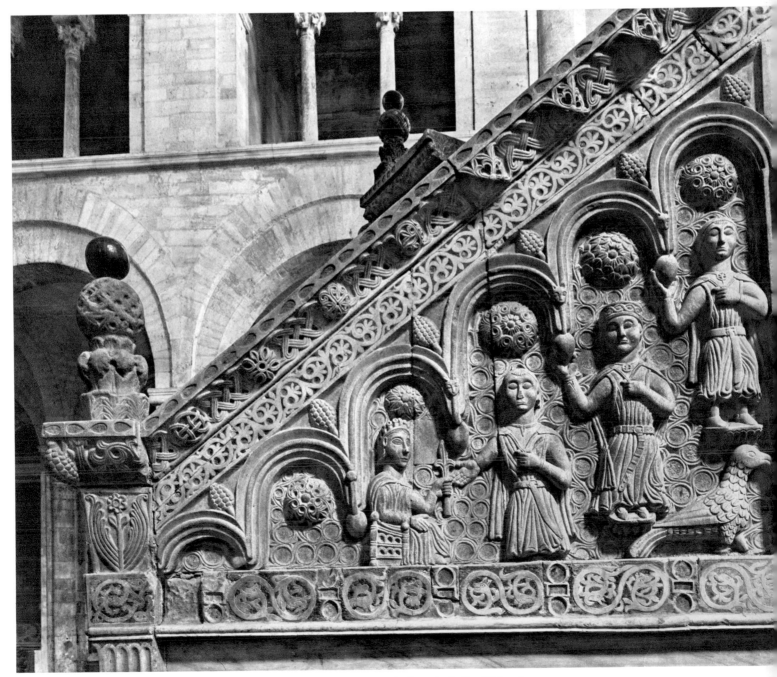

123 BITONTO (Bari), Cattedrale San Valentino

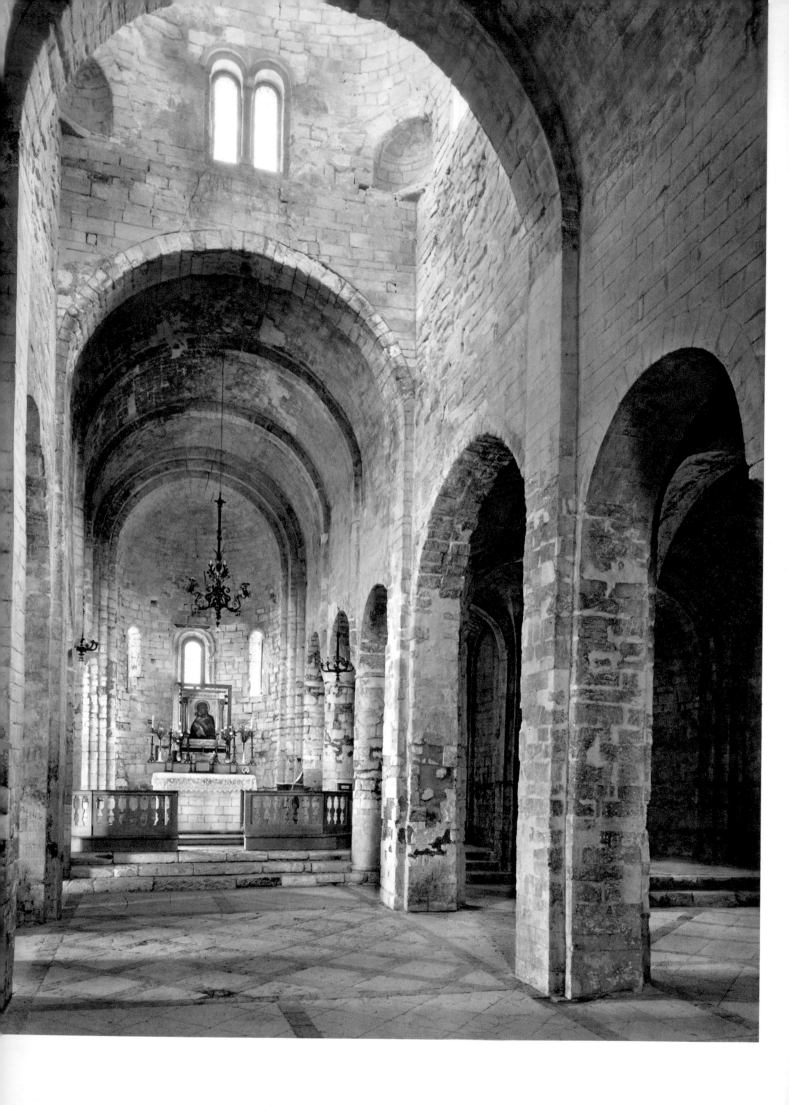

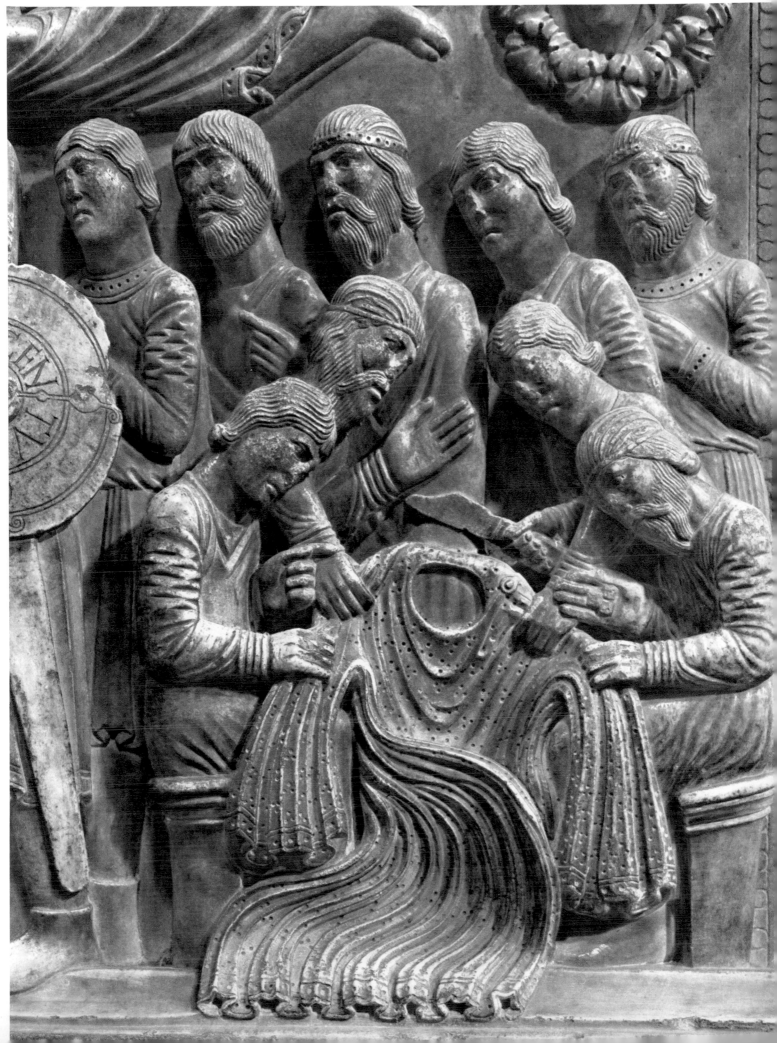

126 PIACENZA, Duomo Santa Maria Assunta

127 MURANO (Venezia), Basilica dei Santi Maria e Donato

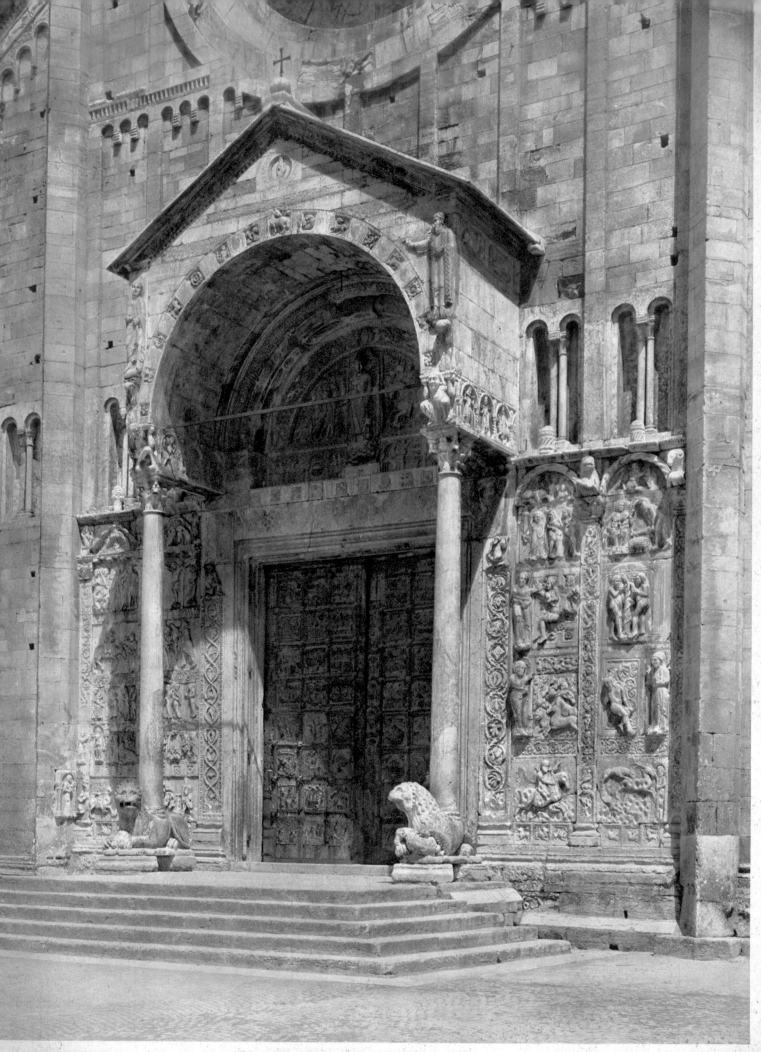

128 VERONA, Basilica di San Zeno Maggiore

THE GERMANIC LANDS

IN ROME ON CHRISTMAS DAY 800, Charlemagne was crowned emperor by the pope – an action he neither expected nor desired. Immediately after placing the crown on his head Leo III knelt before him. In this the pope recognized the secular protection embodied in the emperor, a secular power now sanctified by the Church. It was the manifestation of a desire for an ideal harmony; a desire which was never fulfilled. The Carolingian Empire, the largest political unity to have emerged in Europe since the fall of the Roman Empire, soon disintegrated, and when Otto II was crowned emperor in Rome at Christmas in 967, at the insistence of his father, Otto the Great, everything, from the choice of the date on, has the stamp of an act of political assertion: it was a deliberate and solemn revival of the Empire of the West, in defiance of the Emperor at Constantinople – although no doubt the ceremony was sincerely motivated by a desire for divine blessing which should also be made apparent to all the world.

Charlemagne made his capital at Aachen, where his great palatine chapel, now the cathedral *(pl. 129)* stands after more than a thousand years as a lasting symbol of his power and dignity. This same region opening out towards the Maas was again of great importance in the later revival of imperial power. The city of Maastricht, not far from Aachen, boasts two churches of the eleventh century *(pl. 130, 131)* whose massive westworks exemplify a quite different layout from that usual in monastery and parish churches. The normal west front containing the main entrance is replaced by a towering rectangular structure which spreads across the whole width of the church. It has only a few windows to the outside world, but inside it opens into the body of the church; it contains the porch, accessible through a side entrance, and above that a large oratory overlooking the nave for the emperor and his court. On the top floor there is a room like another chapel, but shut off from the rest of the church, which was reserved for solemn ceremonies such as the homage of a vassal.

Artistically and politically, the most important region was the central Rhineland; it had maintained this pre-eminence since Roman times, and from 1024 to 1138 it was the home of the Franconian emperors. Their imperial cathedral at Speyer *(pl. 186–187)* is the largest Romanesque building in Germany; it is also the most important for the actual details of its construction, although in its surviving form it has undergone modifications. The original church was built between 1030 and 1061, but barely twenty years later, in 1080, Henry IV ordered it to be greatly extended. The consequent extreme length of the building, which retains the crypt of the original

170

church as the imperial burial vault, speaks plainly. Framed by an arch of massive breadth and height the emperor's oratory above the west entrance looks down haughtily on the central nave; moreover the very distance from the oratory to the chancel created a polar tension between the emperor at the west end and the priests at the east. The chancel is flanked on either side in the transepts by a very shallow round-headed niche, rudimentary apses contained in the thickness of the wall. Inside, the niches are emphasized by triumphal arches, confident assertions of imperial power, which echo the arch over the emperor's oratory at the west end. Symbols of imperial power are plainly impressed all over this house of God, even in the deliberately classical ornamentation. Standing in the strongest contrast to the splendour of Speyer are the churches of the reforming movement which began at Hirsau, with the blessings of the emperor.

While there is a connection between the monastic reforms of Hirsau and Cluny, there is little between their architectural aspirations. The puritanical severity of Hirsau evolved at the very same time that the third church was being built at Cluny, a huge structure intended, it is true, to meet the greatly increased needs of the community, but even so in a style of great splendour. The abbey church of SS. Peter and Paul at Hirsau was destroyed during the wars of Louis XIV. It was begun in 1082 and completed in nine years, apparently on the pattern of Cluny II. The principles of the architectural school which it inspired, and whose influence was particularly strong in south Germany, are most clearly seen in another Benedictine church further south in the Black Forest: Alpirsbach *(pl. 168)*. The churches of the Hirsau school have a nave and aisles separated by columns, not piers; the cushion capitals are usually plain, while on the bases cowering demons may be carved. There is a gallery above the entrance; at the east the apses are often rectangular, not curved. There is no crypt, and the ceiling is flat and of wood. The austerity of these buildings left no room for architectural innovation.

The Cluniac reform disseminated through Hirsau was soon followed by the more extreme Cistercian reform which also emanated from France. This too penetrated eastward as far as Austria and was made visible in an even more individual architecture, although at first this did not employ any new elements. The first Cistercian abbey in Germany was founded at the request of Otto of Babenberg, son of the Austrian margrave Leopold III. After studying in Paris, he had entered the Cistercian monastery of Morimond in Burgundy; there he soon became abbot. Later he was appointed bishop of Freising in Upper Bavaria; as Otto von Freising he is known as one of the most important medieval historians. In 1135 or 1136 he persuaded his father to found the Cistercian house of Heiligenkreuz in the southern part of the Vienna woods. The body of the church *(pl. 176)*, which was consecrated in 1187, remains unaltered to this day. It is a basilica of majestic simplicity and strength, roofed with massive rib vaults above plain, square piers. The patronage of Margrave Leopold III, who more than three centuries later was canonized and became Austria's patron saint, furthered the spread of the Cistercian ideal; this ideal was expressed throughout Europe by the foundation of abbeys in wild, remote valleys which were cultivated by the community. Leopold's benefaction to the order in his own domains created there at least a working relationship between the secular and religious powers. A similar accord was never to be achieved between the papacy and the Empire.

The territories of Westphalia and Lower Saxony, with their great episcopal sees, their cathedrals and monasteries, were already producing significant works of art. The earliest pioneer was probably Bishop Bernward of Hildesheim, tutor to Otto III, himself an aristocrat and a great lover of the arts. Once the fateful year 1000 had passed, he embarked on an ambitious programme of building. The church of St. Michael, built between about 1001 and 1033, remains today the purest expression of the spirit of that age. It is a spacious basilica, with a pattern of supports in the arcades consisting of two columns alternating with one pier, a flat wooden roof (painted in the thirteenth century, *pl. 142*), and a transept at the west as well as at the east end *(pl. 141)*. It is likely that the church originally had only one choir, at the east; the western porch was probably converted into a second choir at the end of the twelfth century when the remains of Bishop Bernward were translated there after his canonization in 1193. For his church Bernward commissioned monumental bronze doors *(pl. 143, 144)* which are one of the masterpieces of Romanesque metalwork; each door is cast in one piece, unlike the famous Italian examples at Pisa *(pl. 107)* and Verona, though these are in fact later. Even without these doors – which were used instead for Hildesheim Cathedral – St. Michael is unquestionably the most important building of its period in Germany.

An attitude wholly different from Bernward's is embodied in the High Romanesque former collegiate church at Brunswick *(pl. 147)*. Its founder, Henry the Lion, was not a pious churchman to whom art was a means of expressing praise of God, but a secular ruler who intended the massive building to impress a sense of his own power and wealth on the beholder. It was the first vaulted church in Lower Saxony, which is probably why the square piers of the arcade are exceptionally thick. The vault itself is unusual, a series of groins without transverse arches, which leads the eye eastward without interruption. At ground level, however, the nave is abruptly terminated by a crypt which rises to an extraordinary height above the level of the rest of the church. This never housed the relics of a saint, but was intended from the first to be the burial chamber of the Welf dynasty. So great was their arrogance that even their last earthly resting-place had to appear not so much buried in the earth as raised up above it.

The pride of Henry the Lion is reflected in the famous Lion of Brunswick *(pl. 149)*, which he commissioned as both personal emblem and symbol of his family ('Welf' means whelp, or young lion): the first free-standing piece of Romanesque sculpture in Germany, it was cast in 1166 and originally stood outside the palace of Dankwarderode in Brunswick.

A number of castles built by the Hohenstaufens – of whom Henry the Lion was by far the most dangerous rival – survive; though they are mostly ruined, the two-storeyed palatine chapel in Frederick Barbarossa's castle at Nuremberg is intact *(pl. 162)*, and gives a good idea of the grandeur of more private offerings to God.

Romanesque art in the German-speaking lands is grouped by and large along certain lines of influence. The most impressive of these is the region of the Rhine and its tributaries, with what is perhaps the most beautiful surviving Benedictine church, Maria Laach in the Eifel *(pl. 191)*, and the equally picturesque cathedral of Limburg on the Lahn *(pl. 189)*. Aesthetic effect was not the first consideration: with its towers the cathedral symbolizes the City of God, the Heavenly Jerusalem. The most important buildings, both ecclesiastically and architecturally, are found on

the banks of the Rhine itself. The upper Rhine has the minsters of Basel *(pl. 184)* and Strasbourg *(pl. 185)*, and the three imperial cathedrals: Speyer *(pl. 186–187)*, Worms *(pl. 188)* and Mainz *(pl. 190)*. The lower Rhine is dominated by Cologne *(pl. 196–199)*, the seat of a very powerful bishop-ric: not far upstream there is the two-storeyed church of Schwarzrheindorf *(pl. 192)*, built in the Late Romanesque style by an archbishop of Cologne as both domestic chapel and burial place. A little further downstream is the cathedral of Essen on the Ruhr – formerly an imperial convent – which shows the influence of Aachen *(pl. 201)*, and in Neuss on the Rhine there is the magnificent abbey church of St. Quirinus *(pl. 200)*, begun on the site of an earlier building in the early thirteenth century. There is no other concentration of buildings that can be compared in number, monumentality and splendour with the churches of the Rhine.

The churches of the Danube region are remarkable for their individuality. Regensburg, un-der imperial patronage, was a centre of intense activity; in the city itself there are the Allerheiligen-kapelle attached to the cathedral *(pl. 170)* with its painted walls and dome, the decorated porch of the cloisters of St. Emmeram, and above all the imaginatively ornamented porch of St. Jakob, the church of the Irish monks *(pl. 171)*. A little way downstream lies the Benedictine church at Prüfe-ning, with surviving mural and dome paintings. All of these works, products of the High and Late Romanesque of the twelfth and thirteenth centuries, show an imagination and a love of de-coration whose vitality has no equal elsewhere in Germany. The same thing is found further down the Danube towards Vienna and in Vienna itself. The exterior decoration on the apse of the small, early thirteenth-century church of Schöngrabern *(pl. 174)*, which lies to the north of Tulin in Lower Austria, is as startling in the originality of its carving as the porch of St. Jakob in Re-gensburg. Finally there is the Riesentor, the 'giants' portal', of St. Stephen's Cathedral in Vienna *(pl. 175)*, in which the figurative and abstract carving on arch and jambs displays a dazzling in-ventiveness. It was so rich and so exuberant that in a later, sterner age some of the carvings on the jambs were chipped away, to leave a smooth surface. This decoration, on the main door of the cathedral, must have been added to the earlier Romanesque building around 1240 or 1250. The Romanesque, the first style to prevail throughout Western Europe, was still in favour then along the Austrian reaches of the Danube; in the Rhineland, by 1250, the first signs were coming in from northern France of the second Western style, the Gothic.

129 AACHEN CATHEDRAL (RHINELAND-WESTPHA-
LIA). *Interior looking north-west.* This was originally the
chapel of Charlemagne's palace, dedicated in 805.
Later alterations have not affected the basic structure:
it is a lofty building, sixteen-sided on the exterior,
with an octagonal central space covered by a domical
vault. This central space is surrounded by an ambula-
tory at ground level and a gallery above, on the level of
the palace; behind the spot where the emperor's throne
stood is the westwork. It exemplifies, more than any
other building, the idea of the Roman Christian state
protected and ruled on earth by the Frankish emperor.

Our photograph is not the usual view towards the
Gothic chancel; instead it shows more clearly the
character of the original building. The great bronze
chandelier has hung there since 1184, symbolizing
with its angle turrets the Heavenly Jerusalem. Frede-
rick Barbarossa commissioned it from an Aachen
goldsmith, Wibert, after he had – for political reasons
– contrived the canonization of Charlemagne.

130 MAASTRICHT, THE NETHERLANDS, ST. SERVAAS.
Detail of the westwork. The westwork of St. Servaas is a
particularly impressive example of the type found
in churches built under the Salian and Hohenstau-
fen emperors. It was built about 1087, when the monas-
tery became independent of all secular authority other
than that of the emperor. It was extensively altered be-
tween 1165 and 1177 under the Emperor Frederick
Barbarossa.

The emperor's throne stood in the first floor gallery
of the westwork, beneath a semi-dome in the vaulted
ceiling. The second floor served as a *capella* in the orig-
inal sense, a room where oaths were sworn on the
cappa, the cloak of St. Martin, and later, after that was
lost, on the cloak of St. Martialis which is still kept
at Aachen. A dome, added during later rebuilding,
now conceals and obstructs the imperial gallery.

131 MAASTRICHT, THE NETHERLANDS, *O.L. Vrouwe-
kerk.* The massive westwork, like a section of curtain-
wall between two towers, proclaims its origin of *c.*
1000. Like other westworks, its purpose in the early
Middle Ages was to provide an oratory and throne-
room for the emperor. The topmost section of the towers
is a later addition.

132 TOURNAI CATHEDRAL, BELGIUM. *Interior of the
transept.* The Cathedral of Notre-Dame, built be-
tween 1110 and 1141, is the most imposing building
of the entire region between the Scheldt, the Maas and

the Rhine. The transept, extending on either side of a
vast crossing-space, is terminated at either end by a
monumental apse with four tiers of arched openings.
The many narrow high arcades were a Germanic
Romanesque solution to one of the main problems of
architecture at the time: how to lighten and enrich the
walls of large buildings.

133 SOEST (WESTPHALIA), ST. PATROKLUS. The mighty
collegiate church is a living reminder of the importance
the town of Soest once enjoyed as a centre of trade. Its
long history reaches back to its foundation by Arch-
bishop Bruno of Cologne, the brother of the Emperor
Otto I, in the second half of the 10th century. Instead
of the traditional westwork, a massive tower was erect-
ed at the west end between 1200 and 1220. Sturdy and
square, it has round-headed lights which form com-
plicated patterns in the gables. Below it, instead of a
portal, is an open loggia.

134 SOEST (WESTPHALIA), ST. PETRUS. *Ground floor of
the westwork.* Begun in 1150, St. Petrus is a basilica
with alternating supports in the arcade and high groin
vaults. The most impressive surviving part of the orig-
inal building is the westwork, which served as a pala-
tine chapel. It may have been influenced by the earlier
westwork of the abbey church of Corvey, but here
the space is narrower, the stilting of the vaults more ex-
treme, and the round pillars are given cushion capi-
tals. Despite its late date, the overall impression is still
constricted, primitive and heavy.

135 PADERBORN CATHEDRAL (WESTPHALIA). *West
tower.* The second cathedral at Paderborn was still un-
finished when in 1009 Bishop Meinwerk stopped the
work and ordered the building of a third, which was
ready for consecration as early as 1015. At the west end
there was a choir within a massive, square tower. Af-
ter a serious fire, the so-called fourth cathedral was built
by Bishop Imad in 1058 on the same plan as Mein-
werk's church. Imad built the west tower higher and
made it a conspicuous landmark; stair-turrets cluster
around it like a bodyguard. Imad no doubt intended
it to house his tomb, and was indeed buried in it.

136, 137 FRECKENHORST (WESTPHALIA), THE CONVENT
CHURCH. *Detail of the font; view from the south-west.* A
nunnery was founded at Freckenhorst probably as
early as 851, and a new church with a westwork was
begun on the site of the first church in 1096. It was
consecrated in 1129. Only a generation later the central

section of the westwork was raised to form a tower, and shortly afterward the two side turrets were similarly built up. The present spire dates from 1689. The westwork originally had a two-storeyed portico.

The font inside the church is dated 1129; it has a cylindrical basin divided into two registers by a band carrying an inscription. The upper register shows episodes from the life of Christ; in the lower half, as if vanquished by the Gospel, the powers of darkness lie writhing. One of the lions of hell *(pl. 136)* is so inextricably entwined with his neighbours that their tails wind into his jaws and out of his ears. The carving is of astonishingly high quality for the time.

138 IDENSEN (LOWER SAXONY). *Wallpainting in the church.* At some date before 1129 Bishop Sigward of Minden had a small private church built on his estate at Idensen, intending it as a burial chapel. It is a rectangular aisleless building with a slight suggestion of a transept and, following immediately to the east, a polygonal apse. Its importance lies in its painted decorations which are unique, having been preserved in this secluded spot since they were painted between 1120 and 1130 by monks from Helmarshausen. The painting is of high quality and expressiveness; scenes like the Baptism of Christ, of which a detail is reproduced here, derive from Ottonian and, earlier still, Byzantine models.

139 EXTERNSTEINE (HORN, WESTPHALIA). *Relief.* The Externsteine are five natural rock pinnacles which Bishop Henry of Werl (†1127) transformed into a shrine on the model of the Holy Places in Jerusalem: Golgotha, the chapel on Calvary, Adam's Chapel and the Church of the Holy Sepulchre. It seems not unlikely that these remarkable formations had previously been a pagan place of worship. The rock-cut relief of the Deposition, about 18 feet high, is the earliest work of sculpture on such a large scale in Western Europe. It reflects the traditions of pre-Christian Germanic art and also the spirituality of Christian art of classical inspiration, with its emphasis on proportion and order.

140 CORVEY (WESTPHALIA), ABBEY CHURCH. *Oratory in the westwork.* The original westwork of the monastic church, built between 873 and 885, still survives. Considerable alterations were made to it, but in recent years the interior has been impressively restored to something like its original appearance. At ground level the space is divided by twelve piers and four columns which support the upper storey. This was the imperial oratory, itself two-storeyed, surrounded on all four sides by arcades on square piers which support a gallery on three sides. The fourth side, towards the east, is an arcaded wall, allowing a view down into the body of the church. The altar of the chapel stood in the middle of this wall.

141, 142 HILDESHEIM (LOWER SAXONY), ST. MICHAEL. *West transept end; ceiling.* This outstanding church was built between about 1001 and 1033 under Bishop Bernward, who was later canonized. After a major fire in 1162 restoration work was necessary; the forms of the columns and capitals were altered, and new choir screens were introduced. The painted wooden ceiling *(pl. 142)* dates from the 13th century. The church was reconsecrated in 1189; after various alterations, it was severely damaged in an air-raid in March 1945. It has been rebuilt as a replica, as faithful as possible, of Bernward's original church.

The overwhelming impression made by both interior and exterior is one of harmonious proportions. The nave arcade has alternating supports, one of the earliest examples of this characteristic Lower Saxon feature. The square section of the crossing provides the basic module for the proportions of the rest of the church.

St. Michael's has two transepts, at the east and west ends. The arcaded galleries on the end walls of the west transept – known as the 'angelic choirs' – were perhaps inspired by the galleries in the westworks of such older buildings as the abbey church of Werden or St. Pantaleon in Cologne.

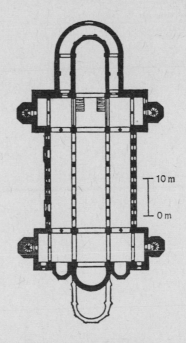

Plan of St. Michael's, Hildesheim

143, 144 HILDESHEIM CATHEDRAL (LOWER SAXONY). *Details of the bronze doors.* These doors were intended by Bishop Bernward for St. Michael's, but were appropriated for the newly-completed cathedral by his successor, Bishop Godehard. Over 15 feet high, each was cast in a single piece in open sand-moulds in Bernward's workshops, in the year 1015 according to an inscription. They are the most eloquent examples of plastic art in the whole Ottonian period. It is possible to distinguish the hands of several different artists in the various panels; the best of these are far superior to any previous sculptural works since classical times. The essence of the action is vividly expressed in the figures' gestures, above all in the best-known panel, which shows God confronting Adam and Eve at the foot of the Tree of Knowledge after the Fall *(pl. 143)*. Equally grand in conception is the portrayal of Eve, suckling her child under a scanty shelter after the expulsion from Paradise *(pl. 144)*: the figure seems to be a prototype of later Madonnas, a prophecy of the sorrows of Mary, whose son's sacrificial death will redeem mankind from Eve's sin and God's curse.

145 KÖNIGSLUTTER (LOWER SAXONY), BENEDICTINE MONASTERY. *North cloister walk.* The Emperor Lothar III founded this monastery and laid the first stone in 1135. The north side of the cloisters, built between 1150 and 1170, is of incomparable richness. The columns, which support an upper storey, are decorated with a variety of patterns and have exquisite foliage capitals of classical inspiration. The burgeoning leaves burst from the depth of the block like sprays from fountains, become entwined with their neighbours and break free again; each one is different, all are essentially Romanesque but already anticipate the organic forms of the art to come.

146 THE BRUNSWICK LION. Made in 1166 to stand in front of Duke Henry the Lion's palace of Danwarderode, this bronze lion, originally gilded, was the emblem of the Duke and of his family. It is the first piece of free-standing sculpture created in Western Europe in the Middle Ages, a perfect example, with its taut strength, of the almost expressionist stylization which Romanesque art could achieve.

147, 148 BRUNSWICK CATHEDRAL (LOWER SAXONY). *Interior looking west; detail of Crucifix.* The former collegiate church built of rough stone under Henry the Lion between 1173 and 1195 was the first large vaulted building of medieval Saxony to be erected in one uninterrupted process. The groin vault without transverse arches is as unusual as it is archaic, and clearly owes nothing to the French manner of vaulting which was already influential elsewhere. The church is a cruciform basilica; instead of the alternating supports common in Saxony, consisting of piers and columns, here there are only thicker and thinner piers. The choir and crossing are raised high above the level of the nave, over a vast crypt. In this eastern area a considerable amount of wallpainting survives, dating from 1220–40, although it is now rather faded. The seven-branched bronze candlestick was given by Henry the Lion to his church.

The great figure of Christ on the Cross *(pl. 148)* is, according to an inscription on the belt, the work of a sculptor called Imerward. It is similar to the earlier, much venerated, *Volto Santo* in Lucca, and is unusual for Germany. It must date from c.1173, when Duke Henry returned from Palestine with relics, of which some were stored in the figure's head.

149, 150 JERICHOW (BRANDENBURG), PREMONSTRATENSIAN CHURCH. *Raised choir; interior looking east.* This church, built quickly around 1200, shows a complete mastery of the technique of building in brick. Even the round pillars with their remarkably shallow bases and trapezoidal capitals are made of brick. The dignified interior, with a flat wooden ceiling, is dominated by the raised choir behind a parapet (also of brick), which ends in the smooth-walled, serenely lit apse. The crypt is accessible from the nave through two open arches, in the manner usual in Italy and not uncommon in Germany (e.g. Speyer, Vreden).

151 LEHNIN (BRANDENBURG), ABBEY CHURCH. *Interior looking east.* Built for a Cistercian abbey between 1180 and 1270, this brick church is quite different from Jerichow in its effect. The internal articulation is more complicated, and whereas at Jerichow the brick is exposed, here it is largely plastered over. The nave and rib vaults show unmistakably the process of transition to the Gothic style.

152 QUEDLINBURG (SAXE-ANHALT), THE CONVENT CHURCH. *Interior looking south-west.* The present church which dominates the town of Quedlinburg, sited on a rock where a fortress stood in prehistoric times, had no fewer than four predecessors on the same site. It was consecrated in 1129 in the presence of the Emperor Lothar III. It is a cruciform basilica with a flat wooden roof; the smooth, solid masses of the outer walls, only slightly articulated, reflect the uncluttered serenity of the interior. As at St. Michael's in Hildesheim, the module is provided by the square plan of the crossing. At the west end there is a narthex with, on its upper floor, the so-called Nuns' Gallery, which opens into the church through four arches.

153 GERNRODE (SAXE-ANHALT), ST. CYRIAKUS. *Relief on the Easter Sepulchre*. The convent at Gernrode was founded in 959 by Margrave Gero, to provide for his young widowed daughter-in-law, who became the first abbess. In the church stands the highly interesting ruined cenotaph, representing the Holy Sepulchre after the Resurrection. The figures carved in relief show considerable artistic skill, and are unique, though they were clearly inspired by the stucco frieze in the Tempietto of Santa Maria in Valle at Cividale del Friuli (750-70), the climax of Lombardo-Byzantine plastic art. On the west side of the Easter Sepulchre, in an elaborate frame, is the figure of a woman – probably one of the three Marys at the tomb. Her bearing and features express restrained sorrow. The work was probably executed about 980, at the same time as the nave.

154 HALBERSTADT (SAXE-ANHALT), LIEBFRAUEN-KIRCHE. *Relief on the choir screen*. The church of Our Lady contains an important Romanesque choir-screen, made of stucco about 1200. Byzantine influence is still perceptible, but the bodies of the figures can be sensed beneath their flowing robes. On each half of the screen there are seven figures under an arcade, Christ and six apostles on the north side, and the Virgin and the other six apostles on the south side. The figure of St. Andrew, on the north, is the most vital and eloquent.

155 GOSLAR (LOWER SAXONY), KAISERHAUS. This is the oldest and most imposing of all the surviving palaces built by the medieval German emperors. A first complex of buildings was erected during the reign of Otto III, for the administration of the silver-mines which had been worked from c.970; then a palatine hall was built by the Salian Emperor Henry III (1039-56), which has remained basically the same, despite later restorations. There would however, in all probability, have been no arcades in the large arch below the gable, which would thus have given greater emphasis to the position of the imperial throne in the centre of the hall.

156 GOSLAR (LOWER SAXONY), NEUWERK CONVENT CHURCH. *Westwork, seen from the south-east*. Of the several fine Romanesque churches in Goslar, this was the last to be built. The east end must have been in use by 1186; although the vault was not built until c. 1200, the form of the piers indicates that it was intended from the beginning. The westwork rises above the level of the nave roof; its polygonal twin towers are in the style characteristic of Saxony north of the Harz.

157 MAGDEBURG (SAXE-ANHALT), TANNERS' HALL. The severe bombing raids of the Second World War, which flattened the Buttergasse in the Old Town, brought to light the former hall of the Tanners' Guild, which had once stood against the town wall. For centuries it was concealed, serving as cellars for a number of houses. After the partition walls had been removed, it was revealed as a spacious hall, all the more remarkable since it it hard to think of a comparable surviving building of the same date, c.1200. Originally at ground level, it now lies 10 feet below: the gradual accumulation of dirt, rubble and refuse has raised the level of the surrounding streets.

158 MAGDEBURG (SAXE-ANHALT), LIEBFRAUENKIR-CHE. *Cloisters*. The early two-storeyed cloisters survived the bombing which damaged other parts of the Liebfrauenkirche; the two-storeyed *Tonsur* which projects into the cloister garth has on its ground floor the monks' washing-place, and is the oldest surviving example of the type in Germany.

159 FULDA (HESSE), ST. MICHAEL. *The Rotunda*. This was originally the chapel of the abbey cemetery. The circular lower storey seems to be the only surviving remnant of the church of 820-22. The building above it was constructed in the 10th and 11th centuries and a nave was added to the west. The central rotunda has an ambulatory and gallery covered with flat roofs; the upper storey rests on an arcade of eight columns, some of which have acanthus-leaf capitals. St. Michael's is the earliest copy in Germany of the Church of the Holy Sepulchre at Jerusalem.

160 PAULINZELLA (THURINGIA), ABBEY CHURCH. *West door*. After Alpirsbach this monastery is the finest of the daughter houses of the reformed Benedictine abbey at Hirsau. It was founded by monks from Hirsau who built the choir and transept between 1112 and 1132; the nave was not completed until c.1160. An open forecourt was originally planned for the west end, but it was turned into a narthex. The slim, free-standing columns of the door and the taut profile of the arches are of south German inspiration.

161 FREIBURG (SAXONY), MARIENKIRCHE. *Goldene Pforte*. The 'Golden Portal' is all that survives of the Romanesque church that preceded the present cathedral. It owes its name to the lavish gilding which originally covered it. In the tympanum the figure of the Christ Child in the lap of the Virgin lies at the centre of the circle described by the archivolts, which determines the proportions of the whole. The jamb statues

stand against alternate shafts, with decorated shafts between them, a variant on the French pattern where statues are ranged closely together to form an avenue.

162 NUREMBERG (FRANCONIA), CASTLE CHAPEL. This small chapel, built about 1180 at the earliest under the Hohenstaufen Emperor Frederick Barbarossa, is of the two-storeyed type for which the palatine chapel at Aachen set the pattern. Four sturdy columns on the ground floor support a gallery around a square well. With its boldly carved capitals and bases, it is the most imposing of all the two-storeyed chapels of the High Romanesque period.

163, 164 BAMBERG CATHEDRAL (FRANCONIA). *Detail of the choir-screen; eastern apse.* The final service of consecration of the cathedral took place in 1237; the early 13th century building was on the same scale as its predecessor, founded in 1004 by Henry II. The 'purification' undertaken in 1828 can only be regretted. Basilican in plan, the cathedral has two choirs and a western transept. The raised eastern apse is particularly ornate, and has five equal sides. Above the large, round-arched windows with decorated surrounds there is a dwarf gallery of the Rhenish type, with groups of triple arches. Below the windows the lowest, plain, stage is not polygonal but rounded, an arrangement characteristic of the Upper Rhineland.

Until the 17th century the two choirs were separated from the nave by rood-screens, of which only the eastern one has survived. Prophets on the north side and apostles on the south side stand in pairs under an arcade of trefoil-headed arches, some of which are plain and some decorated with foliage. The folds of the apostles' garments become more flowing as one progresses north, the heads and gestures more animated *(pl. 163)*; the prophets are even more eloquent. This screen marks the final culmination of Romanesque sculpture, on the brink of Gothic.

165 MAULBRONN (WÜRTTEMBERG), ABBEY. *Lay brothers' refectory.* The Cistercian abbey of Maulbronn, in a wooded valley in the hills of Württemberg, has almost entirely survived. Its two refectories are built in a style which verges on Gothic, yet they are unquestionably Romanesque in their basic conception. In the lay brothers' refectory, in particular, it is only the capitals, with their tight buds, which foreshadow Gothic.

166 FREUDENSTADT I. SCHWARZWALD, STADTKIRCHE. *Detail of lectern.* This piece probably came from the monastery church of Alpirsbach *(pl. 168)*. Carved from a single piece of limewood, it consists of figures

of the four Evangelists facing in different directions and supporting the bookrest. The figures are approximately 3 feet high; their stiff, columnar pose and the rather feeble attempt to indicate the folds of their robes put the date of origin at about 1150. The work shows Byzantine influence.

167 HIRSAU I. SCHWARZWALD, ST. AURELIUS. *Capitals.* The Benedictine monastery at Hirsau was a centre of monastic reform and a leading supporter of the Pope against the Emperor in the Investiture Dispute. The abbey church of St. Peter and St. Paul, which played such a distinctive role in the history of German architecture, was almost totally destroyed in 1692 by the army of Louis XIV. The smaller, older church of St. Aurelius, of 1059-71, is fairly well preserved. The treatment of the arcade, where earlier piers were replaced *c.* 1120, is typically Swabian: large cushion capitals rest directly on the columns without intermediate necking, and have no abacus block between their coping and the masonry above.

168 ALPIRSBACH I. SCHWARZWALD, ABBEY CHURCH. *Nave looking west.* The Benedictine monastery at Alpirsbach was founded in 1095; the church was begun at once and completed within the first half of the 12th

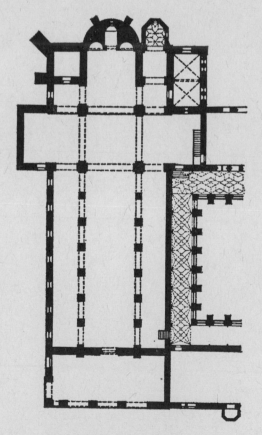

Plan of the abbey church of Alpirsbach

century. The affiliation of Alpirsbach to Hirsau meant that the building followed closely the principles of austerity, painstaking craftsmanship and formal simplicity first embodied in the church of St. Peter and St. Paul at Hirsau. The church was skilfully restored in 1960–62 and is acknowledged to be the most impressive surviving example of the Hirsau school of monastic architecture.

169 ALTENSTADT (BAVARIA), St. MICHAEL. *East end.* This is the best preserved Romanesque building in Bavaria. It was built *c.*1200, of tufa, and is made up of simple formal elements. The east end with two tall towers, a chancel apse, and two smaller apses in line with the side aisles, makes the same monumental impression as a westwork. The wall between the two towers is finished by a lean-to roof, instead of a gable.

170 REGENSBURG CATHEDRAL (BAVARIA), *Allerheiligenkapelle.* The Chapel of All Saints, a High Romanesque structure of crystalline geometrical purity, opens off the Gothic cloisters of Regensburg Cathedral. It was built *c.*1150–60 by one of the bishops as his burial-place, probably in imitation of Early Christian practices in the Near East. Such mathematical precision in layout and classical harmony of forms is very rare in Germany.

171 REGENSBURG (BAVARIA), St. JAKOB. *Detail of the Schottenportal.* St. Jakob was built for the monks of the Irish church (known as 'Schotten', Scots). There are records of an Irish monastery in Regensburg as early as 1075; a new church was built between 1150 and 1184, and was altered and enlarged around 1230. The sculpture on the north portal, the so-called Schottenportal, is famous; our detail is of the area to the left of the doorway. It is divided into upper and lower sections by a blind arcade. In the lower part there are mythical figures on a smooth wall: these were no doubt regarded as protective talismans, representing the sinful, fleshly demons of the natural, anti-Christian world. The most striking group is the pair of lovers, shown in half-length and embracing, which is reminiscent of Etruscan tomb sculpture. The Schottenportal was erected during alterations around 1230.

172 FREISING CATHEDRAL (BAVARIA). *Crypt.* The cathedral of 1159–1205 was the third church built for the diocese of Freising, founded by St. Boniface. Only the crypt survives in its original form. Its groin vault is supported by three rows of alternately square and round pillars. The *Bestienpfeiler* ('pillar of beasts') in the foreground has affinities with the central mullions of such

French portals as those of Moissac and Souillac, of *c.* 1120–50. The pillar seems to be entirely made up of entangled bodies, as though the struggle were taking place within the stone and not merely on the surface. Even on close examination it is difficult to tell which beast is fighting which, which is threatening to swallow another or actually doing so, and which is at bay or trying to escape. This extraordinary work, which has no parallels in the region, must have been carved at the very latest by 1205, and may have been executed as early as the mid-12th century.

173 SALZBURG, AUSTRIA, NONNBERG CONVENT CHURCH. *Detail of wallpaintings.* In the mid-19th century wallpaintings dating from *c.*1150 were found under the nuns' choir. Various saints are shown, each under an arch. The hieratic, flat style of painting displays a particularly close adherence to Byzantine models; though here the artist seems to be striving for an even more other-worldly, wan effect. The rarity alone of surviving Romanesque wallpaintings north of the Alps makes those at Nonnberg outstanding.

174 SCHÖNGRABERN, LOWER AUSTRIA. *Apse of the parish church.* This semi-cylindrical apse is decorated with some of the most interesting Romanesque sculpture in all Austria, dating from the first third of the 13th century. The articulation of the apse (a version of Lombard banding, with an arched corbel table and applied shafts) provides a richly varied framework for the extraordinarily vivid scenes in relief. The subject of some of these is immediately apparent: in the lower register to the left of our illustration, for instance, is the Fall, and in the centre Cain and Abel make their offerings to God. In other cases, however, the motive of the sculptors may have been similar to that at Regensburg *(pl. 171)*: the desire to provide protective talismans against evil.

175 VIENNA CATHEDRAL, AUSTRIA. *Detail of the Riesentor.* Traces of the Romanesque façade are still visible in the enlarged west front of the Gothic cathedral of St. Stephen; the great Riesentor ('giants' doorway') is well preserved. The entrance is under a round arch, between jambs whose rich ornamental carving dates from *c.*1240–50. There are some reminiscences of woodcarving in the forms of the mouldings with their chevron patterns and interlacing bands. The whole portal was originally brightly painted, and must have been a most splendid sight. Austria had in the 13th century all the self-confident energy of a wealthy frontier state; in the Riesentor romantic exuberance is heightened to baroque drama.

176 HEILIGENKREUZ, LOWER AUSTRIA. THE ABBEY CHURCH. *Interior looking west.* The oldest Cistercian abbey in Lower Austria, Heiligenkreuz was founded in 1135; the church was consecrated in 1187. In 1949 the 19th-century organ loft was removed from the west end, opening up the view from the chancel along the nave to the well-proportioned west wall with its three windows. The simplicity of the gabled west front, which has no towers, is matched inside by the restraint in the use of thicker and thinner square piers to suggest alternating supports. The Burgundian rib-vaulting of the nave is probably the earliest in the German lands, dating from *c.* 1150.

177 PETRONELL, LOWER AUSTRIA. KARNER. This is the oldest of the small round churches peculiar to Austria, called *Karner*. They were usually cemetery chapels built over charnel houses. This particular example may have been built as a stronghold in the mid-12th century. The cylindrical body of the church is window-less; another smaller cylinder with three windows is attached to it on the east. Both are articulated by slender shafts which run up to an arcaded frieze and convex cornice.

178, 179 GURK CATHEDRAL (CARINTHIA), AUSTRIA. *West gallery; crypt.* This great monastic and cathedral church was begun in the 1140s by Roman I, as a deliberate attempt to outshine Salzburg Cathedral.

The walls of the first-floor gallery at the west end were painted about 1230. In 1260 the murals were damaged by fire, but restored at once *(pl. 178)*. The main subject is a symbolic representation of the Virgin on the throne of Solomon. The style is typical of the Late Romanesque phase: essentially graphic, with heavily accented folds emphasizing contours and bringing out the details within the main outlines. The Gurk cycle is the most important and best-preserved example of this later style of painting in the German area.

Although much added-to and altered, the body of the cathedral is a relatively unspoilt Romanesque building; in the crypt this is immediately apparent *(pl. 179)*. Its vast size is probably due to the fact that in the 11th century it had to accommodate large numbers of pilgrims come to venerate the shrine of St. Hemma, the aristocratic foundress of the Benedictine nunnery at Gurk. With its great number of columns the crypt, consecrated in 1174, rivals similar ones in northern Italy.

180 CASTEL D'APPIANO (BOLZANO), ITALIAN TYROL. CASTLE CHAPEL. *Wallpainting.* The castle was built on a steep rocky outcrop in the first half of the 12th century.

The little chapel is a plain rectangular chamber with an apse, and two lateral apses in the thickness of the wall. A certain amount of the original wallpainting of *c.* 1150–60 has survived, notably a fresco of Christ as Judge amid the apostles on the wall above the apse, of which we show a detail. The style is markedly dependent on Byzantine painting of the same period. The Crusades had led to particularly close contacts with Greek culture, which had much more influence on painting than on the other arts.

181 NATURNO, ITALIAN TYROL. ST. PROCULUS. *Detail of wallpainting.* This tiny country church in the Alto Adige is one of the oldest in the Tyrol and must closely resemble the little churches built there under the Roman Empire; it dates from the 8th or 9th century. It owes its fame to the remnants of wallpaintings executed at the time of its building and discovered in 1923, which are the largest cycle of Carolingian paintings to have survived. On one of the walls St. Paul is shown escaping in a basket over the walls of Damascus; our detail is from a group of onlookers.

182 ZILLIS (GRISONS), SWITZERLAND. ST. MARTIN. *Wooden ceiling.* The small town of Zillis was given to the bishop of Chur by the Emperor Otto I. The 12th century church which stands today is simple and un-aisled, but covered with a remarkable painted ceiling which probably dates from before 1150. The painting is crude and naïve, but nonetheless of great interest. In 153 panels it illustrates Christ's ancestors and his life, up to the Crowning with Thorns. Incidents from the life of St. Martin also appear, and the ocean, teeming with monsters, flows round the border. Each of the panels is itself framed in an ornamental border; the composition of the individual scenes is clearly derived from manuscript paintings of the Reichenau school.

183 REICHENAU SWITZERLAND. MITTELZELL MINSTER. *West tower.* The west tower was added to the Benedictine abbey church by Abbot Berno (1030–48), after a fire had damaged the original Carolingian structure which had already been extended at the end of the 10th century. It still has its original small windows and external articulation formed by friezes of small arches and long vertical pilaster-strips. The belfry stage was rebuilt in 1437 and the roof is modern, but the overall effect is still unspoilt.

184 BASEL CATHEDRAL, SWITZERLAND. *Detail from the former rood-screen.* The cathedral built between 1000 and 1019 by the Emperor Henry II was destroyed by fire in 1185. A new building was begun at once,

incorporating the remains of the old church. The remains of the original rood-screen were set into the east wall of the transept: these consist of six pairs of apostles standing under an arcade, and a relief with scenes from the life of St. Vincent of Valencia. The style puts the carving, at the very earliest, around the year 1000. Both the relief and the figures of the apostles resemble ivory carvings, enlarged and transferred to stone.

185 STRASBOURG CATHEDRAL (ALSACE), FRANCE. *Interior of the crossing*. When Strasbourg Cathedral was rebuilt during the reign of Frederick Barbarossa, in the late 12th century, the substructure of an earlier church built under the Ottonian and Salian emperors was retained. Work began at the east end. The crypt was extended westward, raising the floor level of the crossing so that it appeared to be an extension of the chancel. The architect accepted the consequences of this: he built a towering domical vault over the crossing and emphasized the separation of the two arms of the transept by inserting a huge pillar on each side.

186, 187 SPEYER CATHEDRAL (RHINELAND-PALATINATE). *Exterior from the south-east; north aisle*. One of the imperial cathedrals erected by the Salian emperors, this is the largest Romanesque church in Germany and among the most important of all Romanesque buildings in Europe. Of the original 435-foot long structure – built between 1030 and 1061 – the aisles *(pl. 187)* and the crypt still exist almost unchanged. Henry IV began an ambitious rebuilding in 1080 as an expression of his imperial power; it is to this period that the most striking features of Speyer are due. At his death in 1106 the work was in its last stages. The transept and chancel were completely reshaped; the transept was given giant niches like triumphal arches in its eastern walls, and the chancel was given a semicircular apse. The outside wall of the new apse was articulated with tall, powerful arcades, alternately blind and pierced by a window. An open gallery runs along below the eaves: this was the first distinct appearance of the 'dwarf gallery', an architectural feature found mostly in the Rhineland, but which also spread to Italy. The dwarf gallery continues around the entire building, forming a visual link between the separate elements. The church was extensively restored in 1957–61, but the crossing tower was not rebuilt in its original form.

188 WORMS CATHEDRAL (RHINELAND-PALATINATE). *Crossing dome*. St. Peter's in Worms, the smallest of the three great Rhineland cathedrals, is both the best preserved and the latest of them; it expresses more forcefully than even Speyer or Mainz the particular strength

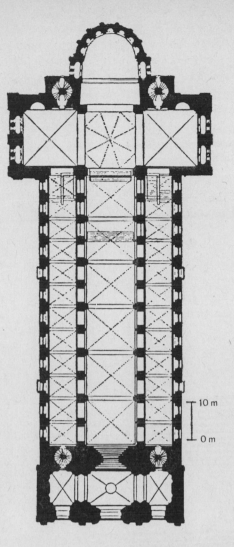

Plan of Speyer Cathedral

of Hohenstaufen building, the sculptural treatment of architectural mass. Following the ground plan and incorporating the remains of an earlier church, Bishop Conrad II began the new building *c.* 1171 as a basilica with eastern and western choirs. The most impressive internal feature is the dome over the crossing: it is similar in construction and form to the crossing-dome of Speyer, but it is more massive, and the blind arcade which encircles its base above the deep squinches is better preserved.

189 LIMBURG A.D. LAHN (HESSE), ST. GEORGE. *Transept*. The former abbey church of St. George stands like a many-towered fortress of the Church Militant on a rock above the river Lahn. The abbey was founded in 911. In 1215 the present building, replacing an 11th-century church, was begun; it was consecrated in 1235

181

and probably completed by the mid-century. At this time in Germany Gothic forms were only beginning to appear.

190 MAINZ CATHEDRAL (RHINELAND-PALATINATE). *Western apse.* The third of the monumental cathedrals along the Rhine is in Mainz, the seat of the first archbishop, St. Boniface, the Apostle of the Germans. Its building history is long and involved. Fragments of the older church were incorporated when, in 1181, an extensive rebuilding programme was undertaken; construction went on more or less continuously until the completion of the west end in 1243. This consists of the transept with its gabled north and south fronts, the crossing tower and the glorious trefoil choir flanked by octagonal turrets. This is architecture treated as an ornate piece of sculpture, the walls recessed and galleried to form multiple layers, which in turn serve to emphasize the nature of the structure itself.

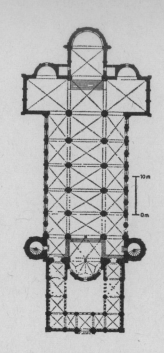

Plan of the abbey church of Maria Laach

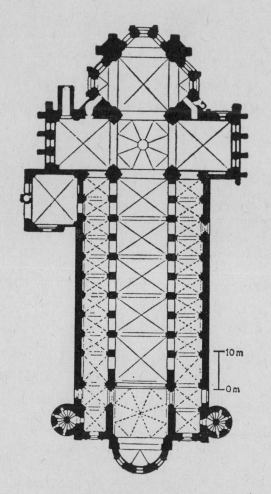

Plan of Mainz Cathedral

191 MARIA LAACH I.D. EIFEL (RHINELAND-PALATINATE), ABBEY CHURCH. *View from the north-west.* The Benedictine abbey for which the church was built was founded in 1093 by the Count Palatine Henry II. Work was interrupted, then resumed in 1112; the church, with flat wooden ceilings, was essentially complete in 1152. The eastern towers were added in 1170, but the upper storeys of the westwork were not finished until the time of Abbot Albert (1199–1216). Finally, under Abbot Gregorius (1216–35) the church was given stone vaults; the 'Paradise' in front of the westwork was also a late addition. In its grouping of relatively simple geometrical solids, the composition of this massive church shows considerable variety and imagination.

192 SCHWARZRHEINDORF (RHINELAND-WESTPHALIA). *East end.* This two-storeyed church was founded by Archbishop Arnold II of Cologne, as a private oratory and burial chapel on his own estates. It was consecrated in 1151. In plan it originally had short, square-ended transept arms and a square chancel of equal length; a semicircular apse was then added. As though forced upward by the projecting gables at its base, a huge tower rises over the crossing; its belfry stage was added later, and the Gothic spire is later still. The dwarf gallery visible at the east end, which once ran all the way round the building, was introduced to the Lower Rhineland simultaneously here and in the apse of St. Gereon at Cologne (*pl. 198*).

182

193 TRIER CATHEDRAL (RHINELAND-PALATINATE).
Detail of west front. The first cathedral on German soil
was erected at Trier by the Emperor Constantine.
Bishop Poppo laid the foundations of the present build-
ing in 1035, beginning with a westward extension of
what survived of the Roman church. The west front
has hardly been altered since. Two square towers rise
over the first bays of the aisles, flanked by round stair-
turrets (on the right of our illustration), with between
them a semi-circular apse (on the left) at the end of
the nave. On either side of the apse, above huge blind
niches at the base of the towers, there are shallow gal-
leries of four and three arches. These are regarded as
forerunners of the dwarf galleries which became so
popular after Speyer, as a means of lightening and
ornamenting the wall.

194 BONN MINSTER (RHINELAND-PALATINATE). *Clois-
ters.* The cathedral at Bonn, erected in two phases –
*c.*1150 and before 1218 – is the masterly and integrated
product of French, Norman and German architectural
concepts. The cloisters date from the mid-12th cen-
tury. The arcades, on monolithic shafts, are recessed in
groups under arches in the thickness of the wall.

195 MÜNSTEREIFEL (RHINELAND-PALATINATE), ABBEY
CHURCH. *Westwork.* Built at the beginning of the 11th
century, this closely follows the westwork of St. Pan-
taleon in Cologne, built by the great Archbishop Bru-
no; it is a rectangular structure, topped by a heavy
square tower. The plan is reminiscent of churches in
Asia Minor: the tower is the centre of a Greek cross, of
which the western arm forms the entrance hall, and
the eastern arm, lengthened, is the nave. Flanking the
entrance are two stair-turrets which turn octagonal at
the base of the central tower.

6, 197 COLOGNE, ST. MARIA IM KAPITOL. *Detail of tomb;
crypt.* The present vast building, with an east end tre-
foil in plan, was essentially complete by about 1048,
and consecrated finally in 1065. It is one of the outstand-
ing buildings of the Rhineland. Severely damaged in
the Second World War, it has now been restored to
its original appearance.

At the east end the land falls away towards the
Rhine: the crypt *(pl. 197)* therefore lies above ground
level and yet completely below the floor level of the
church. It is, after Speyer, the most impressive crypt of
the period of the Salian emperors. Its three aisles are
separated by rows of columns with massive cushion
capitals, which support groin vaults.

In the crypt the tombstone of Plektrudis, foundress
of the original convent *c.*690, was found. The figure

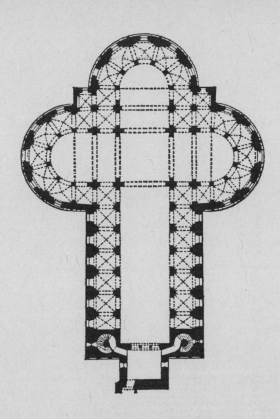

Plan of St. Maria im Kapitol, Cologne

(pl. 196) seems to date from between *c.*1170 and 1180;
it is a major work of the period which led from the
austerity of Salian art to the greater naturalism of art
under the Hohenstaufen emperors.

198 COLOGNE, ST. GEREON. *East end.* For the historian of
architecture, one of the most important works in Co-
logne is the extended east end of St. Gereon. Bishop
Anno's chancel of 1069 on the east side of the Con-
stantinian circular church was replaced *c.* 1150 by
Archbishop Arnold II, a former chancellor of Con-
rad III. The new chancel illustrates the change in the
feeling for form that had taken place in the interim:
instead of remaining somewhat abruptly distinct, the
architectural elements now flow together, in an attempt
to create an organic whole. This is not a trefoil chancel,
but for the first time the rounded apse embraces the
gabled east wall and even reaches out to the towers.
The wall of the apse is pierced and enriched by a dwarf
gallery and a *Plattenfries* – a frieze of rectangular sunk
panels which is a characteristic motif of the region of
Cologne. The design of the east end had a considerable
influence on developments in Late Romanesque
architecture.

199 COLOGNE, ST. APOSTELN. *Interior looking east.* With its classical harmony, the Church of the Holy Apostles is the final masterpiece of ecclesiastical architecture in Cologne. Restored to its original purity after bomb damage in the Second World War, the interior now creates a powerful and unified impression. The chancel and transept arms are of equal length and end in apses, forming a trefoil as at St. Maria im Kapitol; the space thus created is one of repose, which seems the natural goal of all movement. The storeys are linked together vertically by the crossing piers; balancing this are horizontal rows of arches and round-headed windows. The mass of the walls is pierced and enriched by these motifs, without ever losing its solidity and quality of enclosing the interior space. All this combines to give a sense of repose in God – completely different from the Gothic sense of restless striving towards God – more overwhelming than almost anywhere else.

200 NEUSS (RHINELAND-WESTPHALIA), ST. QUIRINUS. *East end.* The present church dates from the early 13th century. Shortly after 1200 a low western choir was built; then in 1209 a new architect – whose name, Wolbero, is given on an inscribed stone – laid the foundations of the eastern choir. The apses here, unlike those at Cologne, are set into the gabled end walls; between their angles the corners of the turrets project. The central tower develops out of a distinctive square 'drum' stage over the crossing.

201 ESSEN MINSTER (RHINELAND-WESTPHALIA). *Interior of the westwork.* Formerly the church of a convent founded in 852, Essen Minster was completely rebuilt between 1039 and 1056 under the Abbess Theophano, granddaughter of Otto II. The westwork then built has survived almost unchanged; its interior reveals it as having been closely modelled on the palatine chapel at Aachen. Three sides of Aachen's octagonal plan were made the west end of the nave, which was later replaced by a Gothic structure. The Abbess no doubt wanted to offer the Emperor, when he held court at the nunnery, an oratory which more closely resembled his imperial chapel than did the westworks of other convent churches. The Corinthian capitals, obviously a reference to the Roman Empire so meaningful for the Holy Roman Emperors, were executed here with particular care.

The seven-branched bronze candlestick was made c.1000 as a copy of the great golden candlestick in the Temple at Jerusalem, as it is shown on the Arch of Titus in Rome. It is the oldest and finest of its kind.

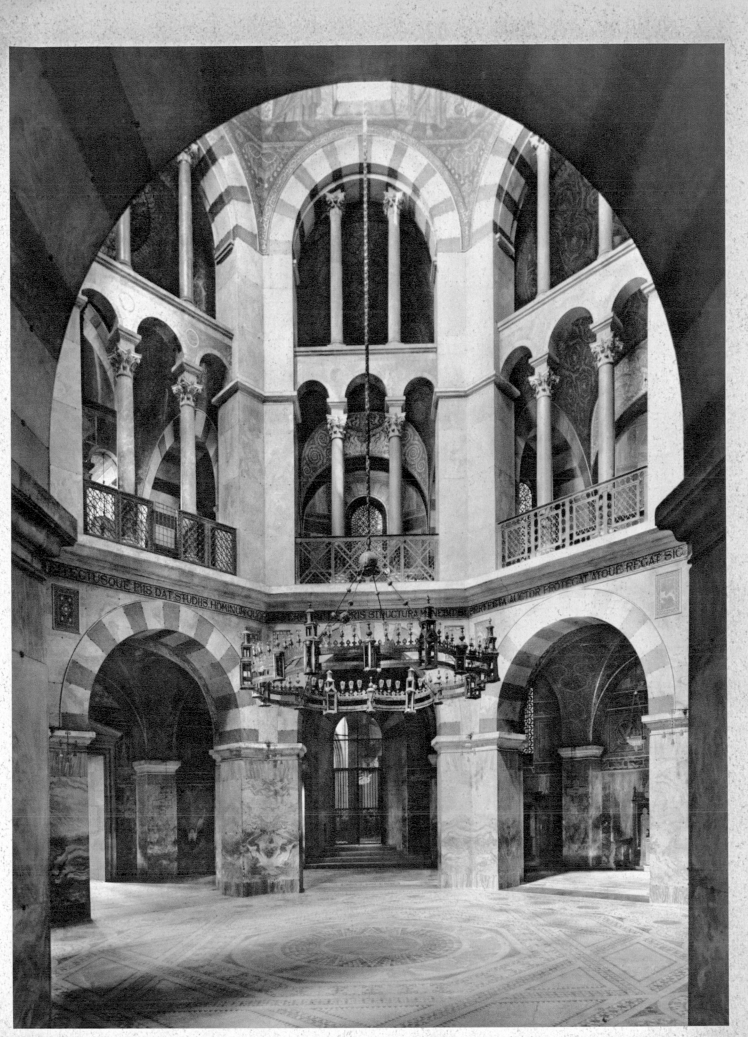

129 AACHEN, Dom

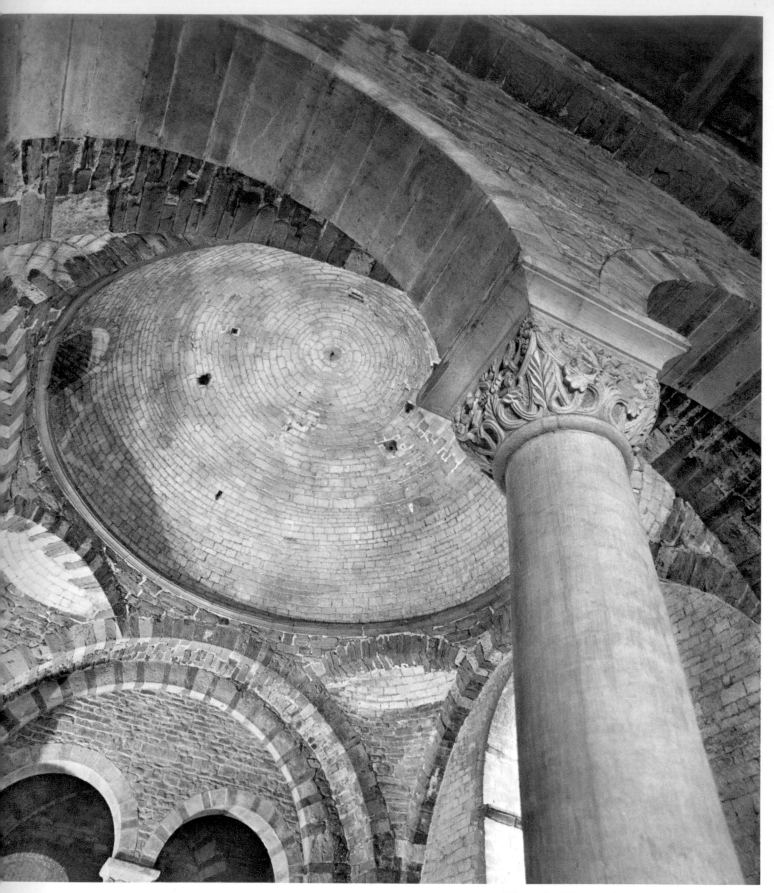

130 MAASTRICHT (Limburg), St.-Servaaskerk

131 MAASTRICHT (Limburg), O. L. Frouwekerk

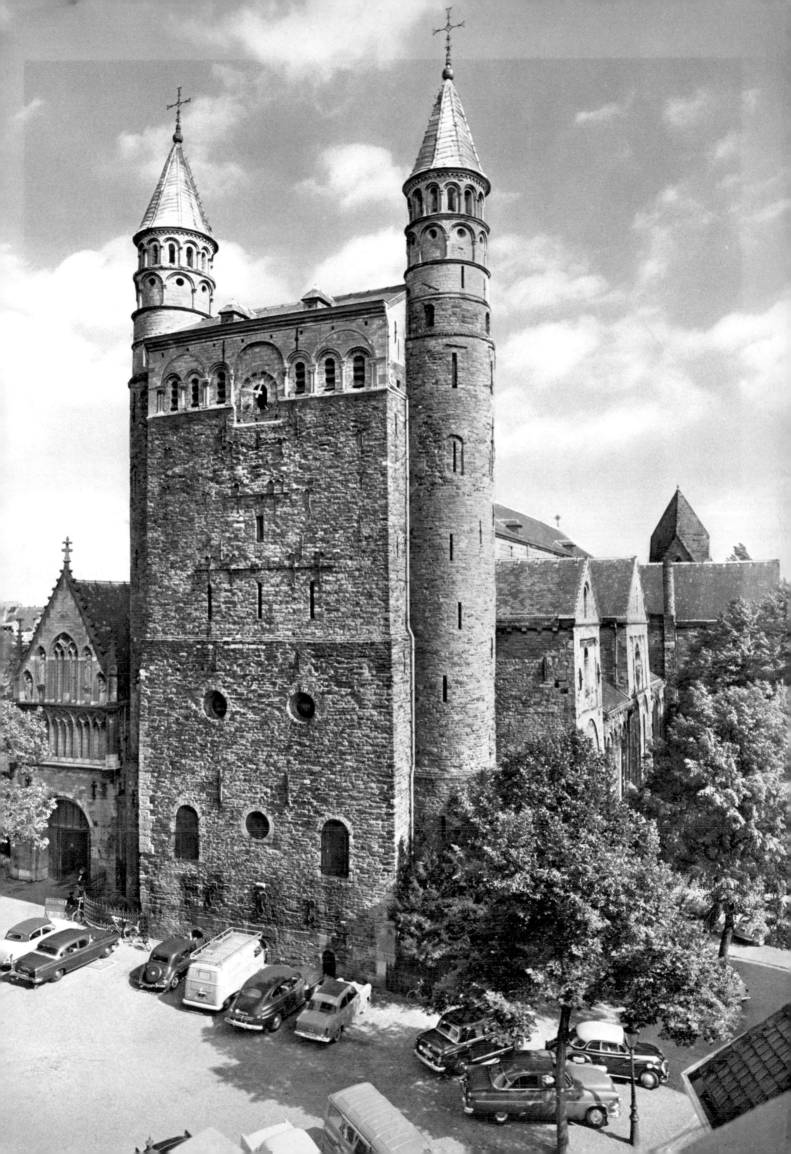

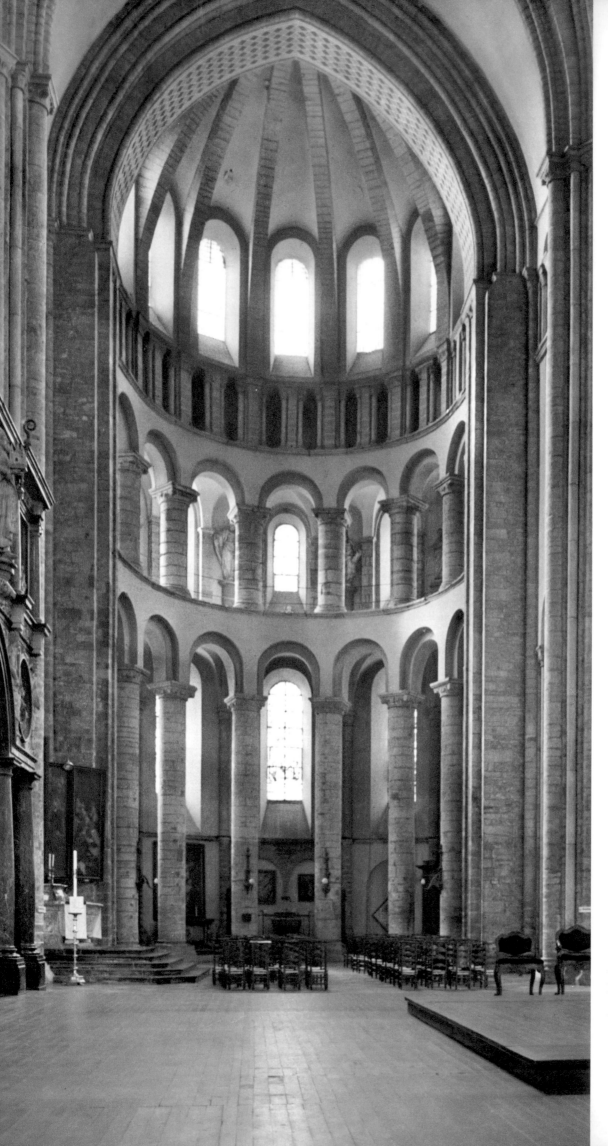

132 TOURNAI (Hainaut),
Notre-Dame

133 SOEST (Westfalen),
St. Patrokli

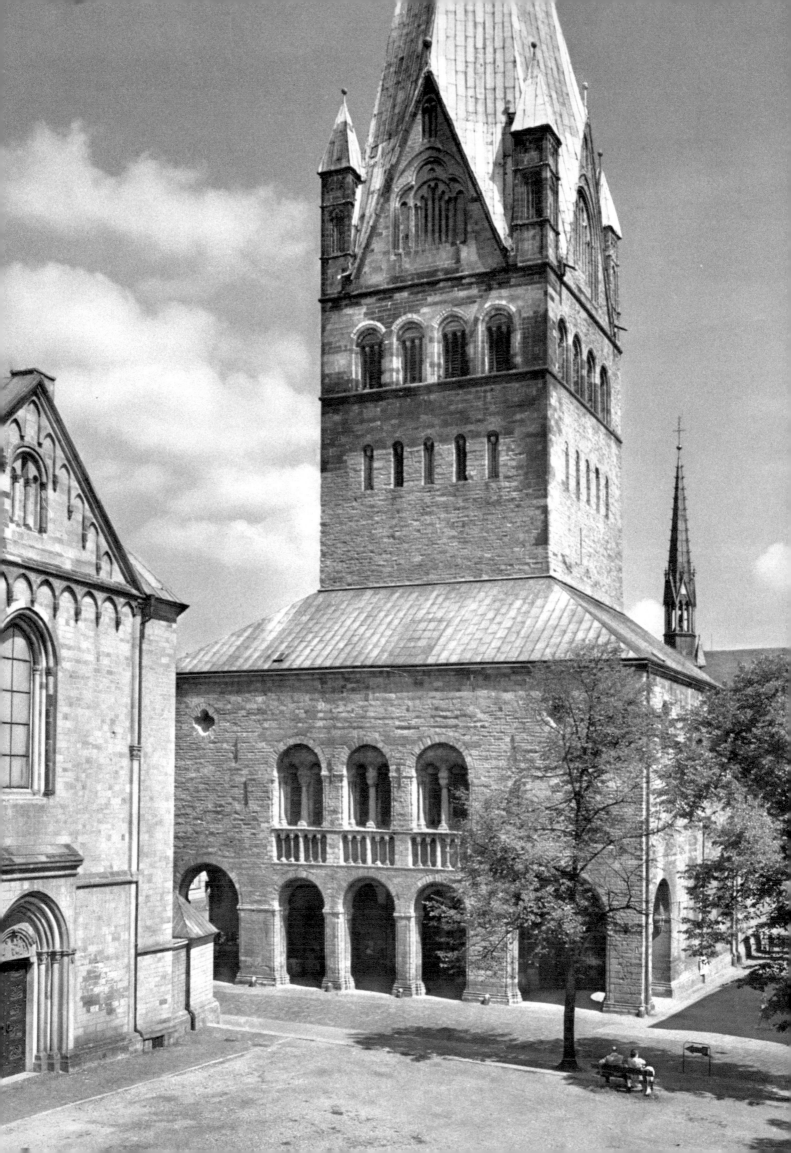

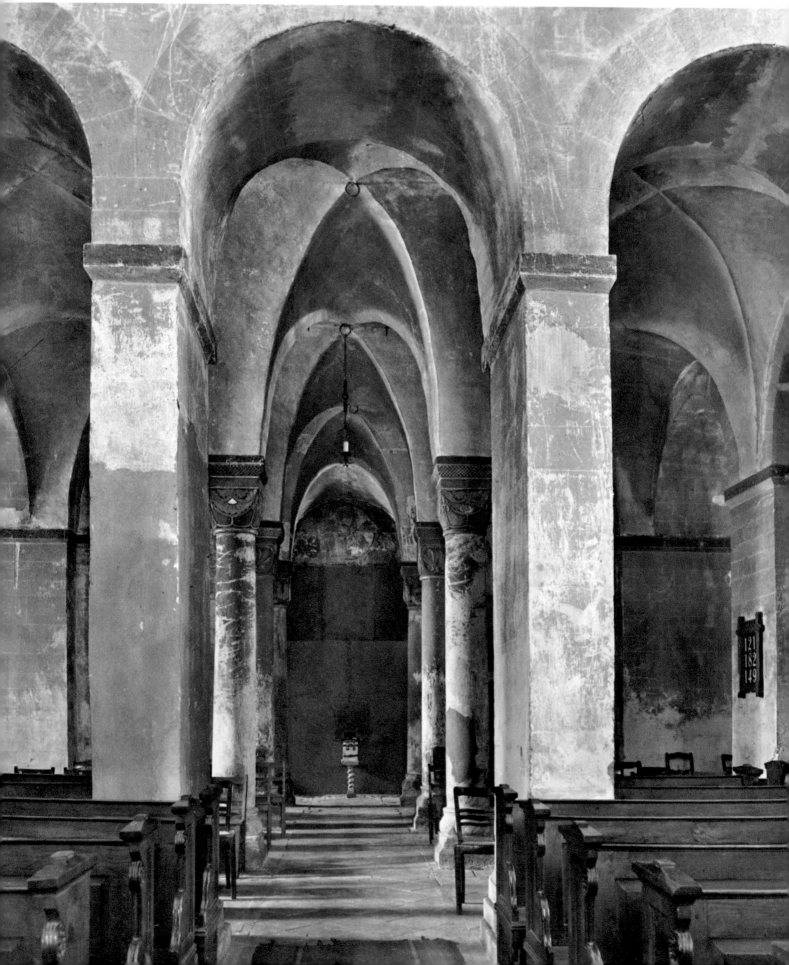

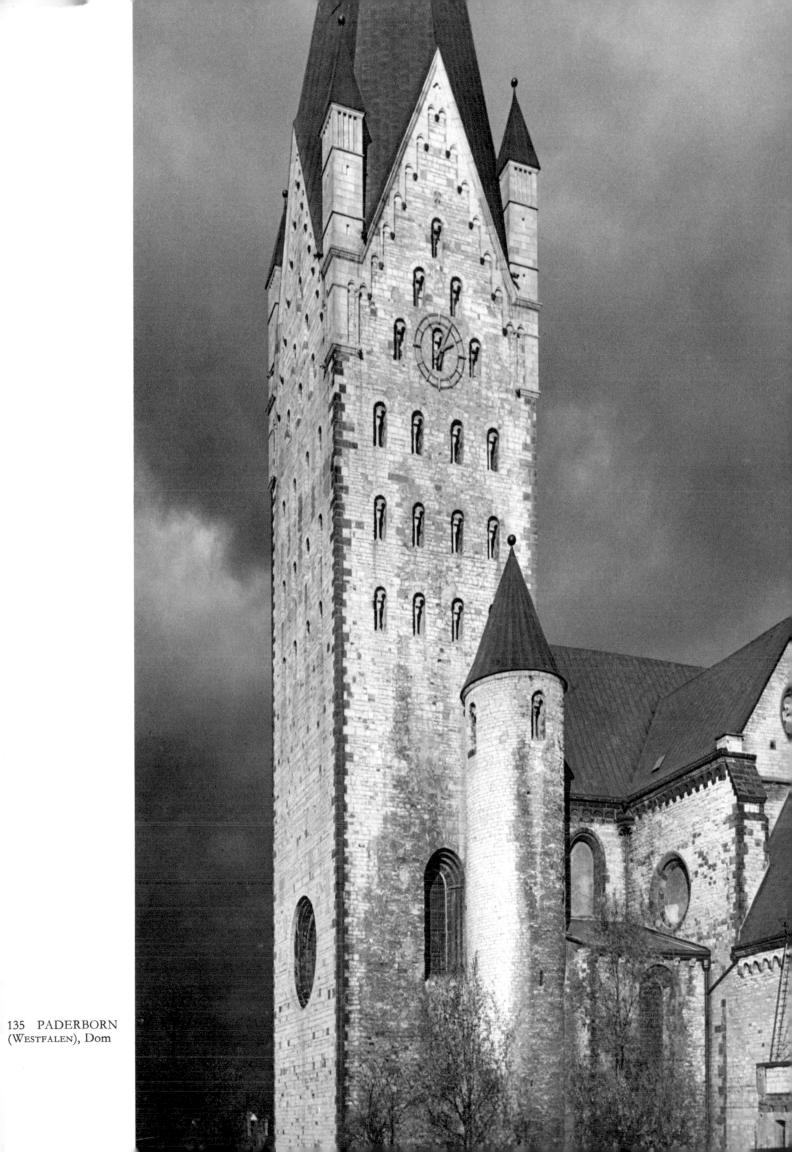

135 PADERBORN
(WESTFALEN), Dom

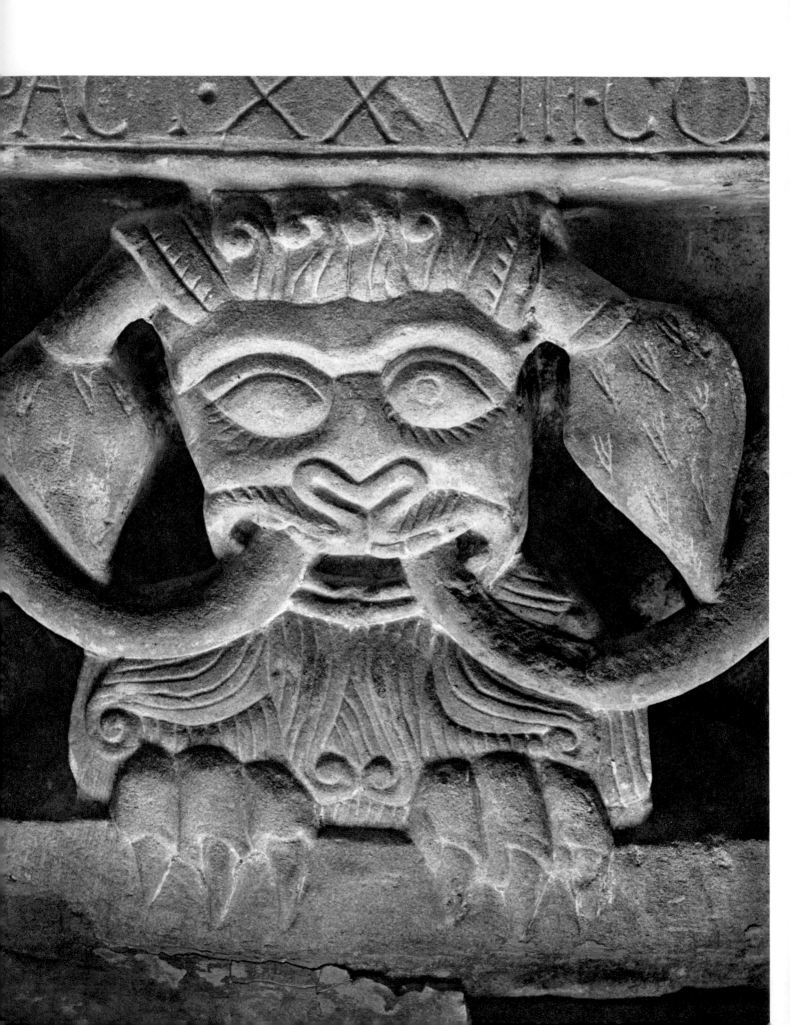

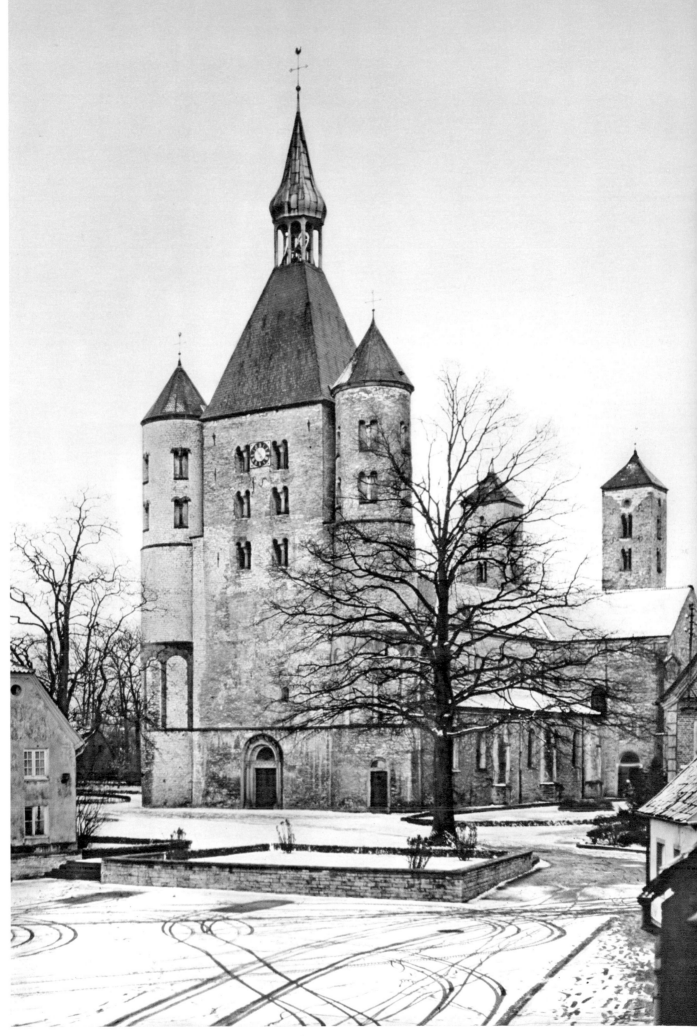

136, 137 FRECKENHORST (WESTFALEN), Damenstift

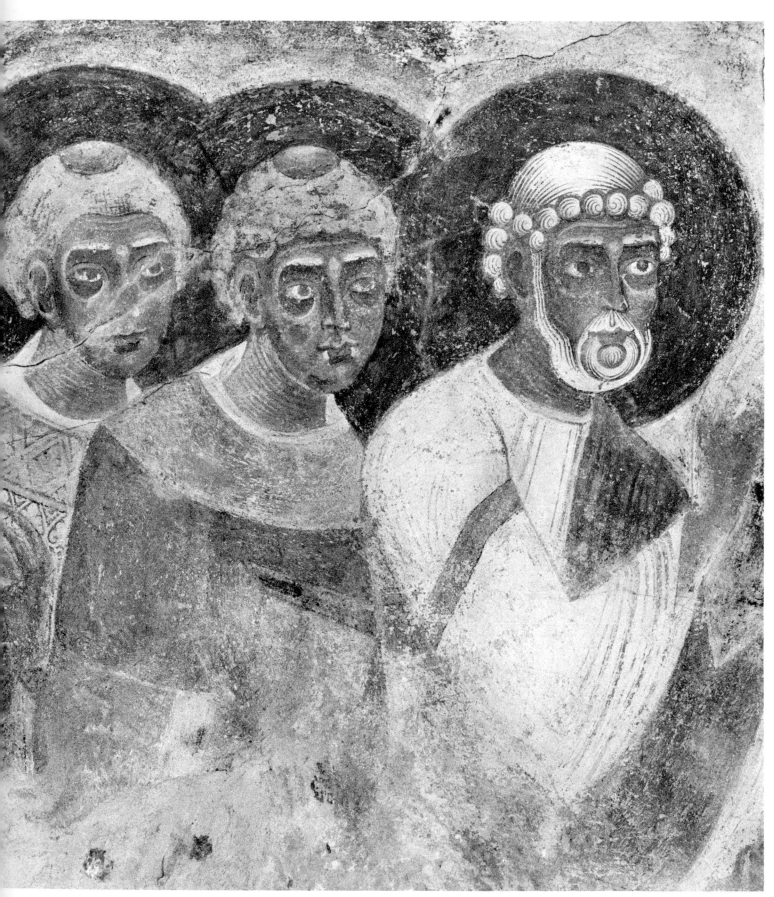

138 IDENSEN (Niedersachsen), Kirche 139 EXTERNSTEINE (Westfalen)

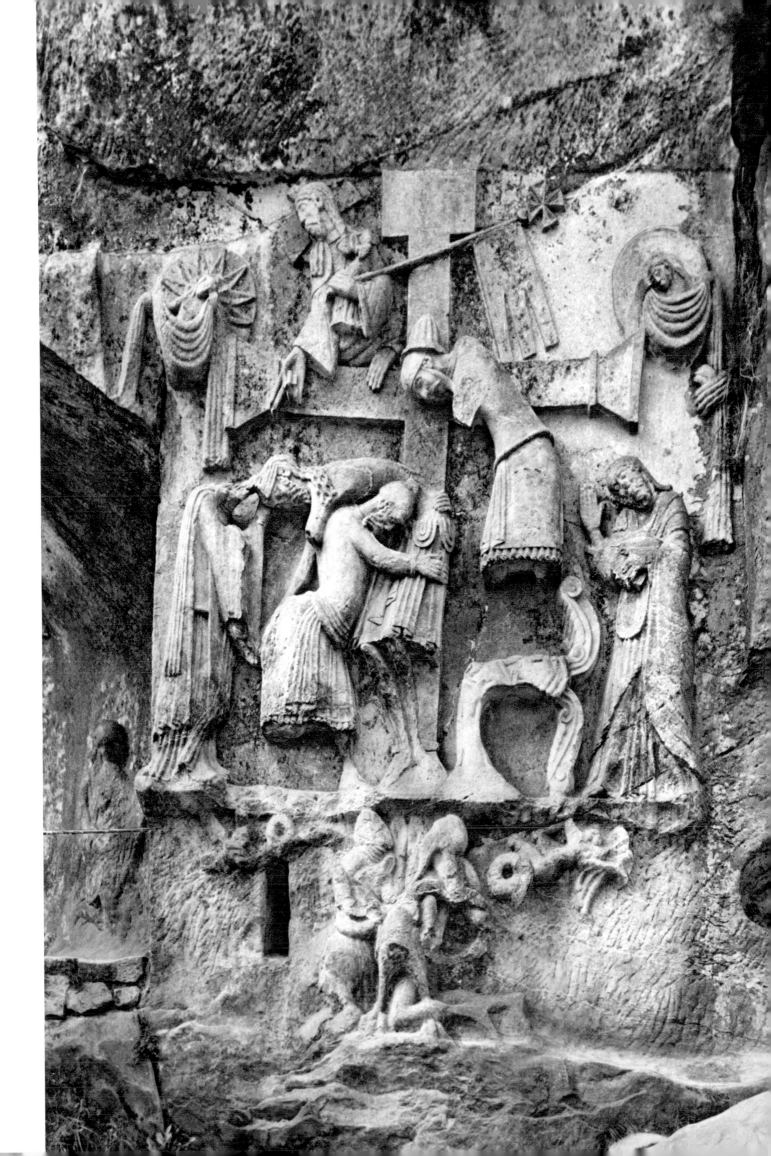

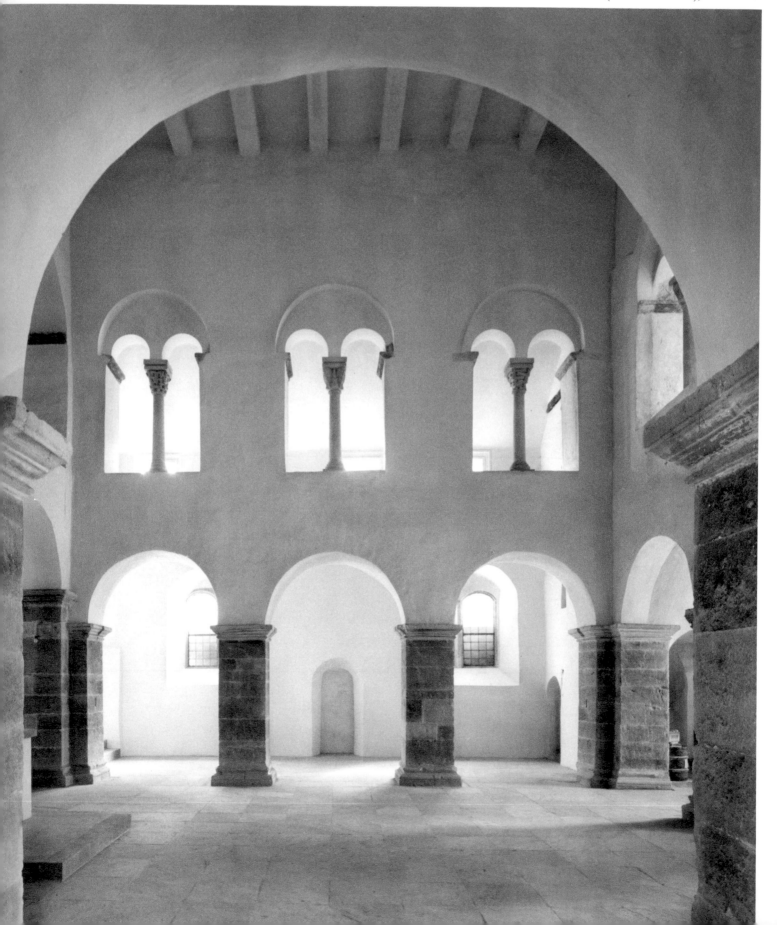

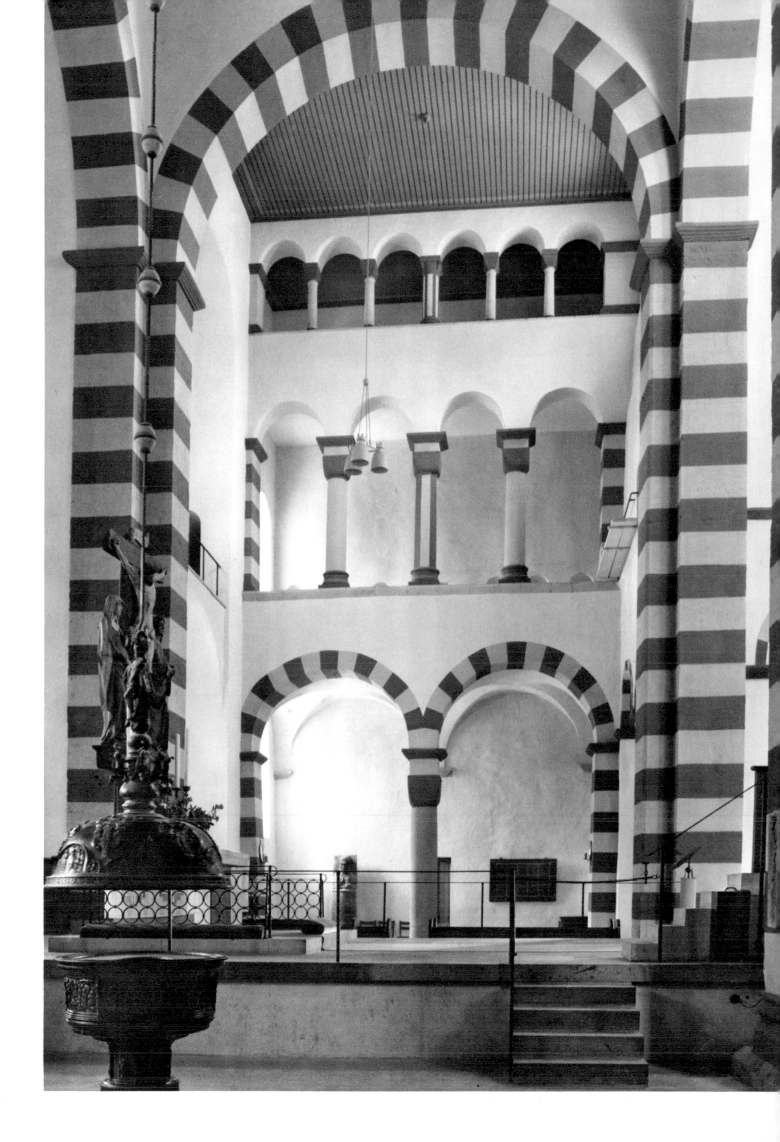

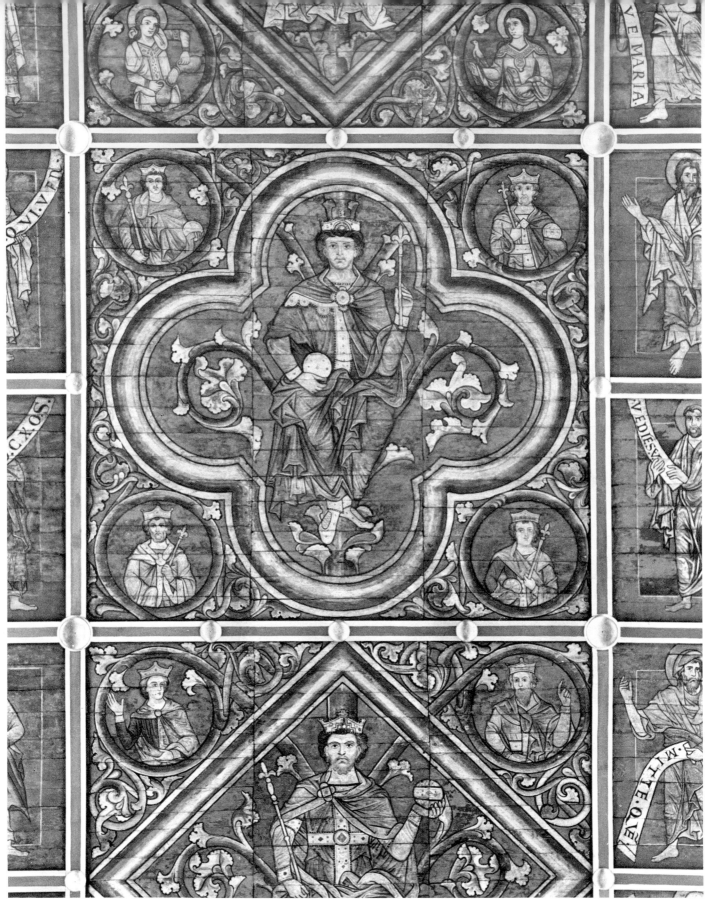

142 HILDESHEIM (Niedersachsen), St. Michael

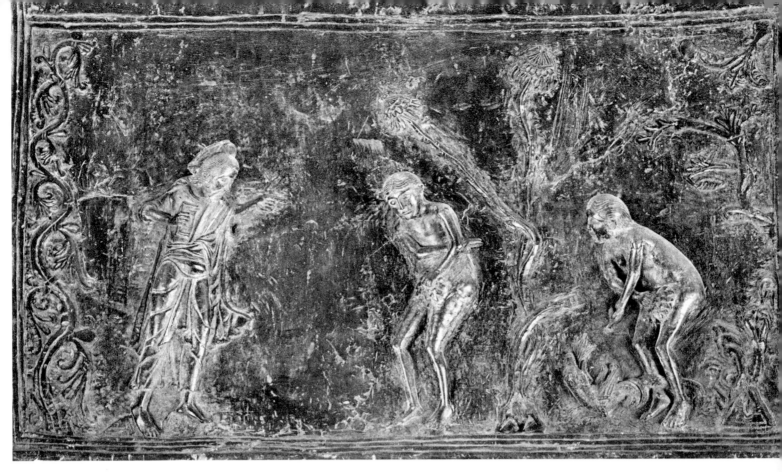

143, 144 HILDESHEIM
(NIEDERSACHSEN), Dom

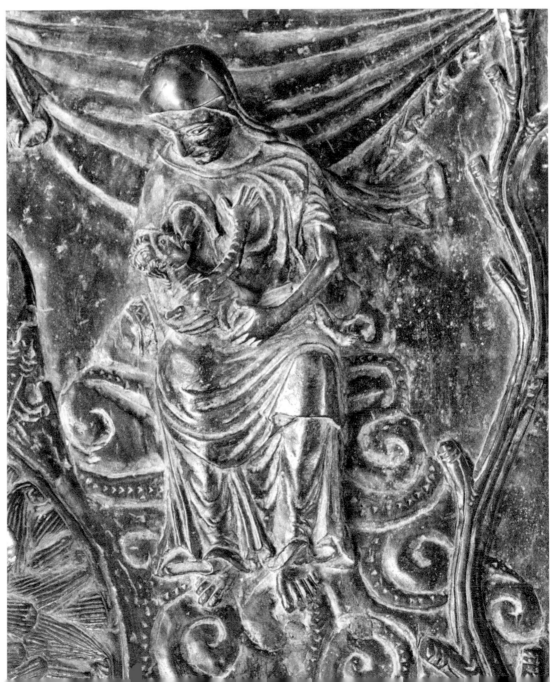

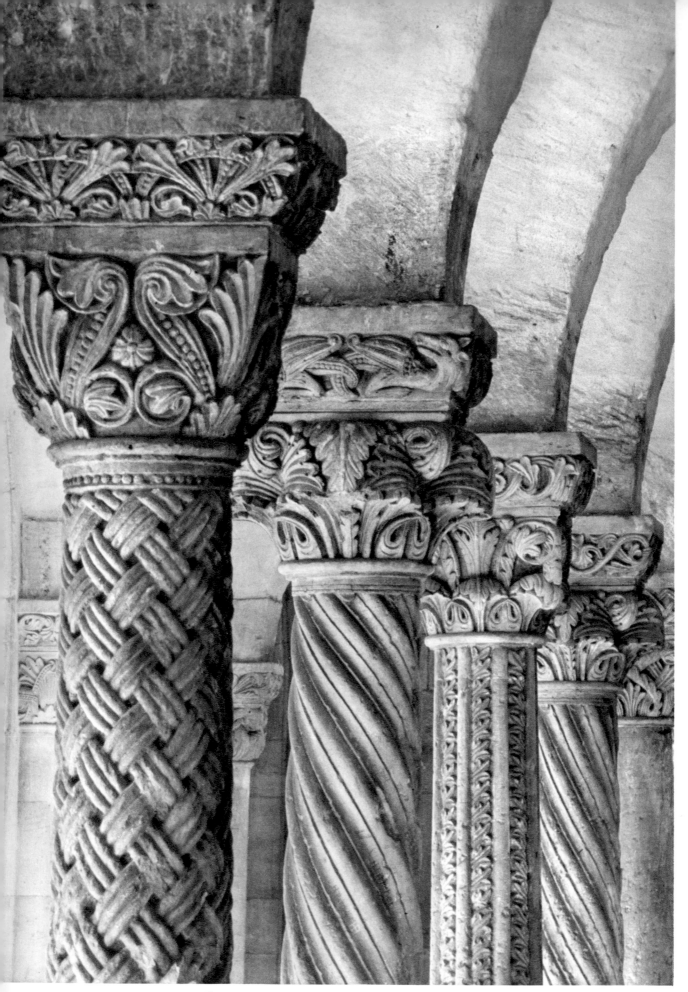

145 KÖNIGSLUTTER (NIEDERSACHSEN), Benediktinerkloster

146 BRAUNSCHWEIG (Niedersachsen), Bronzelöwe

147 BRAUNSCHWEIG (Niedersachsen), Dom 148 BRAUNSCHWEIG (Niedersachsen), Dom

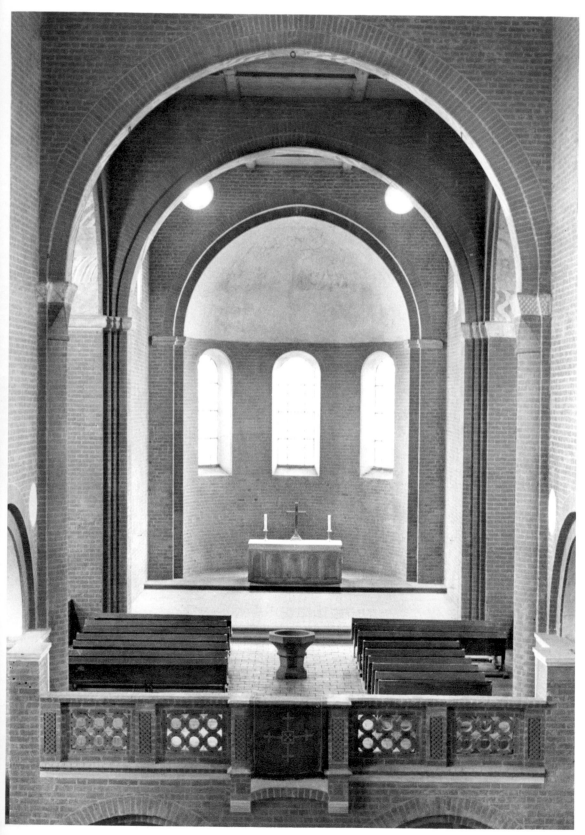

149, 150 JERICHOW (MARK), Prämonstratenserkirche

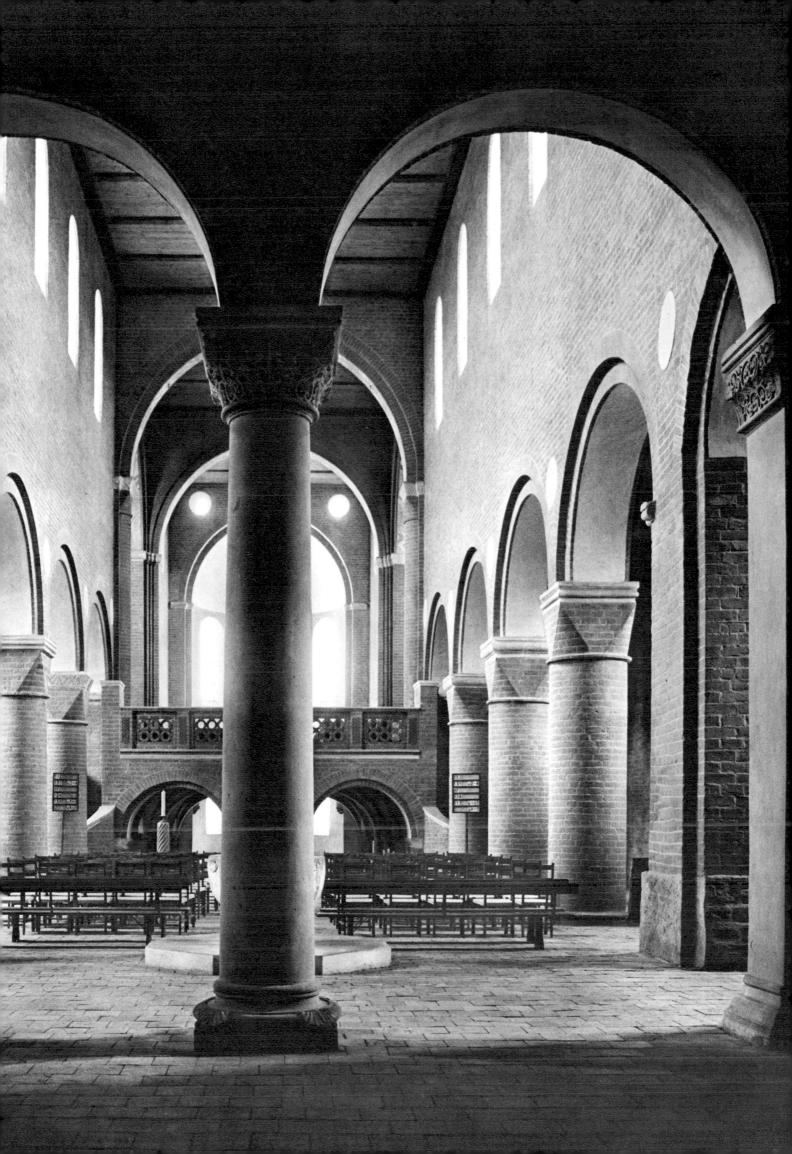

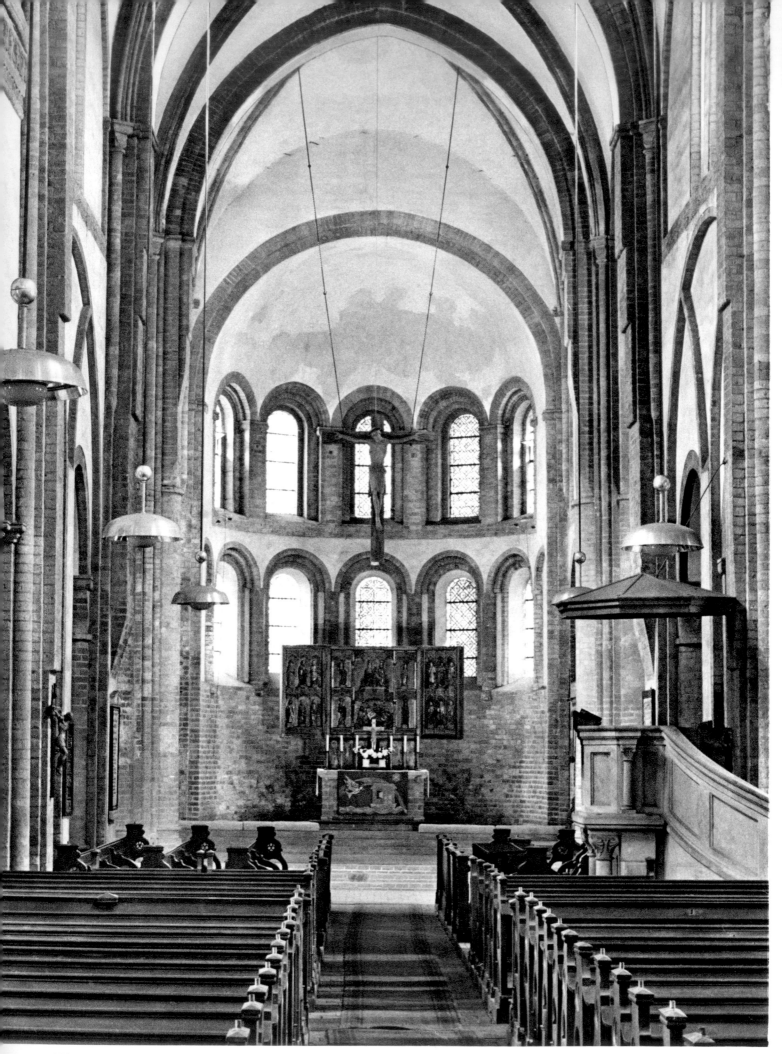

151 LEHNIN (Mark), Klosterkirche

152 QUEDLINBURG (Sachsen-Anhalt), Stiftskirche

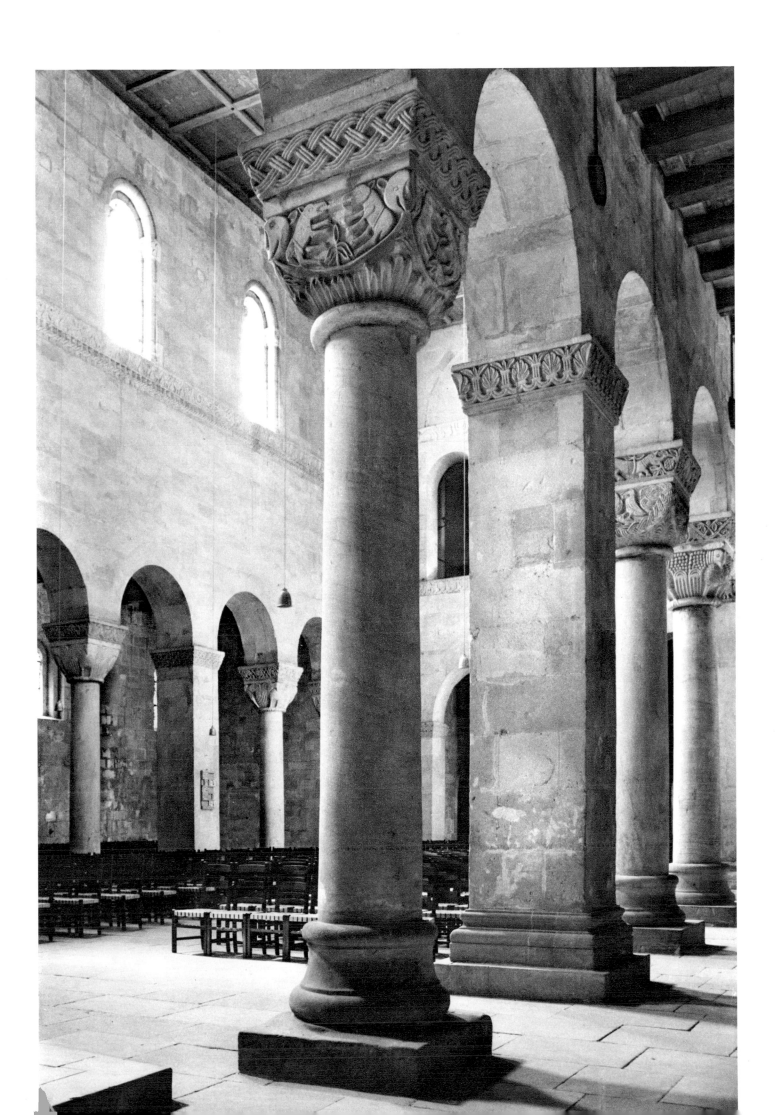

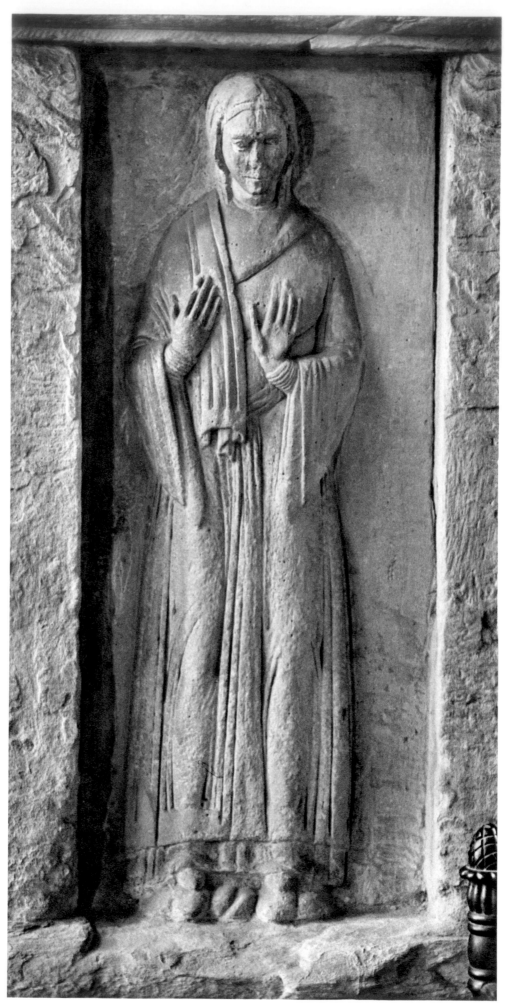

153 GERNRODE (Sachsen-Anhalt), Stiftskirche

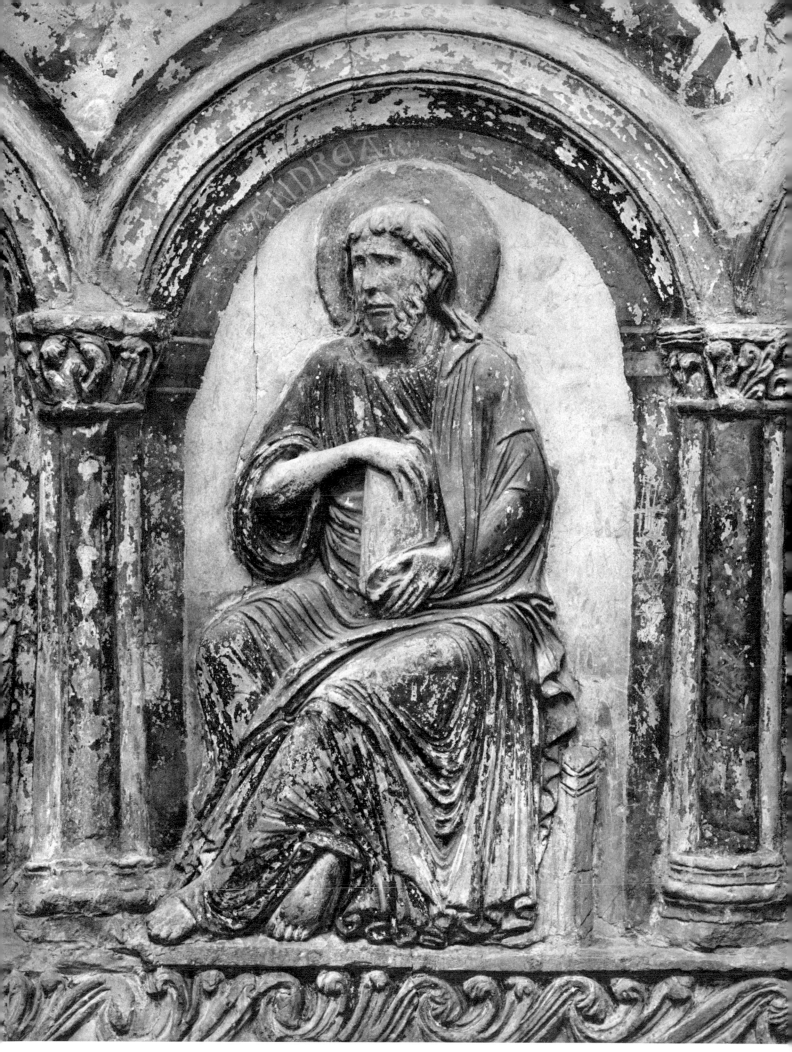

154 HALBERSTADT (Sachsen-Anhalt), Liebfrauenkirche

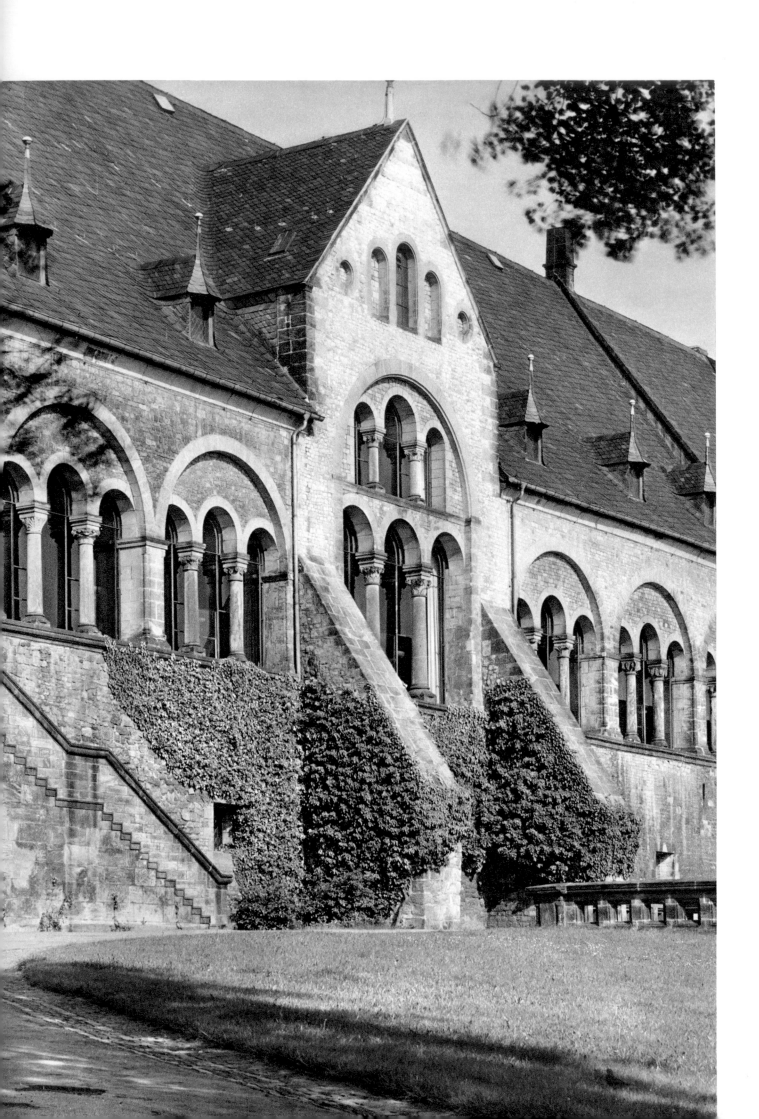

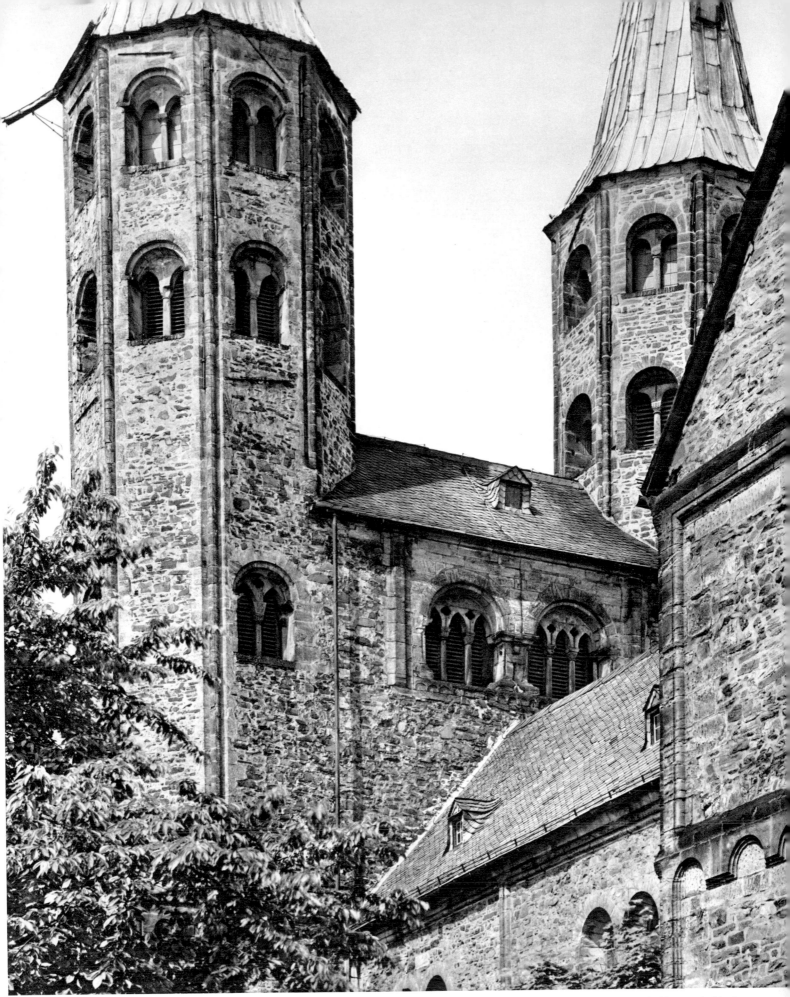

155 GOSLAR (Niedersachsen), Pfalz 156 GOSLAR (Niedersachsen), Neuwerkskirche

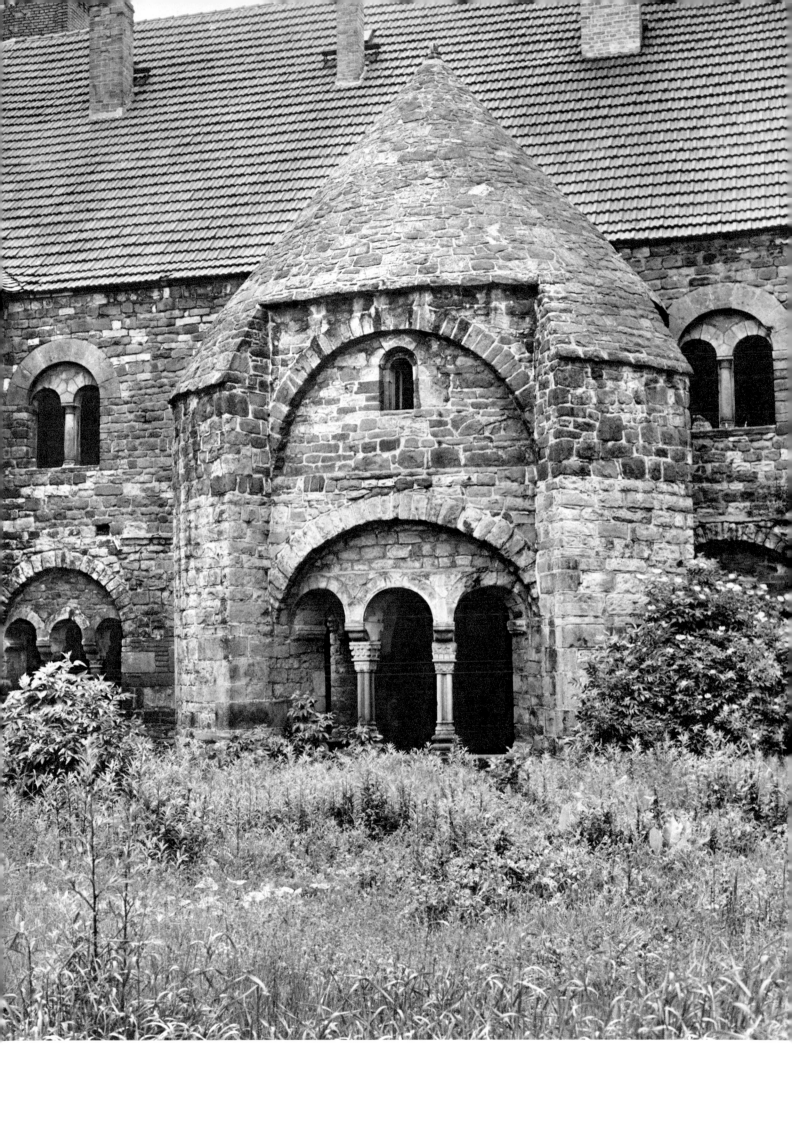

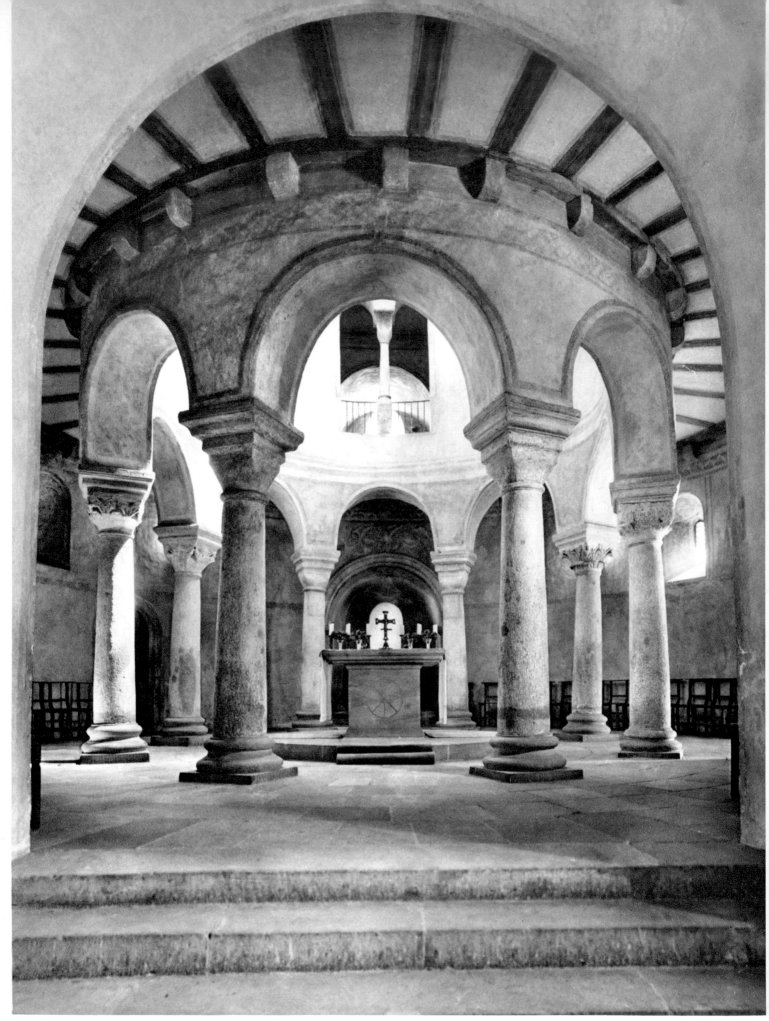

159 FULDA (Hessen), St. Michael 160 PAULINZELLA (Thüringen), Klosterkirche

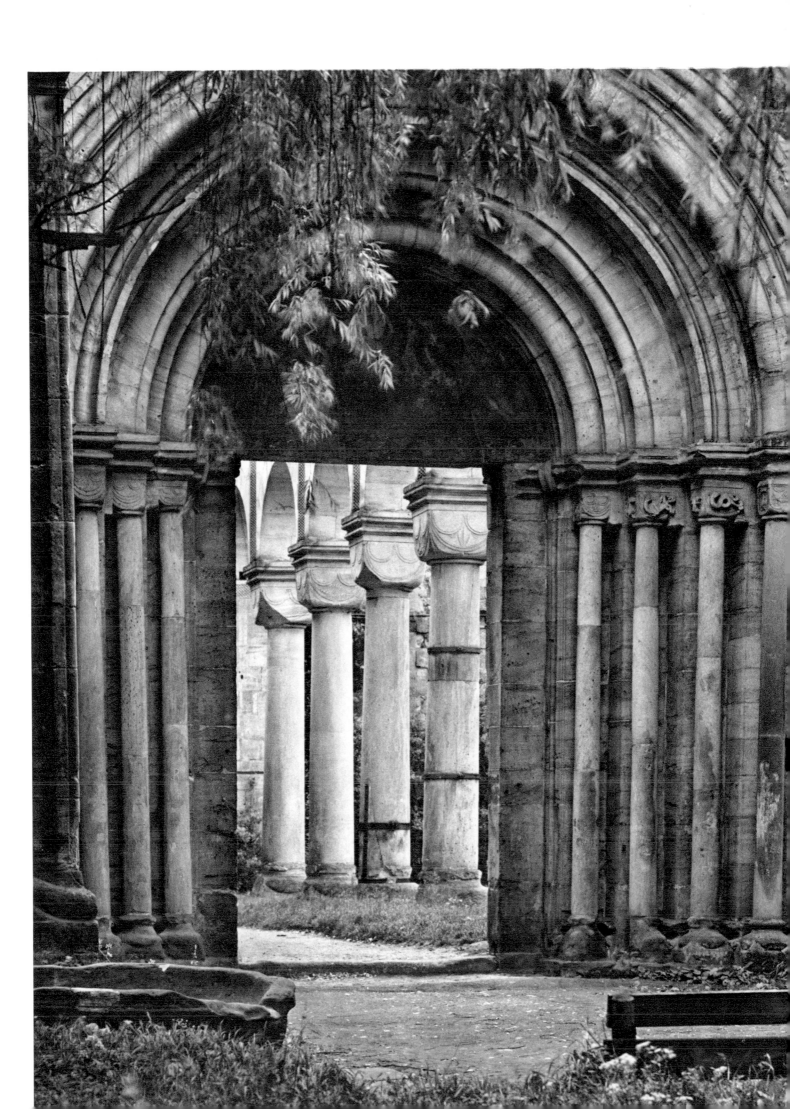

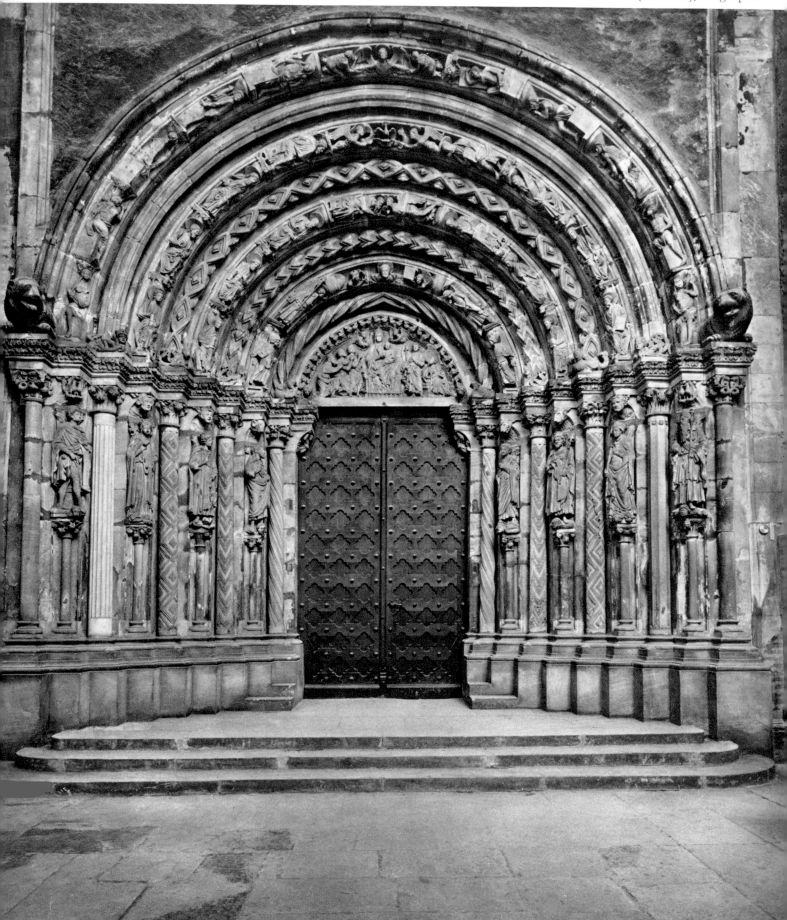

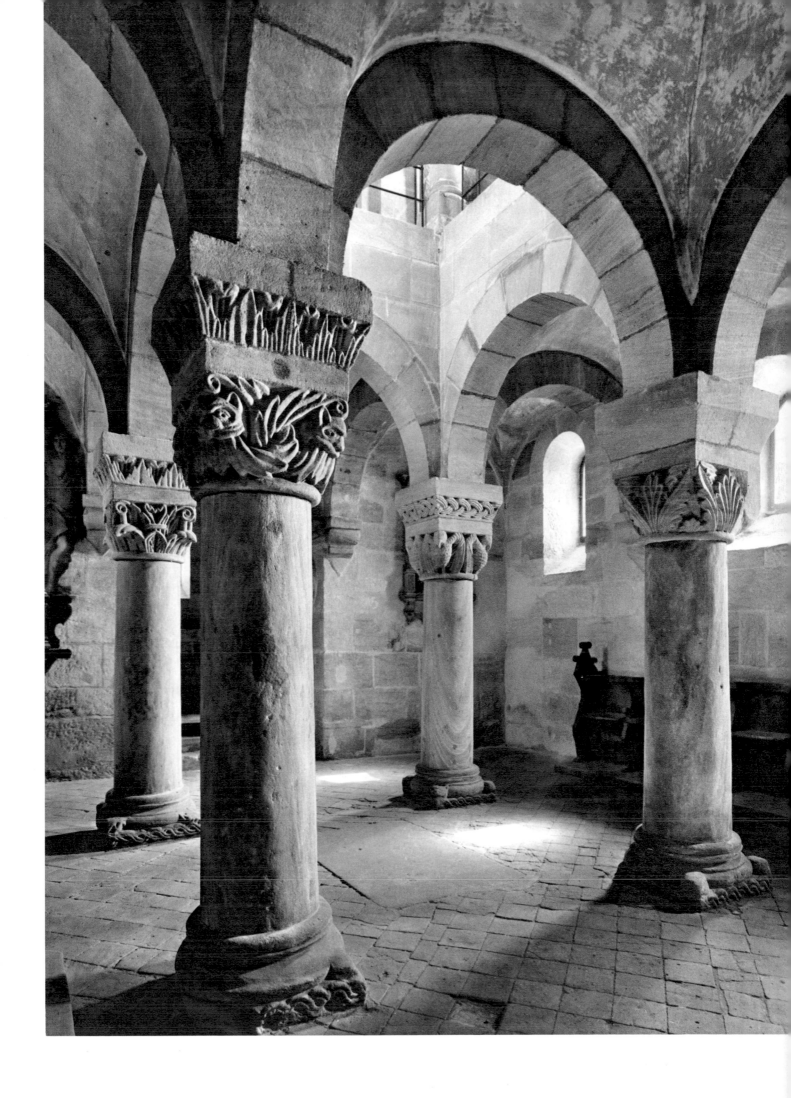

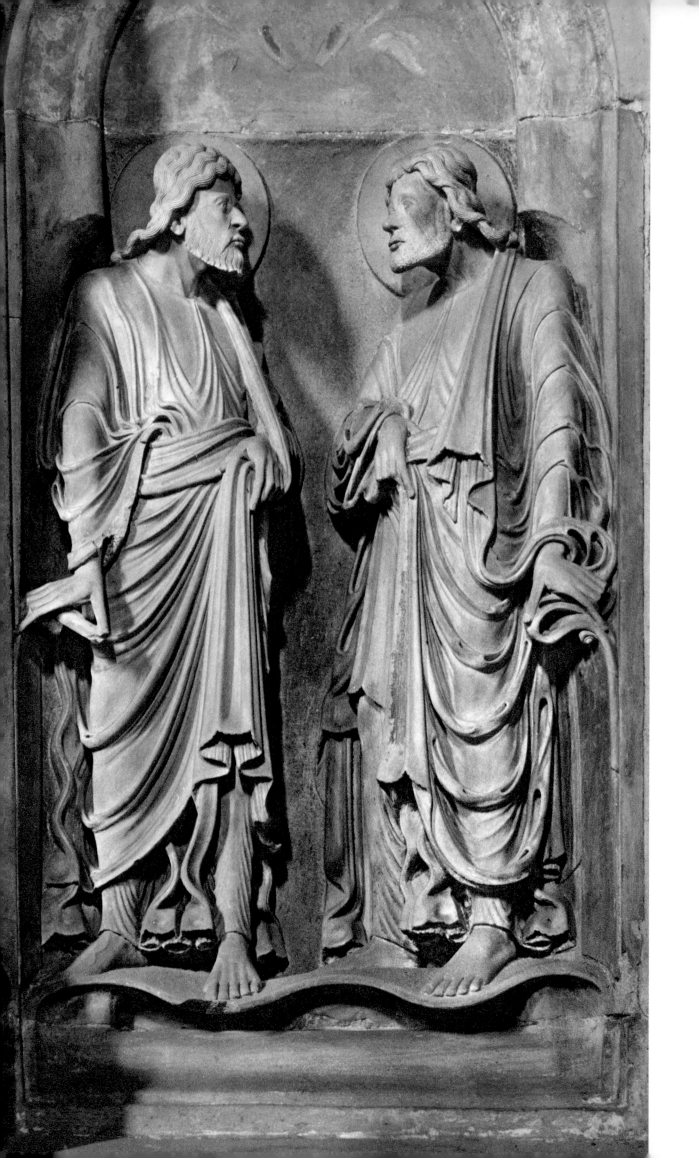

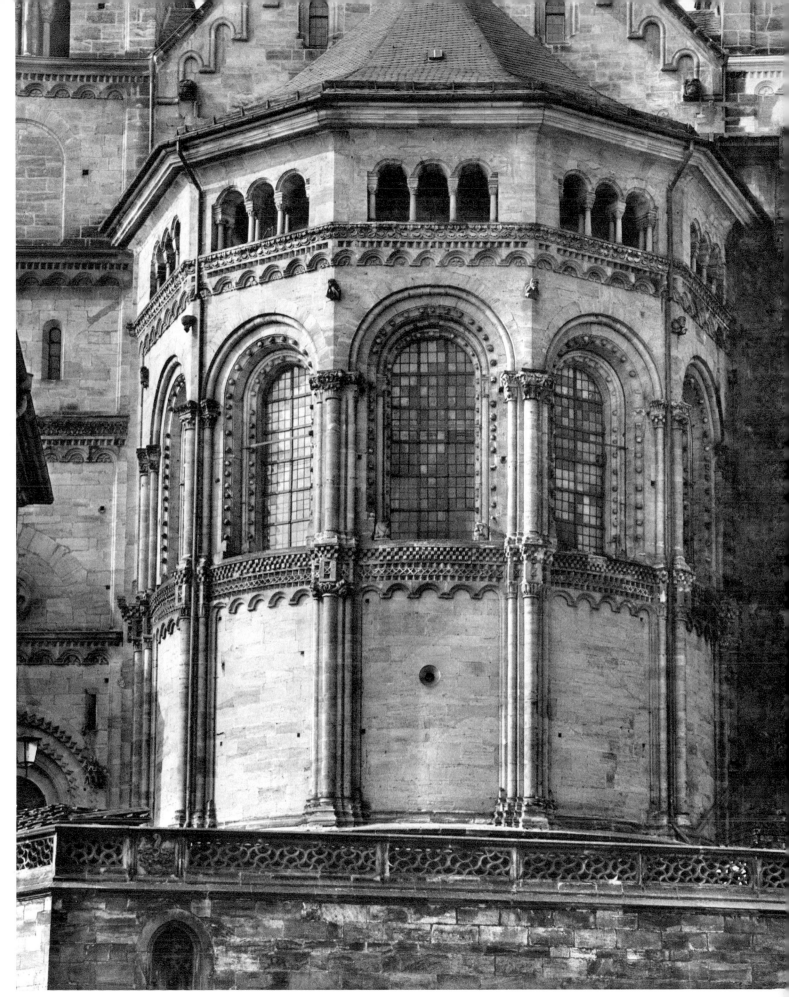

163 BAMBERG (FRANKEN), Dom 164 BAMBERG (FRANKEN), Dom

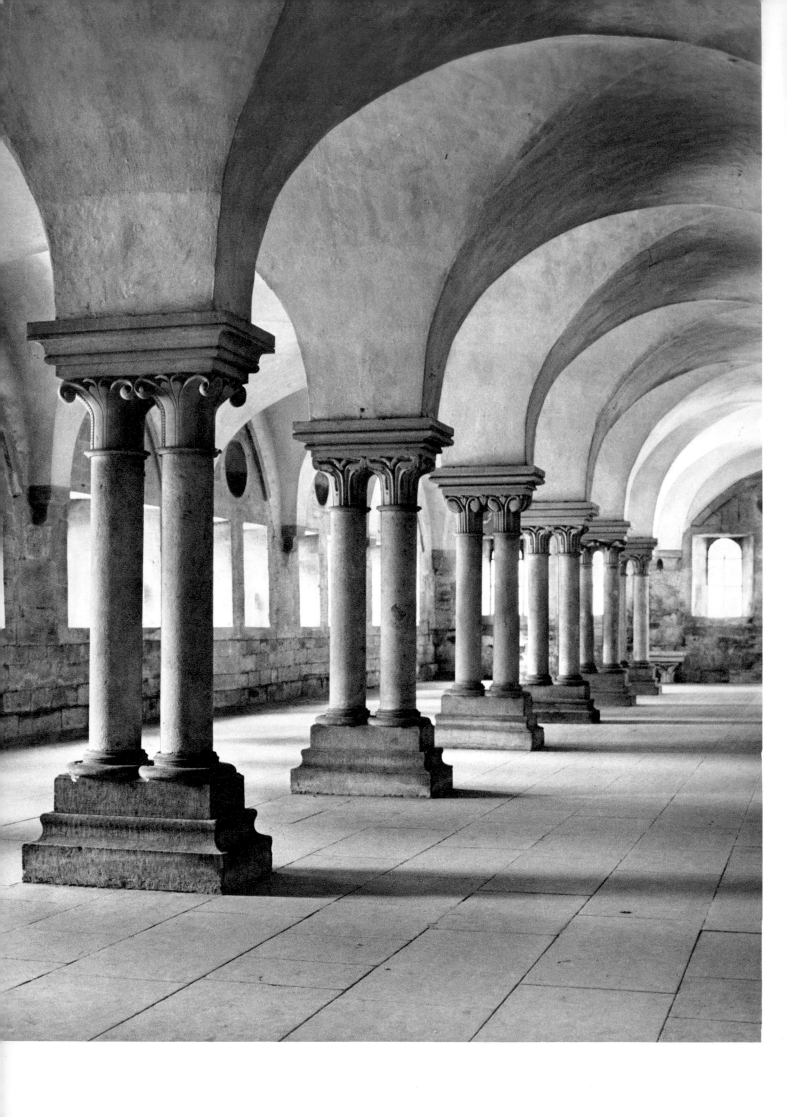

165 MAULBRONN (Württemberg), Kloster

166 FREUDENSTADT/Schwarzwald, Stadtkirche

167　HIRSAU/Schwarzwald, Klosterkirche St. Aurelius

168　ALPIRSBACH/Schwarzwald, Benediktiner-Klosterkirche

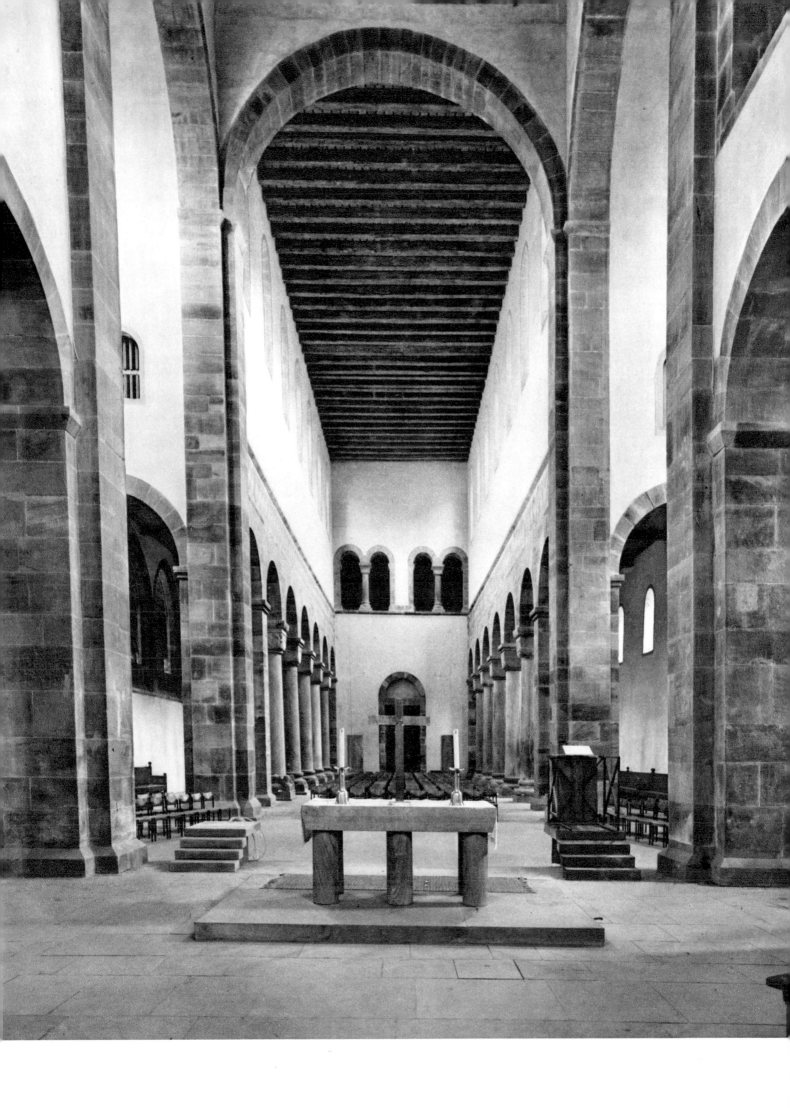

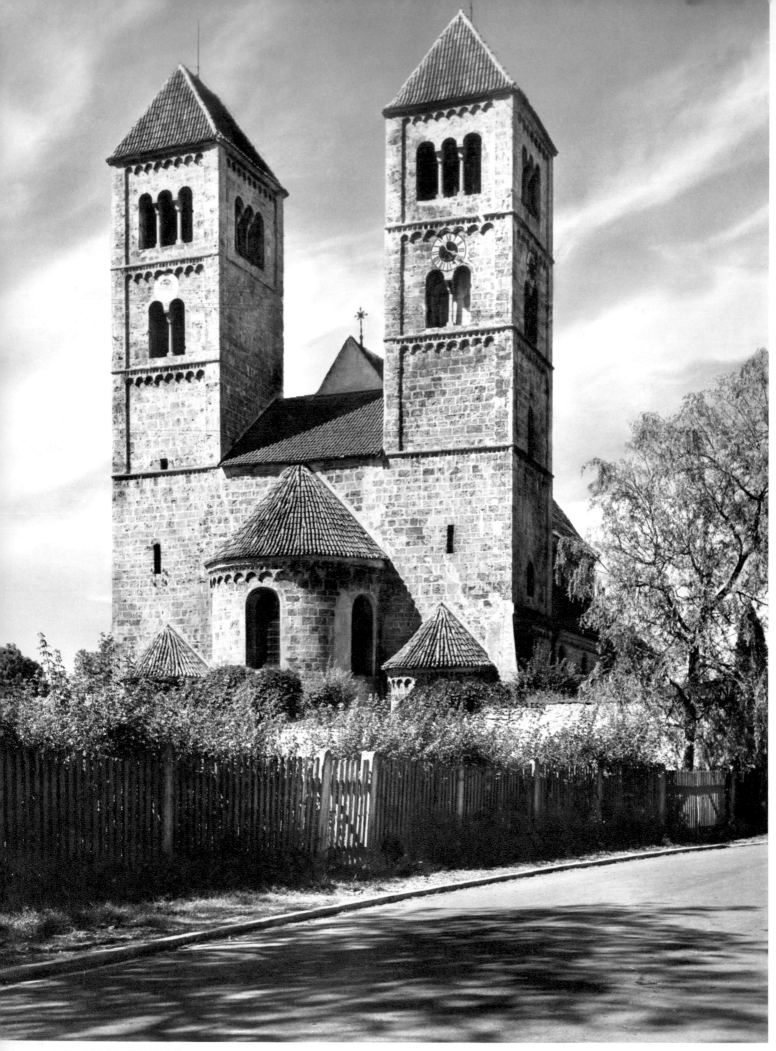

169 ALTENSTADT (Bayern), St. Michael 170 REGENSBURG (Bayern), Allerheiligenkapelle

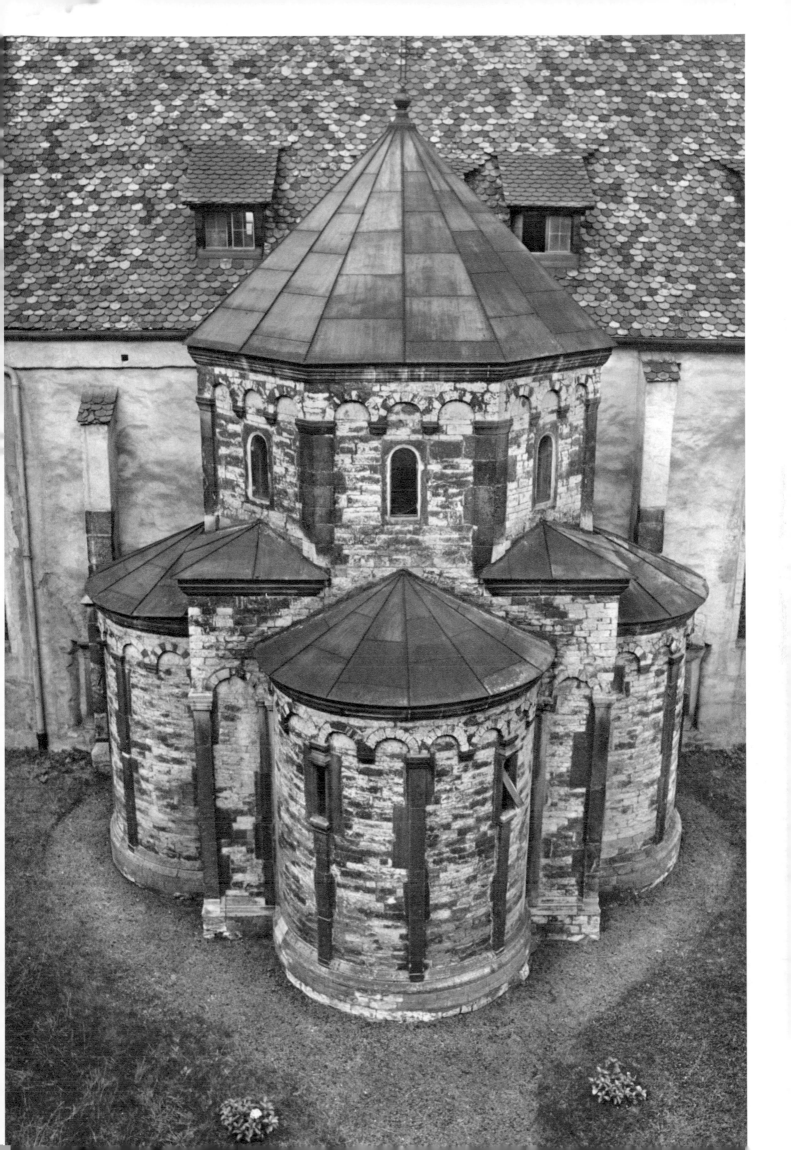

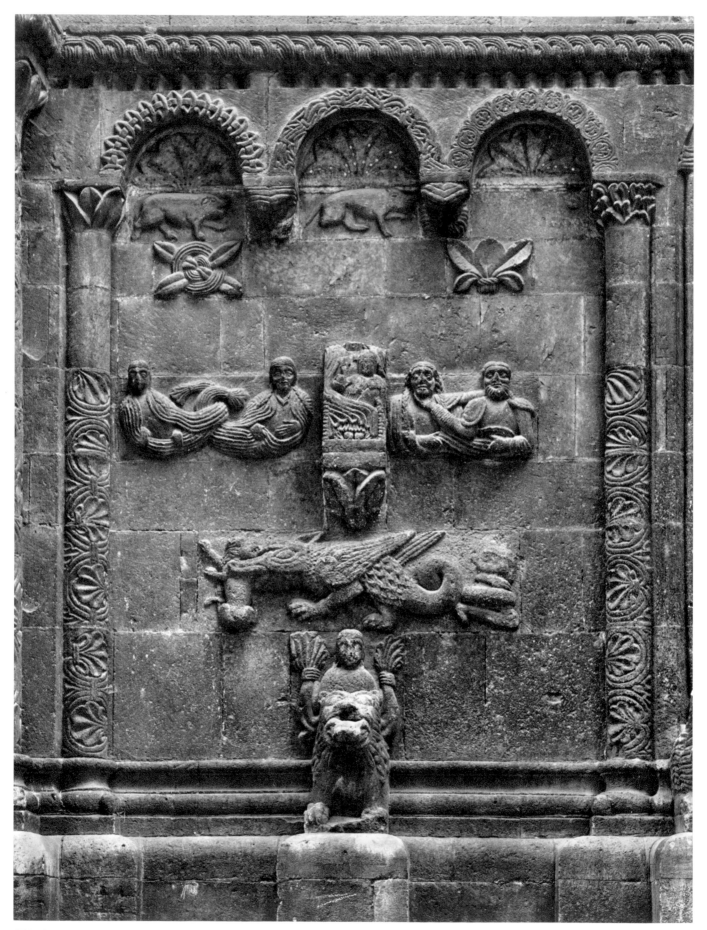

171 REGENSBURG (BAYERN), St. Jakob 172 FREISING (BAYERN), Domkirche

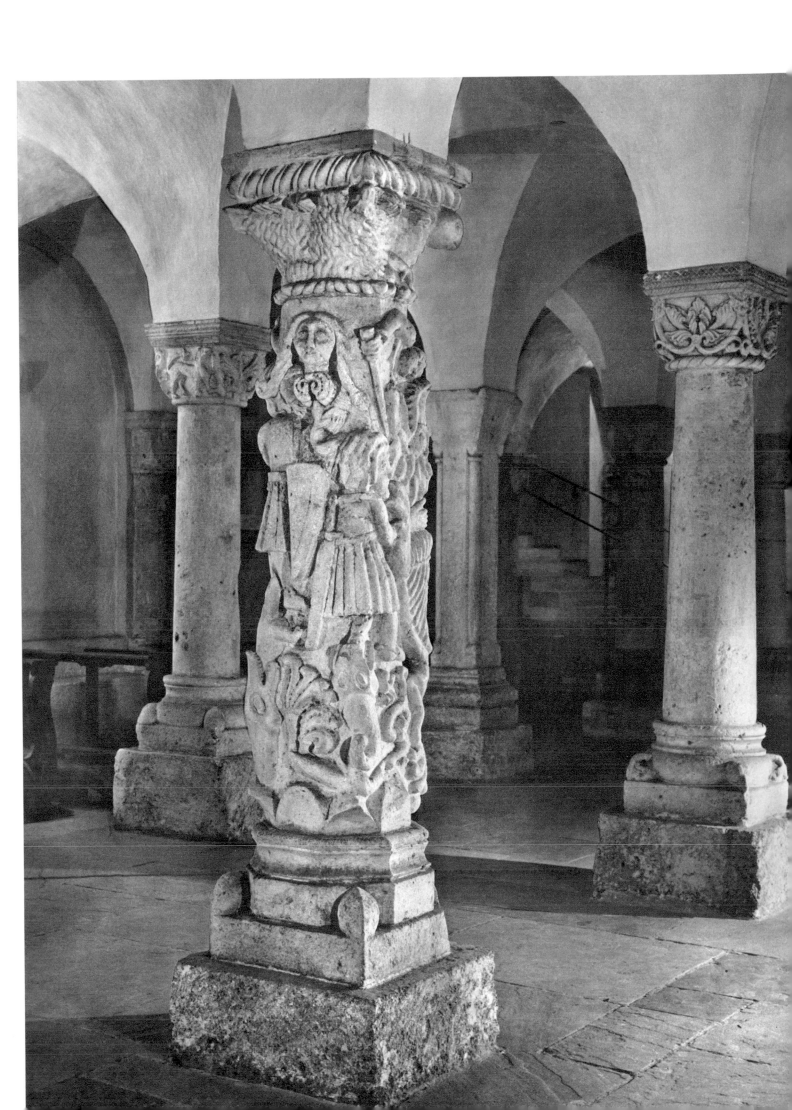

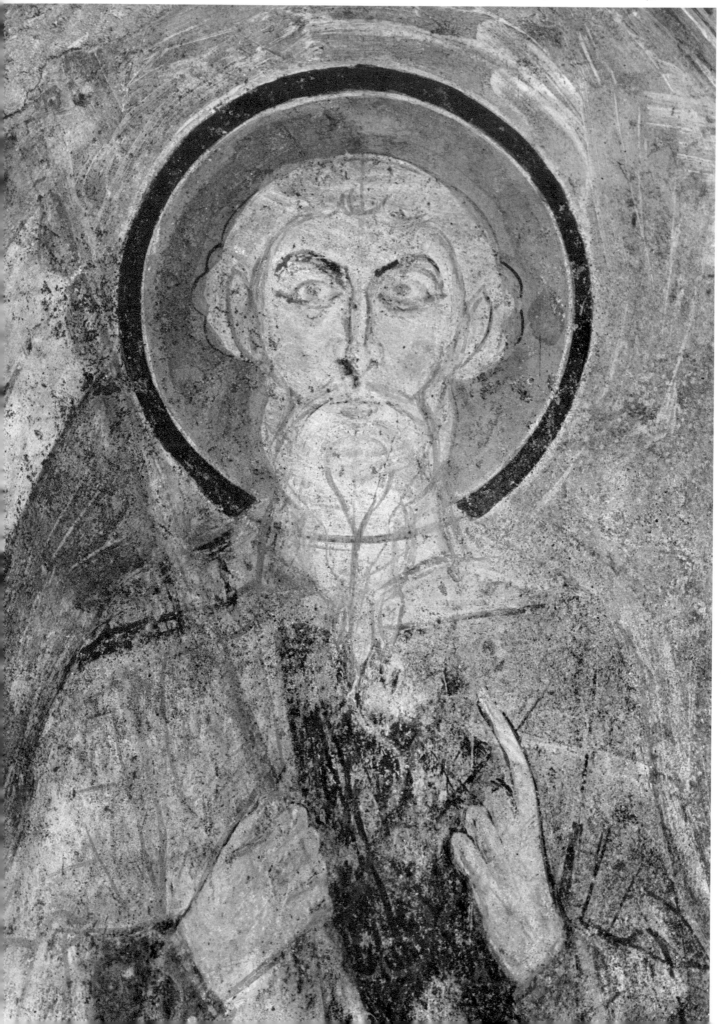

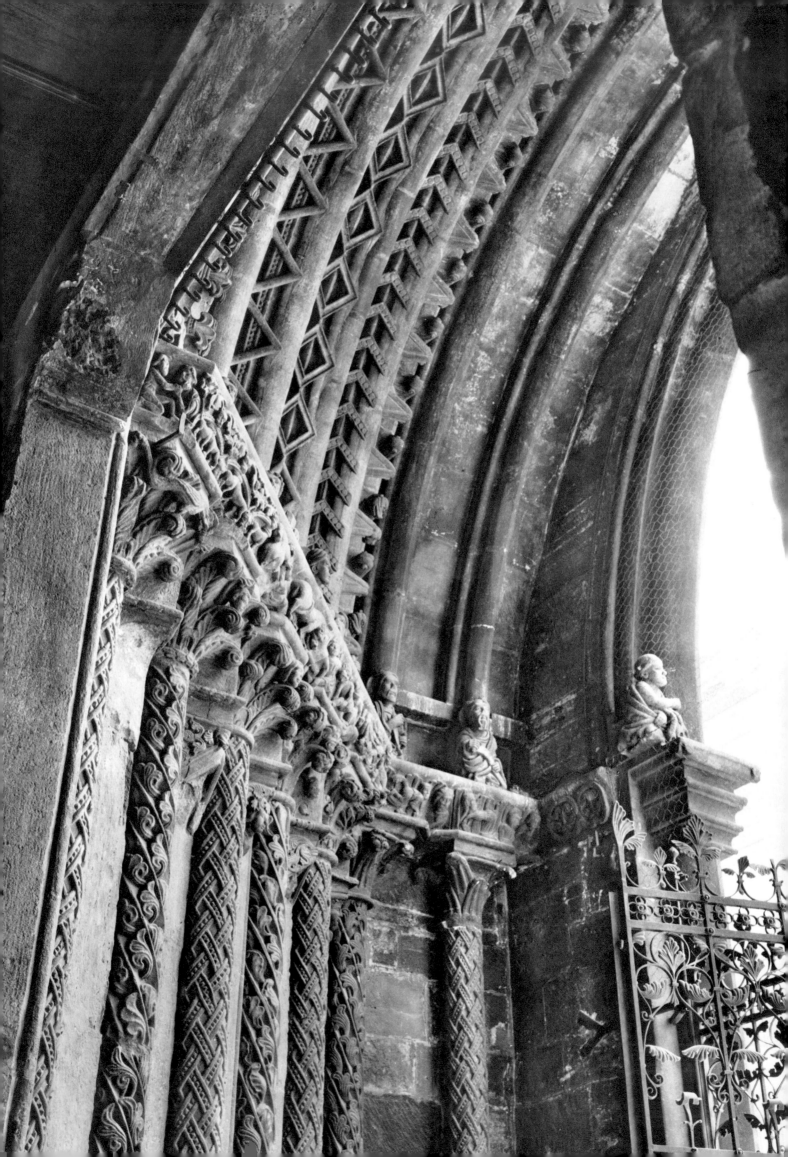

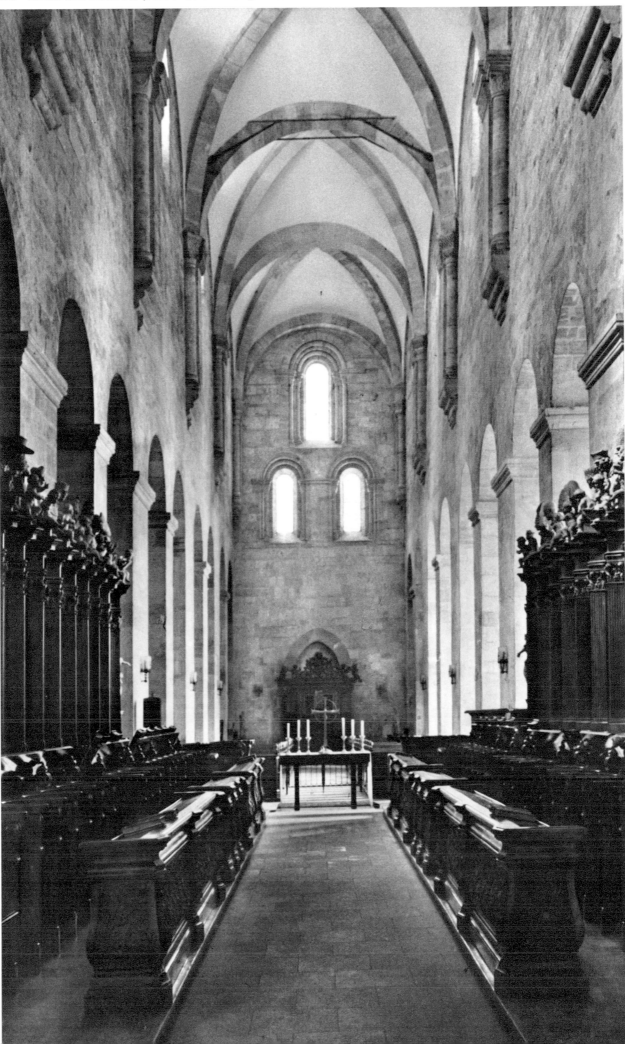

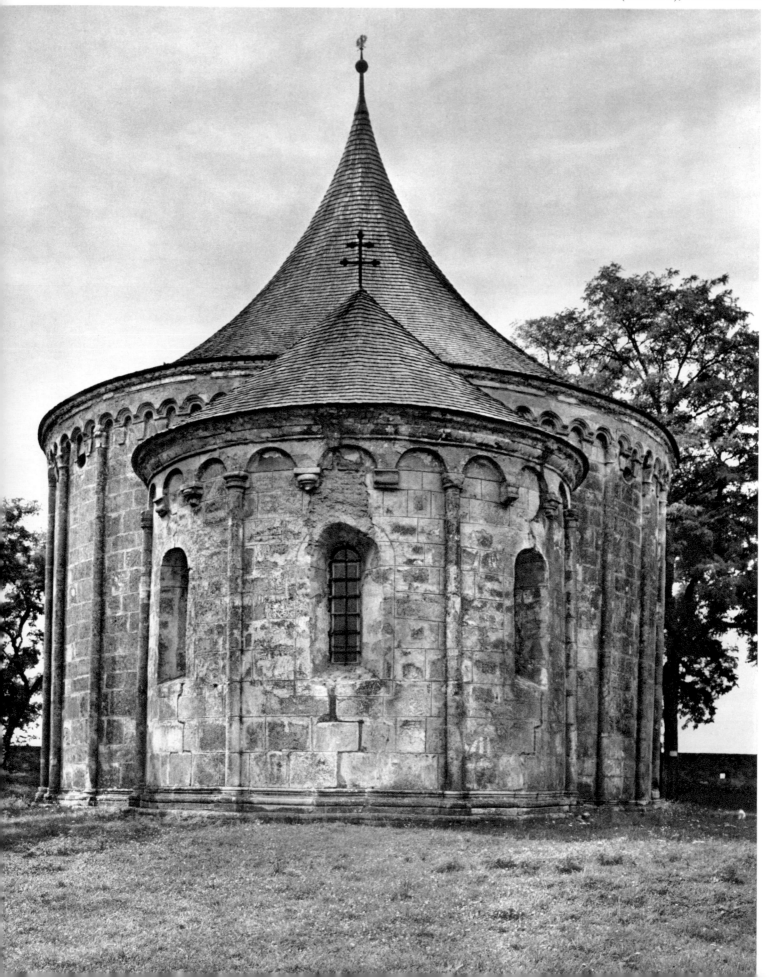

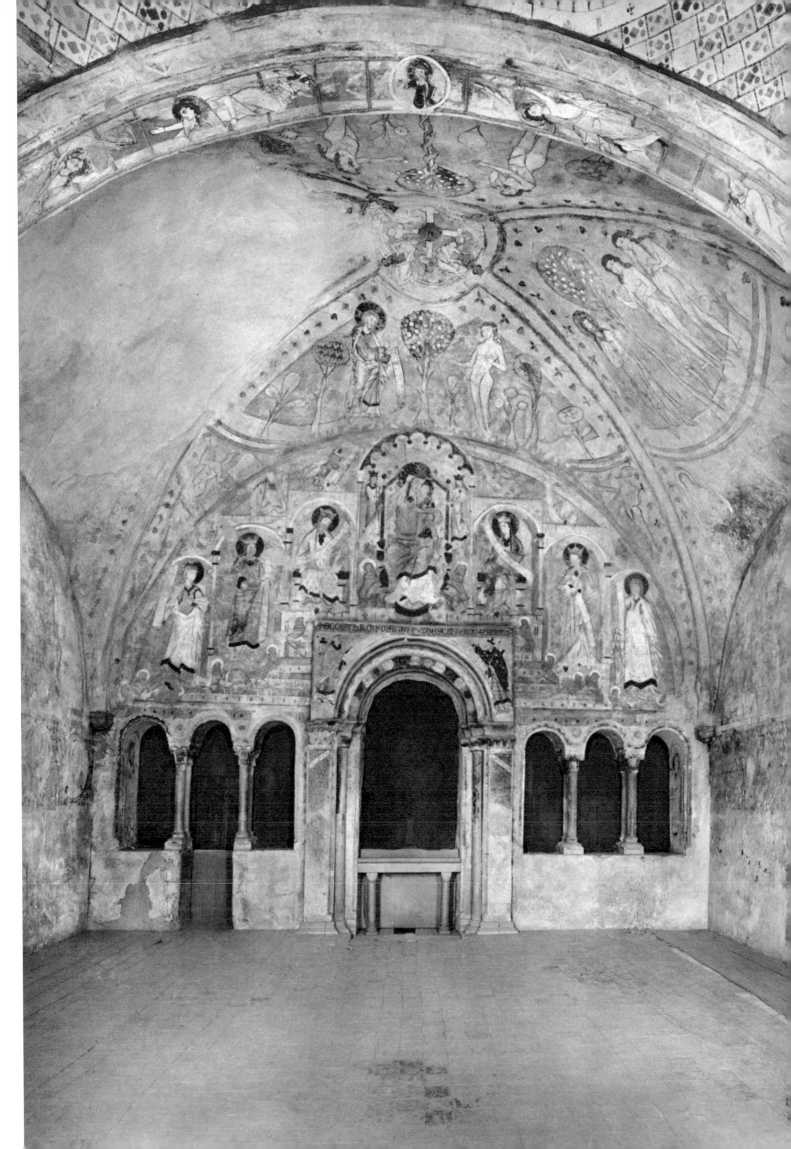

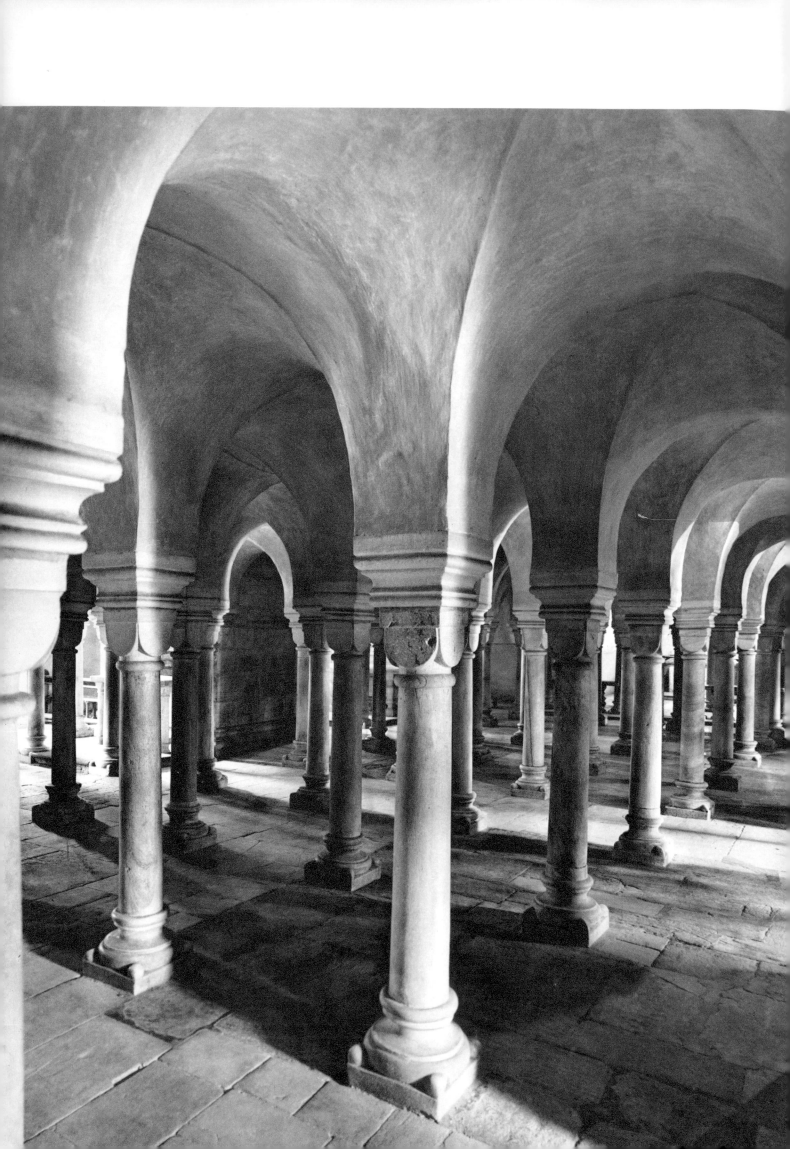

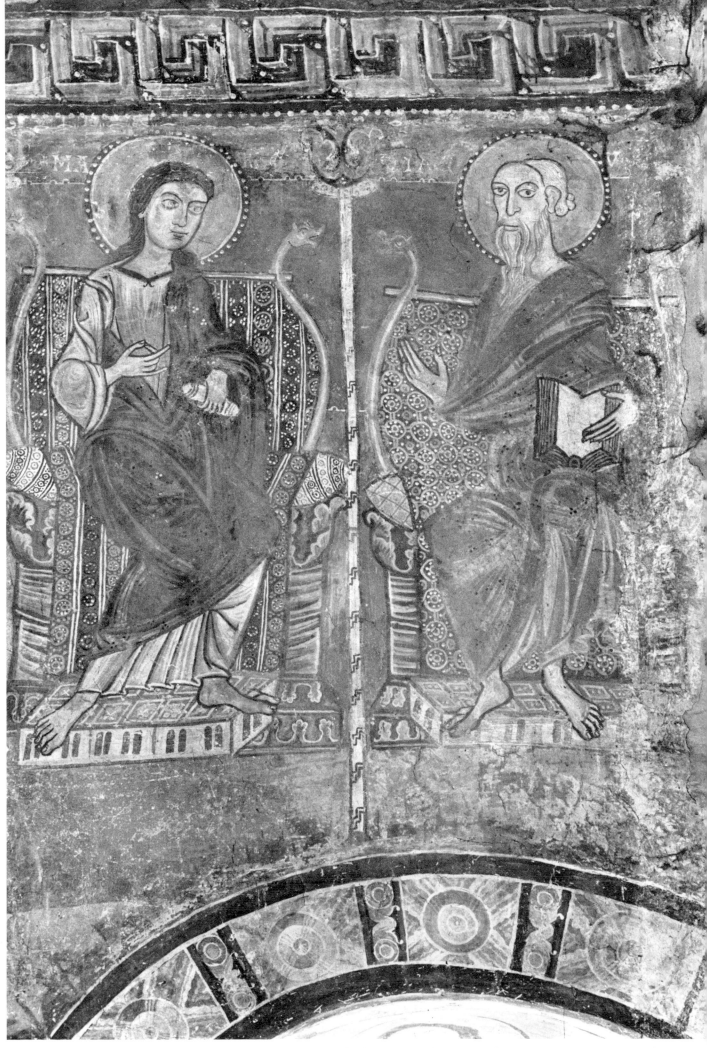

179 GURK (Kärnten), Bischofskirche 180 CASTEL D'APPIANO – HOCHEPPAN (Bolzano – Bozen)

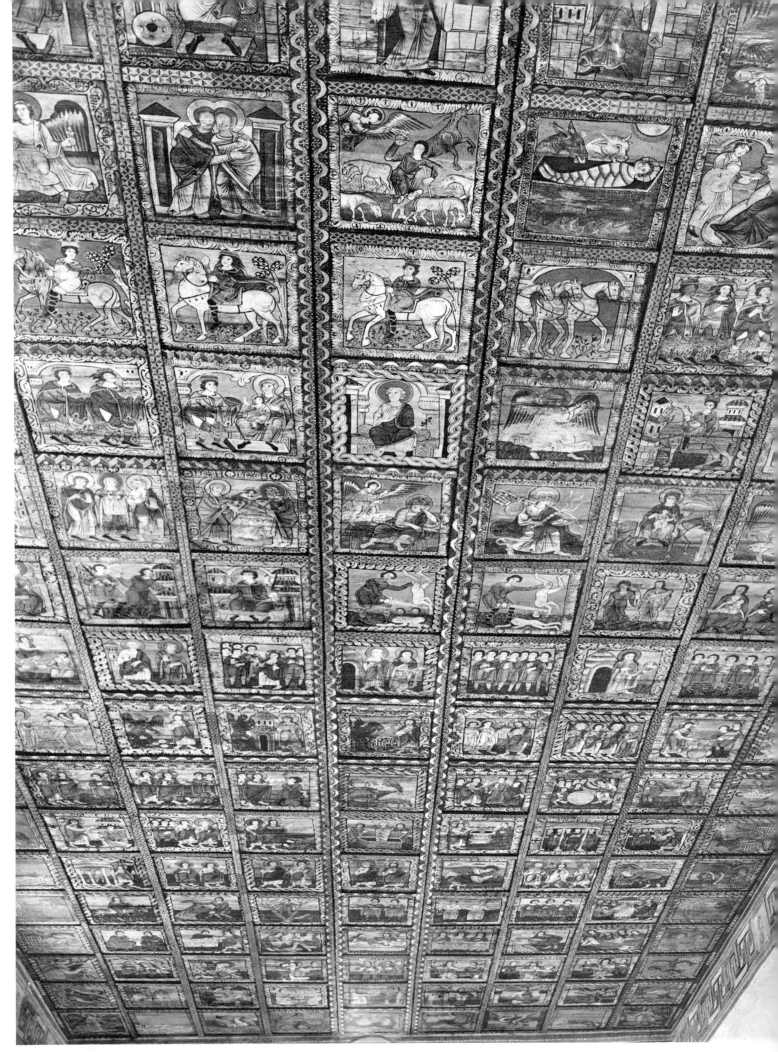

182 ZILLIS (Graubünden), Martinskirche

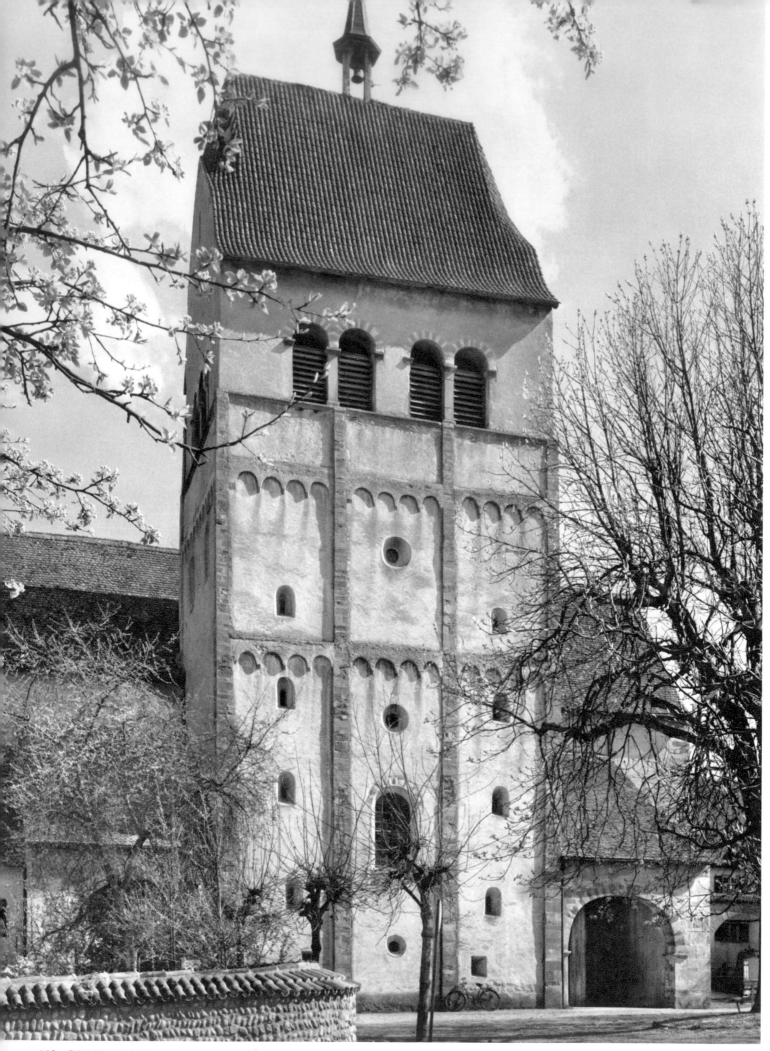

183 REICHENAU/Bodensee, Mittelzell

184 BASEL, Münster

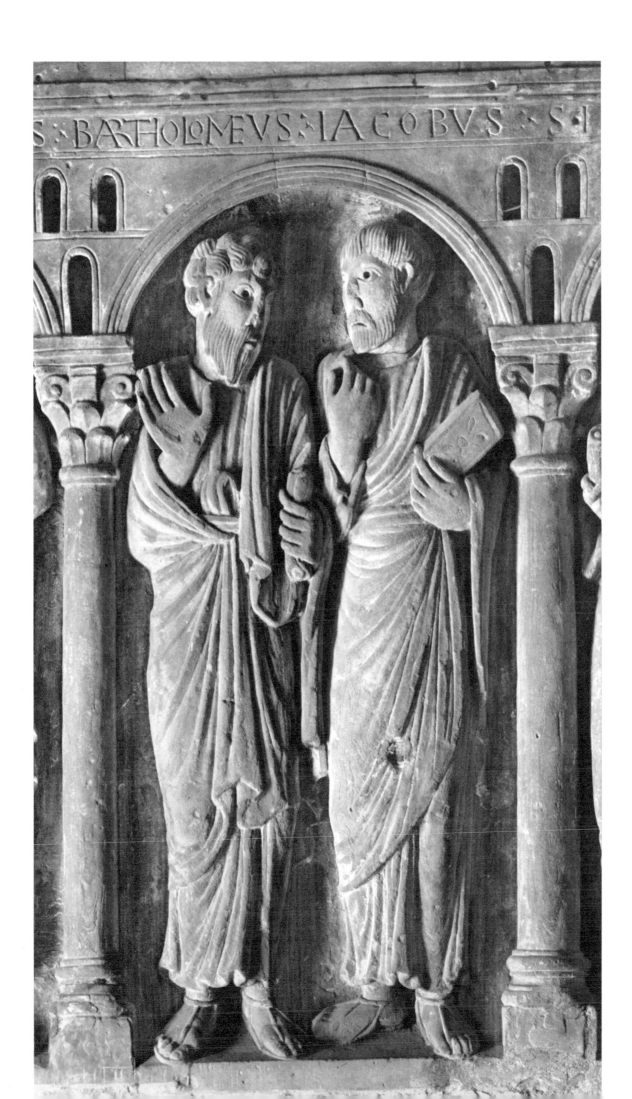

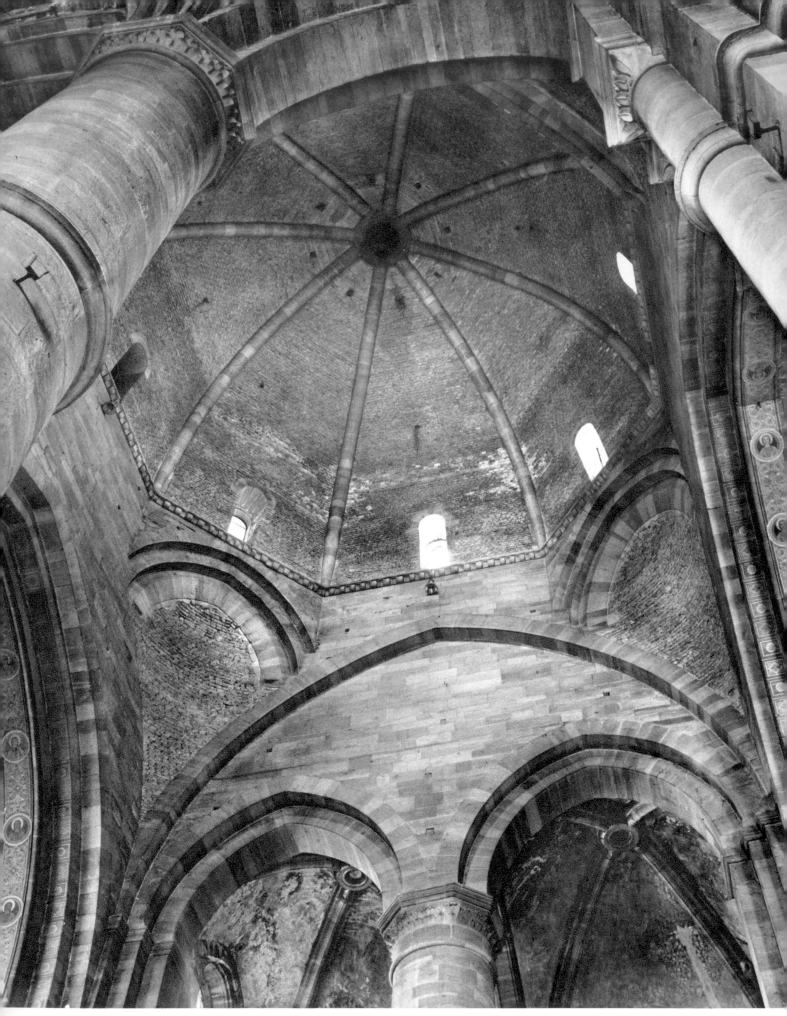

185 STRASBOURG (Bas-Rhin), La cathédrale 186 SPEYER (Pfalz), Kaiserdom

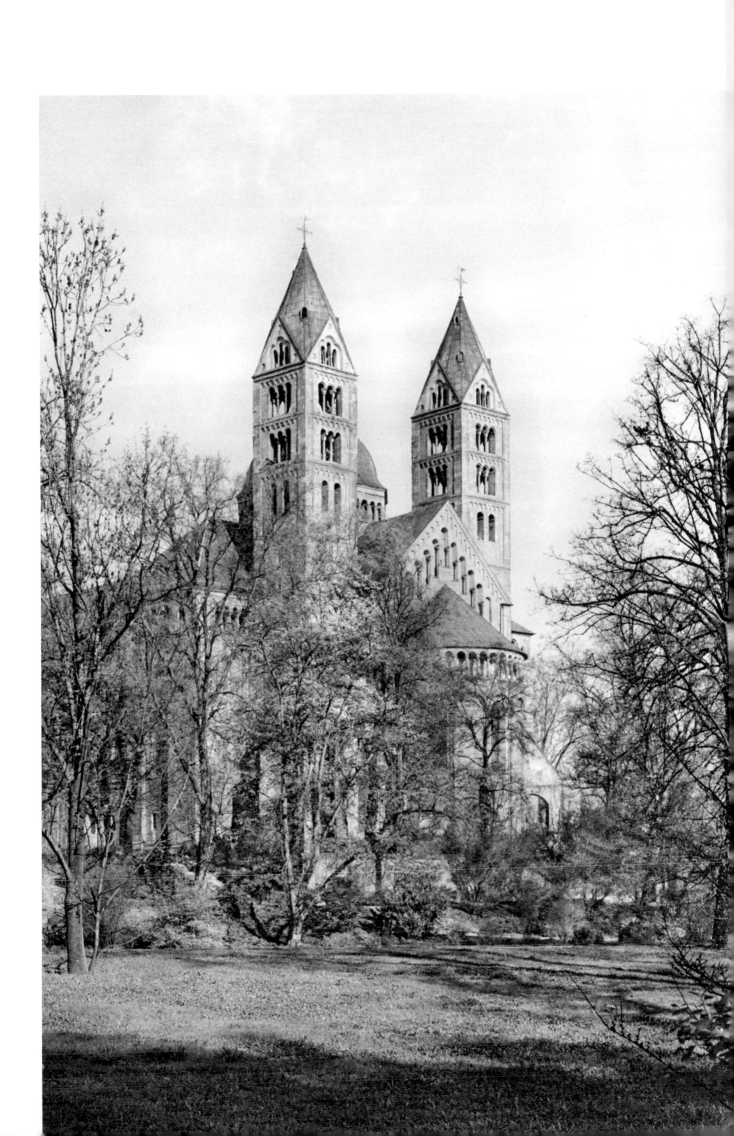

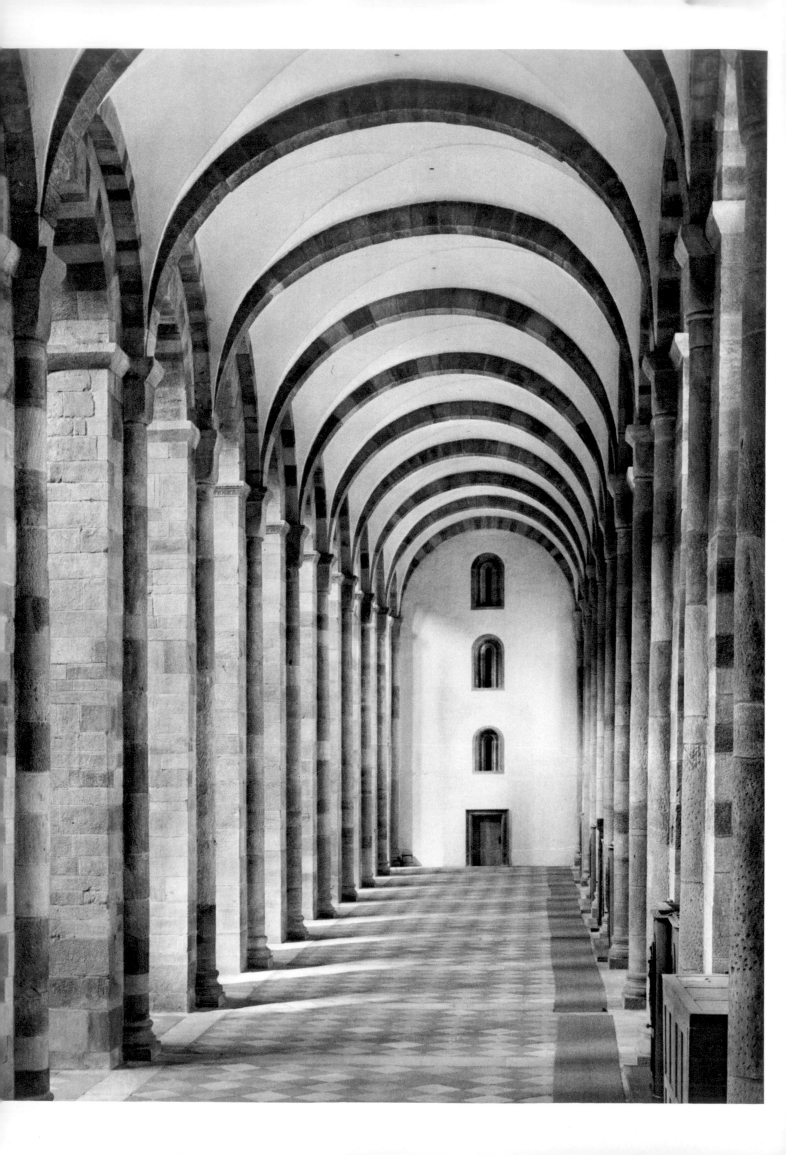

187 SPEYER (Pfalz), Kaiserdom

188 WORMS/Rhein, Dom

191 MARIA LAACH/Eifel, Benediktinerabtei

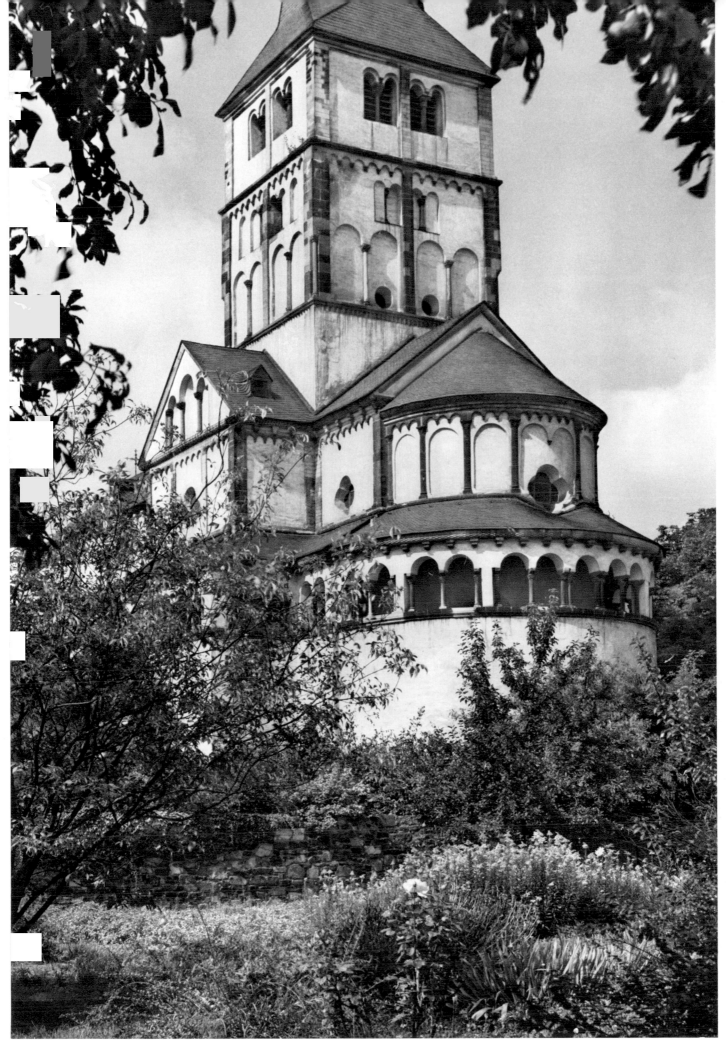

192 SCHWARZRHEINDORF (Rheinland), Kirche

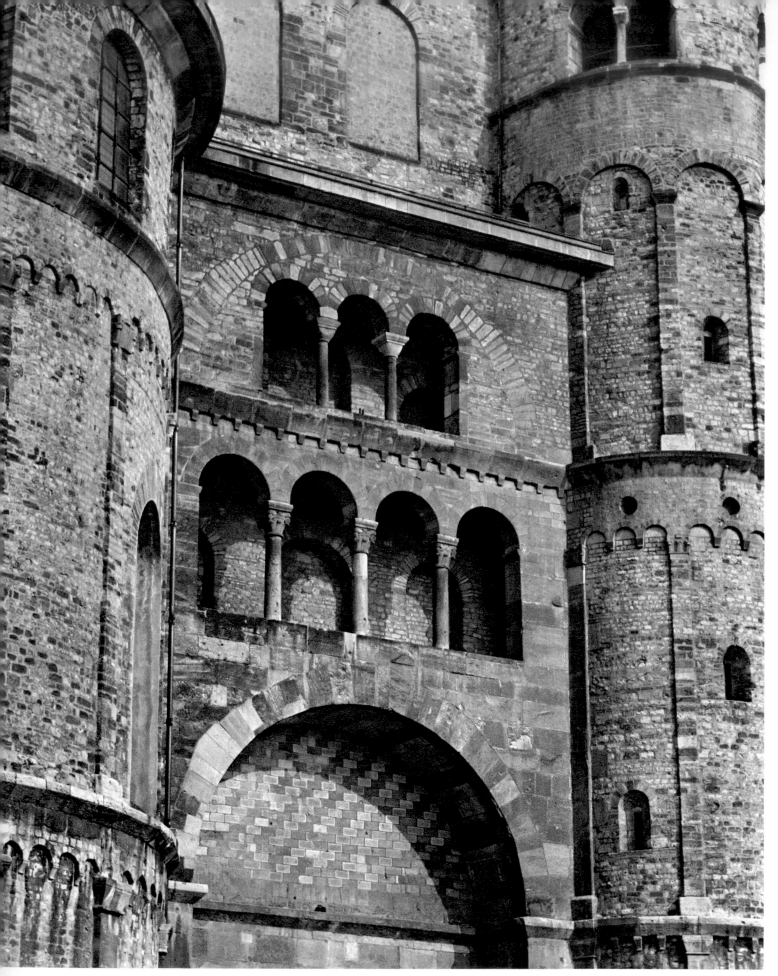

193 TRIER/Mosel, Dom

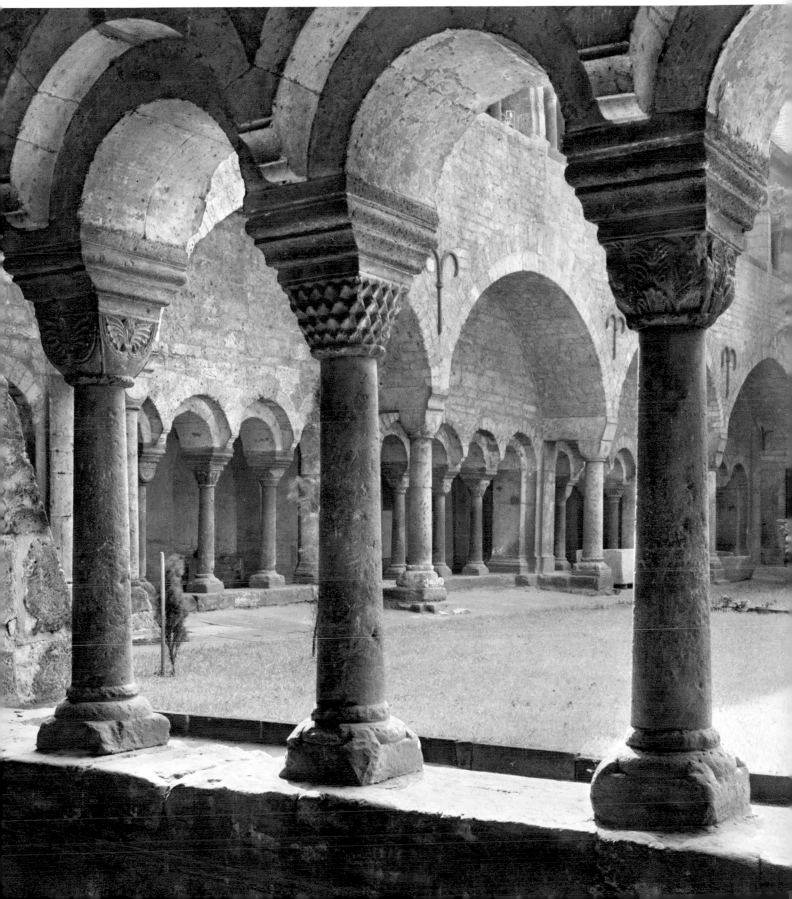

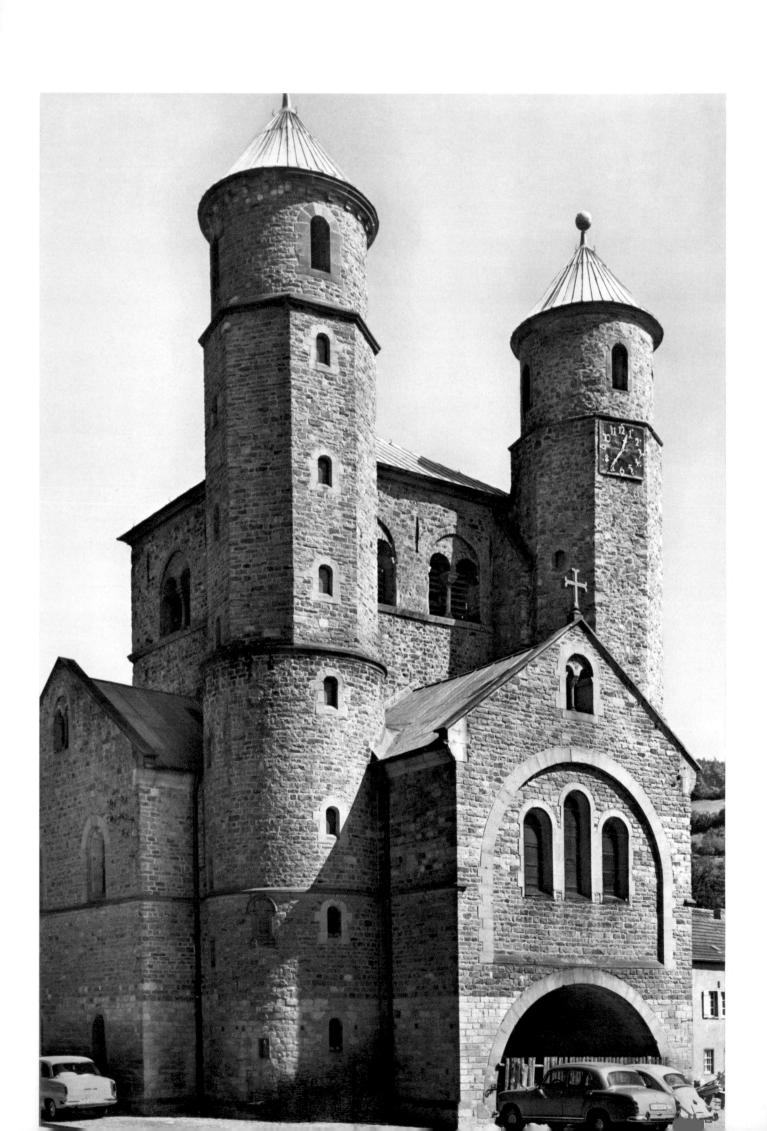

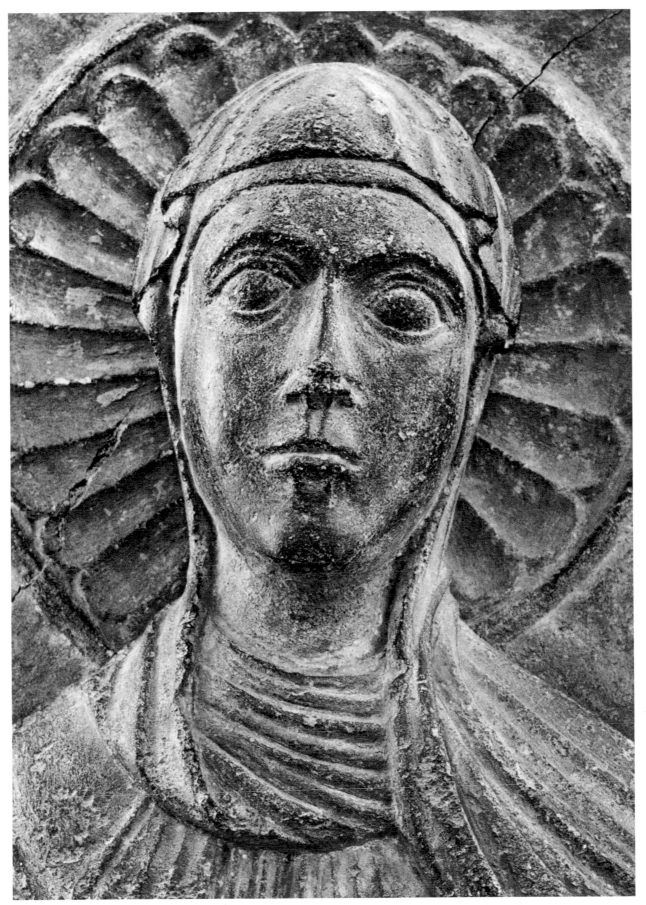

195 MÜNSTEREIFEL/Eifel, Benediktiner-Abteikirche 196 KÖLN, St. Maria im Kapitol

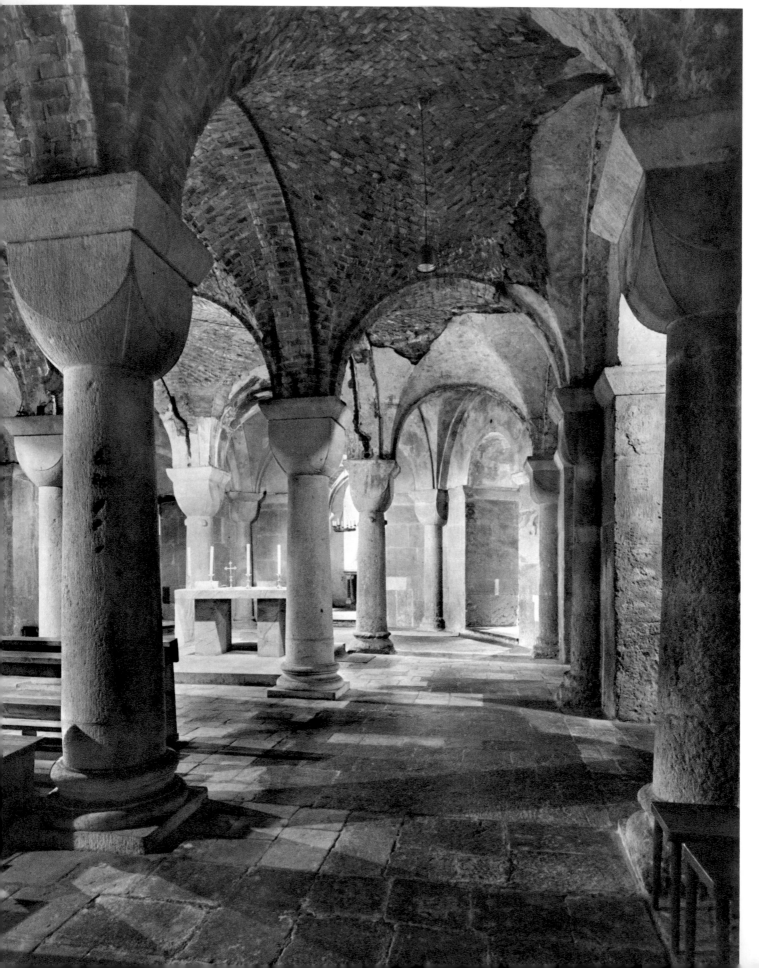

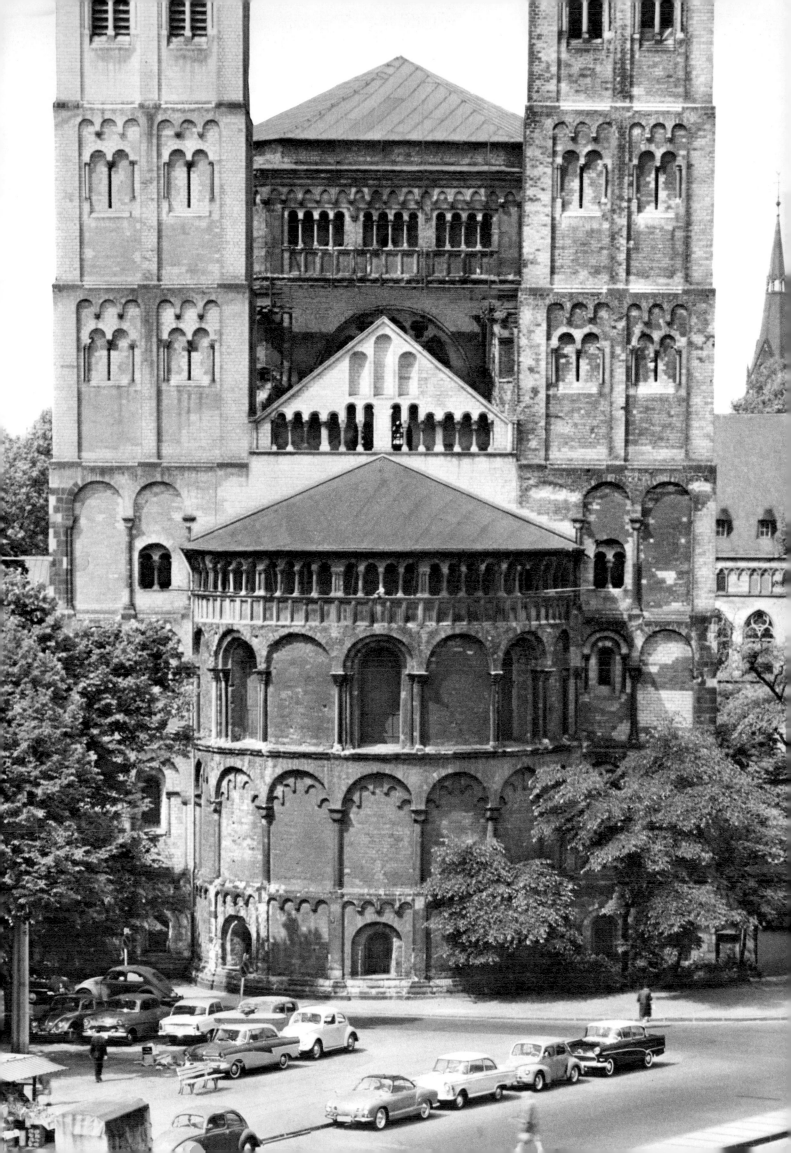

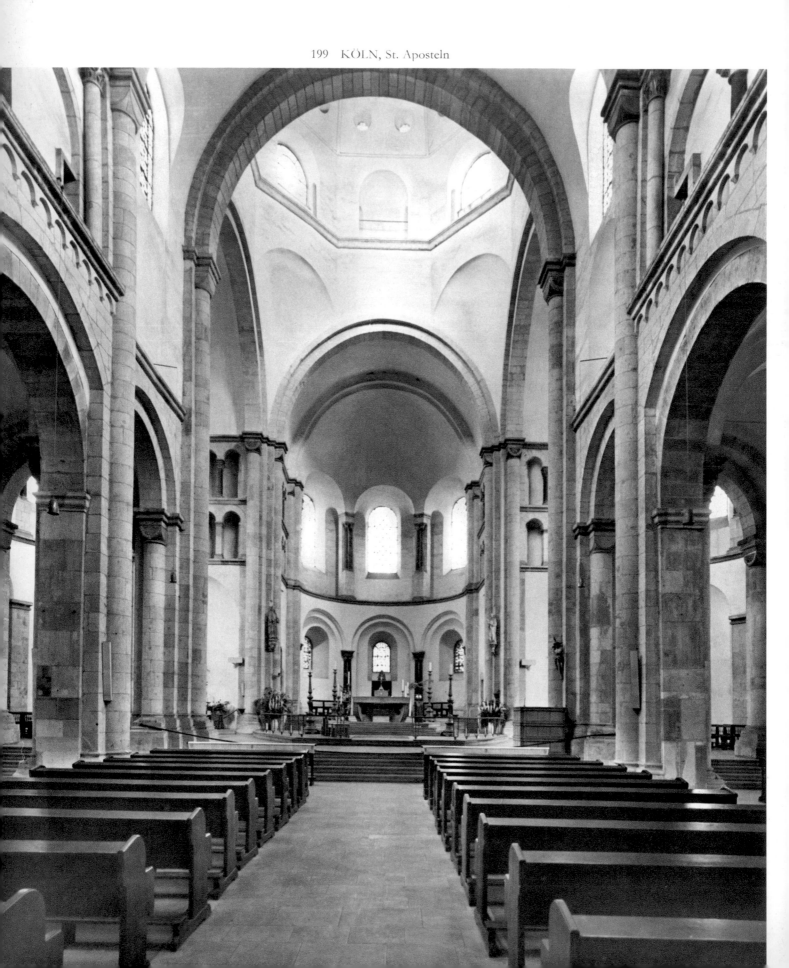

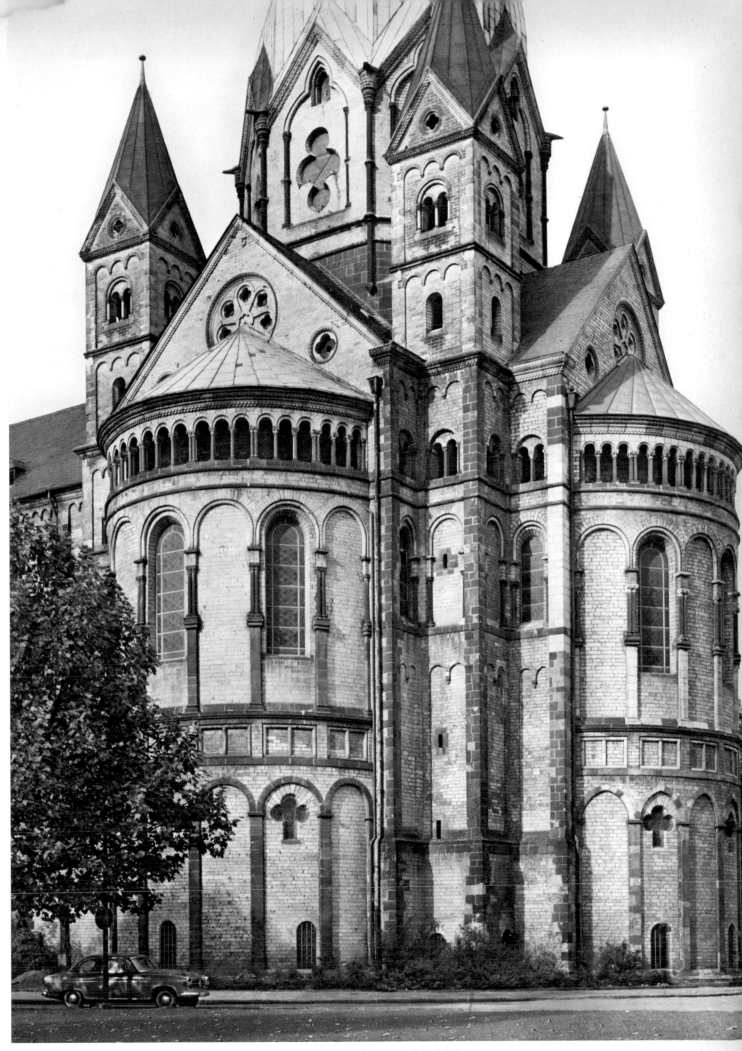

200 NEUSS/RHEIN, Stiftskirche

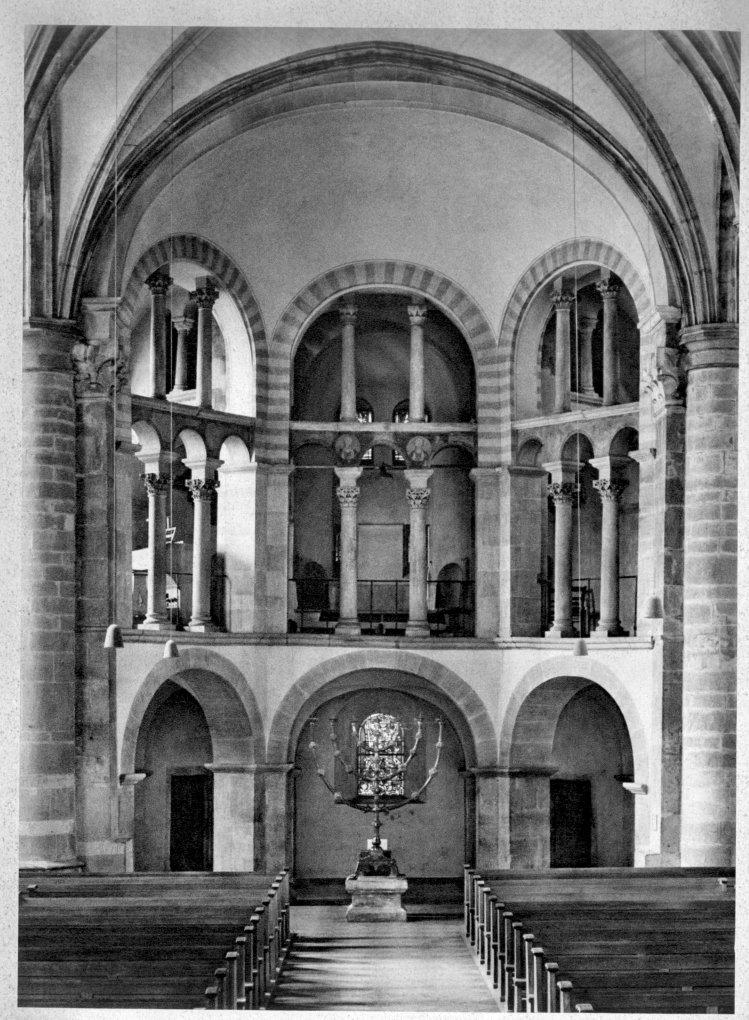

201 ESSEN/Ruhr, Damenstiftskirche

THE BRITISH ISLES

For the earliest Christian art in the British Isles we must go to Ireland, where a form of monasticism, apparently owing much to Near Eastern and Mediterranean models, survived from very early times. Ireland's remote position was the main cause of this survival. Neither the Roman Empire nor the successive Germanic tribes ever advanced further than England: thus there were no classical remains to influence art, and for a long time no threat to Christianity. The Irish monks lived not in monasteries but in loose-knit communities of hermits, each with his own hut, pursuing lives of dedicated asceticism and scholarship. By the seventh and eighth centuries they had established scriptoria from which issued the famous codices whose script and ornament became so influential in Scotland, Northern England, and the Continent. Irish monks went out as missionaries, and played notable parts as teachers in Charlemagne's cultural revival. Their migration was due in part to the fact that in the ninth century the Danes and Vikings began to harass Ireland as well as England and many monks were compelled to go into exile, their monasteries destroyed. Communities went on being founded by their successors on the Continent until the twelfth century: Regensburg in 1111, Würzburg in 1135, Vienna in 1155.

Apart from the illuminated manuscripts and works of small-scale craftsmanship, the Irish produced no considerable works of art. Some of their characteristic round towers still survive (*pl. 227*), which served as strong places of refuge during enemy attacks, and there are also the stone crosses of the tenth century (*pl. 224*), completely covered with intricate carving, which were both landmarks and symbols of the Christian faith. Ireland made no direct contribution to the development of Romanesque art; but indirectly, it was the Irish monks who by their teaching did much to lay the foundations of the Western, Christian civilization which created it.

The role of Anglo-Saxon art was more varied and more lasting. In the field of manuscript illumination such schools as Winchester and Canterbury produced work that is comparable with any on the Continent. In sculpture, the Northumbrian high crosses of Ruthwell and Bewcastle, of *c.* 700, are unique masterpieces, combining Coptic and Early Christian elements with the northern tradition of intricate patterning. Although later Anglo-Saxon sculpture survives only in isolated fragments, it was clearly of high quality, and something of its impressionistic vitality survives in the reliefs in Chichester Cathedral (*pl. 211*).

Of the major Anglo-Saxon buildings only a few foundations remain. We know from a description by Alcuin, who left York in 782 to organize schools at the request of Charlemagne, that

the cathedral begun there by Wilfrid in 767 was a high building with many columns and arches, *porticus* (small cell-like rooms opening off the main body), wonderful ceilings, and thirty altars. Brixworth in Northamptonshire, begun about 675, was already relatively large: it seems probable that it had side aisles (removed by the Normans), and for its arches masons re-used Roman bricks, laying them in a clumsy imitation of Roman wedging. But to gain our ideas of the prevailing styles we must now rely on small parish churches. In the north (for example at Escomb in County Durham, *pl. 234*) these are tall and narrow with short chancels. At both Ripon and Hexham crypts survive of about 600: they are passage-crypts, neatly tunnel-vaulted, with walls covered with fine, hard plaster. In the south Saxon churches generally consisted of a nave and chancel with extra rooms (*porticus*) along the sides sometimes placed so as to form a kind of transept. Many churches seem not to have been conceived as a whole but to have grown by the accumulation of parts.

The decoration is usually fairly crude, though it would doubtless have been more accomplished in the larger churches. The forms of timber decoration are found imitated in stone – for instance the lesenes (narrow decorative strips of stone) on the tower of Earls Barton *(pl. 234)*, and the horizontal courses persisting among the well-laid ashlar blocks of the chancel arch of Escomb. Doors are tall and narrow, often with pronounced impost-blocks, and windows may have triangular heads supported on baluster-like turned stone shafts. The most spectacular survivals are towers: Earls Barton already mentioned, Sompting in Sussex, Deerhurst in Gloucestershire and Barnack in Northamptonshire. These towers often contained the main chamber of the church and were places of safety in the event of an attack.

The Norman conquest brought the architectural style of Normandy fully-formed to Britain. Between 1070 and 1100 a great wave of building – castles, cathedrals, abbeys and parish churches – swept the country. No attempt was made to patch up or enlarge Anglo-Saxon buildings. The new order required a new beginning.

The typical major Norman church has a chancel, transept, and a nave with aisles. There was usually a tower over the crossing and often other towers at the west end. Elevations are three-storeyed, consisting of arcade, gallery and clerestory, and the ceiling would have been flat and of wood (this type can still be seen, e.g. at Peterborough, where it is original, at Ely, and at St. Albans). By the mid-twelfth century stone vaulting began to develop generally; and indeed, as we have seen, the cathedral of Durham *(pl. 231)* was a European pioneer in this respect. In essentials, however – though from the beginning there were strong Rhenish elements – English Norman was the Romanesque of Normandy transplanted, and often at first the very stone was brought over from quarries at Caen in northern France. Where the English churches did soon exceed their Continental counterparts was in the matter of size: Bury St. Edmunds abbey church had a surface area of 60,000 square feet, compared with the 54,000 square feet of the huge double-aisled third church at Cluny (see p. 25) and the Norman nave of Winchester (under its Perpendicular disguise) is still the longest nave in Europe.

Within the fixed pattern there could be infinite variety, giving each building a character and individuality of its own. West ends took a number of different forms: in the centre at both Tewkesbury *(pl. 223)* and Lincoln *(pl. 238)* is a giant arch, but at Lincoln other giant arches con-

tinued around the sides of two chapels projecting beyond the width of the aisles; unlike Tewkes-bury, Lincoln has two towers, and the façade is carried across in front of them like a screen. At Ely *(pl. 240)* there is a massive central tower which was flanked by tower-topped transept arms, forming an unusual triple rhythm.

Inside the churches, the variety is almost as great. At St. Albans, built largely of brick from the ruined Roman town on the site, the nave piers are massive rectangular blocks and the window openings have simple square mouldings *(pl. 208)*, as if the solid wall had simply been cut through. At Winchester the piers are thick and have many attached shafts, while at Durham in the north and at Waltham Abbey near London there are powerful circular pillars with barbaric incized ornament. In the West Country, by contrast, a different system was used involving enormously tall circular pillars which sometimes run through the gallery storey as well; examples of this type occur elsewhere in the country at Oxford Cathedral and in one bay of Romsey Abbey *(pl. 213)* St. John's Chapel in the Tower of London *(pl. 207)*, the transepts of Winchester *(pl. 212)*, and the truncated nave and aisles of Blyth *(pl. 236)* show English Norman in its primitive strength; the stones are somewhat roughly cut and separated by thick mortar, and there is little or no ornament. During the twelfth century the style became more confident, more subtle and more expressive, as Norwich *(pl. 243)* and the Durham Galilee *(pl. 233)* show. Of the means by which variety is at-tained it is sufficient to mention a few: inventiveness in the form and section of piers; differences in the relative proportions of arcade, gallery and clerestory, and in the subdivision of the gallery (at Southwell, *pl. 237*, the gallery is completely open, giving an effect like that of a Roman aque-duct); and the use – growing more lavish with time – of complicated geometrical ornament.

There was relatively little figure sculpture in stone on the Continent at the time of the Norman conquest of England (the great sculptural ensembles are mostly of *c.* 1100 and later); in England the tradition showed a preference for low-relief, somewhat abstract forms, often based on manu-script illuminations. The two outstanding compositions of Anglo-Norman sculpture are the Prior's Door at Ely *(pl. 241)* and the porch of Malmesbury *(pl. 215, 216)* – and they depend on Continen-tal ideas from as far afield as Italy. The fantastic elongated monsters and the armed men caught in luxuriant interlace at Kilpeck in Herefordshire are Scandinavian in origin (compare *pl. 225* with *pl. 246* and *247*). But the Norman delight is the abstract forms of billet, chevron, cable and spiral is everywhere apparent, for instance in the chapter house at Bristol *(pl. 218)*. The supreme master-piece of the Romanesque style in England is Durham Cathedral *(pl. 231–233)*, where all these diverse attractions are united, and which broke new ground in its use of rib vaults higher and of wider span than any before.

202 BARFRESTON (KENT), ST. NICHOLAS. *Exterior from the east.* The church of St. Nicholas consists of an aisleless nave and slightly inset rectangular chancel, roofed in wood and without a tower. It was probably erected at the end of the 11th century; a century later, the upper parts of the building were faced with Caen stone, and the church was further enriched by the addition of a rose window, doorway sculptures, and other carving. The east end is emphatically articulated. Above a plinth stage the fenestration is arranged symmetrically and consists of three narrow round-arched windows between four niche-like blind arches. The gable is bounded at the foot by a heavy string-course elaborately decorated with interlace, flanked by two lions, and supported by corbel-heads. The figures let into the wall are obviously fragments of an earlier ensemble: the eagle of St. John, a dragon, medallions representing a lion and a griffin, St. Martin of Tours in the left-hand niche, and in the right-hand niche what is probably a fragment of the figure of God which formerly, as a print of 1773 shows, occupied the space above the rose window. Rose windows are more commonly found on the west front or transept end; here eight spokes of cylindrical shafts link the hub with the outer ring, which is richly carved with foliage and various beasts.

3, 204 CANTERBURY CATHEDRAL (KENT). *Crypt.* The first episcopal see in England was founded in the royal capital of Cantwarabyrig. The monastery was restored about 950, but destroyed by fire a year after the conquest. In 1070 William the Conqueror appointed Lanfranc, the Lombardic abbot of St. Etienne at Caen, as abbot of Canterbury, and rebuilding began. Lanfranc's aisled nave, transept and triapsidal chapel were enlarged by his successor, Anselm (1093–1114), who extended the chancel and, beneath it, Lanfranc's crypt. Work continued under Prior Conrad, and the new choir was consecrated in 1130.

Anselm's crypt is aisled, with an ambulatory and chapels situated under the arms of the eastern transept, the tangential chapels and the apse. The decoration of both columns and capitals is varied. Each bay is neatly groin-vaulted between transverse arches. Crypts of this type were common in England c.1100 (Winchester, begun 1079; Worcester, begun 1084; Gloucester, begun 1089); they occur on the Continent in Italy and Germany.

The most ornate capitals date from between 1115 and 1125; these have foliage scrolls and corner masks, or scenes taken from the bestiary, similar to decoration in contemporary manuscripts from the Canterbury scriptorium. The workmanship of these capitals is as remarkable as their state of preservation. Some show fantastic animals playing musical instruments *(pl. 203)*, while another has a griffin and serpent attributable – one is tempted to think – to a sculptor who may have known Tuscan as well as French work *(pl. 204)*.

205 RECULVER (KENT), ST. MARY. *Exterior from the south-east.* The foundations of a first church, begun after 669, are visible and show that it followed the pattern typical of early Kentish churches: a rectangular nave, an apsidal chancel of the same width, and rectangular north and south chambers *(porticus)* leading off the chancel. Nave and chancel were separated by an arcade of three arches. The church was enlarged during Norman times, and the surviving towers and gable-end date from this period and later. The sea gradually eroded the headland on which the church was built, and in 1805 the nave and chancel were demolished. The west end was reinforced, and the towers used to provide the off-shore sailor – now as for centuries past – with a conspicuous landmark, known as 'the Twins'.

206 ROCHESTER CASTLE (KENT). *Exterior from the north-west.* Work began on this massive structure in the reign of Henry I (1100–1135); it replaced an earlier Norman castle sited at the point where the Medway widens into a harbour and ancient thoroughfares led across a ford. The keep is seventy feet square with four corner towers a hundred feet high. Access is from the north, guarded by a projecting rectangular tower. Now a ruin, the castle belongs to the second generation of Norman keeps, whose interiors were further subdivided and decorated to a certain extent with geometrical patterns.

207 LONDON, ST. JOHN'S CHAPEL, IN THE TOWER. Shortly after 1066 work began on the castle, sited on a hill on the north bank of the Thames, within the old Roman walls. The keep, built of stone from Caen and limewashed, was completed in 1097. It was a royal residence as well as a fortress. The chapel, virtually unaltered, is one of the finest examples of early Norman architecture in England. The general impression is massive, stern and austere, and the masonry is carefully executed. Two aisles flank the nave and continue in an ambulatory around the chancel. The simple, unmoulded arches of the arcade are narrow and stilted at the east end. The capitals are equally monumental – cushion capitals and simple scalloped capitals, one

with a volute motif and others with a leaf at each corner and a St. Anthony's Cross on each face.

The gallery's square masonry piers have no capitals. The aisles are groin-vaulted, the galleries tunnel-vaulted, and the nave, unusually for England, is also tunnel-vaulted.

208 ST. ALBANS CATHEDRAL (HERTFORDSHIRE). *Interior of the crossing-tower*. The cathedral was begun as a monastic church by Abbot Paul of Caen (1077–88), and had an aisled nave, a transept with stepped eastern apses, and an apsidal chancel. Roman bricks and tiles from the nearby ruined town of Verulamium were used in the building, which was consecrated in 1115. Part of the nave and the crossing survive from this Romanesque church.

The bold, high lantern-tower over the crossing is the crowning glory of the church. Our photograph shows it looking south-east, with the chancel on the left and south transept on the right. Above the vast crossing-arches, which have three square mouldings and are painted, runs a row of twin arches screening a wall-passage. This articulation is more elaborate than that of the nave, which has square piers without any capitals. The painted ceiling of the crossing dates from the 16th century and has been restored; it is about 100 feet from the ground.

209, 210 BRIGHTON (SUSSEX), ST. NICHOLAS. *Font*. This stone font is dedicated to St. Nicholas, the patron saint of seafarers, and was probably imported from France. It is an admirable example of 12th-century Norman workmanship. Restrained in style and symmetrical in design, the drum-shaped bowl is bounded at the foot by a band of floral ornament and at the top by a row of lozenges carved in angled relief. The broad central section shows two separate scenes.

One of the scenes is a legend of St. Nicholas, which reads from right to left. The goddess Diana, furious that her temple has been burnt at Nicholas's instigation, persuades a female pilgrim to burn his church at Myra. But St. Nicholas, standing at the left, gives orders that the jar containing the incendiary oil should be cast into the sea. On the other side of the font Christ and the disciples are shown at the Last Supper, seated at a table laden with vessels. The sculptor has tackled the problems of high relief with remarkable success. Christ, with flowing hair and a cruciform nimbus, raises his right hand in blessing. The disciples wear tight-fitting caps and have no haloes.

211 CHICHESTER CATHEDRAL (SUSSEX). *Relief of the Raising of Lazarus*. Chichester Cathedral was conse-

crated in 1199. In the south aisle of the choir are two panels four feet high, showing Christ's meeting with Mary and Martha and the Raising of Lazarus. Neither their date not their original location is definitely known. They were discovered behind the choir-stalls in 1829, and suffered during the move; there is some doubt about their re-assembly, particularly in the case of Christ's hand in the Lazarus scene. The stone, which came from Caen, still bears traces of original pigment. It seems most likely that the panels date from the second quarter of the 12th century. The scenes are no longer conceived *in vacuo* and the figures have begun to be detached from their background. There are signs of observation from nature, such as the carving of the grave-diggers, one of whom clenches his teeth with exertion. The general tone is, however, still 'exemplary', and the medieval law of 'spiritual perspective', under which relative dimensions were governed by intrinsic significance, still holds good: Christ, being the principal figure, is also the largest. The sculptors of the Chichester panels – for there must have been more than one – had assimilated both French and Nordic influences.

212 WINCHESTER CATHEDRAL (HAMPSHIRE). *North transept*. The core of the cathedral church of the Holy Trinity at Winchester is the Norman church built by Bishop Walkelyn in 1079. However, it has been so extensively added to and refaced that only isolated Romanesque elements are visible today, notably the crypt, the transept and the crossing tower. Both arms of the transept are aisled, like the nave, but have a highly unusual feature in the bridge-like continuation of the aisles across the end walls. The masonry is still rough, and the many shafts are all topped with simple cushion capitals. The arches have plain, square mouldings.

213 ROMSEY (HAMPSHIRE), ABBEY CHURCH. *Junction of nave and north transept*. Romsey Abbey still bears witness to the splendour of the former Benedictine nunnery, whose first foundation dates from the beginning of the 10th century. Architectural evidence points to 1120 as the year in which work on the present church was begun. The crossing is impressive in its simplicity: four massive and tall compound piers support triple-stepped crossing arches. Chancel, transept, and one bay of the nave were completed in 1140, after which an artistic interregnum set in. This first bay of the nave shows that it was intended to have plain circular piers running through both arcade and gallery. When work was resumed in 1150 a new scheme was adopted with an increased emphasis on verticals (with attached shafts carried up without interruption from the ground), and

a refinement of the structural members. The treatment of the gallery openings is unusual, with the tympanum above the twin arches filled only by a colonnette.

214 EXETER CATHEDRAL (DEVON). *South tower.* Exeter Cathedral is the sole surviving example of a variant not found elsewhere in England: its north and south towers are situated over the arms of the transept. The south tower is more richly decorated than its companion on the north (the battlements and pointed corner-turrets are later additions). The four corners are emphasized and reinforced by pilaster-like projections, narrower towards the nave. Above the plain plinth rise three intermediate stages of varying design, each separated by a string-course. Above the second stage there are circular recesses which vary the rhythm, and altogether one can discern an ability on the part of the builders to incorporate subtle rhythmical effects. The climax is reached with the top stage, in which the tension of the tall narrow arcades is released by the use of three large round-headed windows and alternating broad and narrow blind arches.

The cathedral was begun *c.*1130 by Bishop William Warelwast, a nephew of William the Conqueror; it was consecrated in 1133 but work continued until about 1200.

215, 216 MALMESBURY (WILTSHIRE), ABBEY CHURCH. *Lunettes in the south porch.* What now exists of Malmesbury Abbey is merely the remains of a once large and magnificent monastic complex. The south porch is a masterpiece of late English Romanesque. Sculpture appears on the broad outer arch, the side lunettes and the inner doorway, whose tympanum portrays Christ in a mandorla supported by two angels. The lunettes are situated on the inside walls of the porch to either side, above a row of four blind arches. The fully sculptured porch, characteristic of south-western France, does not appear anywhere else in England. While the sculptures clearly show French influence, there are insular touches, such as the way the heads of two of the apostles are curiously inclined, as though they were ducking to avoid the angels soaring overhead, in the direction of Christ on the tympanum. This feature also serves to isolate them, for the pairs of apostles on either side have turned to each other, while the figures nearest the doorway, Peter with his key *(pl. 216,* right) and Paul *(pl. 215,* left), gaze at the apparition of Christ. There is great variety in the figures' hands, their different postures, the position of their feet, and the type of robe they are wearing. The south porch was probably the last piece of work to be carried out on the rebuilt abbey, about 1180.

217, 218 BRISTOL CATHEDRAL (GLOUCESTERSHIRE). *Entrance and interior detail of the chapter house.* Bristol grew rapidly after the Conquest. The church served an Augustinian abbey founded in 1142; the chapter house dates from that late phase in Norman architecture when, fully aware of their technical ability and material resources, builders and clients were extending themselves to the limit.

The chapter house adjoins the south transept and is approached from the east walk of the cloister by way of a vestibule *(pl. 217)* three bays wide and two bays deep. The piers, which are square with attached demi-shafts, support scalloped capitals and heavy rib vaults. The arches and ribs have strips of bead-moulding, and the walls are articulated with plain and very shallow niches devoid of capitals. The vestibule vault is low to accommodate the dormitory above it. Its restraint is in dramatic contrast to the spacious unaisled chapter house, which is elaborately decorated. The east wall with its windows was rebuilt after 1831; other isolated features have been restored, but faithfully so.

The fascination of the room derives from a contrast between simple, clear proportions and extremely varied wall articulation. The upper part of the wall is decorated with intersecting blind arches, whose shafts are alternately plain and spiral-beaded. The capitals assume various forms, scalloped, scaled, foliate and volute. The transverse arch which divides the chamber into two bays is decorated with opposed bands of bead-filled zigzag between two roll mouldings, and springs from squat scalloped capitals. The diagonal ribs again have opposed strips of zigzag, with the resulting rhombs filled with stellate flowers. The enrichment of the walls reaches its climax in the lunettes, which are covered with zigzag and continuous trellis-work.

219 IFFLEY (OXFORDSHIRE), ST. MARY THE VIRGIN. *Capital on the south door.* St. Mary's is one of a group of small but elaborately decorated Late Romanesque churches in England, all of which came into being between 1160 and 1180. The south door was probably carved before the west front; unlike the west door, it has capitals. On the inner capital on the left, carved in the crisp manner typical of Iffley, a female centaur is shown carrying a bow and arrow and suckling her young. The moral – evils breeds evil – would have been plain to any 12th-century Christian.

220 LANGFORD (OXFORDSHIRE), ST. MATTHEW. *Relief of the Crucifixion.* St. Matthew's possesses two stone reliefs of Christ on the cross. Neither is *in situ:* one is on the east wall of the south porch, the other on the porch's gable-end. Controversy surrounds the appraisal

and dating of the Crucifixion on the gable-end. Assessment is made more difficult by the reassembly, during which the figures of St. John and the Virgin were transposed, and the whole group placed in an awkward niche. In view of the incorrect position of the thumb on Christ's right hand, it seems likely that the blocks of stone on which the arms are carved were also transposed; if the blocks were reversed, the arms would be inclined upwards so that Christ would hang from the cross. Like the other Christ at Langford, this composition seems to be an Anglo-Saxon work, but it is probably somewhat later, dating from the mid-11th century.

221 OXFORD, ST. PETER'S-IN-THE-EAST. *Crypt.* The existing Norman church was endowed by Robert D'Oilly in 1140 and probably completed about 1150. It consists of a nave, chancel and crypt. The crypt, seen here from the east, is a rectangular chamber divided into three aisles of equal height with groin vaults separated by transverse arches. In the east is a small altar niche, and in the west a tunnel-vaulted shrine chamber situated between the original steps leading down from the nave. The capitals vary in elaboration, and some are figured.

222 GLOUCESTER CATHEDRAL. *Detail of the chapter house.* In 1089 a completely new church was begun for the Benedictine community at Gloucester. The monastic complex was probably finished about 1160, and from this period large sections of the chapter house survive. A blind arcade runs along the wall, with three-dimensional chevron mouldings in some of the arches.

223 TEWKESBURY (GLOUCESTERSHIRE), THE ABBEY CHURCH. *West front.* Tewkesbury Abbey, consecrated in 1123, belongs to the second wave of Anglo-Norman churches. The west front is unique in its boldness of conception; it probably dates from the mid-12th century. The 14th-century turrets, the Gothic windows of the aisles, the disappearance of the gabled roof, which collapsed in 1614, even the Gothicizing central window so ineptly inserted in 1686 – none of these things can seriously distract from the monumental effect of the recessed façade with its tall, unadorned shafts and simply moulded arches. Over 60 feet high, it is an eloquent symbol of the pride and majesty peculiar to Anglo-Norman architecture. Like the lofty cylindrical piers inside, it reflects the English fondness for elongation.

224 HEREFORD CATHEDRAL. *East wall of the south transept.* The Norman cathedral was of the triapsidal type, with an elongated three-bayed chancel, transept, cross-

ing tower and aisled nave of eight bays. Little survives of this no doubt imposing building, except in the south transept, where the east wall is still recognizable as an architectural composition of c.1100. The section which opens into the south aisle of the choir is three-storeyed, whereas the wall proper has five storeys. Below, grouped in threes and not later in style than 1105, is a series of blind arches, in which budded capitals appear alongside the cushion and scalloped varieties. Above them, one to each bay, come large and archaic-looking blind arches, the central one with inset shafts. Above these there is a low triforium passage with three triple openings on squat shafts. Then comes a remarkable storey which testifies to the changed architectural ideas of a new generation: a row of narrow and attenuated blind arches. At the top comes the clerestory with its wall-passage arches interrupted, here as so often elsewhere, by late Gothic vaulting. Only at this level does the chevron motif appear, indicating the second decade of the 12th century. The bay next to the crossing seems to be later, but has been much restored.

225 KILPECK (HEREFORDSHIRE), ST. MARY AND ST. DAVID. *Jamb of the south door.* This small church, dating from the middle of the 12th century, is a uniquely important example of English Romanesque for three reasons: it is excellently preserved, its rich sculptural decoration can be seen *in situ,* and it is an outstanding product of a regional school of sculpture. The church possesses two highly important ensembles, the chancel arch and the south doorway, of which we illustrate the left-hand jamb. The outer shaft is carved with a fearsome snake-like dragon, its head pointing downwards. In the scrolls of the inner shaft there are two warriors dressed in ribbed garments, possibly coats of mail. The lower figure (shown here) turns his back on the serpent and raises his left hand towards the door. The dragon is unmistakably Nordic, in the Ringerike style.

226 EARDISLEY (HEREFORDSHIRE), ST. MARY MAGDALENE. *Font.* The stone font at Eardisley is excellently preserved and of high quality. It is remarkable, in view of the troubled times through which Herefordshire, on the border of Wales, passed between 1140 and 1170, that such a homogeneous style should have evolved, and that such a compact and closely-related group of doorways and fonts (of which there is another important example at Castle Frome) should have come into being as a result. The school is characterized by a relief technique which concentrates, with few exceptions, on not more than two levels, and a sculptural treatment which achieves dramatic emphasis by a close juxtaposition of light and shade.

The Eardisley font is goblet-shaped; heavy plaiting encircles the rim, while at the base there is a cable-moulding and a row of interlace forming pretzel-shapes similar to the interwoven knots found in Irish art. The sequence in the central, figured, band is as follows: a battle scene, a saint, Christ with crozier and cruciform nimbus, a man enmeshed in scrolls, and a lion. Only Christ, the saint and the lion – here a symbol of Christ – are free from the entwining scrolls. Christ is shown with his staff planted firmly in the ground, wresting Adam from Limbo. The bird perched on his left shoulder should no doubt be seen as the dove of the Holy Ghost. The treatment of the folds of drapery, while similar to that at Kilpeck, is not identical, and the broken folds in the skirt of Christ's robe suggest the swiftness of his action. The font may be attributed to the years around 1145.

227 GLENDALOUGH (CO. WICKLOW), IRELAND. ST. KEVIN'S KITCHEN AND ROUND TOWER. The name Glendalough describes the topographical situation of the first monastic settlement there: 'Valley of the Two Lakes'. St. Kevin made his hermitage beside the upper lake towards the end of the 6th century. A large monastic community grew up during the next two centuries, attracting thousands of pilgrims, and was even called the 'Rome of the West'. Immediately outside the perimeter wall stands the church, popularly known as 'St. Kevin's Kitchen'. Of modest size, it is still reminiscent of its origin, the dry-stone prayer cell of the early hermitage. While the lime-mortared masonry presupposes a certain amount of experience on the builder's part, the nave walls slope inward slightly, apparently a memory of earlier building techniques in which stones were laid to as to converge and form a a false vault. The small round chimney-like tower perched on the west end of the roof is an 11th-century addition, as is the sacristy. The taller round tower, visible beyond, is one of the finest of its kind in Ireland; masonry of various periods can be seen in its fabric.

228 CLONFERT (CO. GALWAY), IRELAND. ST. BRENDAN'S CATHEDRAL. Doorway. The ornate sandstone doorway was probably added to the 10th-century church during a restoration in 1164. The general shape is Irish. The jambs slope inward (a feature which Late Gothic masons tried to counteract by inserting an inner limestone arch): this in fact reflects the inward-sloping walls of early Irish buildings. Practically every other feature of the portal is based on foreign ideas.

The embroidery-like ornamentation of the jamb-shafts recurs on the west portal of Lincoln Cathedral, then newly completed. It would be very tempting to associate the head-motif on the gable with Celtic archetypes. At Clonfert, however, the subtly elongated triangles with their daisy motif and the shape of the heads themselves are so expressive of something classically Mediterranean that a connection with Italian or Spanish works seen by pilgrims seems plausible. Doorways with multiple mouldings and a similar wealth of sculpture were particularly common in the Norman south of Italy. The portal at Clonfert was undoubtedly painted at one time, so coloured bodies may have been visible under the heads in the arcade. No explanation of the fifteen heads has yet been found.

229 MONASTERBOICE (CO. LOUTH), IRELAND. South cross. Stylistic analysis of this superb cross, which is remarkably well preserved, suggests a date of origin early in the 10th century. According to an inscription it was set up under an abbot named Muiredach, perhaps the one who governed the monastery from 887 until 923. It represents a very advanced type of pictorial or Bible-cross. It rises to a height of 17 feet, with a remarkably thick shaft and pyramidal base; the apex is shaped like a miniature single-celled church with a shingled roof with crossed gable-beams. The edges of the cross are covered with geometrical ornament and inhabited scrolls. On the east side (illustrated here) the lowest panel unorthodoxly combines the Fall with the Murder of Abel, thus illustrating cause and effect. Above comes the struggle between David and Goliath and above that Moses is shown striking the rock: water gushes forth, to the astonishment of the Israelites. Below the annulus of the cross is the Adoration of the Magi. The centre and arms of the cross are devoted to the Last Judgment; to the left of Christ is David, harping, while to the right is the Erythraean Sibyl. The dove of the Holy Ghost flutters above. In the left-hand arm of the cross (to Christ's right) the blessed face inwards, while on the right the damned are driven away by devils. Below Christ St. Michael weighs souls.

230 KELSO (ROXBURGHSHIRE), SCOTLAND. ABBEY CHURCH. North arm of the west transept. Kelso Abbey was founded in 1128 by a community of Tironais from France. In addition to the usual eastern transept the church possessed a transept at the west, not unlike that at Ely in layout. Its internal elevation consists of a row of interlacing blind arches decorated with chevrons, and above that two arcaded wall-passages, the top one with quatrefoil shafts. The end wall differs in having a door running through the lower stages. On the extreme left and right can be seen two of the massive nave piers, with scalloped capitals.

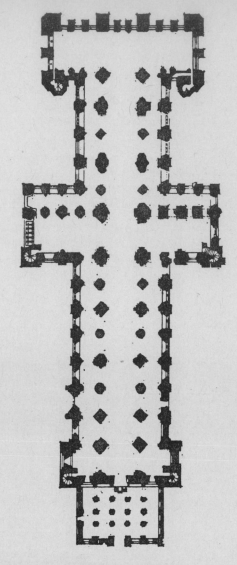

Plan of Durham Cathedral

With rib vaults and pointed transverse arches, the cathedral was extremely progressive architecturally. Another original feature is the interlacing blind arcade which runs below the aisle windows.

The battlements of the west towers *(pl. 232)* were added in 1801, and the south wall and cloister windows were 'restored' in the 19th century. Above the west cloister walk is the dormitory, built *c.*1500. The plinth stage of the towers dates from the church's consecration in 1133; building continued, and the four richly ornamented upper stages, with their alternation of tall blind arches and window openings, are an expression of Early Gothic.

The remarkably elegant narthex, or Galilee *(pl. 233)*, was probably completed *c.*1175. It is a rectangular chamber divided into five aisles. The arches, adorned with a bold chevron motif, rest on slender quatrefoil piers with waterleaf capitals. The piers originally consisted only of two monolithic shafts of Purbeck marble; the paler shafts were added to strengthen them in the 15th century.

234 ESCOMB (CO. DURHAM), ST. JOHN'S. *Chancel arch.* This early 8th-century church is of particular historical importance. The proportions – long, narrow and tall – are typically Anglo-Saxon. Many of its building techniques and even its stones are of Roman origin. Roman influence is clearly discernible in the form of the chancel arch with its radiating voussoirs; however the jambs, with their alternating horizontal and vertical slabs, are characteristically Saxon.

235 FOUNTAINS ABBEY (YORKSHIRE). *Nave from the south aisle.* Fountains Abbey was founded in 1132 by Benedictine monks from York who adopted the Cistercian rule. Completed in 1170, it was abandoned in 1539 and is now in ruins. Entering the church today and seeing the eleven-bay arcade of pointed arches stretching away, one cannot fail to be deeply impressed by the purposeful unity of the place, and the heavy cylindrical pillars which still rise from the floor of the nave. As in French Cistercian churches, the aisles were covered with transverse tunnel vaults, whose springing can just be detected.

236 BLYTH (NOTTINGHAMSHIRE), PRIORY CHURCH. *North aisle.* Today one can only guess at the original appearance of the church, founded in 1078. The simple volute capitals are of a type that disappeared *c.*1095. The groin vaults and transverse arches of the north aisle betray hurried execution, and display the rough masonry and large joints of the earliest Norman buildings in England; they enable one to sense the impact

231–233 DURHAM CATHEDRAL. *Nave; exterior looking north-west; interior of the Galilee.* The new cathedral was begun by the Normans in 1093. With its aisled nave and chancel, transept with eastern aisles, crossing tower, twin west towers, and narthex, Durham is one of the most magnificent cathedrals in Europe.

The nave *(pl. 231)* is of six bays, with alternately compound and enormous cylindrical piers. All the capitals are plain, while the arches of arcade, gallery, clerestory and vaults are adorned with roll-mouldings, chevron, dentils, or hollow grooves. The cylindrical piers themselves are covered with incised ornament. The vaulting shafts are carried down to the ground in front of the compound piers; above the cylindrical piers, the vaulting ribs are carried on corbels at gallery level. Where the vaults meet the nave walls, their thrust is countered by arches under the gallery roof which foreshadow Gothic flying buttresses in function.

of a building erected during the very aftermath of the Conquest – a building indeed which was the most accurate reproduction in England of a Norman church.

237 SOUTHWELL MINSTER (NOTTINGHAMSHIRE). *Nave.* Southwell Minster is a member of the second and more advanced generation of Norman churches in England, all begun during the second and third decades of the 12th century. The character of the nave is still essentially Romanesque, despite Gothic windows in the aisles and west end, and the ceiling of 1880. The main impression is one of horizontality. The arcade consists entirely of short cylindrical piers; above it is an undivided gallery whose arches are as wide as those of the arcade. The clerestory openings are also single arches, though smaller, screening a wall-passage; outside, the windows at this level are circular. The arcade arches are decorated with billet moulding, and the gallery arches surrounded by three rows of scallops.

238 LINCOLN CATHEDRAL. *West front.* The original Norman west front has been enclosed and partly obscured by additions of the mid-13th century. The façade, with its stout masonry and giant niches, was built *c.*1092. After a disastrous fire in 1141 it was restored and embellished; the three ornate doorways date from this period, and so too does the carved frieze which runs across the façade above the central door and side niches. Here, in a manner unknown elsewhere in England, selected scenes from the Old and New Testaments are illustrated: in a box above the south niche, for instance, Daniel is shown in the lions' den. The windows above the three doorways are Late Gothic insertions.

239 EARLS BARTON (NORTHAMPTONSHIRE), ALL SAINTS. *West tower.* None of the other Anglo-Saxon towers is as elaborate as this one. Except for the battlements, is it essentially as it was built in the second half of the 10th century. The tower, with a west door constructed of huge stones, formed the main body of the Anglo-Saxon church. The walls are articulated by four slightly stepped stages separated by string courses and vertically divided by narrow pilaster strips: the first stage is plain, the second has round arches resting on the string-course, and the third has two tiers of inverted Vs reminiscent of the timber-building techniques on which the whole of this form of stone ornamentation is based; in the belfry stage the centre of each face is occupied by an elaborate five-light window with chubby turned baluster-shafts. The single triangle-headed windows are equally typical of Anglo-Saxon design.

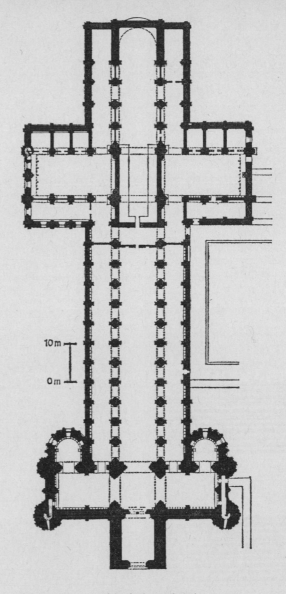

Plan of Ely Cathedral

240, 241 ELY CATHEDRAL (CAMBRIDGESHIRE). *Exterior looking north-west; Prior's Door.* Diverse in structure, Ely Cathedral comprises a west porch (1200–1215), a west transept with corner towers and a west tower, an aisled nave, an octagon in place of the original Norman crossing tower (1322–42), an aisled east transept and choir, and, adjoining it to the north, a Lady Chapel (1349).

The west end exemplifies the late phase of the evolutionary process which led from the richly articulated Romanesque of the last quarter of the 12th century – a style which already seems perfunctory in many respects – to the Gothic. The complex articulation of the west transept contrasts strongly with the quiet arrangement of the nave walls: verticals are emphasized by turrets at the corners and shafting carried through several of the many tiers of arcading. The church was

begun in 1083, but the west end was not completed until the end of the 12th century; the superstructure of the central tower dates from *c.*1400.

The magnificent Prior's Door *(pl. 241)* formerly led from the south aisle into the cloisters. Every member except for the tympanum is covered with foliate scroll-work. The loops on the outer jambs, which culminate in city-gates, are inhabited by human figures, fantastic animals, and signs of the zodiac. Throughout one senses the proximity of Burgundy and northern Italy. The inner order of the doorway terminates in corbel-heads carved in the round. The group of Christ in Majesty flanked by angels, on the tympanum, spills over dramatically onto the lintel – an example of the 'expressionism' which manifested itself in English sculpture around the middle of the 12th century.

242 CAMBRIDGE, HOLY SEPULCHRE. The round church was largely rebuilt during a restoration in the 19th century, though on the basis of existing data. Its affinity with the Church of the Holy Sepulchre in Jerusalem is apparent. It would seem correct to place this building on the threshold of the period when the second generation of large Norman churches was begun, between 1110 and 1120.

243 NORWICH CATHEDRAL (NORFOLK). *Chancel.* The cathedral was begun in 1096 by Herbert de Losinga, formerly prior of the Benedictine monastery at Fécamp; building continued until the middle of the 12th century. In plan it owes something to the third church at Cluny, with an ambulatory and radiating chapels. The central chapel today dates from 1930, but the side chapels are intact: they are curiously bent round towards the east, and their height is also exceptional. The apse is defined by a semicircle of five deeply-moulded arches. The compound piers, like those at Ely, have half-columns towards the arch and attached shafts towards nave and ambulatory. The gallery has undivided openings and volute capitals; the arches are stilted, and the openings are almost as high as the arcade below. The uppermost story and vaults were rebuilt in the Gothic period. Behind the altar is the ancient bishop's throne.

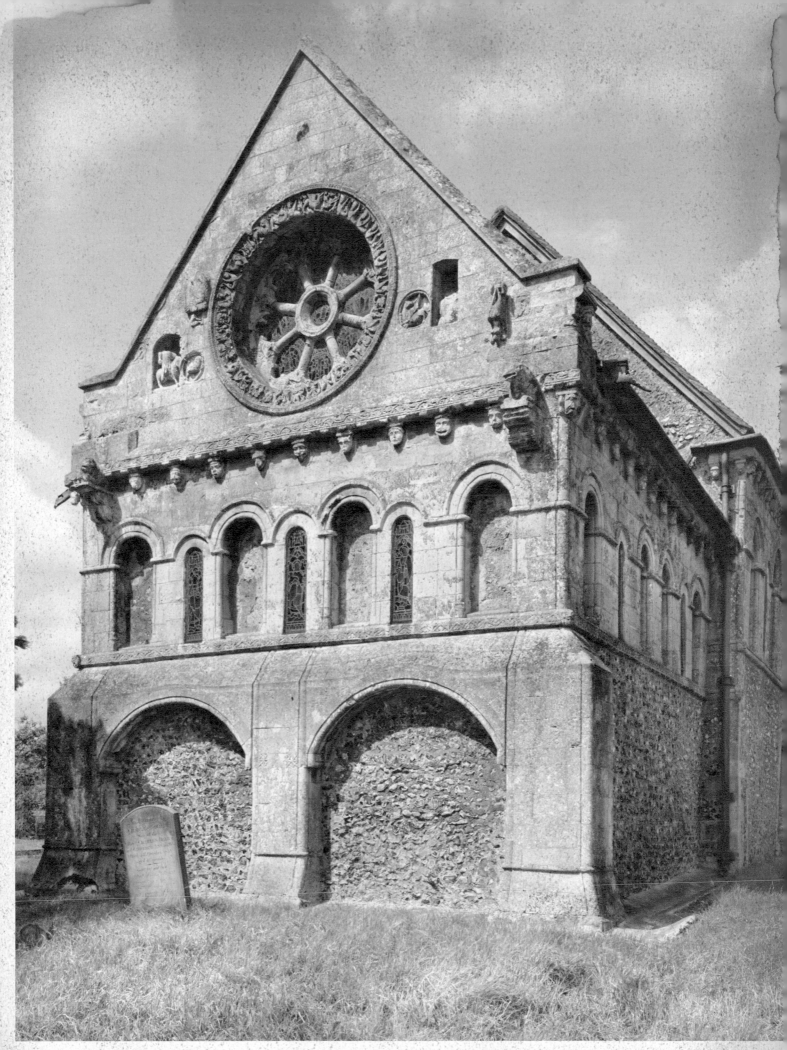

202 BARFRESTON (Kent), St. Nicholas

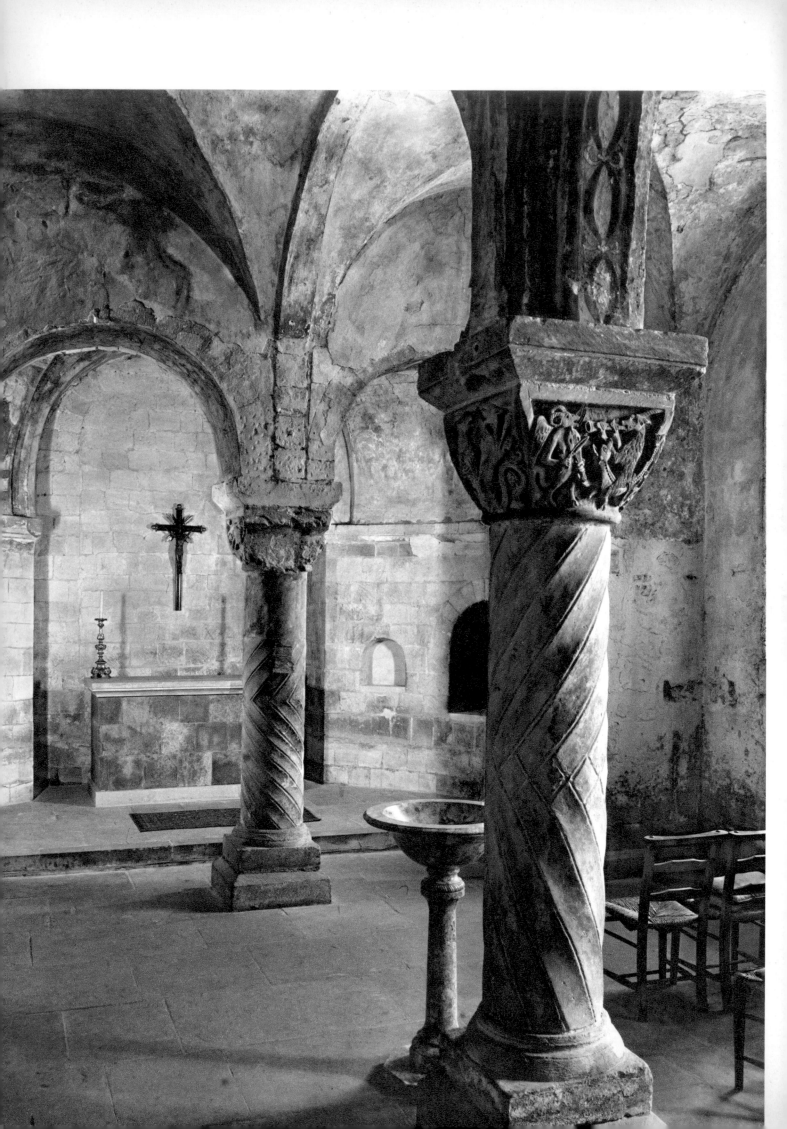

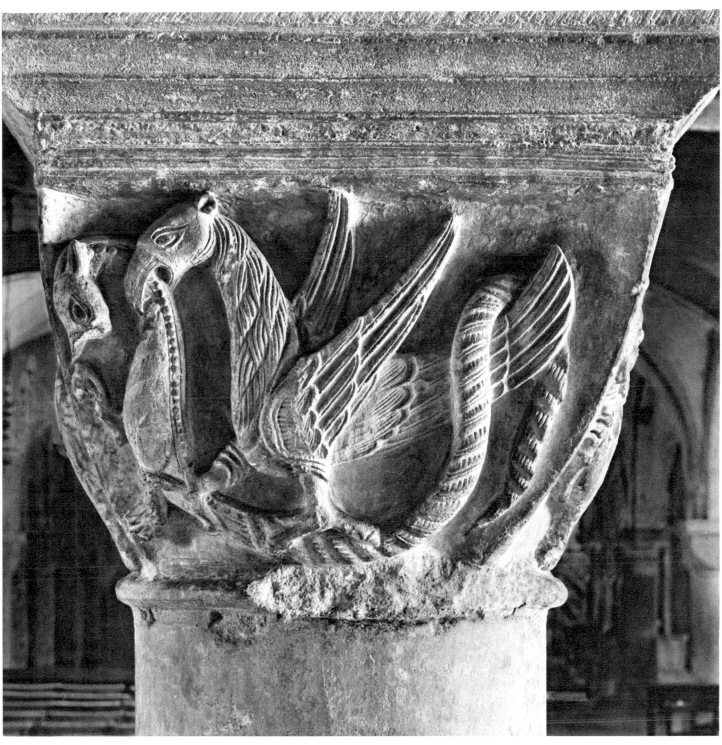

203, 204 CANTERBURY (Kent), Cathedral

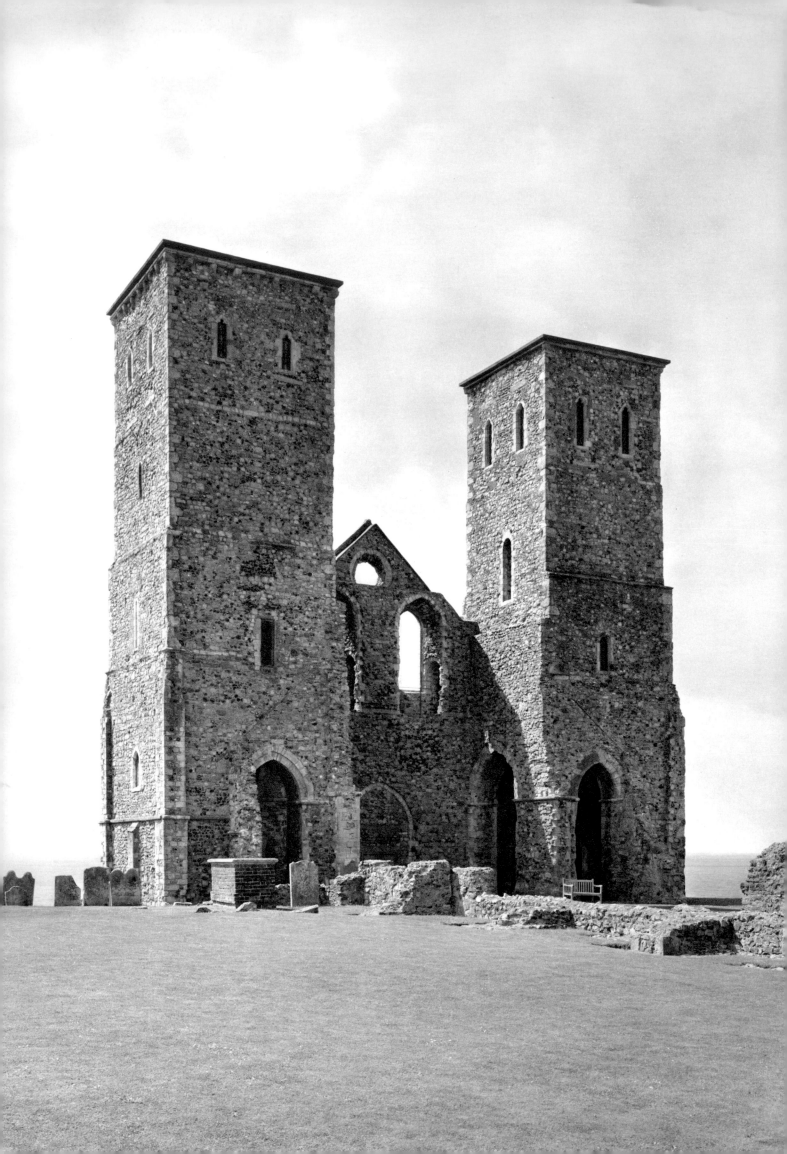

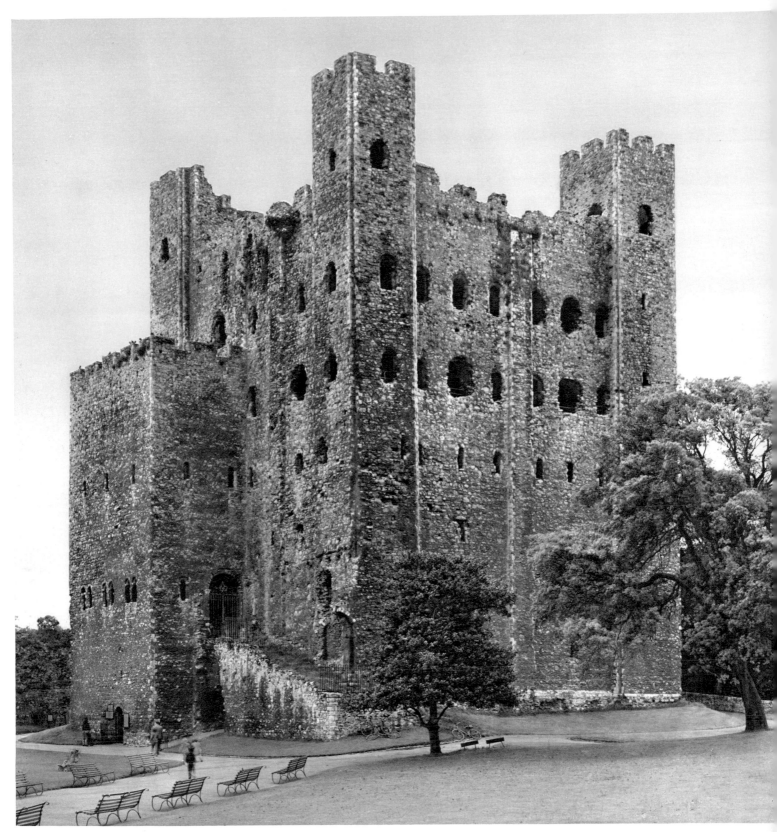

205 RECULVER (Kent), St. Mary 206 ROCHESTER (Kent), Castle

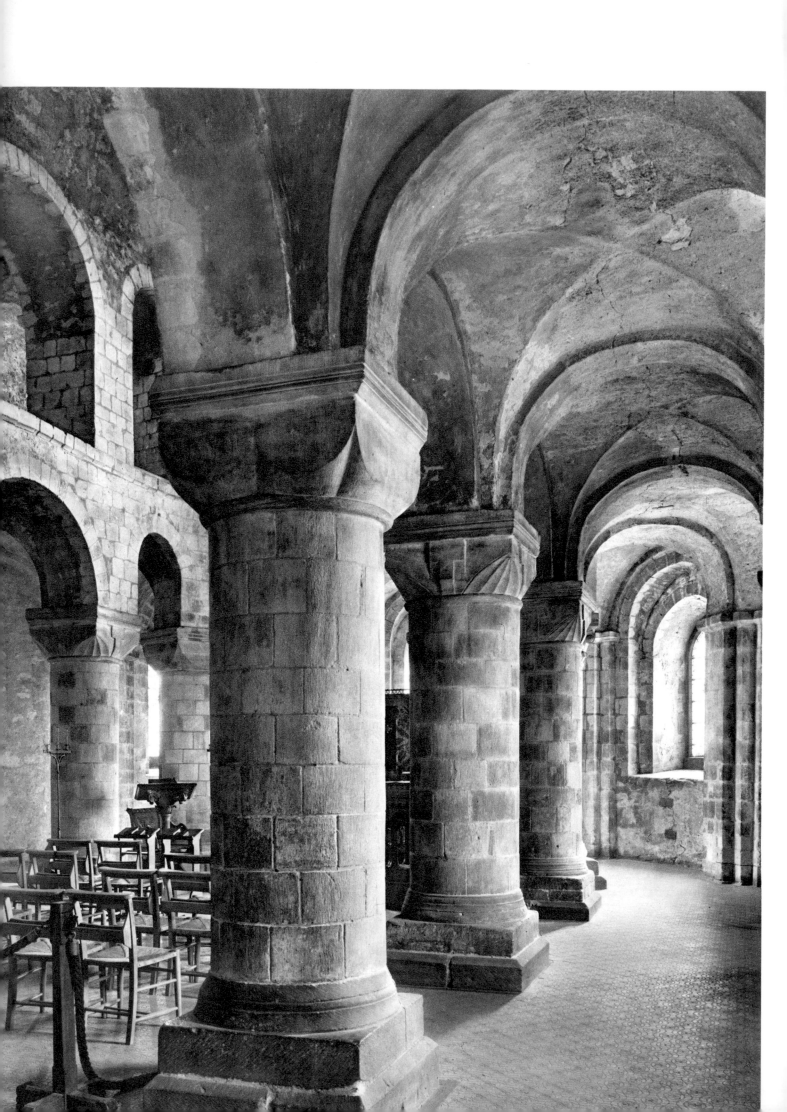

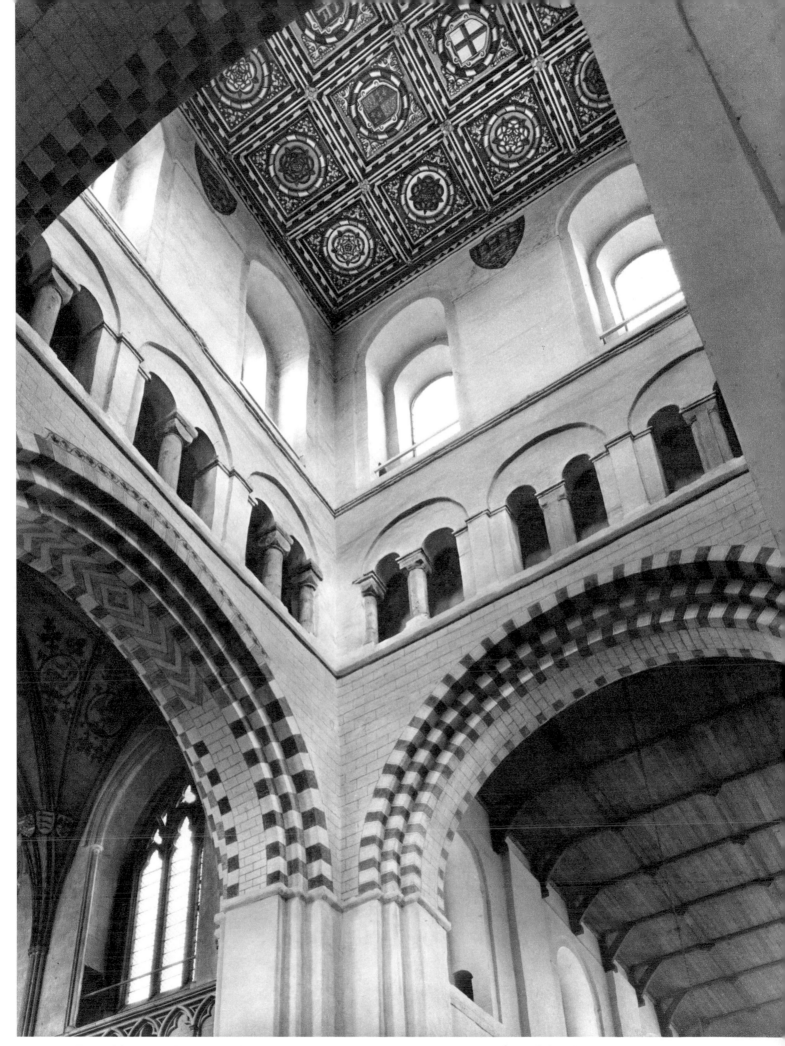

207 LONDON, Tower, St. John's Chapel 208 ST. ALBANS (HERTFORDSHIRE), Abbey

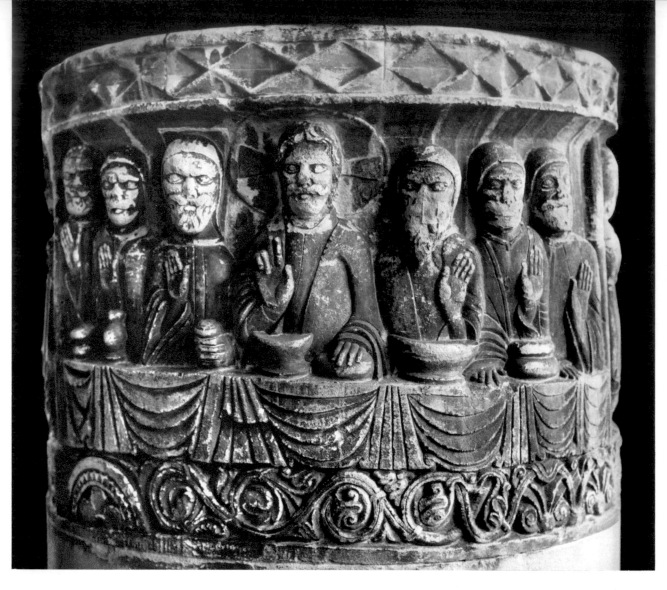

209, 210 BRIGHTON (Sussex), St. Nicholas

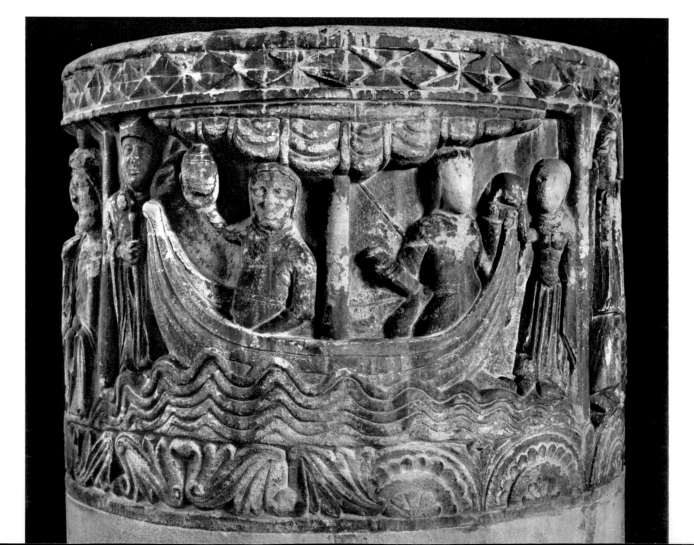

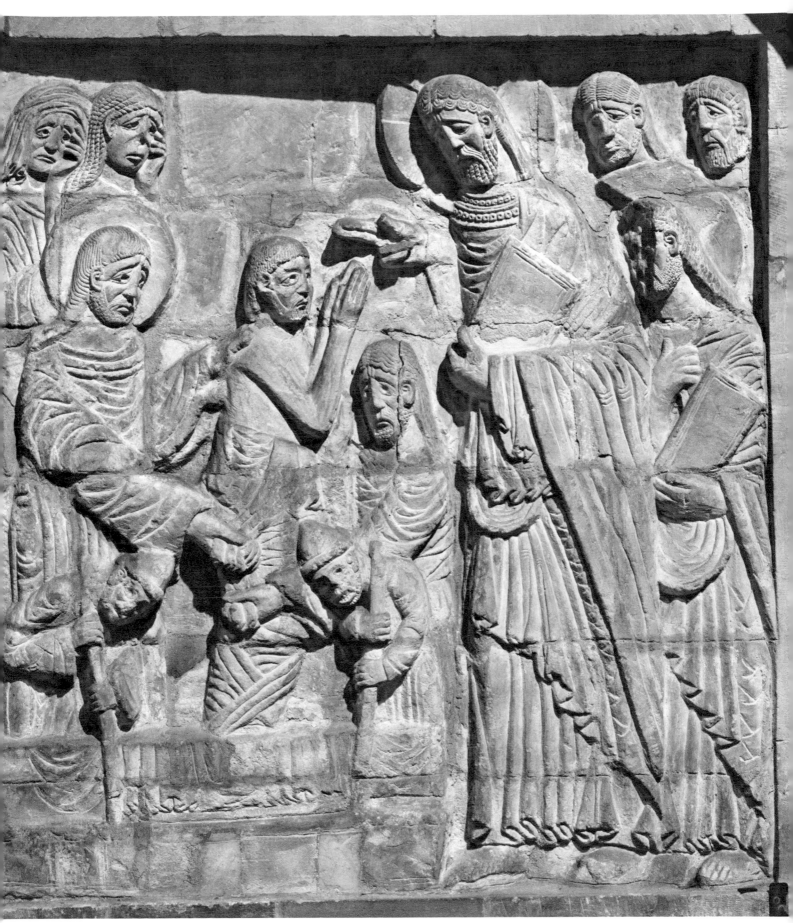

211 CHICHESTER (Sussex), Cathedral

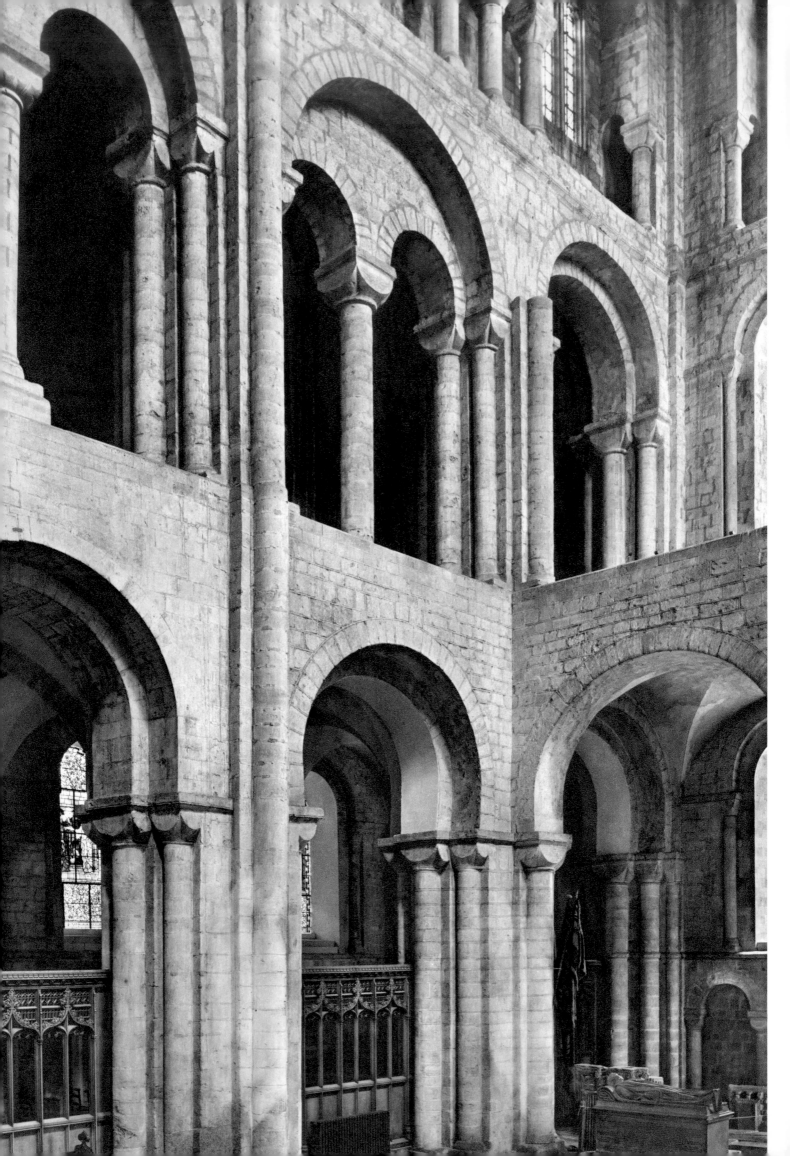

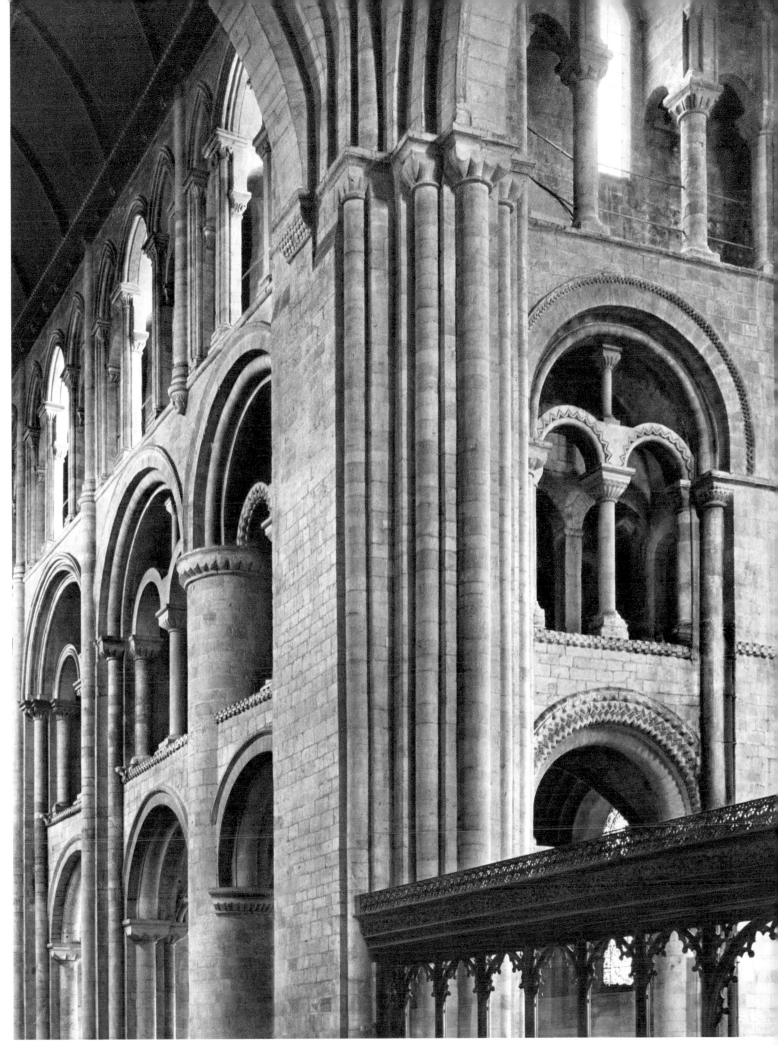

212 WINCHESTER (Hampshire), Cathedral

213 ROMSEY (Hampshire), Abbey

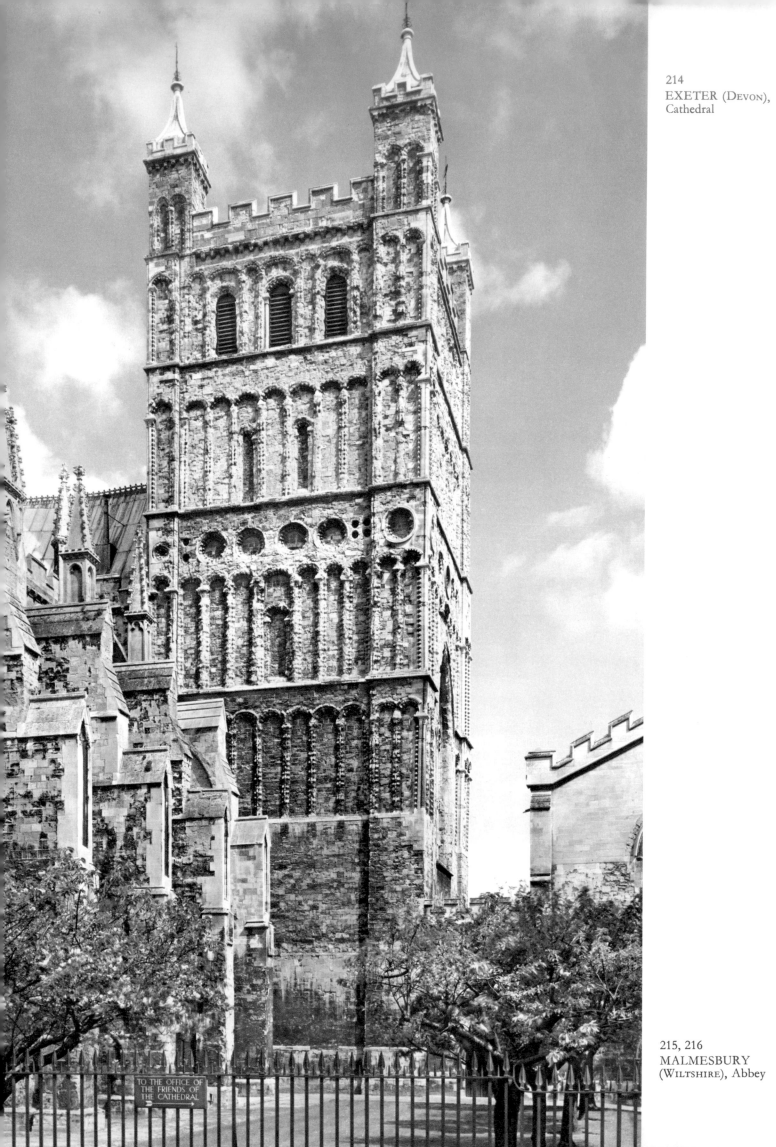

214
EXETER (Devon),
Cathedral

215, 216
MALMESBURY
(Wiltshire), Abbey

TO THE OFFICE OF
THE FRIENDS OF
THE CATHEDRAL

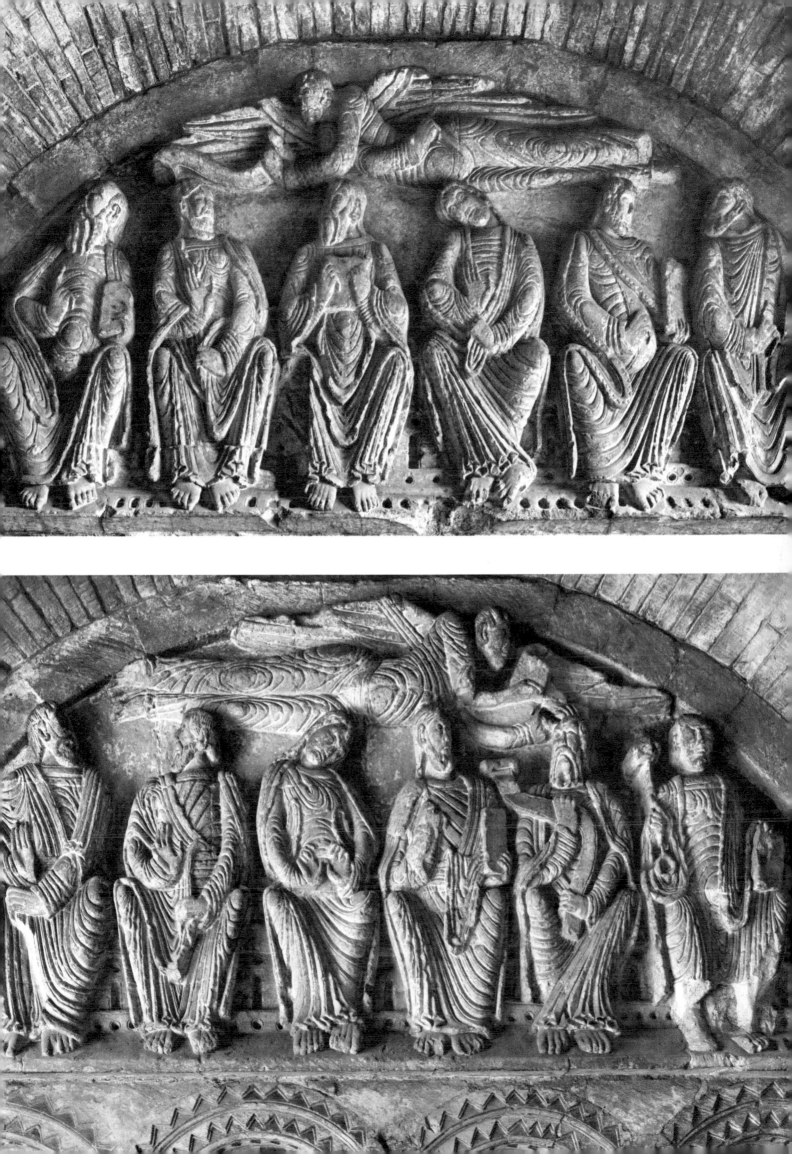

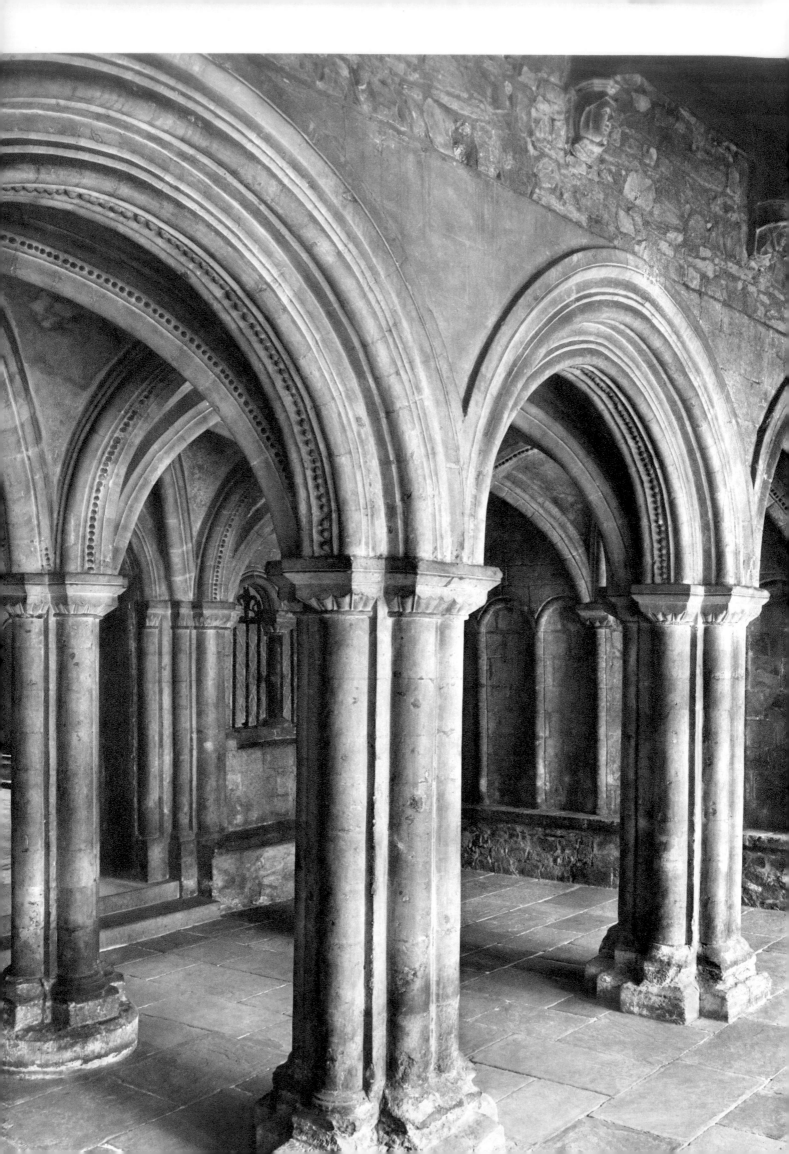

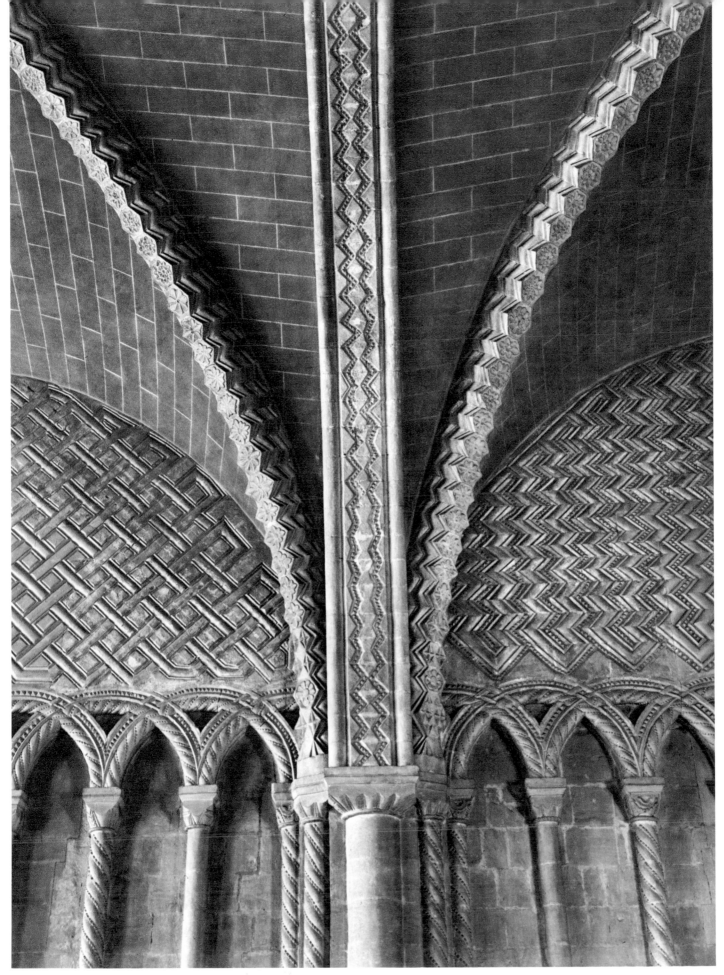

217, 218 BRISTOL (GLOUCESTERSHIRE), Cathedral

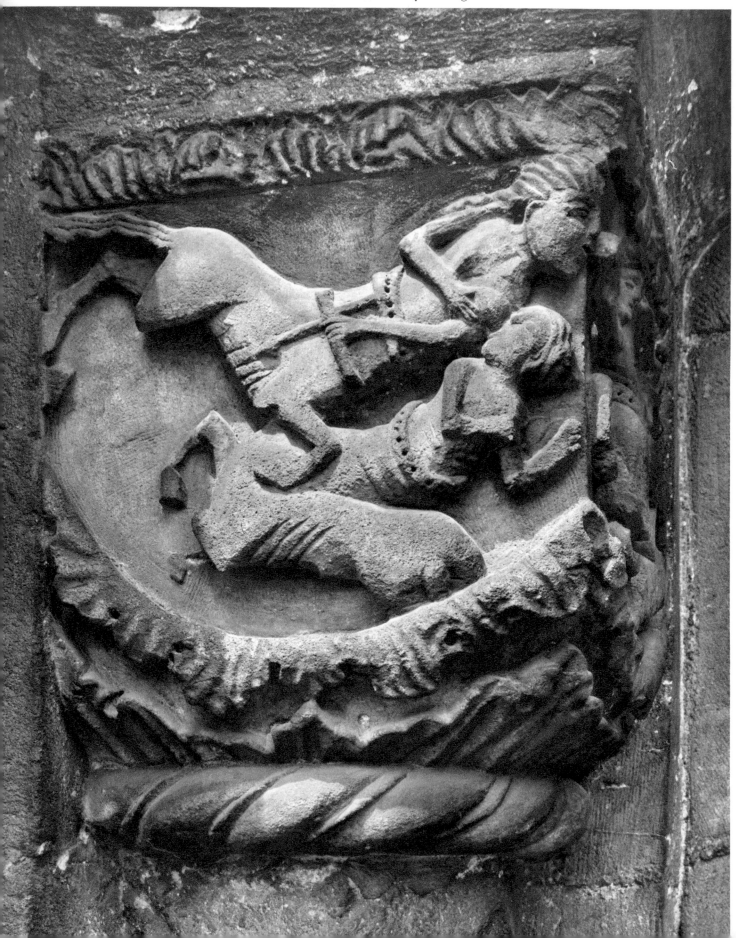

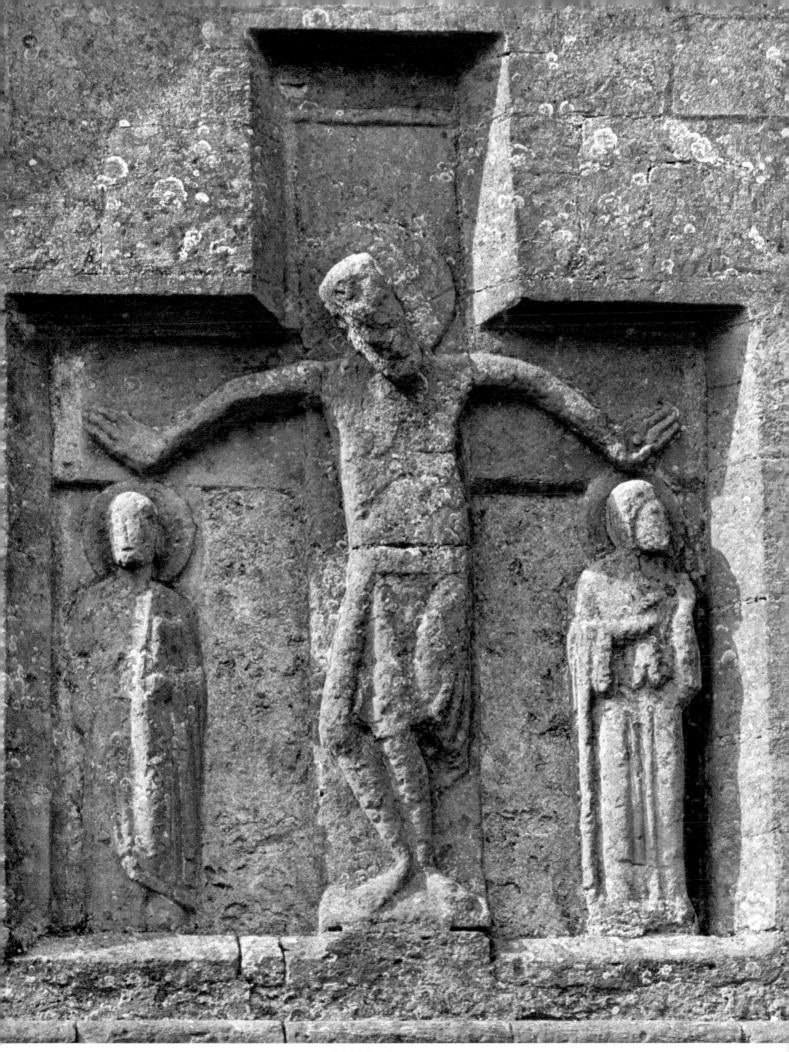

220 LANGFORD (Oxon), St. Matthew

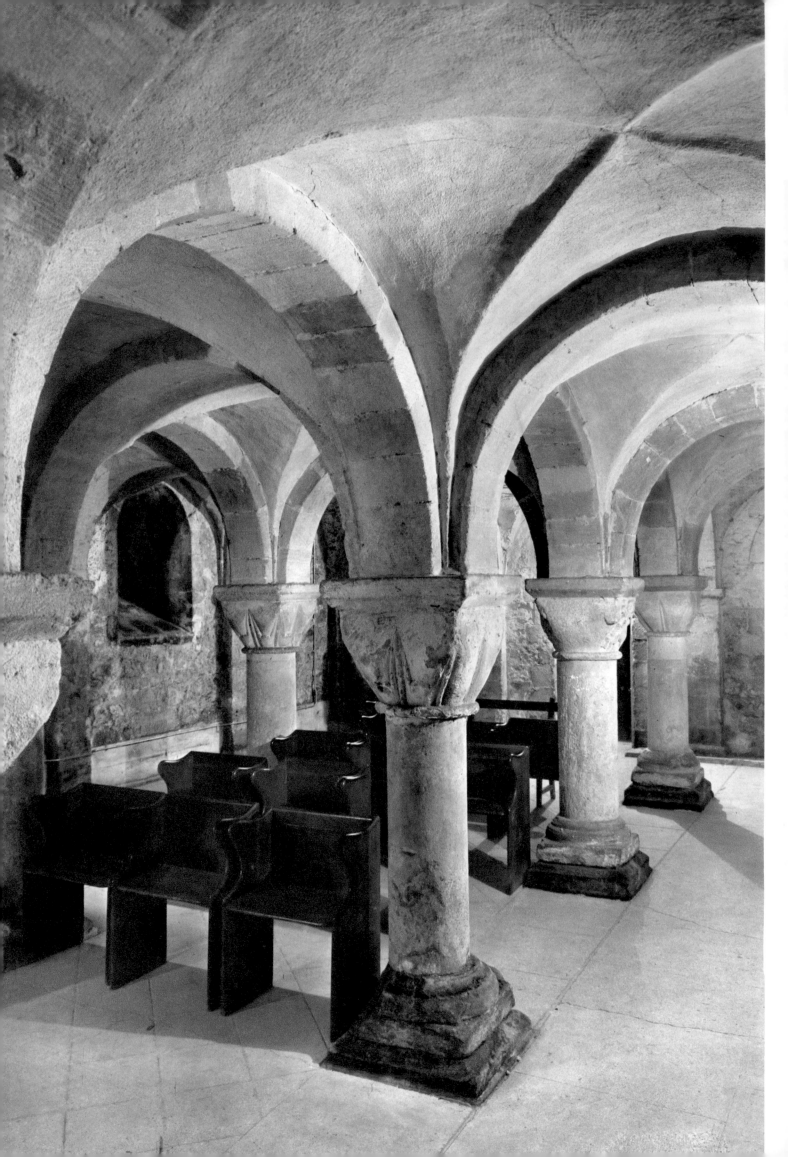

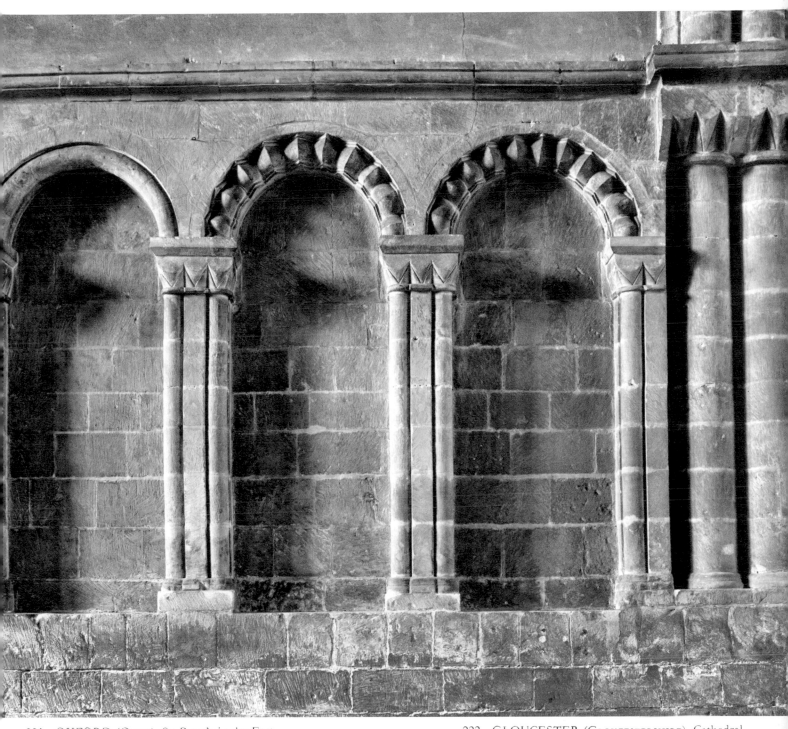

221 OXFORD (Oxon), St. Peter's-in-the-East 222 GLOUCESTER (Gloucestershire), Cathedral

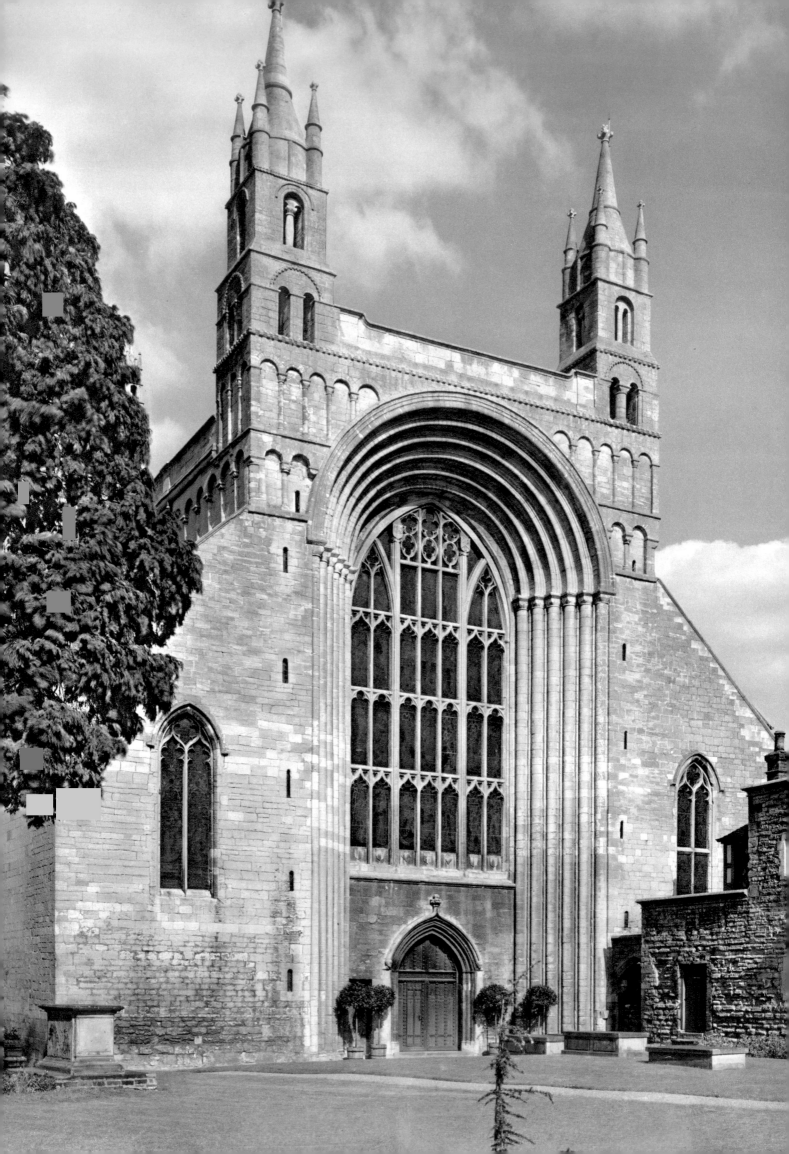

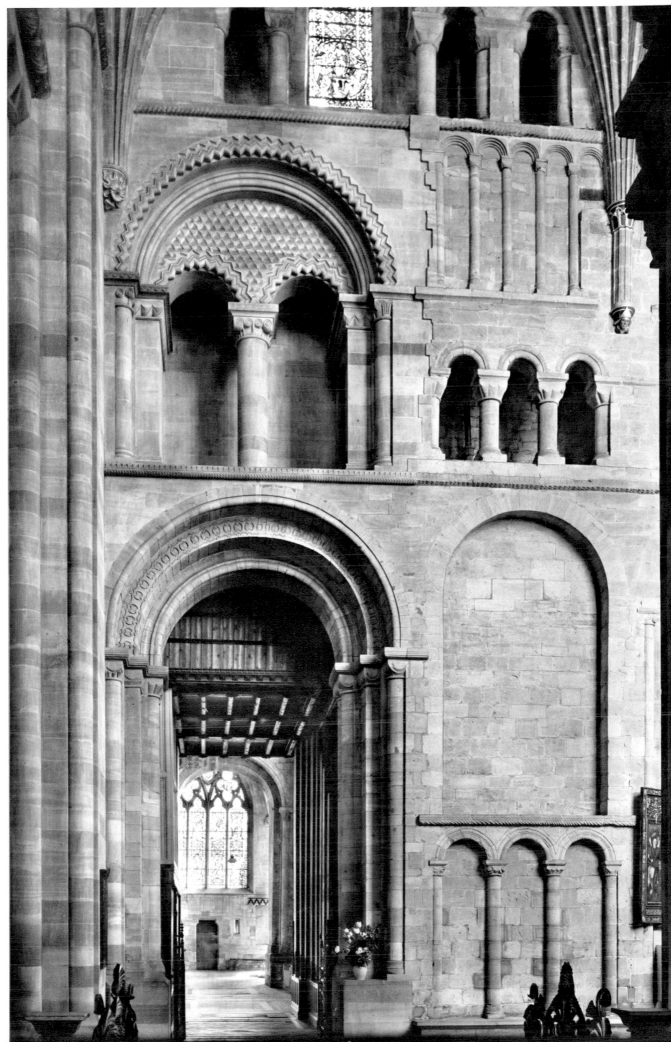

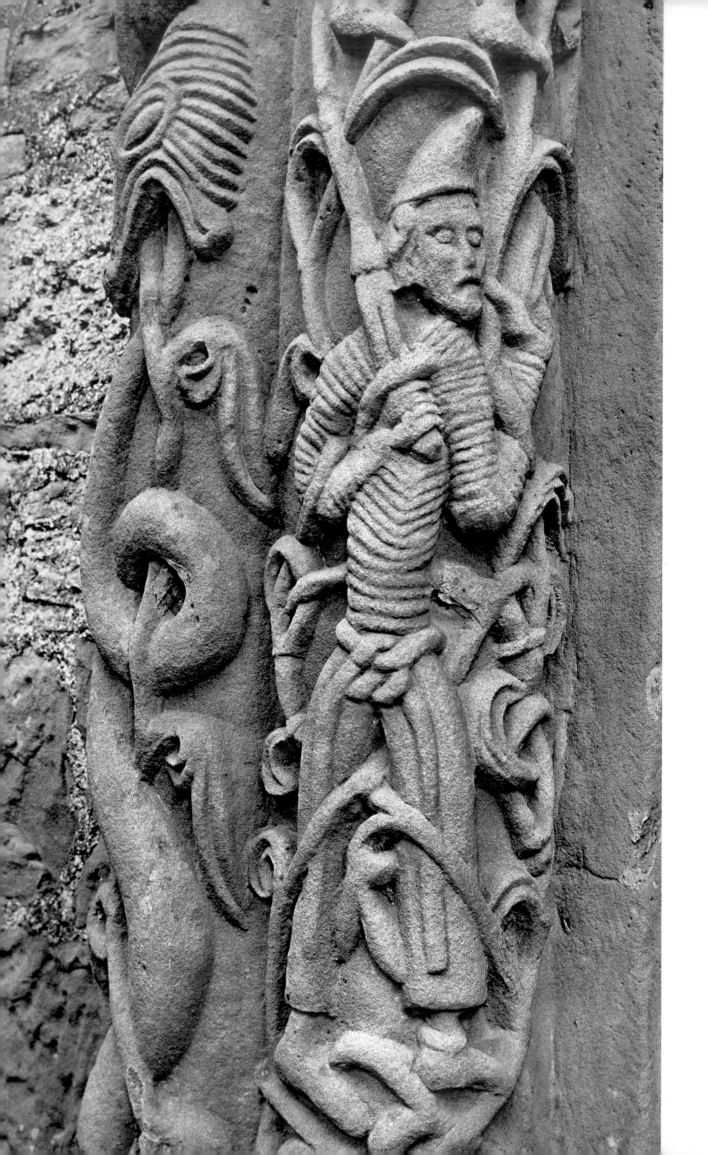

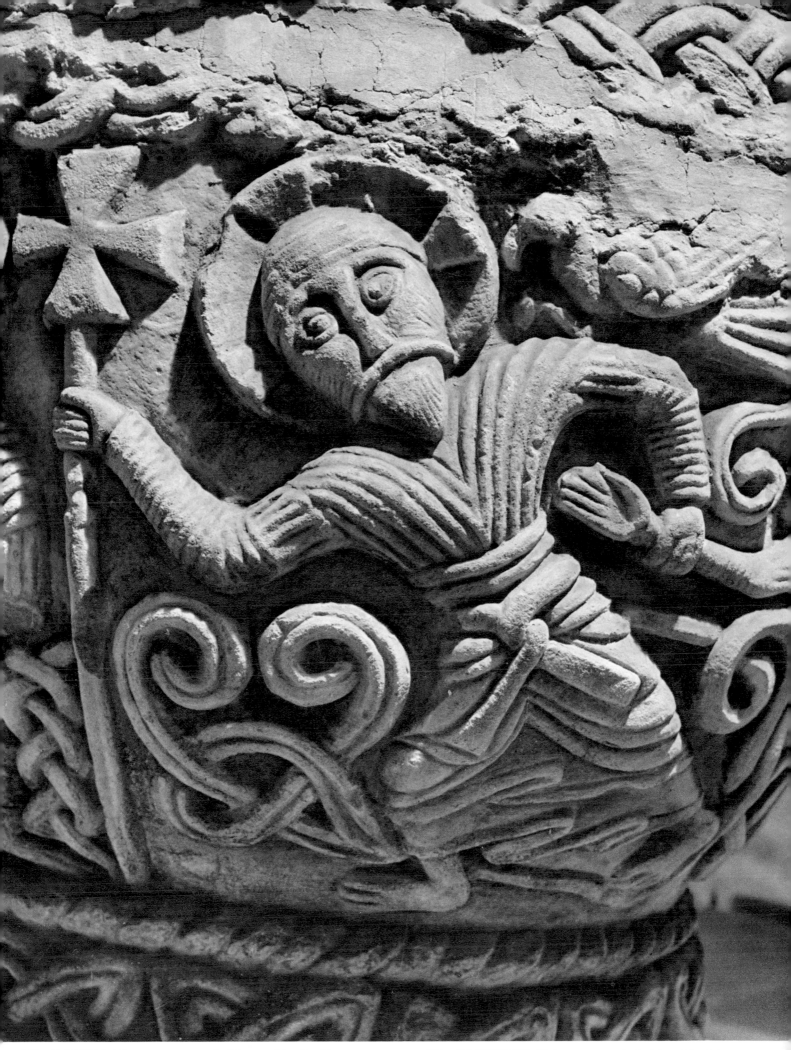

225 KILPECK (Herefordshire), St. Mary and St. David 226 EARDISLEY (Herefordshire), St. Mary Magdalene

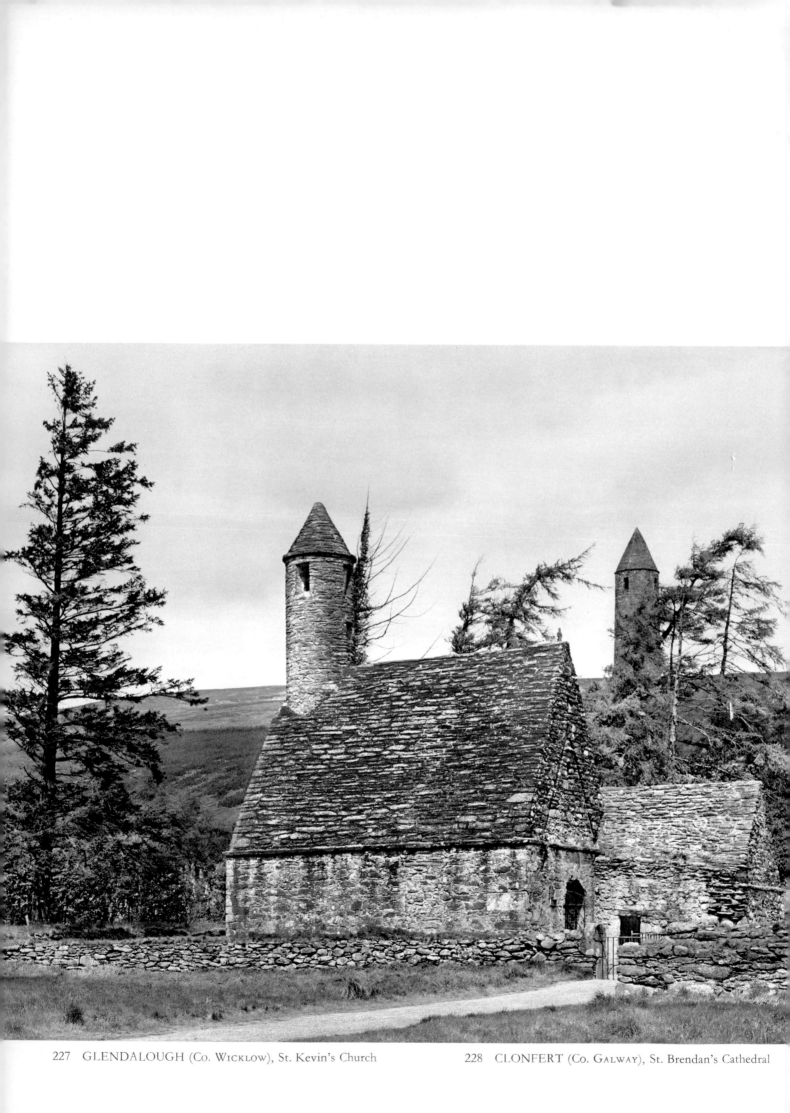

227 GLENDALOUGH (Co. Wicklow), St. Kevin's Church 228 CLONFERT (Co. Galway), St. Brendan's Cathedral

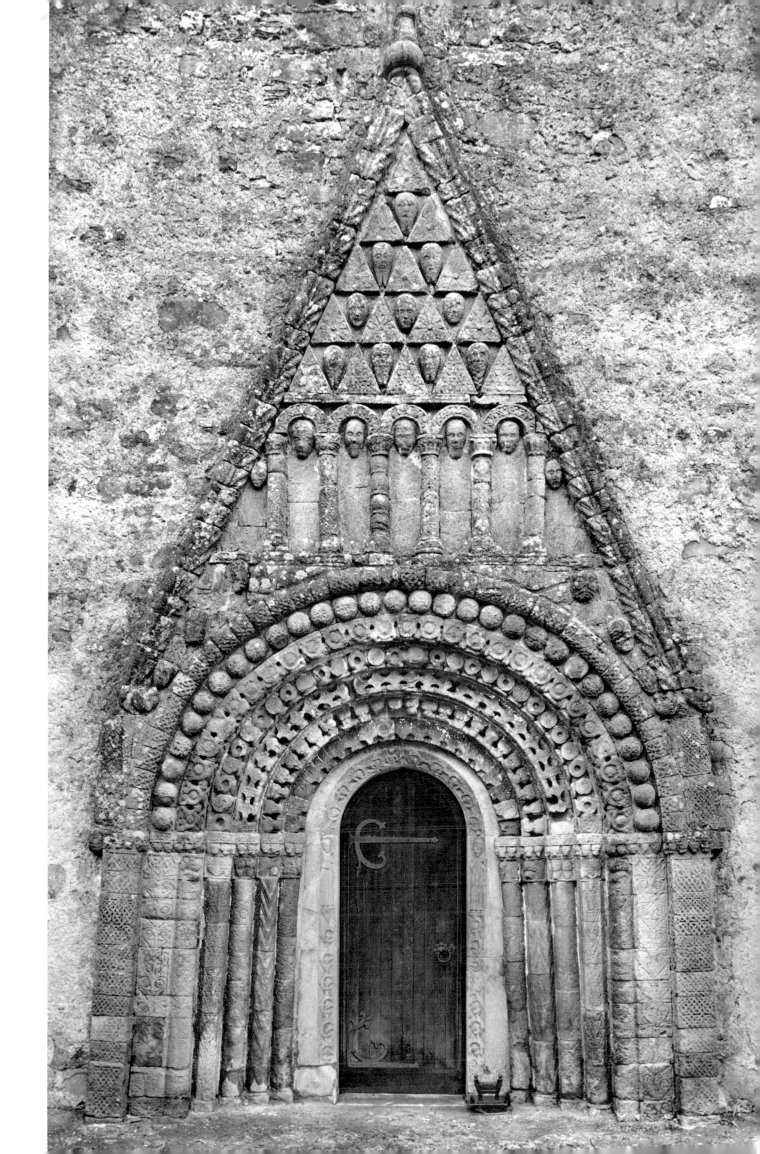

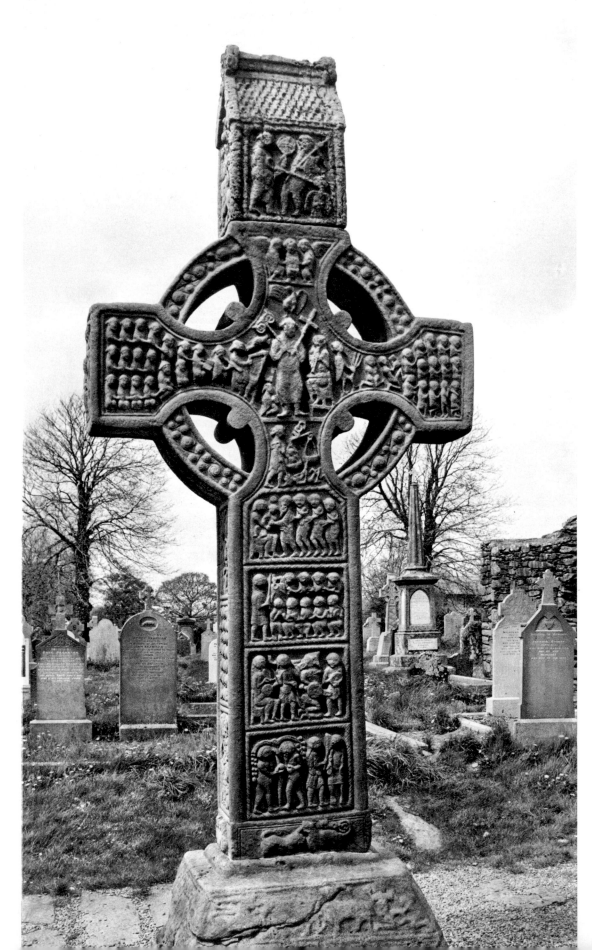

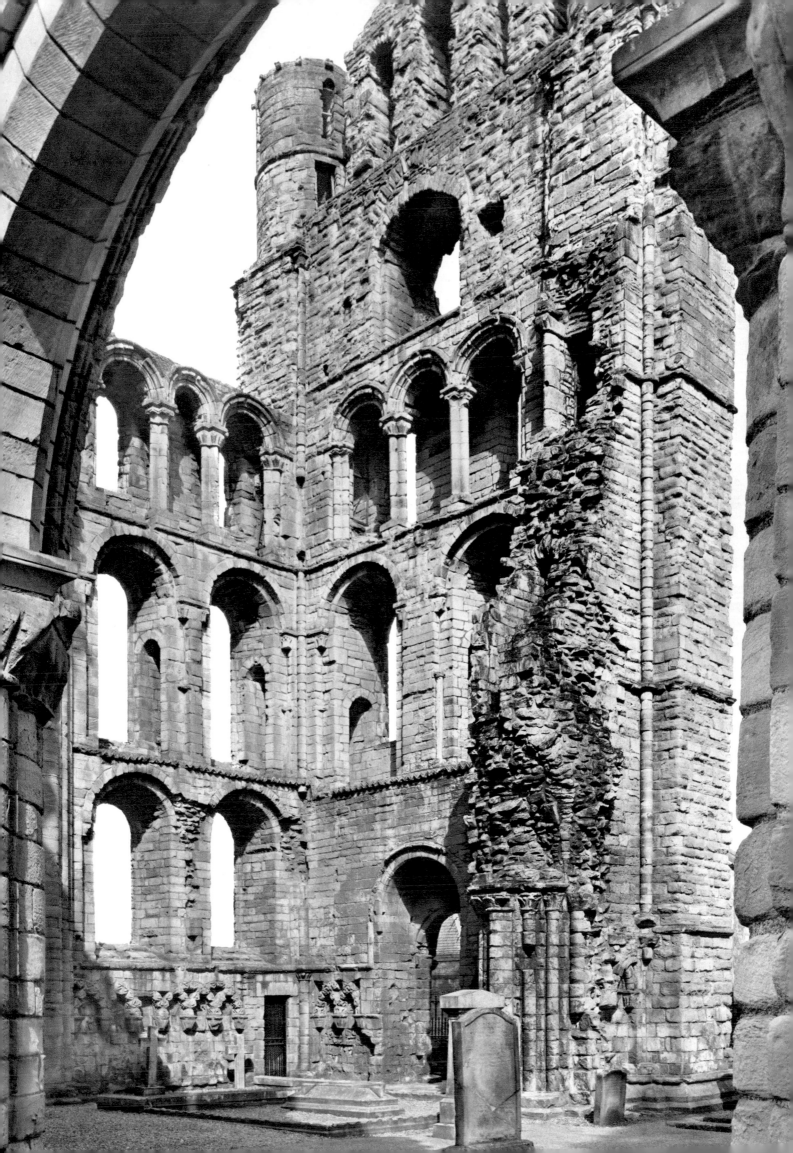

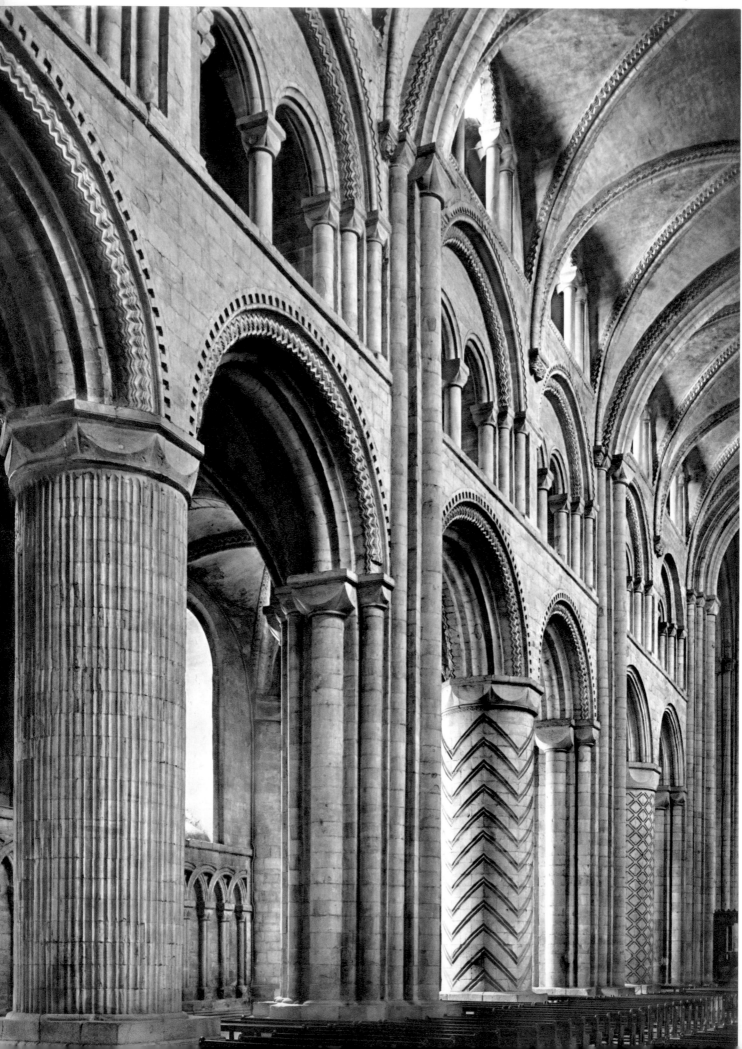

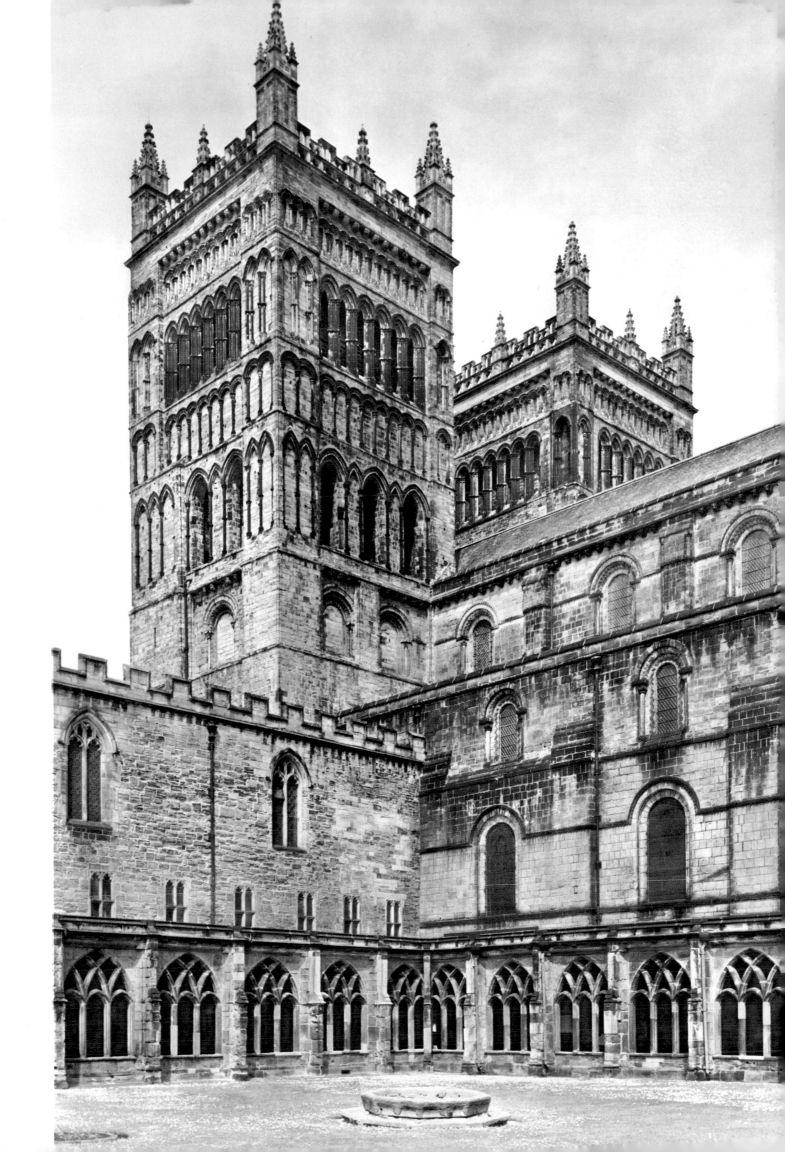

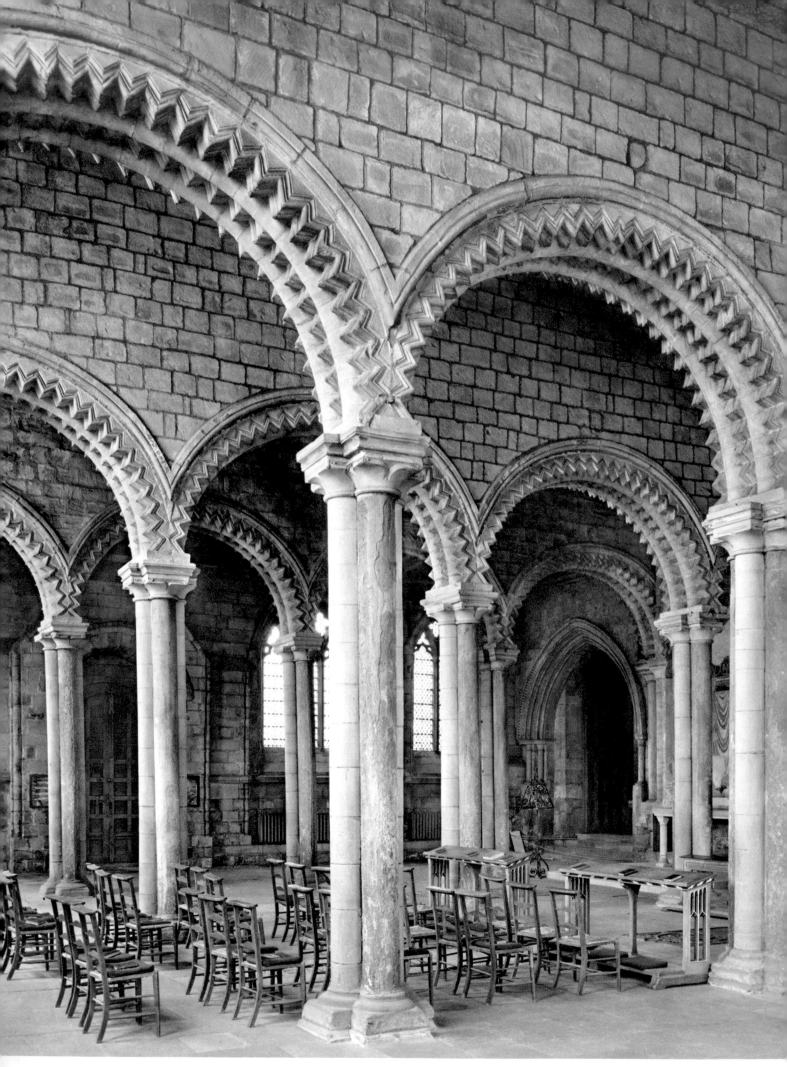

233 DURHAM, Cathedral

234　ESCOMB (Co. Durham), St. John's Chapel

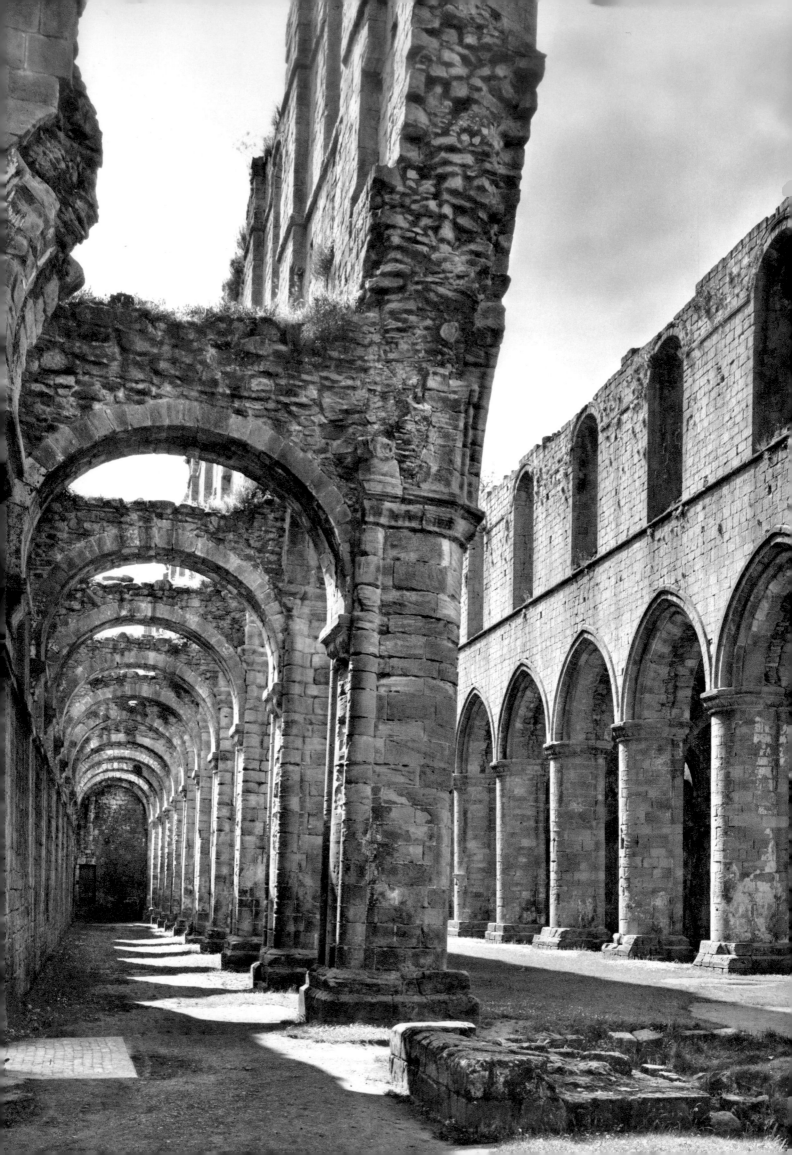

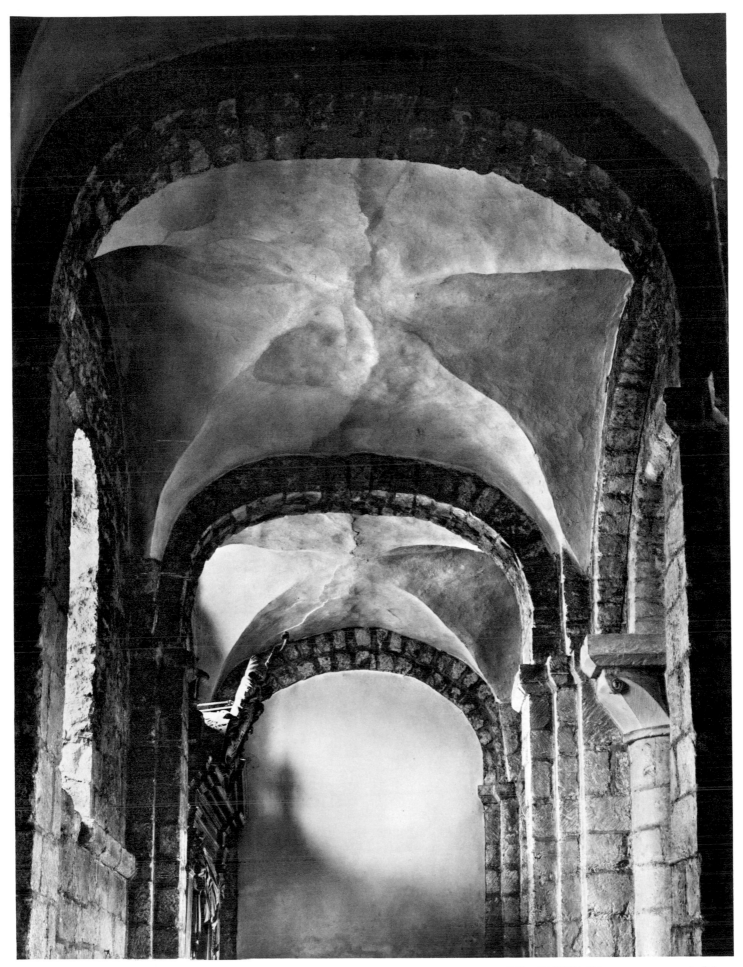

235 FOUNTAINS ABBEY (Yorkshire) 236 BLYTH (Nottinghamshire), Priory

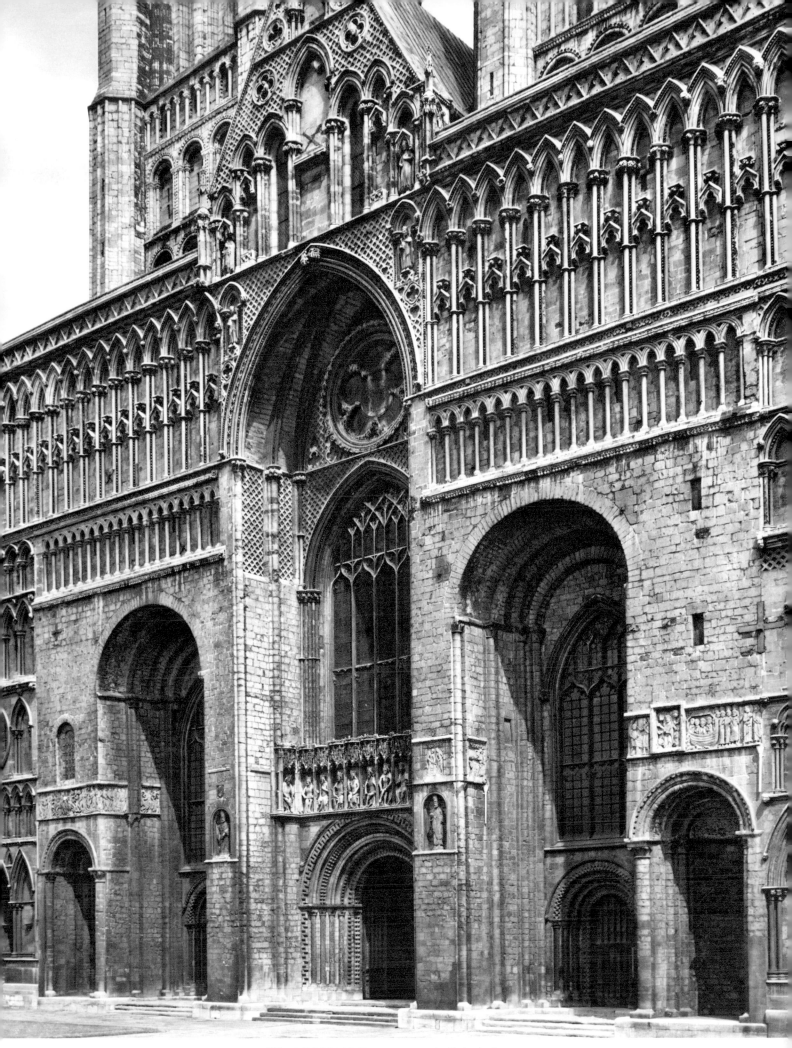

238 LINCOLN (Lincolnshire), Cathedral

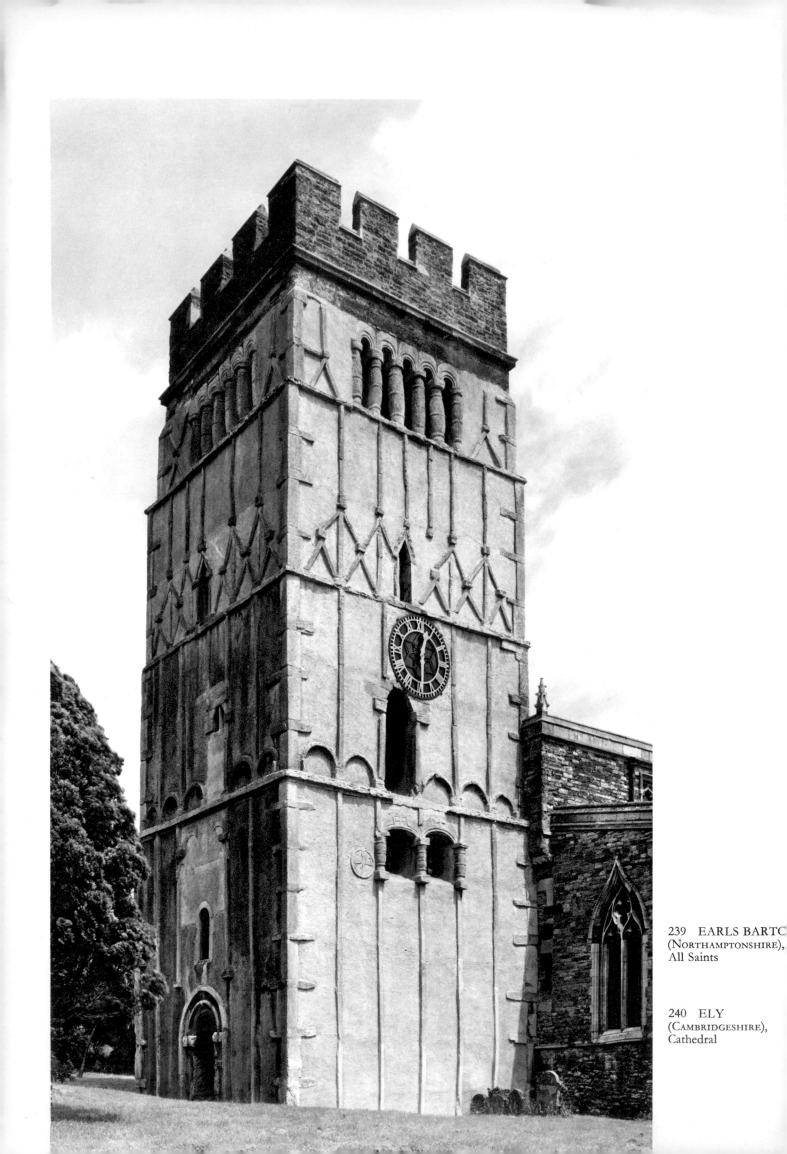

239 EARLS BART[O]
(Northamptonshire),
All Saints

240 ELY
(Cambridgeshire),
Cathedral

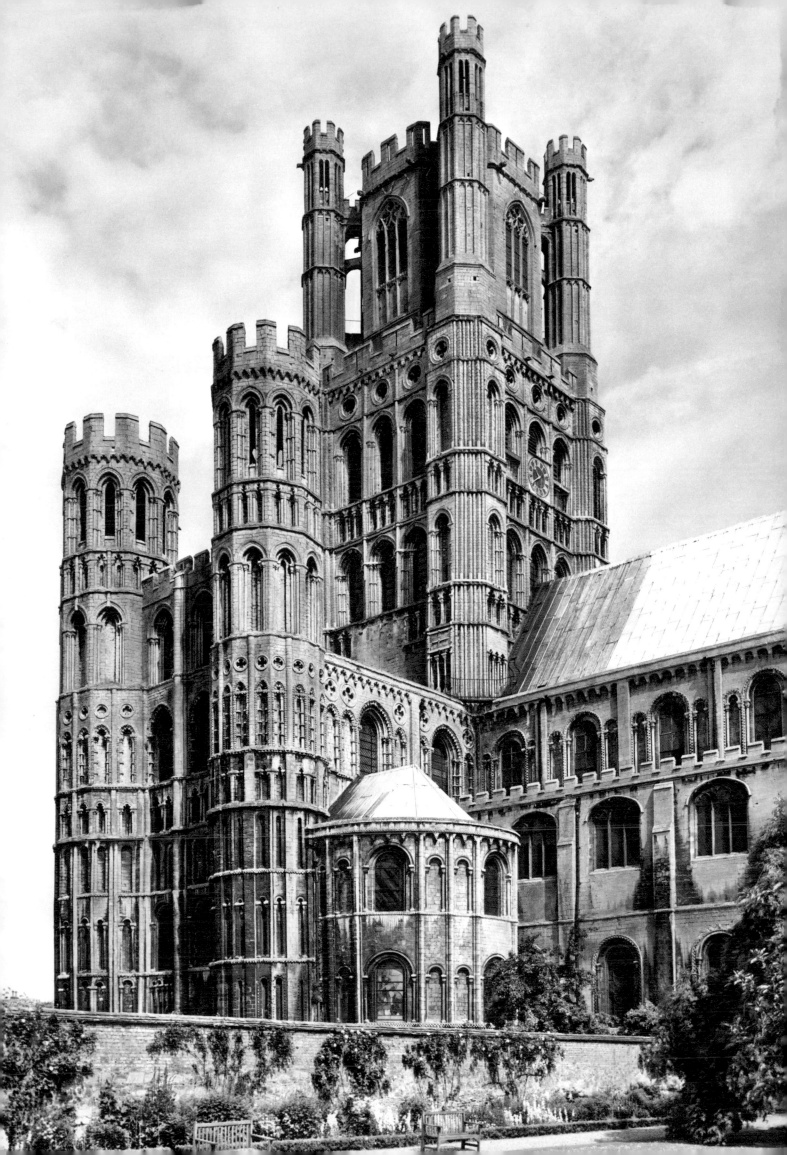

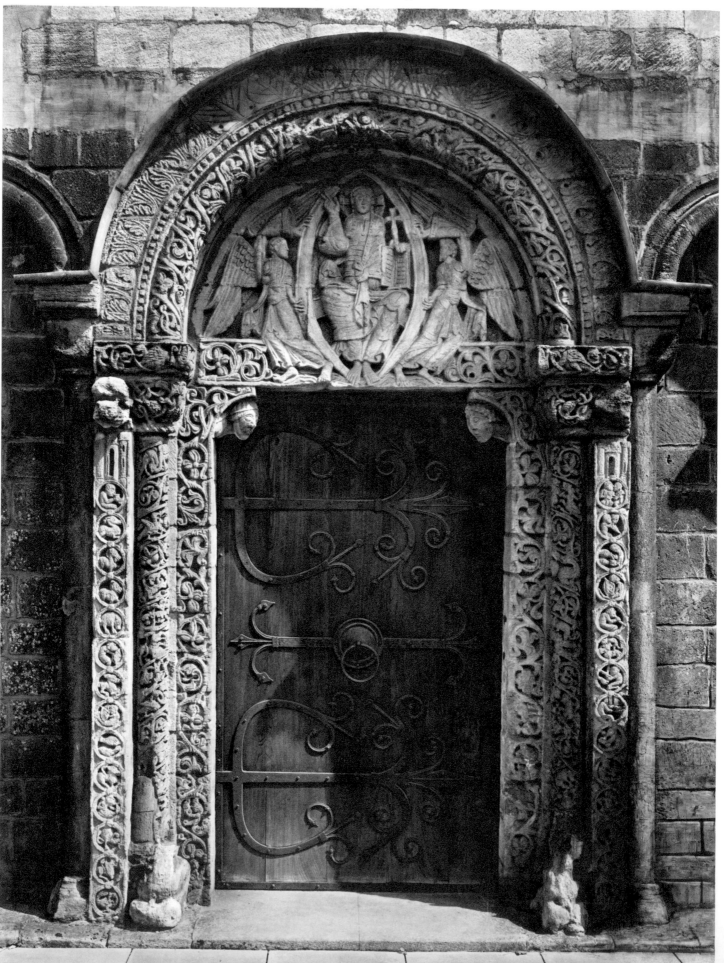

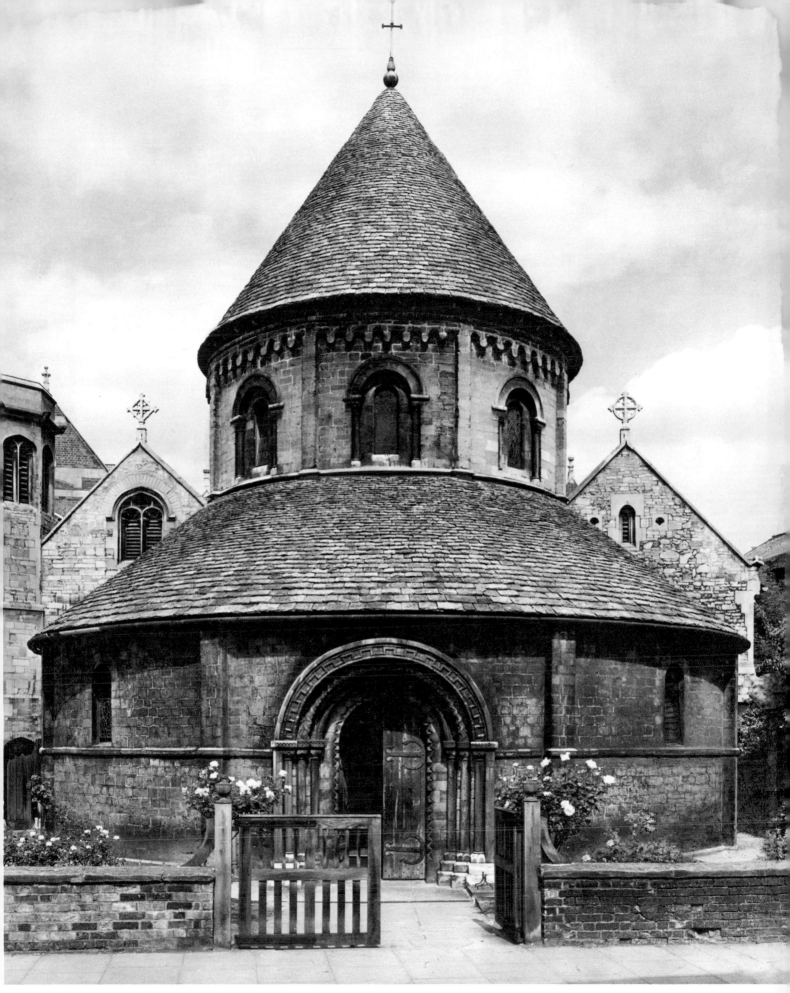

242 CAMBRIDGE (CAMBRIDGESHIRE), Holy Sepulchre

243 NORWICH (NORFOLK), Cathedral ▶

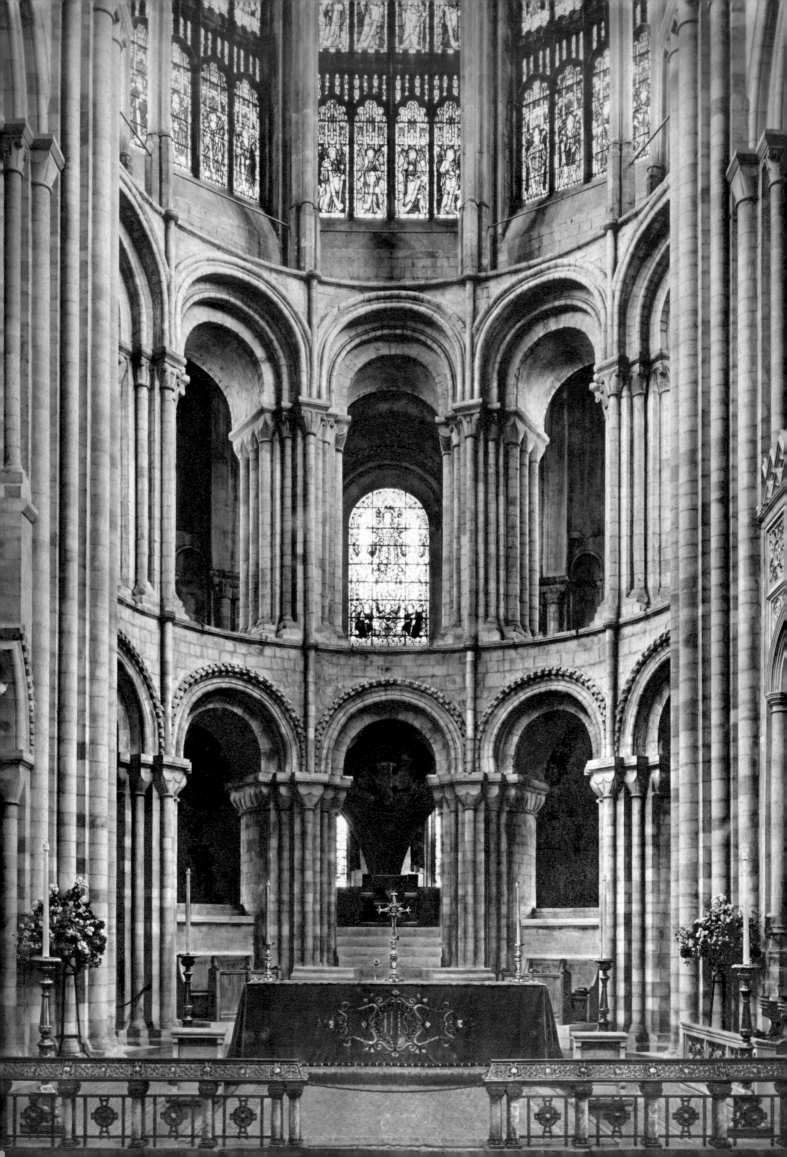

SCANDINAVIA

THROUGHOUT THE CENTURIES which led up to the emergence of Romanesque in Europe Scandinavia was a pagan territory. In the mid-tenth century the process of conversion began, with royal approval: missionaries came from Bremen and Hamburg in north Germany, and from England. New architectural forms, suited to the new faith, were introduced; political reasons usually led kings to extend their invitation to missionaries from one country rather than another, and the result is that some churches betray German influence and others Anglo-Norman. All mark the introduction of masonry to Scandinavia.

Denmark was the first country to adopt Christianity; it was followed by Norway around 1000, and by Sweden about a century later. At the beginning of the twelfth century, Scandinavia became an independent ecclesiastical province, under an archbishop at Lund in southern Sweden (then in Denmark). To celebrate this event, the old cathedral of Lund was very much enlarged *(pl. 250)*, with a transept and crypt and a system of alternating supports; the nave was probably originally covered with groin vaults. The architect seems to have been from Lombardy. The strongest influence in Denmark was German, and the church of Kalundborg *(pl. 249)*, founded in the 1170s, owes the form of its towers and its brick fabric to German Romanesque. (As also in Lombardy and south-western France, brick was used where stone was not readily available.) The plan of Kalundborg is highly unusual – a Greek cross with towers over the four arms as well as over the crossing. More conventional as a centralized building is the round church at Bjernede on Zealand *(pl. 248)*, of stone.

While most of the stone and brick building in Scandinavia was colonial in style, highly distinctive art was produced which owed nothing to the rest of Europe, and is characterized by an extreme virtuosity in the use of wood. A vigorous and integrated culture had existed long before the arrival of Christianity. Scandinavian society was composed of warriors (whose raids had such an impact abroad), and peasants; among the peasants, women cultivated the soil and tended the animals, while men were hunters and fishermen. Life centred on the sea: the interior was difficult to penetrate, and long remained only sparsely inhabited. The thick forests supplied wood for farms and houses, communal halls, and the tough, elegant ships in which the Vikings undertook their hazardous voyages. Skilful woodcarvers decorated the walls, posts and doors of the halls, the prows of the ships, the waggons, tools and utensils with fantastic ornament of entwined ribbons and figures.

In the communal halls a highly individual technique, that of 'stave' construction, was brought to perfection. Excavations show that halls built in this manner existed all over the region, persisting for the longest time in Norway. And it is in Norway that we can still see how the form was taken over in the construction of Christian churches. In these churches staves, or supporting masts, are erected at regular intervals around a rectangular inner space *(pl. 245)*. A narrow aisle runs on all four sides between the masts and the plank walls; the masts, linked at mid-height and at the top, rise up through the centre of the church and support a steep-pitched roof with, at its centre, a small belfry. The internal division of these buildings, with a broad central space between narrow aisles of equal width, must not be confused with that of the Christian basilica: the structural principles are fundamentally different, even if, after the addition of a chancel cell at the east end, the result is superficially similar. At Borgund *(pl. 244)* there is a chancel, and the nave and aisles are surrounded by a porch-like open ambulatory; each architectural element is clearly articulated on the exterior by a separate roof, and the entrances are emphasized by gables. The upper parts of the church are decorated with finials which must owe their inspiration to the prow-ornaments of the great Viking ships: altogether the techniques and the forms of stave-churches reveal the hand of experienced shipwrights, experts in the use of timber.

There is virtually nothing of the Christian south in Norwegian carving; the vigorous all-over patterning, in which men and animals are linked together by exuberant foliage or swelling serpentine forms, only occasionally acknowledges the existence of another convention: thus on the posts from Hylestad church *(pl. 246, 247)* columns with bases and capitals – one damaged – can just be made out, almost lost under the wealth of interlace. Throughout the Middle Ages Norway had links with Britain, and carvings unmistakably in the yet more serpentine style of Urnes are found inland there, in Herefordshire *(pl. 225)*. Stone sculpture, such as the figures on a font at Tryde in Sweden *(pl. 254)*, shows less assurance. The long faces and large eyes, and the stiff, stick-like bodies, show an affinity with metalwork and traditional carving in wood (and in fact the Gothic figure sculpture of Scandinavia continued to be marked by this tendency to thinness). As with architecture, one may conclude that – because the forms themselves were as new as the faith they expressed – Romanesque art proper in Scandinavia was a colonial art.

244 BORGUND, NORWAY, STAVE CHURCH. *Exterior from the south.* This is the best known of Norway's stave churches, preserving almost without alteration the mast construction of the 12th century. The entire emphasis of the building is on the vertical: it rises in stages like the surrounding mountains and is given visual unity by the shingles which cover the walls and roofs. The turret on the roof of the nave repeats in miniature the outline of the whole building and lends it particular *élan.* A low porch runs all the way round the church, offering shelter and, at the east end, forming a vestry.

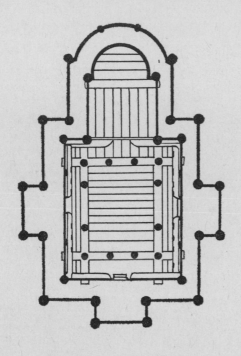

Plan of the stave church, Borgund

245 HOPPERSTAD (SOGN), NORWAY. *Interior of the church.* This interior is a synthesis of the older tradition of construction in wood and the new Romanesque influences. The arcades of round-headed arches and the plain cushion capitals imitate the forms of architecture in stone. The cross-beams between the pillars were added later, though still in the Middle Ages. The canopy over the northern side-altar is masterly, both in its carvings and in the paintings on its miniature vault, which date from the 13th century.

246, 247 POSTS FROM HYLESTAD (SETESDAL), NORWAY. These wooden posts were formerly in the porch of the stave church at Hylestad, and are now preserved in the Historisk Museum in Oslo. Elaborate scrolls frame

scenes from the saga of Sigurd Favnesbane, a Norse epic hero, who plays a leading role in several of the Eddas and the *Volsungasaga,* and is the Siegfried of the *Nibelungenlied* and Wagner's *Ring.* In the reliefs from Hylestad and other churches in the region we have the earliest representations of the human figure in Norway; they probably date from the late 12th or early 13th century.

248 BJERNEDE (ZEALAND), DENMARK. ROUND CHURCH. Of the surviving round churches in Scandinavia, the ones at Bjernede, between Sorø and Ringsted, and Torsager, near Aarhus in Jutland, deserve special mention. The similarities in their designs allow them to be called sister-churches. At Bjernede, the lower part of the central cylinder is built of small granite blocks, while the upper part is of brick. According to an inscription in the south porch the church was built by Sune Ebbesøn, a powerful vassal of King Waldemar, who died in 1186. Sune's main residence was probably near the round church, which would have thus been a private chapel and may perhaps be dated *c.*1160–80.

249 KALUNDBORG (ZEALAND), DENMARK. VOR FRUE KIRKE. The church of Our Lady was founded in the 1170s, at the earliest, by the Danish magnate Esbern Snare, who intended it to house his tomb. It was built in the form of a Greek cross with a central tower and a tower over each of the four arms. An attempt in 1827 to make an interment in one of the central pillars was catastrophic: the massive tower collapsed and crushed the vaulting and arcade of the nave. The church was rebuilt in 1867–71, and painstakingly restored between 1917 and 1921 by the architects Andreas and Mogens Clemmensen. The manner of construction and the brick fabric are characteristic of Zealand, but some of the details betray the influence of traditions of wooden construction. The groundplan and five towers are without parallel in Scandinavia.

250–253 LUND CATHEDRAL, SWEDEN. *Interior looking east; pillars in the crypt.* The present cathedral was preceded by another founded soon after 1080 by King Canute; some remains of it are incorporated in the east side of the north transept. The 12th-century basilica has a nave with aisles, a transept, and an apsed chancel. In the middle of the east wall of each transept arm there is a chapel with a rectilinear east wall, while between these chapels and the chancel there is on each side a vestry. The plan of the upper church is repeated in the crypt which lies beneath the transept and the chancel. The

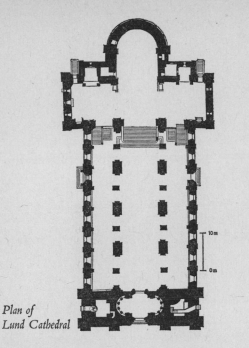

*Plan of
Lund Cathedral*

arcading and clerestory of the nave, which has no gallery, and the vaulting of chancel and aisles date from the first half of the 12th century; the vaulting of the nave was not undertaken until after a devastating fire

in 1234 which destroyed the original wooden roof, and has since been rebuilt by restorers.

The Romanesque character of the 12th-century church is clearly visible in the crypt, of *c.*1130. But there are significant additions of a later date, including the two famous pillars with carved figures. Popular tradition has it that they illustrate the legend of the giant Finn and his wife, but they have also been identified with the story of Samson and Delilah. Another interpretation would be that the crouching figure bound to the shaft of the pillar, attempting to strangle an animal, is a symbol of evil.

254 TRYDE, SWEDEN. *Detail of the font.* The stone-mason who carved this font, which dates from *c.*1160, was certainly the master-craftsman of a major workshop, which can be linked with those of Lund and Hablingbo on the island of Gotland. Figures of princes and princesses – perhaps portraits of the founders or their ancestors – stand round the sides of the font; in the way in which they stand out from the surface the pairs of highly stylized figures resemble pilasters. The treatment of folds and the execution of the details are reminiscent of metalwork.

313

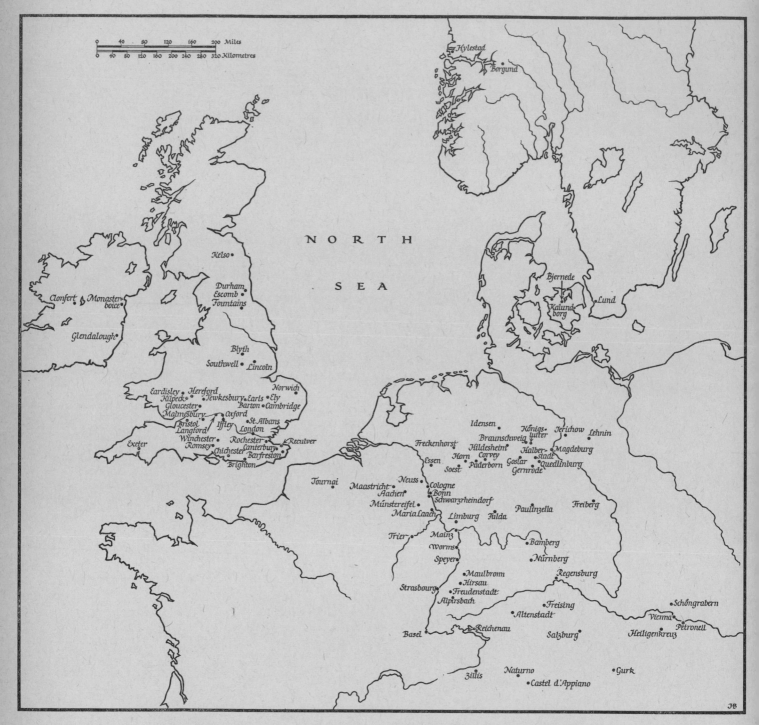

Sites of Romanesque monuments in the Germanic lands, the British Isles, and Scandinavia,
illustrated in Plates 129-254

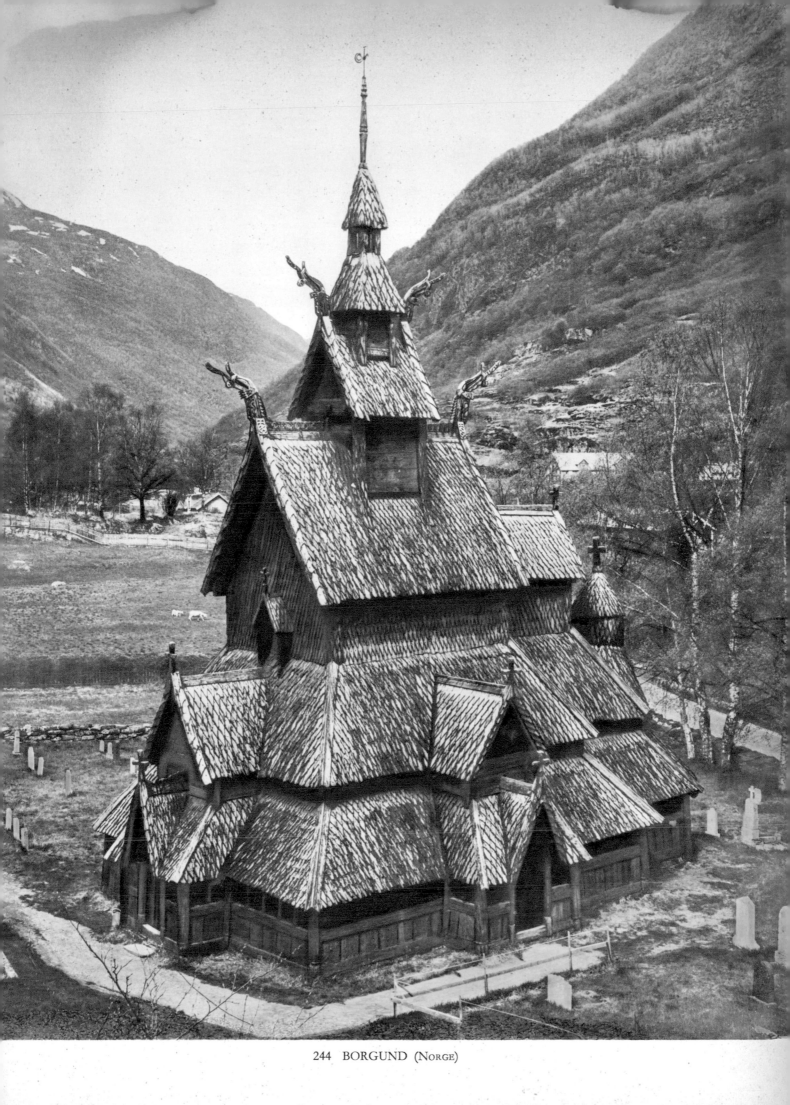

244 BORGUND (Norge)

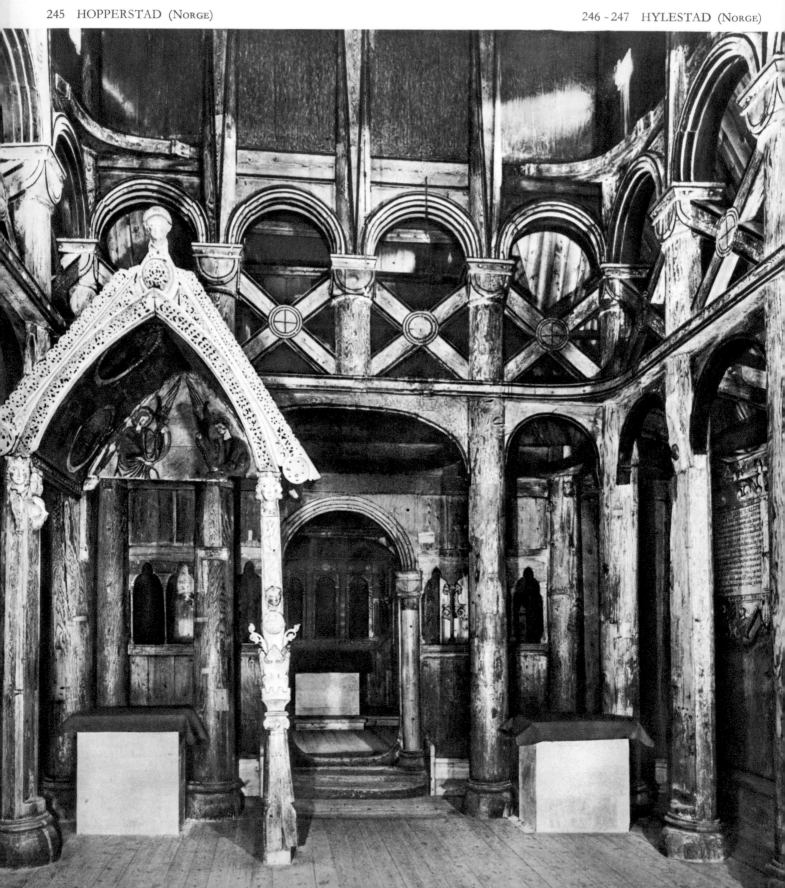

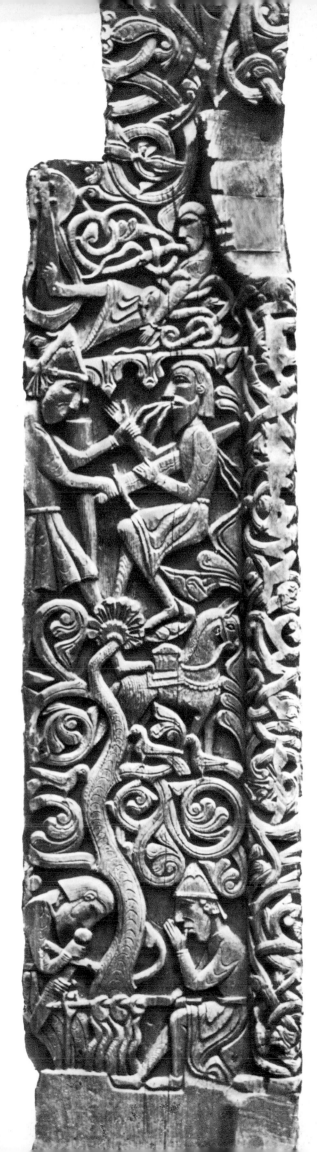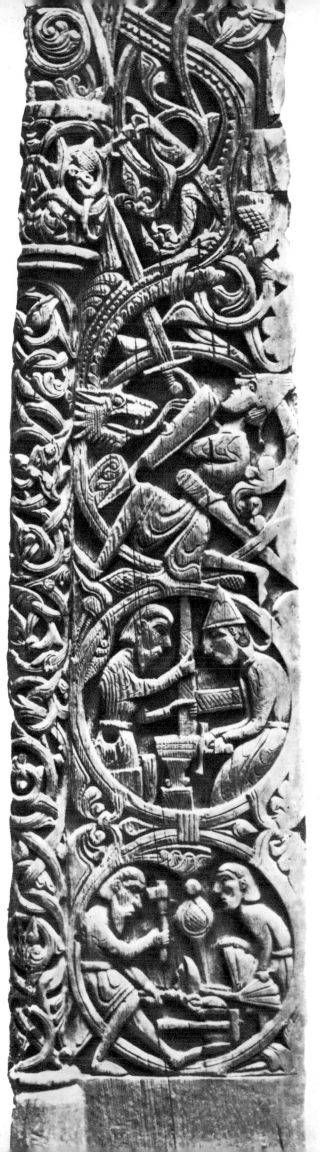

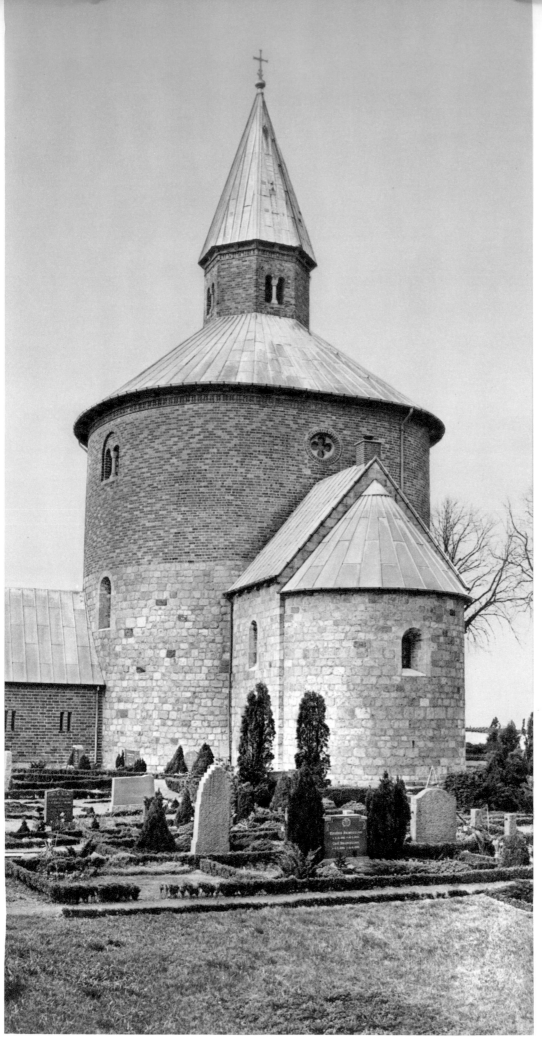

248 BJERNEDE (Danmark)

249 KALUNDBORG (Danmar

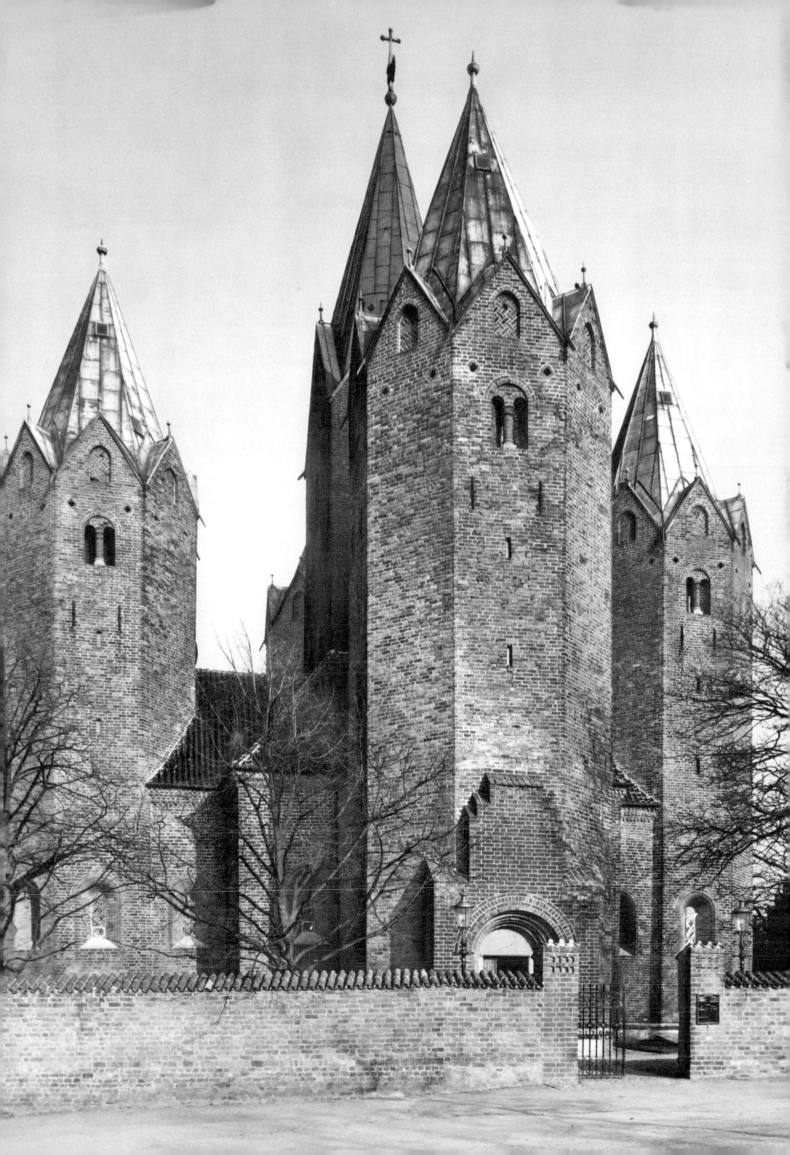

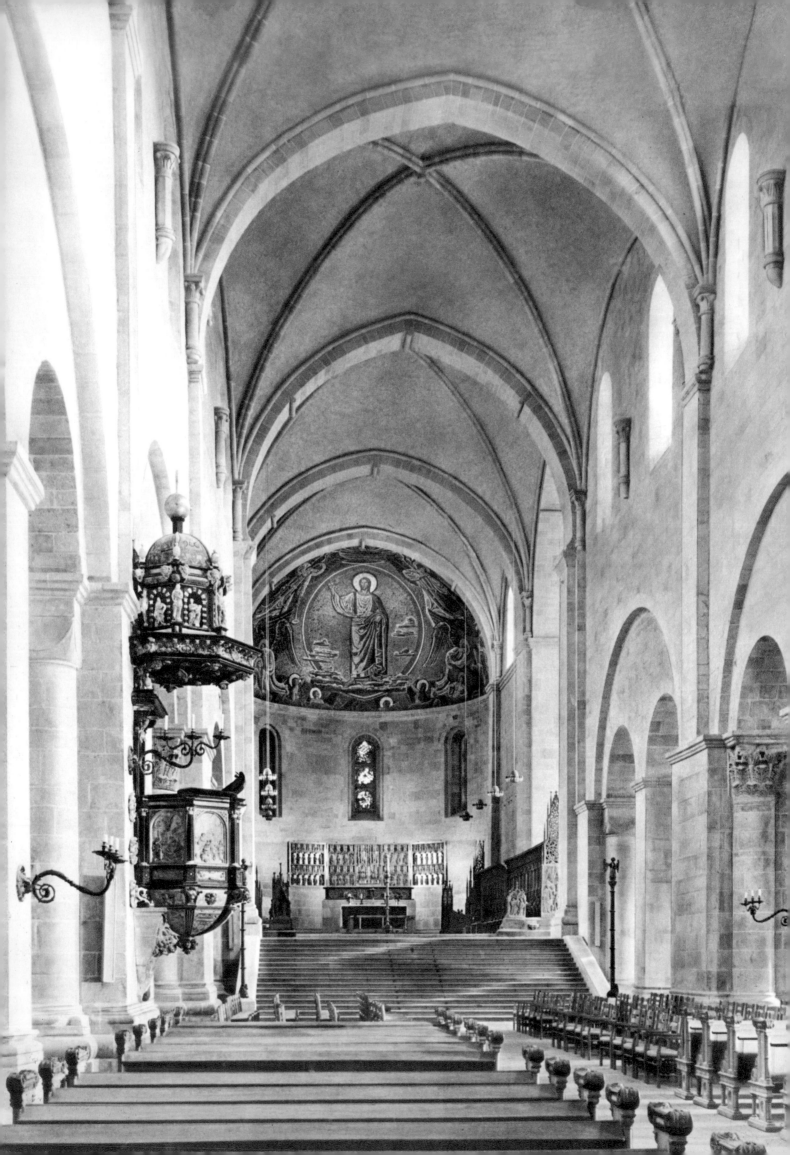

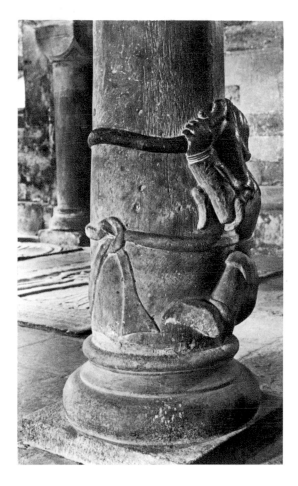

250-253 LUND (Sverige)

254 TRYDE (SVERIGE)

INDEX OF PLACES

Numbers in italic refer to the plates